MEXICAN SUITE

MEXICAN

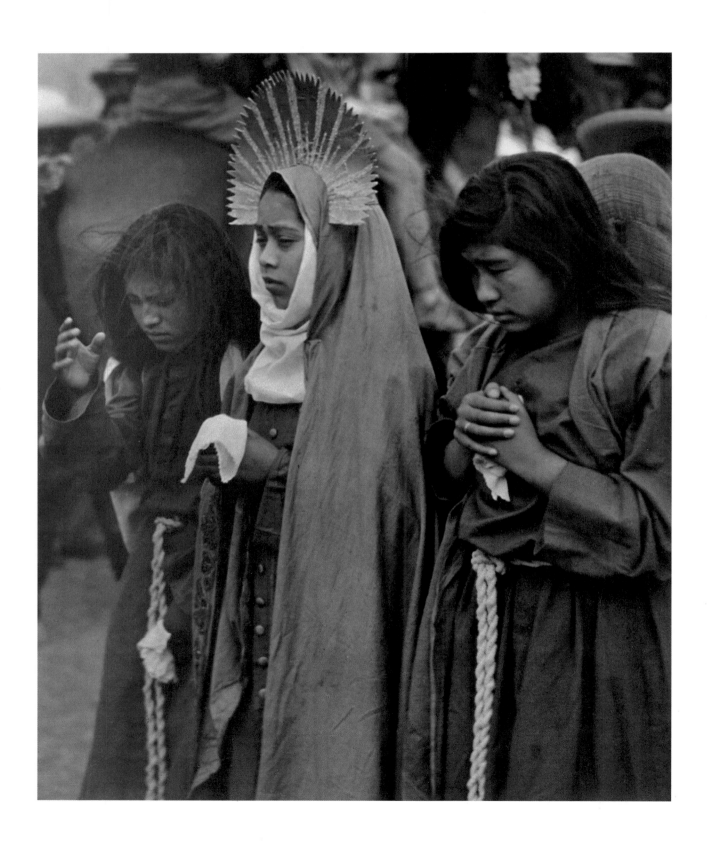

SUITE

A History of Photography in Mexico

by Olivier Debroise

Translated and revised in collaboration with the author by Stella de Sá Rego

UNIVERSITY OF TEXAS PRESS AUSTIN

Originally published as *Fuga Mexicana: Un recorrido por la fotografía en México,* by Olivier Debroise, Consejo Nacional para la Cultura y las Artes, 1994.

Library of Congress Cataloging-in-Publication Data

Debroise, Olivier

 [Fuga mexicana. English]
 Mexican suite : a history of photography in Mexico / by Olivier Debroise ; translated and revised in collaboration with the author by Stella de Sá Rego.—1st ed.
 p. cm.
 Includes bibliographical references and index.
 ISBN 0-292-71611-7 (cloth : alk. paper)
 1. Photography—Mexico—History.
 2. Photographers—Mexico. I. Title.

 TR28.D4313 2001 00-39295
 770'.972—dc21

Frontispiece:
Rosa Covarrubias
Untitled, ca. 1950
Gelatin silver print
Collection, Adriana Williams, San Francisco
Photo courtesy Throckmorton Fine Art, New York

Design by José Clemente Orozco

FIDEICOMISO PARA LA
CULTURA
MEXICO/USA
THE ROCKEFELLER FOUNDATION ◆ FUNDACION CULTURAL BANCOMER
FONDO NACIONAL PARA LA CULTURA Y LAS ARTES

The publication of this work was made possible in part by a grant from Fideicomiso para la Cultura Mexico/USA • Fondo Nacional para la Cultura y las Artes • Fundación Cultural Bancomer • The Rockefeller Foundation • whose purpose is to foster mutual understanding and cultural exchange between the artistic and intellectual communities of Mexico and the United States of America.

Contents

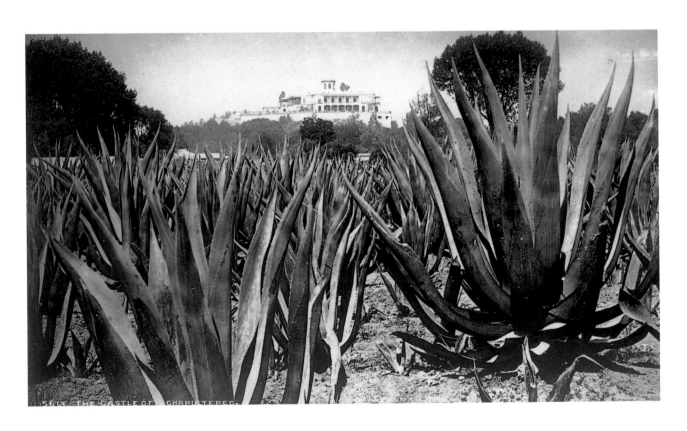

William Henry Jackson (attributed)
The Castle of Chapultepec, ca. 1883–1884

Albumen print
Center for Southwest Research
General Library, University of New Mexico, No. 996-013-0004

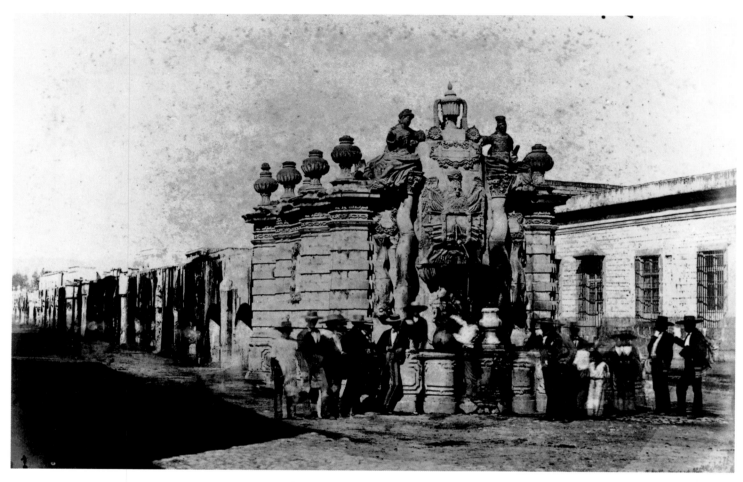

Claude Désiré Charnay

El salto del agua, ca. 1857–1859

Albumen print
Fundación Cultural Televisa–Centro de Cultura Casa Lamm,
Mexico City

Translator's Preface

I was excited to discover Olivier Debroise's book *Fuga mexicana: un recorrido por la fotografía en México* in 1995, a year after its first publication, in the bookstore of the Universidad Nacional Autónoma de México branch campus in San Antonio. The need for a history of photography in Mexico was obvious, and more so for non-Spanish readers. Beyond a few monographs on the work of particular Mexican photographers or others who worked there and brief inclusion within general histories of Latin American art, little existed in English. *Fuga mexicana* (1994) was the first history of photography in Mexico to treat the subject broadly, from its origins in the nineteenth century to the last quarter of the twentieth century. This book becomes the first such history in English.

The University of New Mexico's programs in the History of Photography and Latin American Studies and the Mexican collections at the General Library's Center for Southwest Research are widely recognized. Therefore, it seemed natural to undertake this project to make the history of photography in Mexico, as well as our own collections, more accessible to scholars and the general public.

This edition has been revised to include more current material and explanatory notes for an audience less familiar with Mexican history. The author has eliminated some of the general history of photography that is available in English and added more of the early history of photography in Mexico. Much of the latter comes from, or is based on, earlier published studies, notably *Sobre la superficie bruñida de un espejo* (Rosa Casanova and Olivier Debroise, 1989). These sources have been noted. Additionally, this edition contains some factual corrections, rearrangement of text and illustrations, and a number of new images—many from the collections of the Center for Southwest Research.

I am grateful to those responsible for the first edition, published by Consejo Nacional para la Cultura y las Artes: Olivier Debroise and his collaborators, many of whom are mentioned at the end of chapter 1. The U.S.-Mexico Fund for Culture provided support for this publication, together with the University of Texas Press. My thanks to them and, in particular, to Theresa May, editor, for making this publication possible. The Fototeca del Instituto Nacional de Antropología e Historia (INAH)—an indispensable resource for the study of Mexican photographic history—provided many of the images reproduced in this text. Others were made available through the generosity of Throckmorton Fine Art, New York. The General Library and the Latin American and Iberian Institute of the University of New Mexico provided invaluable professional support.

Individuals who contributed research, resources, and criticism should be recognized. First, I am grateful to James D. Oles for his critical reading and suggestions, assistance with illustrations, and personal support. Kathy Lewis and Salena Fuller Krug of the University of Texas Press provided careful and thoughtful editing of this text. Among the many friends and colleagues in Mexico and the United States who offered their help, I would like to mention a few here: Georgina Rodríguez, Russ Davidson, Susan Barger, Thomas Southall, Martha Davidson, Pablo Ortiz Monasterio, Marietta Bernstorff, and Roberto Hinestrosa.

Stella de Sá Rego

MEXICAN SUITE

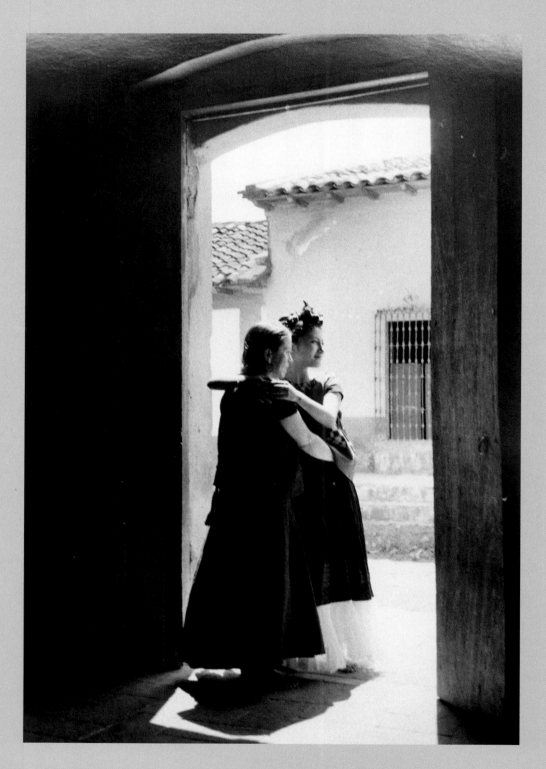

Lola Álvarez Bravo
La visitación, 1934

Gelatin silver print
Collection, Center for Creative Photography, The University of Arizona
© 1995 Center for Creative Photography, The University of Arizona Foundation

1 *Overture*

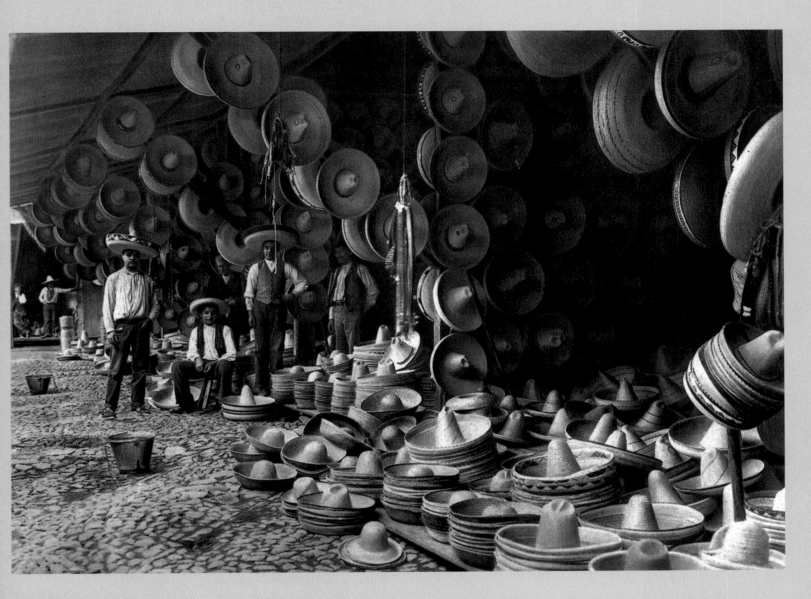

Hugo Brehme
El Volador, sombrería, ca. 1920

Gelatin silver print
Center for Southwest Research, General Library
University of New Mexico, No. 998-006-0001

Histories of History

Histories of photography and critical essays on the medium have traditionally taken an art-historical approach and made little mention of the use of images outside the realm of artistic practice. With the passage of time, the status and value of many photographs have been substantially modified. Once scattered throughout the various departments of archives and libraries, today they are brought together under a single rubric: Photography. This phenomenon was analyzed by Douglas Crimp in 1981:

> Julia van Haaften . . . is director of the New York Public Library's Photographic Collections Documentation Project, an interim step on the way to the creation of a new division to be called Art, Prints, and Photographs, which will consolidate the old Art and Architecture Division with the Prints Division, adding to them photographic materials culled from all other library departments. These materials are thus to be reclassified according to their newly acquired value, the value that is now attached to the "artists" who made the photographs. Thus, what was once housed in the Jewish Division under the classification "Jerusalem" will eventually be found in Art, Prints, and Photographs under the classification "August Salzmann." What was Egypt will become Beato, or du Camp, or Frith; Pre-Columbian Middle America will be Désiré Charnay; the American Civil War, Alexander Gardner and Timothy O'Sullivan; the cathedrals of France will be Henri LeSecq; the Swiss Alps, the Bisson Frères; the horse in motion is now Muybridge; the flight of birds, Marey; and the expression of emotions forgets Darwin to become Guillaume Duchêne de Boulogne.[1]

Representative of a current within photographic criticism, Crimp assumed a cautious stance before this profound reevaluation of photography and expressed his reservations about the relocation and reclassification of images according to aestheticizing criteria. By "ghet-toizing" photography, we often lose sight of its primary motivations and true impact. It distorts the intentions of photographers, attributing to them an "artistic eye" when, in fact, many were simply pragmatic camera operators. This does not mean that they lacked ingenuity, subtlety, and, in some cases, talent. These qualities, however, were subjugated to the necessities of legibility and verisimilitude, not to mention those of an ever more competitive market.

"Photography was invented in 1839; it was only *discovered* in the 1960s and 1970s," notes Crimp.[2] Within the history of aesthetic forms, this recent "discovery" began in the departments of photography in major museums. In this respect, the work done by the Department of Photography of the Museum of Modern Art (MOMA) in New York—the first to mount important exhibitions of "photographic artists" such as Ansel Adams, Paul Strand, and Eliot Porter—firmly established the criteria for evaluating the aesthetic quality of photographic images.[3] This revaluation of photographic practice was quickly extended to a series of individuals who might never have imagined that their works would one day be included in the holdings of an art museum. Once discovered, certain photographers who were identified as "artists" in the line first established by Alfred Stieglitz were duly selected to receive the same treatment.

As "orchestrators of meaning," the various directors of the Department of Photography at the Museum of Modern Art have transformed the reading of images.[4] Beaumont Newhall, curator of a 1937 exhibit at that institution commemorating the first centennial of photography, and the author of one of the most complete histories of the medium, broadened the criteria for appreciation of images and "located two main traditions of aesthetic satisfaction in photography: from the optical side, the *detail,* and from the chemical side, *tonal fidelity.*"[5] Using these criteria, Newhall undertook the validation of a group of photographers who, at the time, were almost completely unknown. Among these were the nineteenth-century "photographers of the Frontier"

(Carleton Watkins, William Henry Jackson) and their twentieth-century successors (beginning with Ansel Adams). This recovery and reappraisal was inconsistent with the positions of Alfred Stieglitz and Paul Strand, who emphasized the "poetry" of the photographic image. In time, Newhall came to emphasize "notions of rarity, authenticity, and personal expression" (employing what Christopher Phillips calls "erudite vocabulary") to evaluate photographic images. These criteria were further developed and defined by John Szarkowski, who introduced the idea of the "exclusively photographic," thus differentiating photographic practice from that of the other graphic arts. According to Phillips:

> Szarkowski's ambitious program for establishing photography in its own aesthetic realm has been set forth explicitly in no single work, but arrived at piecemeal in a series of slender essays over the last twenty years. His project has followed, I think, three main lines. These include: (1) the introduction of a formalist vocabulary theoretically capable of comprehending the visual structure (the "carpentry") of any existing photograph; (2) the isolation of a modernist visual "poetics" supposedly inherent to the photographic image, and (3) the routing of photography's "main attraction" away from the (exhausted) Stieglitz/Weston line of high modernism and toward sources formerly seen as peripheral to art photography.[6]

One of the earliest and most obvious examples of this new focus concerns the photojournalistic works of Lewis Hine, Bill Brandt, and photographers such as Dorothea Lange who were employed by the Farm Security Administration (FSA) to document rural social conditions and government programs under Franklin Delano Roosevelt's New Deal. Initially intended for publication in government reports or the popular press, their images assumed new functions and status when, removed from their original supports and printed on luxurious papers, they were transformed into works of art. Having already lost their character as news through the simple passage of time, they now lost their character as historical documents. Later, the photographs of a number of "amateurs" were rediscovered. Most of these photographers were scientists of one sort or another, who used the medium to document their research. More

recently, a new wave of "artistic" interest has arisen around the (often quite arid) work of nineteenth-century studio portraitists whom the history of art had previously ignored, considering their works repetitious and, for the most part, unoriginal.

The formulation of this new phenomenology of the photographic image occurred at precisely the same time that other media—particularly television—began to dominate the field of communications and the development of "live" technologies relegated photographic communication to the rank and level of the newspaper editorial. In effect, the extreme speed, if not immediacy, of the transmission of visual information removes pho-

Jesús L. Martínez
Zacatecas del sur, Ixchateopan, Guerrero, ca. 1900

Reproduced in *El Fotógrafo Mexicano* 2, no. 6 (December 1900)

tography from the field of action.[7] This has been demonstrated during recent events: the U.S. military invasions of Granada and Panama, the 1989 demonstrations in China, and the Gulf War of 1991.[8] Another example involves a photograph of the funeral of the Ayatollah Khomeini in 1988 showing the corpse being knocked from its bier by the pressure of the fanatical crowd. Taken by an amateur, the photograph did not arrive in editorial offices until ten days after the fact, resuscitating the memory of an event that was no longer considered news. This phenomenon has become even more pronounced: Mexican photojournalist Luis Humberto González, for example, was unable to cover the U.S. intervention in Panama during the 1989 Christmas holidays, partly due to the censorship imposed on the press by the invading army, but also because the news coverage was immediately monopolized by television.[9]

The impact of these technological changes has not been stressed enough, in my judgment. Yet it explains many of the complaints of photographers today concerning their gradual alienation from the events they depict (and from the ideological discussions that this engenders in the case of photojournalism), as well as such ambiguous tendencies as the aesthetic revaluation of historical images and narrow formal studies that restore to photography its original preciousness as a unique object, what Walter Benjamin called its lost aura.

Although more apparent in the United States and Europe, this absorption of the history of photography by aesthetic history has its parallel in Latin American countries: Brazil, Colombia, Cuba, Peru, and Mexico have already constructed their own histories of photography, at times in conflict with those proposed by the Museum of Modern Art in New York or the George Eastman House in Rochester.[10] In Mexico, this epistemological break—opening the way for an eventual new understanding of photography—was made possible by the archive of Agustín Víctor Casasola.

Illustrated History

The photographs compiled by Casasola for the first two decades of the twentieth century were published in the form of a book entitled *Álbum histórico gráfico* in 1921. Early on, powerful historical and ideological connotations were conferred upon this body of work: as a "collective memory" that proposed a unified view of the Mexican Revolution. But the *Álbum histórico gráfico* was not an immediate success. It was published during President Álvaro Obregón's program of "national reconciliation" (1921–1924), when Mexicans wanted to forget the cruel years of bloody struggle. In the end, only the first five albums of the sixteen originally planned were published. In marked contrast to this earlier reception, the later *Historia gráfica de la Revolución mexicana,* published by Casasola's eldest son, Ismael, in 1942, was a resounding popular success.

If in the first years of turmoil following the Revolution these photographs were viewed with fear and repugnance, the weight of institutionality and the desire to grasp the meaning of the struggles [eventually] transformed the Casasola Archive into a space of metamorphosis and irrefutable interpretations. Reproduced, commented upon—one could almost say "imprinted on the collective unconscious"—the photographs selected demonstrate that their interest does not reside primarily in the examination of popular violence but, rather, in the mythologizing aestheticization of the revolutionary process.[11]

From the aestheticization of the content (the Revolution) to the aestheticization of the container (the photograph) is but a small step. Carlos Monsiváis closed this gap at the end of the seventies in his prologues to two volumes of selected images from the Casasola Archive, published in Mexico by Larousse and the Librería Francesa with the assistance of the photographer's family. From that time on, the photographs attributed to Casasola (which had previously been very poorly reproduced) began to appear in finely printed, limited edition art books. They also appeared in government propaganda, in movies and on television, and decorated the walls of tourist restaurants specializing in "distinctively Mexican atmosphere." In 1979, the Mexican government acquired the archive and, building on this foundation, established the premier repository of photographic materials in the country: the Fototeca del INAH (Photo Archives of the National Institute of Anthropology and History) in Pachuca, Hidalgo, one hour's drive from Mexico City.

In the seventies, this phenomenon—in which historical photographs were simultaneously aestheticized

and made to function as vehicles of ideology—became more widespread, driven by the actions of a number of photographers "in crisis": a crisis of photographic representation characterized by a commitment to ideological values, on one hand, and, on the other, a search for what John Szarkowski called "the photograph itself," an exclusively photographic language without reference to other visual arts.

The Latin American Colloquia

In 1977, two major events took place that were, to a degree, an outgrowth of the counterculture or culture of opposition that emerged in Mexico after 1968. They revealed a new interest in photographic images and initiated a broad renewal of the historical imagination of Mexicans. First, Pedro Meyer and Raquel Tibol created the Consejo Mexicano de Fotografía and, through it, organized the First Exhibit of Latin American Photography, held in Mexico City in conjunction with the First Latin American Colloquium on Photography. Tibol recalls those times:

> In January 1977, we began to meet in restaurants, cafes, and the house of Pedro Meyer to begin planning the first Latin American colloquium on photography. The project was considered by almost everyone to be impossible. It was then that we conceived our first plan: a colloquium, a group exhibit of contemporary Latin American work, complementary individual shows, and workshops. Initially, we tried, with Pedro Meyer, to "sell" the idea to the Instituto de Investigaciones Estéticas at Mexico's National University—and failed . . .[12] The Instituto found no academic justification for sponsoring a regional meeting of artists whose professional credentials were not recognized [or conferred] by institutions of higher education.
>
> In the end, a high-ranking government official . . . , Víctor Flores Olea, who understood the importance of the projected colloquium, and then-director of the National Institute of Fine Arts Juan José Bremer decided to assume the adventurous responsibility, offering institutional support during a moment of grave economic and political crisis in almost every nation of Latin America . . .

The founders' second formal meeting occurred in a public place . . . not the Café Voltaire of the Dadaists, but in fact, the VIPS[13] restaurant on Avenida Insurgentes in San Ángel. It took place on February 17, 1977, and Pedro Meyer recorded the proceedings, summarizing the important points. Those present were: Lázaro Blanco, Enrique Franco, Pedro Meyer, Raquel Tibol, and Jorge Alberto Manrique . . . In that first meeting at VIPS we proposed that the title and theme of that first colloquium be "What is and could be Latin American social photography?"[14]

At this colloquium (later baptized *Hecho en Latinoamérica,* after the title of the accompanying catalog) as well as at the second one held in 1980 in Mexico City, photographers' concerns centered on the dichotomy between form and content.[15] There was a tendency to condemn formalism, given an overwhelming imperative to exhibit, make known, and call attention to the raw realities of Latin America and, through photography, force a confrontation with European and North American experiences. In his inaugural address to the second colloquium, Pedro Meyer stated:

> Those who return to their countries of origin in Latin America, after learning photography in other parts of the world and dominating technique, must reclaim the content of their images.
>
> Those who seek to transplant foreign concerns and criteria to their new [and native] reality, in the name of the "universality of art," will almost surely find themselves feeling displaced and alienated. Their images will be realized with technical proficiency, but without the strength that comes from being true to oneself. That intangible element, which escapes objective definition, is the strength that is born of conviction.[16]

Lázaro Blanco, for his part, appealed to "formal purity," tonal precision, and compositional syntax to bring reality into the photograph. "We should not lose sight of the fact that the photographer is responsible for what the spectator perceives. A clearly delivered message will be more effective than one filled with visual static which only results in confusion."[17] To which U.S. art historian Shifra M. Goldman responded:

Stillfer and Wolfskill

*First Competition of Fine Arts, Círculo Católico de Puebla
(5th Salon of Photography)*, ca. 1900

Reproduced in *El Fotógrafo Mexicano* 2, no. 1 (July 1900)

In the case of Latin American photography . . . the dominant "style" appeared to be documentary and non-manipulated photography, although there was certainly no lack of symbolic and experimental forms that utilized non-traditional means . . . Perhaps it is too early to say if the predominance of straight photography over manipulated works can be seen as a Latin American aesthetic, a result of the internal necessities of the countries involved. There is no doubt that Sr. Blanco summarily dismisses manipulated and experimental photography, which he feels abandons two of the most important intrinsic properties of photography, the relationship with time and the link to reality . . .[18]

This singular debate was central to many of the presentations at the first colloquium: those of German photographer Roland Günter, U.S. critic Martha Rossler, Brazilian photographer Stefania Bril, Cuban film director Mario García Joya, and Mexican publisher Rogelio Villarreal.

Those who worked with photographs in Latin America at the end of the seventies seemed unable to move the dialogue into a broader sphere. Perhaps overly influenced by Gisèle Freund's theory of the "social function of photography," they insisted on presenting their images of Latin American poverty, revolutionary struggles (Cuba, Nicaragua, El Salvador), or resistance (Brazil, Argentina, Uruguay, Chile) that were directed to a preconceived and somehow "idealized" audience: viewers in developed, and dominant, countries "who must be made to understand."

A kind of "My Lai syndrome"[19] reinforced the conviction that photography, "used correctly," could be a

Lola Álvarez Bravo
Mi rival 2, ca. 1940

Gelatin silver print
Private collection, Mexico City

potent weapon in the struggle for social justice. The desire to make an impact, using—in this case—the camera as a means of raising consciousness, derived from the importance placed on photography by the regime of Fidel Castro and the penetration of the Mexican and Latin American photographic milieus by ideas forged in Cuba. There photography had been used openly as an instrument of propaganda, whereas in the United States it was used to the same end, but subliminally.

The only dissonant voice among the chorus of presentations at the Second Colloquium was that of photographer Lourdes Grobet. In an article entitled "Imágenes de miseria: folclor o denuncia" (Images of Poverty: Folklore or Indictment), published in *Hecho en Latinoamérica 2,* the proceedings of the Second Colloquium, she wrote:

> Too often, qualitative and highly subjective moral values are applied to contextualize poverty. This attitude can lead photographers to aestheticize poverty. We are surrounded by images of "pretty Indians" or filthy children with enormously expressive faces; melodramatic situations abound because the image-makers make no attempt to understand the conditions that engender a social class that is exploited and, consequently, impoverished.[20]

Monsiváis responded to Grobet's essay, taking a position against the repertoire of stereotypes found in Mexican photography, with its tendency to easy folklorization and aestheticization. In the end, he introduced an alternative (which should have been given closer attention by those photographers concerned with the impact of their politically committed works) that foreshadowed practices common after 1985, consequences of the social reformation that occurred following the earthquake of September 19:

> Recently in Durango, at the Second National Meeting of Working Class Neighborhoods [II Encuentro Nacional de Colonias Populares], I saw on the walls of the primary school that hosted the discussion of 1,500 delegates an exhibition of photographs depicting life in these working-class neighborhoods, [and] the process of their organization and politicization. These photos were not serving a denunciatory function there. On the contrary, they ratified, brought

together, and acted as signs of a painful identity, combatively earned.[21]

While Mexican photographers discussed the possibility of creating a photographic institution, a kind of "Academy of Fine Arts" for photography, Eugenia Meyer and a group of historians and sociologists put together—in record time—the first large retrospective exhibit of Mexican photography, presented jointly in the Museo Nacional de Historia and the Museo Nacional de Antropología in Mexico City.

Historical Images

The research carried out by Eugenia Meyer and her team resolved a number of questions. More importantly, it indicated that a continent lay submerged beneath the tip of the iceberg. The more than three hundred photographs exhibited aroused a great deal of curiosity and left viewers wondering about the extent of the country's photographic riches yet undiscovered.[22] As a result of these activities, the Mexican government—through the INAH—acquired the Casasola Archive and provided facilities to house it in the former Convent of San Francisco in Pachuca. This was a clear indication of renewed interest in photography and photographic history. Moreover, it was an unmistakable announcement that a change in the status of these images was underway.

In the catalog to the exhibition, entitled *Imagen histórica de la fotografía en México,* Meyer and her collaborators treated photography as a "social document" and offered a critical evaluation from the historical point of view, leaving aesthetic interpretations aside. This approach, similar to that of Raquel Tibol, concerns what we might call the "Casasola effect."[23] This refers to the formidable success of the images of the Revolution and their impact on the construction of the idea of Mexican nationality and of an official mythology (that of the "institutionalized revolution"). As a result, historians began to enlarge the period of photography's impact and from this foundation to (re)construct a "graphic history of Mexico" that would include more than the revolutionary phase. "In our opinion, there are no innocent photographs . . . Consciously or unconsciously, the photographer actively participates in the historic moment. Above all, he leaves a record of the historical

process through which he has lived," Eugenia Meyer insisted.[24] Therefore, all photography is objective testimony, for even when "the subjectivity of the photographer leaves its impression . . . [the photograph] has significative intentions in that it preserves invaluable sources for the history of a nation," continued Meyer in a typically official Mexican mood.[25]

The reevaluation of photography initiated in 1977 did not manage to totally avoid aestheticization, typically the driving force behind this type of recovery and ratification. "There were moments in the research when one encountered touching, human elements. This was the case with Romualdo García, a photographer from Guanajuato who captured the life of his city with its problems and class conflicts," according to Meyer.[26] In reality, the sudden appreciation of these photographers owed less to their social content than to a renewed sen-

timent of nostalgia, an aesthetic consciousness of past times.

In addition to García, other "image-makers" were discovered at this time: Abel Briquet, Charles B. Waite, Guillermo Kahlo, Natalia Baquedano, Eduardo Melhado, José María Lupercio, Constantino Jiménez—names that until that time were unknown, forgotten.

Twelve years later, in 1989, Mariana Yampolsky and Francisco Reyes Palma presented an exhibition in Mexico City's Museo de Arte Moderno entitled *Memoria del Tiempo,* commemorating photography's one hundred and fiftieth anniversary. The point of departure for their show and the accompanying publication of the same title was, in fact, the work of Eugenia Meyer (complemented by a number of brief, more recent studies, particularly those of Flora Lara Klahr and Marco Antonio Hernández, Alejandro Castellanos, Rosa

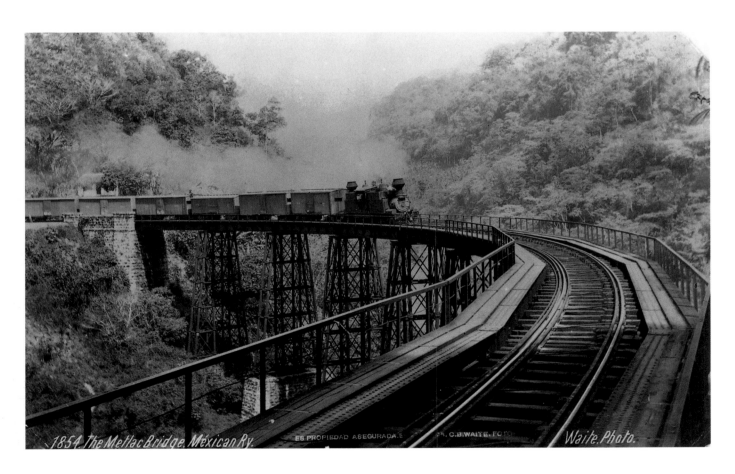

C. B. Waite

The Metlac Bridge, Mexican Ry. [Railway], ca. 1900

Gelatin silver print, Center for Southwest Research,
General Library, University of New Mexico No. 996-003-0027

Casanova, and others).[27] After considering a number of approaches, the organizers structured the show "with a view to the diverse social functions and, therefore, uses satisfied by photography."[28] Within these parameters, they experimented with free associations to indicate categories and subcategories, possible themes, and visual models of reference.

Herself a photographer, Yampolsky could not—and did not want to—avoid certain formal associations or completely ignore formal qualities, while Reyes Palma, from his perspective as a historian and archivist, endeavored to maintain the conceptual framework. Despite its material limitations, the exhibition turned out to be surprisingly balanced and inclusive.

The vision of Yampolsky and Reyes Palma began to diverge consciously and deliberately from that of Eugenia Meyer and her team from the moment that they began to focus their attention on the function of the images within a historical perspective. The inclusion, for example, of sections devoted to sports and applied sciences (micro- and macrophotography, astronomical images, etc.), as well as amateur works, introduced new analytical perspectives. *Memoria del Tiempo* contained a factor of doubt, a certain (self-)critical distance, that cannot be located in the work of the team that put together the 1977 exhibit, dazzled as they were by their discoveries. In the catalog of *Memoria del Tiempo,* Reyes Palma wrote:

Without a doubt, photography is a cultural presence that invades the social, private, even intimate spaces of our lives. One hundred and fifty years after the official announcement of its discovery, photography has found its place, if somewhat uncomfortably, in museums. Despite having been consecrated as art by the cultural institutions of the great metropolitan centers, the majority of its expressions remain outside aesthetic appreciation or, at least, linked to a variety of practical applications not properly considered artistic. For its acceptance to be complete, then, this large undefined area of society in which photography has so firmly rooted itself must be taken into account.

If we extend the limits of this reevaluation of photography beyond the aesthetic to include the complexities of its public and private functions, we also broaden the museum's role as an open cultural space and recuperate that aspect of photography that has made it a contradictory art.[29]

By including this notion of "broaden[ing] the museum's role as an open cultural space" under pressure from photography, the opinion of Francisco Reyes Palma coincides with that of Douglas Crimp, who wrote:

If this entry of photography into the museum and the library's art division is one means of photography's perversion of modernism—the negative one—then there is another form of that perversion which may be seen as positive, in that it establishes a wholly new and radicalized artistic practice that truly deserves to be called postmodernist. For at a certain moment photography enters the practice of art in such a way that it contaminates the purity of modernism's separate categories, the categories of painting and sculpture. These categories are subsequently divested of their fictive autonomy, their idealism, and thus their power.[30]

The present study intends to follow this approach, breaching the barriers of genre and style and looking beyond the parameters of aesthetic appreciation borrowed from the history of art. Instead, I have attempted to reconstruct the reasons for which particular images were taken, selected, and, finally, published.

A photographic image receives many influences: those of the "creator" and—in "supporting roles"—of the patron (who might be a business, photo agency, publisher, or government office) and the subject (in the case of portraiture, the sitter). These may persuade or oblige the photographer to acquiesce to their functional requirements for a particular image or conform to the client's aesthetic tastes and sensibilities. As a medium of communication, photography is—first of all—a "visual service."

Those Vast Cemeteries of Images

The majority of old photographs we see—in looking through family albums, for example, or examining archival collections—no longer interest us today. They

seem so anecdotal and incomprehensible, their subjects forgotten. "Whose face is that?" we wonder. "What does this landscape illustrate?" And these unknowns remain, nearly always, unexplained.

Every image can be deciphered, but at what cost? In contrast, the more explicit photographs seem to command our attention.

There are other images, rejected in their own time, that acquire an indefinable patina that transforms them into the expression of a certain moment. They come to represent, on a metaphorical plane, the "essence" of a certain historical moment. The photographic collection is thus never a "dead archive." Many surprises occur within its labyrinths, modified by the view of each researcher who looks inside. This may seem obvious, but it is important: when one is faced with an overabundance of images, numerous possibilities for interpretation present themselves. I hope to develop some of these in the course of this study, making it clear that doing so implies both imposing new meanings on them and creating, in each case, a new "history."

The historian of photography is overwhelmed by the sheer number of photographs housed in archives. There are more than three thousand glass-plate negatives in the archive of Romualdo García in Guanajuato. The Fototeca of the INAH in Pachuca includes more than thirty thousand images in the Casasola Archive alone, without counting the other collections housed there. At the Archivo General de la Nación (National Archives of Mexico), the archive of the Hermanos Mayo contains five million negatives. Elsewhere, those of Hugo Brehme, Enrique Díaz, Lola Álvarez Bravo, and Juan Segara have not been fully inventoried yet, not to mention those in provincial cities that are gradually coming to light.

The great majority of these images are, obviously, "unpublished" in the sense that only a tiny fraction of them—the tip of the iceberg—were ever selected for reproduction by their creators or by publishers. Very few escape the category of "visual information" to be perceived as artistic creations. Herein lies the ambiguity of the photographic medium, more often an instrument of reproduction than of personal expression.

The overwhelming quantity of images and frequently observed versatility of photography as a medium of direct representation open to multiple readings oblige the historian of images (who so often comes from an art historical background or applies the critical apparatus of aesthetics) to modify the parameters of analysis.[31]

To be complete, any analysis of photography as a means of representation has to include its commercial vocation, that application of the medium that Charles Baudelaire so roundly denounced in 1859.[32] The official history of photography dwells too much on exceptions and places too much value on a series of "photographic artists" liberated from the control of the dominant taste of their clientele; such artists were relatively atypical if one takes into account the much greater proportion of "anonymous" or semi-anonymous images. For that reason, historians of photography must transform themselves into scholars of abundance and repetition, forcing themselves to understand the reason for these repetitions. They have to embrace the prolific production of commonplaces and stereotypes before fixing their attention on the exceptional examples closer to our perception of photography as established by Alfred Stieglitz and his group and later taken up in Mexico by Manuel Álvarez Bravo and those who followed his "formula for success" with greater or lesser critical fortune.

Because of its diversity, the history of photography cannot be summarized in a single volume without leaving out some of the protagonists, a few of whom, perhaps, were more important than first appears. This study is not meant to be exhaustive. Rather, I have selected relevant images from among the millions that exist in the various archives I consulted and attempted to document them using existing sources, both written and oral.

This book is organized thematically. I searched for the origins of certain genres and styles of representation and followed their evolution to the present, in some cases. In others, I established ruptures that, if not completely arbitrary, are obviously disputable. In every case, I tried to define the territory, to reveal some structural constants and demonstrate repetitions and variations. Likewise, I gave greater attention to some little-known figures and passed more quickly over the work of those photographers who have already been more thoroughly documented.

This study discusses photography in Mexico from the 1840s—when the earliest daguerreotypes were made in Mexico—to the last decade of the twentieth century, tracing the proliferation and impact of photography over

that period. It does not treat, in an exhaustive manner, the production of contemporary photographers. Nevertheless, I have indicated some current developments and attempted to sketch out possible lines of continuity.

I have discussed the work of several photographers in each chapter, considering quantity or quality according to the case. While I have not attempted to deal with the entirety of their production, I have indicated the scope of their photographic activity. Working in this way allowed me to avoid numerous digressions and repetitions. Obviously, many of the photographers, ar-

chives, and even genres only mentioned in passing here merit greater study and more thorough analysis.

This study has a collective character: it is the result of the spontaneous collaboration of many people interested in photographic history who have provided me with information, opened their archives to me, saved newspaper clippings, or called my attention to particular images. They are not always mentioned in the footnotes, yet I have a special debt to Esther Acevedo, Rosa Casanova, Waldemaro Concha, Karen Cordero, Nicole Girón, Annick Lempérière, Patricia Stevens Lowinsky,

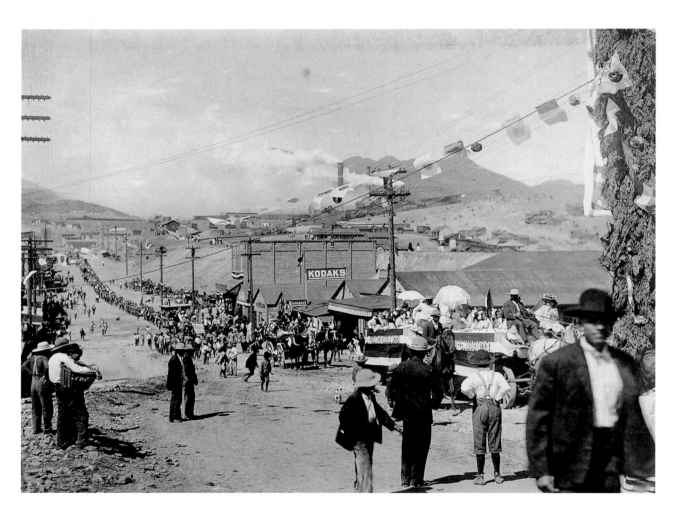

Anonymous
Parade, Cananea, ca. 1906

Gelatin silver print
Courtesy Throckmorton Fine Art, New York

Cuauhtémoc Medina, Patricia Mendoza, Carlos Monsiváis, Alfonso Morales, Carole Naggar, James D. Oles, Patricia Priego Ramírez, Francisco Reyes Palma, Carla Rippey, Fred Ritchin, José Antonio Rodríguez, Philippe Roussin, Antonio Saborit, Carla Stellweg, Francisco Toledo, and Juliet Wilson Bareau. I would also like to express my gratitude for the indispensable help and patience of the team of researchers and photographers at the Fototeca del INAH Pachuca, in particular the late Servando Aréchiga, who permitted me to explore the archive and helped me in the visual documentation for this book. The Centro Nacional de Investigación, Documentación e Información de Artes Plásticas del Instituto Nacional de Bellas Artes (INBA) and, particularly, Alejandro Castellanos, historian of photography there, allowed me to consult documentation that was in the process of being compiled at the time.

This book commemorating photography would not have been possible without the direct contribution of many photographers. I am especially grateful to David Maawad, Pedro Meyer, Pablo Ortiz Monasterio, José Luis Neyra, Víctor Flores Olea, Adolfo Patiño, and Mariana Yampolsky, as well as the members of the Consejo Mexicano de Fotografía.

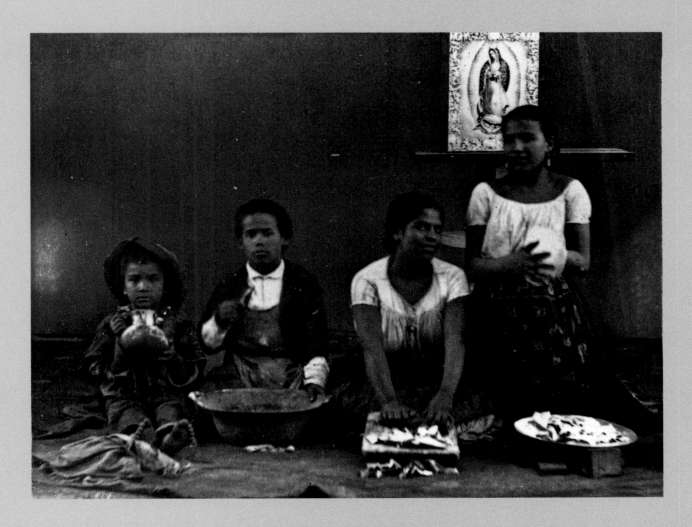

Aubert & Cía.
Tortilleras *and Children with Image of the Virgin of*
Guadalupe, ca. 1864–1867

Albumen print, carte-de-visite
Center for Southwest Research, General Library,
University of New Mexico No. 997-013-0049

Of the Miraculous "Imprint" and Other Illuminations

Father Luis Becerra Tanco's *Felicidad de México en el principio, y milagroso origen que tubo el santuario de la Virgen María de Guadalupe,* published by Viuda Calderón in 1675, is a text that describes the miracles surrounding the famous appearances of the Virgin of Guadalupe in 1531.[1] A learned Mexican doctor and mathematician, Becerra Tanco was especially keen—and in this his book differs from earlier Guadalupan exegeses—to find solid evidence for the powerful Marian cult in Mexico. To this end, the second edition of *Felicidad de México* included an anonymous engraving explaining (with scientific pretensions) how the image of the Virgin came to appear on the cloth mantle of Juan Diego, after her fourth and final apparition on the Hill of Tepeyac, just outside of Mexico City. In the print, rays of sunlight illuminate the image; a luminous fluid (represented as a cloud or vapor) is projected over the mantle, outstretched like a screen. As a sign or proof of her apparitions, the Virgin produces an image of herself by using certain common properties of light: she prints herself photographically on the cloth. The commemorative engraving depicts the exact moment of this divine "click." With this photograph, Juan Diego would be able to prove the miracle's existence to the episcopal court.

Oddly, the mechanism described by this anonymous artist contains the seeds of what would be, two centuries later, a new technology: the process "of reproducing nature from itself."

There was no single inventor of photography. The idea of fixing images seen through the camera obscura (first constructed in 1545 by the Dutchman Reiner Gemma Frisius and widely used after the publication of a treatise by the Neapolitan scientist Giovanni Battista Della Porta) fascinated graphic artists, painters, chemists and opticians, writers and poets.

The camera obscura and its variant, the camera lucida, became the favorite instrument of painters of landscape views (*vedute*), fashionable in Europe during the eighteenth century. More than landscapes as we understand the genre today, these pictures were intended to be descriptive, scientific representations of a particular space: three-dimensional enlargements of maps. "In this tradition"—writes Jean François Chevrier—"the treatment of landscape participates in the same illusionistic quest as the architectonic view or urban view . . . It would be worth mentioning the 'topographic view,' since the desire for realism in representation of the forms and space seems to prevail over intentions of subjective interpretation."[2] These images—comments Chevrier further on—had a value inseparable from their artistic quality: the image reproduced on the ground glass of the camera obscura was of the greatest imaginable clarity. "No object"—wrote the Venetian painter and patron Francesco Algarotti at the end of the eighteenth century—"can be seen better than through the optical camera in which Nature paints things closer to the eye with finer and firmer brushes, and those more distant with strokes ever more muted and soft."[3]

Daguerreotypomania

At the beginning of the nineteenth century, modern chemistry and optics made it theoretically possible to retain images. Swedish scientist Carl Wilhelm Scheele published his experiments on the light sensitive properties of silver chloride in 1777. Englishman Thomas Wedgwood published a treatise (1802) on "drawing" shadows and silhouettes on a surface coated with silver nitrate, but was unable to fix the image. By 1827, Frenchman Joseph Nicephore Niépce had succeeded in permanently fixing a light sensitive image, obtaining the result that a number of others were also working toward: William Henry Fox Talbot in England, Hippolyte Bayard in Paris, Hercule Florence in Campinas (near São Paulo) in Brazil, Enrique Martínez in Ciudad Real (now San Cristóbal de las Casas), Chiapas,[4] José Manuel Herrera at the Colegio de Minería in Mexico City, and others, unknown and forgotten . . . The invention of photography was less a question of finding a way to reproduce images than of retaining them, fixing them permanently on a support.

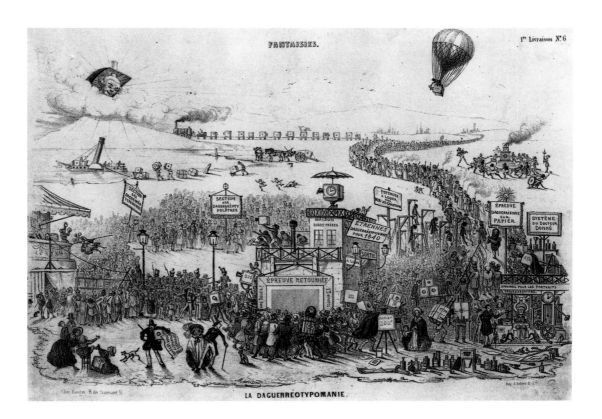

Théodore Maurisset

La Daguerreotypomanie

Reproduced in *La Caricature*
(December 1839)

Months before its announcement by Jacques Louis Mandé Daguerre in Paris and Henry Fox Talbot in London, there was already speculation about the use by painters and engravers, archaeologists, geographers, and, perhaps, astronomers of the technique of image reproduction that we now know as photography. In the weeks following the famous declaration of François Arago in the French Chamber of Deputies in July of 1839, daguerreotypy became fashionable among the well-informed European middle class. Those with the means quickly acquired their "daguerrean boxes" and, with the instruction manual in hand, eye to the lens, attempted—often without success—to "capture Nature."

A famous caricature by Théodore Maurisset, published in Paris in December 1839, eloquently describes the masses of new photographic enthusiasts, crowding around the daguerreotype cameras of wood and copper, establishing clubs for "daguerreo-worshipers," producing equipment for portraitists . . . or gallows from which to hang the unfortunate engravers and miniaturists who would be put out of business by the new technology. As an accompanying text explains:

Daguerreotypomania: This [is the title of] the illustrated announcement for that admirable invention which has been so highly praised, admired, and well-paid; discovery worthy of a national subvention for the simple reason that the nation hasn't the least need for it whatever. Yet, thanks to the luminaries of the Academy of Sciences, thanks to the zealousness of a distinguished representative . . . ; Pardon! An illustrious scholar . . . Pardon! No, excuse me! A famous astronomer.[5] Perhaps the quality is not exactly high, no matter, we won't dwell on that, it has yet to be perfected; this sublime traveler-commissioner/agent of the Academy, this scientific editor, having placed his lungs at the service of the daguerrean discovery, it now happens that this instrument is declared to be necessary to everyone and it is decided that everyone will pay for it, in spite of the fact that positively no one has any use for it.[6]

The object of all this discussion—the daguerreotype—consists of a small sheet of copper bathed in a thin coating of polished silver that reflects the sitter's face like a mirror and secures a permanent image of incredible clarity and detail. Depending upon the angle at which it is viewed, the image appears negative or positive. The silver is perfectly smooth, so highly polished that it is without any apparent grain. Today, more than one hundred and fifty years later, the daguerreotype image remains unrivaled for clarity and permanence.

On July 30, 1839, the French Chamber of Deputies debated whether the government should purchase the

patent for Daguerre's process and "give it to the world." One deputy asked chemist Gay Lussac, a defender of the invention, if it would be possible to use the daguerreotype to make portraits and was told: "The problem is practically solved." The question clearly indicated what was expected of the medium and the direction of its development.

Just months later, thanks to the luminous lenses developed by the Austrian Josef Petzval in 1840 and thanks to certain advances in chemistry that increased the sensitivity of photographic emulsions, the photographic portrait conquered the world. It became the vehicle for an idea of civilization, through images that surreptitiously implanted in the consciousness of viewers ways of being, dressing, posing, and presenting oneself. Like other American nations, Mexico participated in this "daguerreotype mania."

On December 3, 1839, the French engraver Louis Prélier—who had lived in Mexico City, at 9 Calle de Plateros, since 1837—returned from France aboard the ship *Flore* after having purchased two cameras in Paris.[7] No sooner had he arrived in Veracruz than he organized a public demonstration (as Daguerre had done only months before) in the port, and soon thereafter "the Palace in the Plaza de Armas, the principal buildings there with their portals, part of the royal road, the Convent of San Francisco, the Bay and Castle of Ulúa, the dunes west of the city [were] transmitted to the plates."[8] The event was fully reported by the press in both Veracruz and Mexico City. On January 26, Prélier repeated the demonstration in the plaza in Mexico City, where "the cathedral [was] perfectly reproduced."[9]

At almost the same time, another Frenchman, Father Louis Compte, arrived in Rio de Janeiro and, on January 21, demonstrated the daguerreotype to Brazilian emperor Pedro II, who himself became an amateur daguerreotypist and encouraged the introduction and development of photography throughout the Brazilian Empire. Several weeks later, Father Compte disembarked in Montevideo, where he remained for several months.

On this subject, it is worth relating the testimony of an Argentinian resident of Montevideo, Mariquita Sánchez, who attended the "daguerrean experiments" performed in that city by Comte in early 1840. In a letter to her son, she admired the images made in Brazil only a few weeks before:

In a view of [Rio de] Janeiro, in a plaza reduced to the size of this paper (imagine the reduction of scale), appear little dots that with the aid of a magnifying lens we see to be shirts and stockings hung from a clothesline in the yard of a house that, doubtless, never imagined that it would enter into history. What an object of meditation, my Juan, how ignorant we are![10]

Barely two years after the first cameras arrived, "professional" photographers appeared in Mexico. Fugitives from the traditional visual arts, these adventurers came in search of easy money.[11] As pioneers, they confronted fundamental technical problems: how to obtain the necessary chemical products in Mexico and how to preserve them in uncertain climatic conditions.

Unlike other technological innovations of the nineteenth century, photography was quickly accepted into Mexico. During the first twenty years of its existence, the new medium was carried to the farthest regions of the country by itinerant photographers who traveled traditional commercial routes, stopping in a town just long enough to practice their trade before moving on to the next. Above all, photography touched the private lives of people. The insertion of photography into Mexican culture was not only widespread, but profound. "The art of photography has become so common in our times that families have their photographer in the same way that they have their lawyer or doctor," wrote a journalist less than two decades after the introduction of photography into Mexico.[12]

Using the new medium at their disposal, photographers embarked upon the task of producing portraits of their clientele (limited to those who could pay the rather elevated price). They placed their knowledge and art at the service of the classes in ascension. By providing them with visual references, they facilitated the self-affirmation of the urban middle class. In this sense, photography was the first instrument of technology to define—while simultaneously attempting to eliminate—the border between the private and the public sphere. Individually, the portrait was invested with a series of subjective, sentimental values (commemorating certain events, sent to distant relatives and absent friends, etc.). As a collective practice, it served as a link and means of visual communication. Photographs defined and reconstituted the "social landscape" within

the mythic space of the "family album," that nineteenth-century, middle-class version of a domestic altar or hall of ancestors. These personal images and private testimonies circulated widely. Marcel Proust was perhaps the first to detect this fetishistic quality ascribed to portraits. Throughout *Remembrance of Things Past*, the novel's protagonists repeatedly have their portraits made and exchange these effigies, worship or destroy them—even steal them if the situation requires it. Certainly, they attribute to these portraits immense sentimental and mnemotechnical value. According to Alain Corbin:

> The contemplation of one's own image is a privilege . . . Photography allows for the democratization of the portrait. For the first time, the fixing, possession, and reproduction in multiple copies of one's own image became possible . . . Access to the representation and possession of the image of one's self exacerbated the sense of self-importance, democratized the desire for social acceptance. Photographers clearly understand this. In the studio-theater, filled with accessories, columns, [and] drapes, everything lends itself to enhance the stature of the sitter, to exaggerate his importance and flatter his ego . . . This theatralization of attitudes, gestures, facial expressions and pose, whose historical importance Jean-Paul Sartre recognized and understood, has come to permeate daily life.[13]

Before the advent of photography, the European middle class had become accustomed to having their portraits made in the studios of miniaturists. They learned something from this experience that later allowed them to confront the camera with a certain self-confidence—the theatrical distance described by Gisèle Freund in her dissertation.[14] This was not the case for the señoritas from Mexico's inland, rural provinces—the Tierra Adentro—or for the plantation owners from the Bajío. They arrived inexperienced at studios that itinerant daguerreotypists had hastily improvised in hotel rooms. They seated themselves uncomfortably, assuming a conventional pose in compliance with the "maestro's" orders, eyes wide with anxiety as if expecting something terrible to happen. They can still be seen today in the few daguerreotypes that have survived in Mexico: dressed in their Sunday best, perhaps, although not in the contemporary style of the day. Women wear

silk shawls and Spanish mantillas, a luxury, no doubt. Men boast chaps of jaguar skin and vests embroidered with silver and hold in their hands the inevitable wide-brimmed sombrero.

These itinerant daguerreotypists operated with a minimum of equipment, but even so, the camera and accessories weighed at least 70 kilos and were very fragile and difficult to transport. They pursued a clientele that, initially, was quite small: the opulently wealthy land-owning families of the fertile areas northwest of the capital; the rich traders along the road from Veracruz to Mexico City; the miners from the center and north of the Republic that squandered their fortunes as fast as they made them; traders in European or Asian wares at regional markets. The itinerants followed the traditional routes of the mule trains and pilgrims. They appeared from time to time at the large seasonal gatherings: the fairs at Zapopán and San Juan de los Lagos, the fiestas of Guadalupe and the Virgen de los Remedios. Exhausting business at one plaza, they moved on to the next. Randall W. Hoit, Francisco Doistua, Andrew J. Halsey, and Richard Carr came and went from New York to

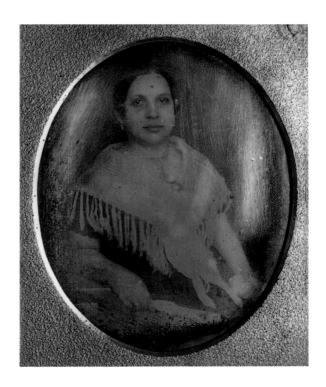

Anonymous
Portrait of a Mexican Woman, ca. 1845

Daguerreotype
Reproduction authorized by the Fototeca del INAH-CONACULTA
Pachuca, Hidalgo

New Orleans, from Veracruz to Havana, Campeche, and Mérida . . .

In their brief stopovers in these cities, the daguerreotypists left no other trace than a few anonymous images, carefully conserved by their owners. Often, they made views of the landscapes and cityscapes that they passed through. Some made sets of daguerreotypes that they put on public view, like the Frenchman Philogone Daviette, who was in Mexico briefly in 1842 before establishing a practice in 1846 in Lima, where he exhibited a series of views taken in fifteen different regions of the New World.[15]

The pioneer photographers had to exercise their profession over an extended geographic area in order to survive. Daguerreotypes were fascinating, but expensive: during the 1840s, their cost varied from 2 to 16 pesos, according to size. A comparison is provided by Madame Calderón de la Barca, who informed her mother in a letter written from Mexico in 1840 that "a French cook receives some 30 pesos [per month], a housekeeper 12 to 15, a butler around 20 or more, a footman 6 or 7, servants and chambermaids 5 or 6, a gardener 12 or 15."[16]

The daguerreotype and, a little later, the ambrotype were thought of as personal objects, like jewelry. Their use, however, was exclusively private. Placed in cases of embossed leather lined with satin or velvet, they were sometimes tinted with color in imitation of oil-painted miniatures. This appears to have been particularly characteristic of Mexican or, more broadly, Latin American daguerreotypes. The covering over of the photographic image with paint expresses a relation with the clientele distinct from that in Europe or North America. In Latin America there appears to have been less concern for the visual fidelity of the icon and greater interest in the aura of the composed object (image and frame). In the early years of the medium, there was an attempt to establish styles derived from the Western pictorial tradition combined with archetypical canons—romantic and specifically middle-class—of the mid-nineteenth century. Moreover, in these countries there was also an affirmation of the photographic image as an object of veneration, of worship, part and parcel of a long Catholic, and even pre-Christian, tradition.

Landscapes, panoramas, and city views—which were of great interest to European amateur artists and which had a determining influence on the origin of photography[17]—did not play an important role in the early history of photography in Mexico. There are examples, to be sure, of an incipient production of landscapes in Latin America, and these will be discussed later in this text. Yet the daguerreotypes made in Colombia by Baron Gros, those taken of the Port of Veracruz and of the Plaza Mayor in Mexico City by Prélier, and an anonymous daguerreotype of a street scene made, perhaps, in Peru or Ecuador (now in the collection of the Société Française de Photographie in Paris) remain exceptional in the earliest years of Latin American photography and predate the establishment of the profession there. That such subjects were chosen at all appears to have been mainly due to the necessity for long exposure times at that point in the technical development of the medium, which made portraits impossible. Only later, with the development of techniques of mass reproduction and, particularly, of stereoscope viewers, would the public display a greater interest in landscape photography.[18]

The Last Alchemist: Théodore Tiffereau

Among those foreign photographers who made daguerreotype views in Mexico, Frenchman Théodore Tiffereau might be considered a paradigm of the itinerant photographer. Trained as a chemist at the École Supérieure de Nantes, Tiffereau went to Mexico in 1842 with the intention of studying the methods employed in the extraction of silver and mercury in Mexican mines. Years later, he admitted: "On leaving France, I decided to conceal my work under the cover of a new art, daguerreotypy. Before my departure, I stocked up in Bordeaux with the necessary supplies and apparatuses . . . Approximately two months later, I obtained satisfactory results . . . Under the cover of my new activity, I traveled through those immense regions . . . always taking as many shots as possible with my daguerreotype."[19]

Although apparently working as a daguerreotype portraitist, Tiffereau visited the states of Tamaulipas, San Luis Potosí, Jalisco, and Michoacán mainly to carry out experiments designed to transmute silver into "artificial gold." He claimed to have first succeeded in Guadalajara in 1846; he repeated his experiment several weeks later in Colima and once more in Guadalajara before returning to France in 1847.

In 1853, Tiffereau twice attempted to prove his discovery to the skeptical members of the Academy of Sciences in Paris. He was unsuccessful and attributed his remote successes to "the influence of the sunlight, so intense and favorable in the lovely climate of Mexico."[20] He ended up managing a photographic studio in Auteuil and preparing chemicals in the nearby neighborhood of Passy. He patented a hydraulic clock that also failed to bring him the fortune he desired—a sad end for the last alchemist, misplaced in modern times.

Some of Tiffereau's Mexican daguerreotypes, however, attracted the attention of the members of the Société Héliographique de Paris, a branch of the Academy of Sciences. Ernest Lacan, editor of the weekly *La Lumière,* one of the first publications specializing in photography, did not hesitate to compare Tiffereau's exotic images with Baron Gros's views of Columbia and with those of the Nile and Palestine made in 1850 by Maxime du Camp . . . even with the scenes of Moscow and Saint Petersburg taken by Roger Fenton.

Like so many other images, the actual daguerreotypes of Théodore Tiffereau have been lost with the passage of time. Memory of them survives, barely, in the detailed descriptions of Ernest Lacan, published in *La Lumière* in July 1854.

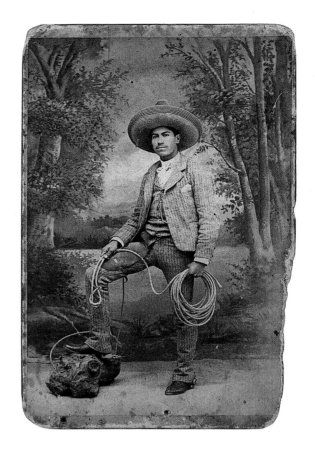

Anonymous
Portrait of a Charro, ca. 1870

Albumen print, carte-de-visite
Reproduction authorized by the Fototeca del INAH-CONACULTA
Pachuca, Hidalgo

M. Tiffereau had at his disposition only defective cameras, imperfect plates, impure and insufficient chemicals . . . None of this prevented him from obtaining very interesting results . . . Three were made instantaneously. They are: the Port of Mazatlán, the Port of Tampico in which sailing ships appear—their masts can be clearly distinguished, their ropes stand out against the sky; and, above all, the Tecualtiche market.[21] Just imagine a large space, arid as a corner of the desert, where squeezed together under the burning rays of the sun [are] a multitude of individuals wearing wide-brimmed sombreros and wrapped *a la española* in a white garment that looks like a sheet, or better, a shroud. The appearance of this crowd, divided into groups, is a fantastic thing; this market looks like a witches' sabbath. Above all, it is notable . . . for the speed at which it must have been made. This was [taken] in December 1846 . . .

M. Tiffereau also brought several portraits that provide an idea of the ideal Mexican type. Among

these, we mention two portraits of señoritas of great beauty, despite their dark complexions and somewhat heavy figures.[22]

The following year, in an article about the applications of photography to science, Ernest Conduché described other daguerreotypes made by Tiffereau: "In addition to practical details about the extraction of minerals depicted in these proofs, we can see the strata in which the metal lies in perfect detail and [thus] receive an accurate description of this fine industry."[23]

Even though we know more about Tiffereau than about his contemporaries, thanks to the writings of his friends in France, he was not alone in traveling through the Mexican highlands. The case of English photographer Richard Carr, who traveled through Mexico and Central America between 1845 and 1850, is typical. Upon learning of the discovery of gold in California and of the massive immigration of prospectors and adventurers there, Carr left to go into business in San Francisco.[24]

3
Canon

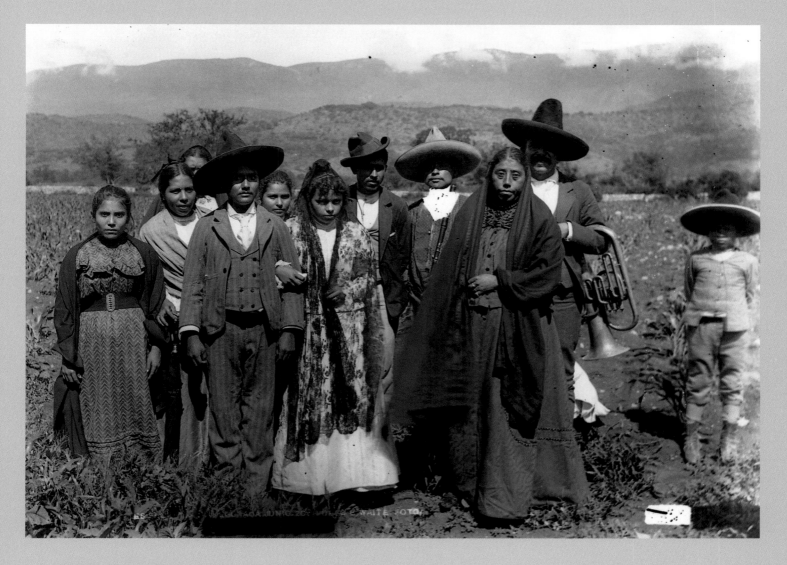

Charles B. Waite
La boda, ca. 1900

Modern copy from collodion negative
Reproduction authorized by the Fototeca del INAH-CONACULTA
Pachuca, Hidalgo

Technology at the Service of a New Class: Portraiture in Mexico

Even more than in Europe or the United States, the production of portraits dominated the photographic profession in Mexico up to 1870 or 1880. This generic distinction is due not to the nationality of the photographers, but to the differing demands and priorities of the clientele and the multiple functions that the medium was made to serve in Mexican society.

The ubiquitous nature of the portrait in the thirty or forty first years of photography is also related to the particular composition of that society. Cameras were few, in part because of their high price (to which the costs of shipping and duty were added). Moreover, there was no erudite middle class interested in carrying out this type of technical experimentation, working with their own hands.

No one should be surprised by the absence of a Mexican nineteenth-century equivalent of the work of Atget in France, Julia Margaret Cameron in England or Matthew Brady and Jacob Riis in the United States . . . It is a question of priorities and patronage: the nineteenth-century middle class relied on pictures only to eternalize the majesty—presumed or real—of their exterior, physical features. Photo-

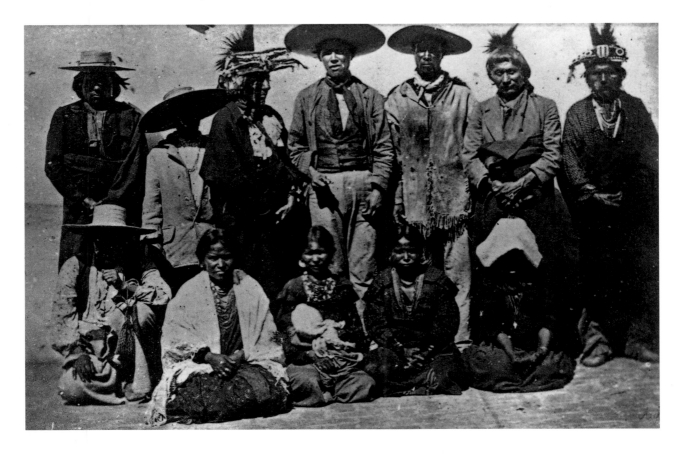

Aubert & Cía.
Kickapoo Delegation to the Court of Maximilian, ca. 1865

Albumen print, carte-de-visite
Center for Southwest Research, General Library, University
of New Mexico No. 997-013-0050

graphs were important as expressions of sentiment [to be exchanged] or models for outward behavior, but were not and could not be considered art since they lacked the power to transform the sitters' greatness and humanity into universally valid objects.[1]

Carlos Monsiváis extends this description of the situation that prevailed from 1850–1870 to the end of the nineteenth century. One thing is certain: this fascination with the image (which allowed the ever-increasing number of photographic professionals to move from an insecure to a stable economic and even socially prominent position) had a profound impact on Mexican society.

In Mexico, photography not only amazed the aristocracy and the new middle class that copied European models; it also dazzled—perhaps through its indefinable magical aspect—rural societies that developed a

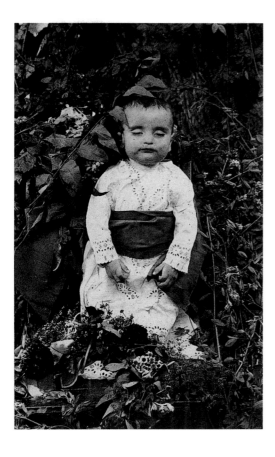

Anonymous
Angelito, ca. 1870

Albumen print, carte-de-visite
Private collection, Mexico City

widespread, "syncretic" devotion to photographs. They transformed the images of their personal heroes (tribal leaders, relatives and ancestors, etc.) into cult objects, part of Mexico's "iconographic capital"—the country's traditional "fascination with images" that goes back to the Precolumbian era—so often described, but seldom appreciated for its symbolic values. In these cases (too frequent in Mexican "popular culture" to be ignored) the images—paintings, engravings, and photographs—are invested with mythic values and become confused with other "relics." They acquire a status of "emanation" of the absent, of presence, thus reaffirming, paradoxically, the original function of photography. How else can we explain, among so many other examples, those portraits in carte-de-visite format of the Kickapoo Indian chiefs who visited the Austrian archduke Maximilian, then emperor of Mexico, in 1865 and went voluntarily to the photographic studio of Antíoco Cruces to have their portraits made? Or the Indian chieftain who posed in the neoclassic decor of Romualdo García's studio in Guanajuato, in front of a backdrop that depicted a bucolic European landscape? Not to mention the very common portraits of *angelitos* (deceased infants and young children), objects of private devotion that were made from an early date in Mexico by photographers who specialized in these images, such as Juan de Dios Machain, who worked in Jalisco at the end of the nineteenth century. In his archives are portraits of the deceased and their survivors made in back yards or in the streets in front of their homes.[2]

Photography soon found a place on domestic altars, placed among candles, bouquets of flowers, fragrant herbs, and holy cards with pictures of saints. As early as 1842, the French daguerreotypist Philogone Daviette was selling photographic reproductions of images of the Virgin of Guadalupe. Manuel de Jesús Hernández also found an early daguerreotype reproduction of a neoclassical print of Christ and the Virgin.[3]

Photographic portraits of government officials, printed and distributed in great numbers, were ubiquitous in nineteenth-century Mexico. The quantity produced is surprising, especially considering the economic situation of the country. In 1876, following the death of President Benito Juárez, the Cruces and Campa studio produced an edition of twenty thousand copies of his portrait in carte-de-visite format, an enormous number that far surpassed that of any other publication. Does

this indicate a primacy of the image over the written word? This familiar official portrait of the Benemérito has been reproduced by printmakers, sculptors (a three-dimensional translation appears atop the monument to Juárez in Mexico City's Alameda Park), and painters, including Juan Cordero, David Alfaro Siqueiros, Rufino Tamayo, and Diego Rivera.

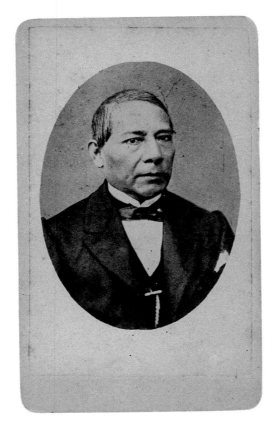

Anonymous
Benito Juárez, ca. 1870

Albumen print, carte-de-visite, Reproduction authorized by the Fototeca del INAH-CONACULTA, Pachuca, Hidalgo

Portraits of Maximilian were even more widespread. These were sold not only in Mexico, but in Europe, where a cult devoted to the memory of the martyred emperor had developed. In 1865, the French photographer Auguste Péraire produced a photographic print that depicted Maximilian and Carlota kneeling before an "apparition" of the Virgin of Guadalupe.

What vague, unexplained religious sentiment attaches itself to photography and its derivative technologies?

In 1871, the Studio Fotografía Artística run by Cruces and Campa offered discounts to their clients as well as "a photo of the Savior of the World" with every order of a half-dozen portraits.[4] Mexican photographic archives contain many images, some photomontages, of Teresa Urrea, the Saint of Coborca. Considered a protomartyr of the Mexican Revolution, in the 1890s she led the campaigns at Temosáchic, Sonora, that were eventually crushed by the army and was worshipped for several decades in northern Mexico and the southern United States for her miraculous powers. One of these images, located in the Felipe Teixidor collection at the Fototeca del INAH, shows the saint dressed in a penitent's habit, standing on the terrestrial orb, distributing health to humanity.

Even today, photography serves as a vehicle for many religious sects, such as that of Niño Fidencio, who has a devoted following in the state of Zacatecas, and of Juan Soldado, saint of illegal immigrants, whose tomb is venerated in Tijuana.

The Creation of a Profession

The first Mexican daguerreotypist that we can identify with certainty was named Joaquín María Díaz González. A student of painting at the Academy of San Carlos, he was a pupil of the neoclassical painter Primitivo Miranda. In 1844, Díaz opened an ephemeral studio on the Calle de Santo Domingo where he painted miniatures in oil and made daguerreotypes, competing with the foreign photographers Andrew Halsey, Francisco Doistua, and others.[5] Apparently, the business was not very successful, since there was no printed mention of his studio after 1858.

Díaz González represents an exceptional, even avant-garde, case. At this early date, only four years after the announcement of Daguerre's process and before the technique had been substantially improved, it was not economically feasible for photographers to establish a permanent studio. In Mexico, as in other parts of Latin America, daguerreotypists continued to be itinerants until the mid-1850s. This was due to a number of factors, but primarily to the high price of daguerreotypes. Consequently, the clientele was small and the daguerreotypist eventually had to seek his fortune in more prosperous regions.

Daguerreotypy is limited to the production of a single, unique image. In the most literal sense of the word, it mirrors reality, preserving its appearance at a

given moment. Aside from its photographic verisimilitude, daguerreotypy is closer to the traditional concept of painting than to the reproducible graphic techniques that were increasingly widespread after the invention of lithography at the end of the eighteenth century.[6]

The negative-positive (calotype) process developed by Fox Talbot offered the possibility of multiple copies, something that the mid-nineteenth-century inventors had been seeking. Frederick Scott Archer and Claude Niepce de Saint-Victor, nephew and follower of Nicephore Niépce, succeeded independently in accomplishing this goal, using glass instead of paper as a support. In combination with modern optics, photography became, after 1860, something more than a simple mechanism of representation. It became a medium in the modern sense: an instrument of communication and knowledge.

The notion of copy introduced and represented by the daguerreotype was disappearing, replaced by the broader concept of reproduction: an apparently small and insignificant change in the collective imagination. Yet the possibility of obtaining multiple, virtually identical, and inexpensive copies added to a certain fetishization of the original. It also provided the pedagogical tools for a modern history of art that relied on photographic reproductions more than on firsthand experience with the originals.

The transition from daguerreotypy to the reproducible negative/positive processes represented not only a quantitative, but also a qualitative change. The democratization of the medium, now faster and cheaper than before, increased competition. Photographers responded with an endless array of new strategies to attract an ever more demanding clientele. Studios were filled with sumptuous decor: elaborately painted backdrops, fine carpets, elegant furniture. The image lost something of its simplicity, as well as the sharpness and presence characteristic of the daguerreotype. Walter Benjamin made this observation in 1931:

The [daguerreotype] procedure itself caused the models to live, not out of the instant, but into it; during the long exposure they grew, as it were, into the image . . . Everything in these early pictures was set up to last . . . Therefore, these incunabula of photography are often misrepresented by emphasis on the artistic perfection or tastefulness in them. These images were taken in rooms where every customer came to the photographer as a technician of the newest school. These photographers, however, came to every customer as a member of a rising class and enclosed him in an aura which extended even to the folds of his coat or the turn of his bow tie. For that

Aubert & Cía.
Coronel Porfirio Díaz, Hero of the Battle of La Carbonera,
ca. 1865

Albumen print, carte-de-visite, Reproduction authorized by the
Fototeca del INAH-CONACULTA
Pachuca, Hidalgo

aura is not simply the product of a primitive camera. At that early stage, object and technique corresponded to each other as decisively as they diverged from one another in the immediately subsequent period of decline. Soon, improved optics commanded instruments which completely conquered darkness and distinguished appearances as sharply as a mirror.[7]

The sudden apparition of new techniques—glass-plate negatives coated with collodion emulsion, salted and

albumen paper prints, and tintypes—unleashed a price war that brought photography within the reach of a much broader segment of the population. Under the pressure of such competition, even daguerreotypes became more accessible. Prices collapsed, and the technology, henceforth universally known as photography, embarked upon its process of democratization. The enlargement of the clientele offered new prospects to incipient photographers. Those quasi-mythological personalities who journeyed incredible distances with their fragile equipment now opened top-floor studios on principal avenues in the commercial centers of large cities.

The first of these commercial photographic studios in Mexico City was owned by foreigners. The Frenchman Emmanuel Mangel Dumesnil arrived from Buenos Aires in 1853 or 1854 and opened La Fama de los Retratos, the first such establishment on record. He left the business in 1855 or 1856. After that, it was operated by a German watchmaker known as Rodolfo Jacobi, who employed a number of "imported" camera operators. Among these was Teodor Gottfried Dimmers, a German specialist in cartes-de-visite and probably the person who introduced the cabinet card format to Mexico.[8]

In 1856, there were seven studios in Mexico City, five of which were duly registered and paid taxes. Only four years later, there were already more than twenty. By 1870, we can count seventy-four photographic studios, from the large and luxurious galleries located in the center of the capital—on major commercial thoroughfares like Plateros, San Francisco, 5 de Mayo, Escalerillas, and Monterilla—to the poorest neighborhoods on the outskirts of the city, such as San Cosme and Santa María la Ribera. In comparison, there were only twenty-six studios in all of Colombia in 1870 and thirty-one in the La Plata region of Argentina.

Between 1864 and 1867, the first "boom" of photography in Mexico occurred. Twenty new studios opened, dedicated to the production of cartes-de-visite and cabinet card photographs. This sudden explosion of activity was directly related to the political situation at that time. The strict and unprecedented imperial protocol established by the court of Maximilian necessitated a reaffirmation of social attitudes through acts of representation in which photography would have a determining function.

Among the European professionals who went to Mexico in the wake of Maximilian were those dedicated to the production of luxury items: tailors, hotel managers, pastry chefs, cooks, and photographers. The Frenchmen Amiel, Mérille, and François Aubert arrived, followed by Jean Baptiste Prévost, Adrien Cordiglia, and Auguste Péraire; and the Spaniards Julio de Maria y Campo, José Pedebiella, and J. B. Parés (associated in Veracruz with a photographer named Ventura). The

MÉXICO,

Cruces y Campa. 2ᵃ de S. Francisco nº 4

Cruces y Campa
Portrait of a Young Girl, ca. 1865

Albumen print, carte-de-visite
Center for Southwest Research,
General Library University of New Mexico
No. 986-025-0027

North American photographers J. Tomwang, Vaughan and Company, and John Tutrig also worked in Mexico during the French Intervention.[9] At the same time, the Mexican studios of Francisco Montes de Oca, Lauro Limón, Andrés Martínez, Luis Campa, Antíoco Cruces, Agustín Velasco, Joaquín and Maximino Polo, Luis Veraza, Manuel Rizo, and Julio Valleto also benefited from this fashion trend. In this period, photographic firms became solidly established, to the extent that some photographers operated more than one studio in the same city. In regard to photography, Mexico's Second Empire was synonymous with prosperity. A curious demonstration that photography was truly considered an economic alternative is the case of a Treasury employee named Francisco Cervantes, who "became a photographer rather than serve the Empire."[10]

The Profession of Photographer: First Phase

By the mid-1860s, photographers had ceased to be experimental scientists or erstwhile painters who had converted to modern techniques of reproduction. In only a few years, specialized industries had emerged in Europe and the United States to produce increasingly precise cameras, as well as every imaginable type of related equipment and chemical products. In contrast, photographers in Mexico and other less-industrialized countries were obliged to become small manufacturers. This situation contributed to photographers' being considered—above all in provincial cities—"learned" persons in the vanguard of scientific knowledge, on a par with physicians and apothecaries.

For the most part, nineteenth-century Mexican photographers belonged to the elite class, the only group with the means to acquire the expensive, imported, and ever more sophisticated equipment and to subscribe to the photographic reviews published in France, England, and Spain.

Some of these photographers were able to travel to the United States, or, better yet, to France, to study the latest advances in the medium. Miguel Servín, for example, studied in Paris with Alphonse Poitevin (inventor of photolithography and author of a widely used manual of daguerreotypy and photography). Antíoco Cruces and Octaviano de la Mora also spent long periods in Paris, while Srs. Latapi and Martel of the Droguería La Profesa named themselves the Mexican representatives of the Société Française de Photographie, a venerable institution that still exists and that was considered at the time the *ne plus ultra* of the photographic vanguard.[11]

A number of these photographers studied at Mexico City's prestigious art school, the Academy of San Carlos, which allowed them to advertise their services as "artistic photographers" (to differentiate themselves from "agricultural or hydraulic" photographers, as one journalist of the day joked).[12] Although marginalized by this "commercial" activity, they never completely broke with the academy. Jesús Corral, for example, professor of drawing, worked as a painter in the studio of Agustín Barroso, where he painted portraits in oil using photographs "to eliminate the tedious long sittings."[13] Luis Campa, associate of Antíoco Cruces, won a number of prizes for painting at the academy's annual salons, served on juries, and became director of the drawing curriculum. From Italy, he brought an important collection of photographic reproductions of Greek and Roman sculpture, paintings, and prints, which became achingly familiar to the generations of art students who were obliged to copy them during their first year.

Beginning in 1870, photography made a discreet entrance into the annual salons organized by the academy, which took place just before Christmas. More importantly, photographs began to appear in the municipal exhibits of the Arts and Trades School, which had a broader curriculum. Very early on, women participated in these exhibits. The first recorded female participant is Margarita Henry, "Galdina," a student of the School of Arts and Trades for Women, who exhibited photographic enlargements of a portrait of a Sr. Prieto.[14] Another citation states that Vicenta Salazar exhibited "two good photographic portraits of the child María Villalobos in the Municipal Exhibit of 1874."[15] José Silencio was director of the photography class at the School of Arts and Trades for Women from 1871 to 1899.

Photographers employed both academic and independent painters to retouch and color portraits. Lorenzo Aduna, professor of life drawing at San Carlos, worked in this capacity at the studio of Juan María Balbontín in 1858; José María González, a genre painter who had received many awards, was the colorist for Carlos M. Bosque; Ramón Sagredo, painter of *Ismael in the Desert*

and another celebrated canvas at the time, *The Death of Socrates,* was successively associated with the photographers José María Maya, Luis Veraza, and Julio Valleto.

The vogue for hand-colored images—particularly portraits—endured in Mexico at least until the introduction and widespread distribution of Kodacolor film between 1950 and 1960. It persists even today, although the practice is at the point of disappearing, maintained solely for its nostalgic quality. Along with the restricted practice of photo-sculpture, hand-colored photographs have been relegated to the status of "popular art," reclaimed by erudite culture and a history of art that is ever more interested in marginal phenomena.[16]

Hand-coloring had been applied since the early days of daguerreotypy and enjoyed its golden age with the ambrotypes and tintypes produced in the 1850s. The latter processes, intermediary between the overly expensive daguerreotypes reserved for the wealthy and the democratization signaled by the introduction of the card photographs produced in multiple copies, lent themselves to a number of experiments that apparently enjoyed public favor during a brief five-year period from 1854 to 1859. Yet hand-colored photographs were not simply a "popular" practice in Mexico to be viewed as kitsch or as belonging only to suburban or provincial photography. Since at least the 1880s, hand-coloring was practiced by even the most prestigious urban studios, such as that of Cruces and Campa, who advertised colored prints as "illuminated enlargements." In 1900, *El Fotógrafo Mexicano,* a review published by the American Photo Supply Company, included formulas for hand-coloring inks. A little later, some of Hugo Brehme's lyrical views were delicately hand-colored.

The illuminator took on other functions. Besides retouching portraits with color in a more or less discreet manner, he or she sometimes covered the entire emulsion in oil. This technique became more common after the introduction of solar enlargements that made it possible to obtain images the size of a conventional painted portrait. In the course of inventorying the painting collections in Chapultepec Castle, art historian Esther Acevedo found a number of "oil paintings" that were, in fact, painted-over photographic enlargements. Among these was a full-length portrait of Porfirio Díaz from the early 1900s.[17] Not everyone appreciated these alterations. However, the argument advanced was not

photographic, as demonstrated by this comment from an 1862 newspaper:

[Ramón Sagredo and other artists] sacrificed their best years and resources to a most beautiful art that is, unfortunately, little appreciated . . . Consequently, they have abandoned those studies that cost them so dearly . . . Today they contribute their talents and the fruit of their long vigils to the profit of photographers who, employing them in the coloring of photographic portraits for the paltry stipend of one-third of their value, take advantage of the labor of these former students of the Academy.

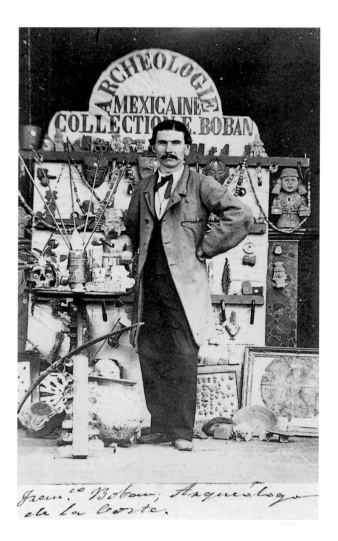

Anonymous, ca. 1865
Eugène Boban, Archaeologist to the Court of Maximilian

Albumen print, carte-de-visite
CONACULTA-INAH
Reproduction authorized by the Museo Nacional de Antropología e Historia

We do not condemn the speculative conduct of the photographers, which we find logical. However, we do condemn the public's lack of taste . . . that leads them to readily imagine that photographic portraits will be even more life-like after the application of color. A very grave injury to the truth!

The gentlemen who believe this should know that only the outlines of a photographic portrait are used and that, sometimes, even these are lost because the shadows and idiosyncrasies that make up the [sitter's] individuality disappear under the layer of color that covers the surface . . . as a result the colorist has to copy [these details] from another portrait, rendering the execution poor and the color false.

Some will say that even preserving the outline of the photograph is already an advantage over portraits drawn from life. To this we will respond that it is not an indispensable requisite . . . The painter that colors a photograph . . . will always sacrifice part of his genius to the trivial pursuit of his predecessor's footsteps and the poverty of an inferior execution will replace brilliance, beauty, and stylishness, exhibiting—in place of animated and expressive images that are the fruit of genius . . . inanimate wooden busts.[18]

Some painters worked freely in both media. Antonio Orellana, Juan Cordero, José Escudero y Espronceda, and Hermengildo Bustos were among the best-known painters to use photography as a basis for their works. The portraitist Salvador Ferrando, from Tlacotalpan, Veracruz, and the renowned landscapist José María Velasco were both painters and photographers.[19]

In 1872, Salvador returned from Rome, where he had been sent on scholarship from the Academy of San Carlos. He opened a photographic studio in Mexico City, but—perhaps due to the intense competition—preferred to return to Tlacotalpan, where he had a double career as photographer and painter of portraits and views of the river port. The great majority of his known paintings were copied from photographs that he took himself.

The case of José María Velasco is more complex. He already enjoyed a solid career as teacher at the Academy of San Carlos, where he held the position of professor of perspective drawing—ceded to him by the Italian Eugenio Landesio—until he resigned (or was fired) in 1872 because of his disagreement with the policies of President Juárez. Recently married, Velasco found himself obliged to open a photographic studio in order to support his family, but "had no luck" with this business, according to his biographer, Luis García Islas.[20]

Art criticism of the first half of this century concerned itself with the valorization *a posteriori* of Velasco's painting and deliberately suppressed this episode in his life. Given the modern concept of the "artistic genius," it seemed imprudent to imply, in effect, that Mexico's leading landscape painter, the "inventor" of a way of seeing the Mexican physical environment, had been a mere "copyist." This behavior reveals the low esteem in which photography was held, resulting in the distortion of a chapter in the history of Mexican art.

It does not appear that José María Velasco shared this disdain for modern technological means of image reproduction. Recent research by Esther Acevedo has shown that Velasco collaborated with the scientist and photographer Eduardo Hay on a scholarly trip to Huauchinango, Puebla, in 1865. The painter described the photographic equipment and field laboratory he used on this expedition. In 1878, Velasco introduced the use of photographs in his perspective class. He allowed students to copy from the images (some of which he had probably taken himself on the outskirts of Mexico City) instead of drawing directly from nature. Velasco was only exercising the commonly held opinion of his contemporaries: if photographs "mechanically" reproduced reality, why not copy them as if they were nature itself?

Despite a certain reluctance on his part, the archaeologist Carlos Martínez Marín demonstrated that Velasco used photographs to illustrate the *Anales del Museo Nacional* (after joining that institution as a draftsman in 1880).[21] In 1892 (on the occasion of the quadricentennial of the discovery of America), Velasco produced several drawings, published in the *Anales,* based on photographs of excavations by Francisco del Paso y Troncoso at the sites of Cempoala and El Tajín, in Veracruz. The photographic originals had probably been made by the photographer and archaeologist Teobert Maler.[22] It seems certain today that José María Velasco used photographs to compose some of his majestic landscapes of the Valley of Mexico.

No one has yet determined the extent to which the

In the Photographer's Studio

Once the period of itinerancy of the early years of photography was past, photographers basically became sedentary professionals who shared their clientele's social status and way of life.[23] The most important studios, such as Rodolfo Jacobi's La Fama de los Retratos, beside the Portal de Mercaderes, or Antíoco Cruces and Luis Campa's Fotografía Artística, at the other end of the Zócalo, entirely occupied large buildings. These had galleries where views and portraits of famous people were exhibited along with oil paintings, and comfortably furnished and tastefully decorated waiting rooms in which clients were received and shown catalogs of poses. There were also dressing rooms in which to change clothes and groom oneself before entering the sacrosanct studio, situated whenever possible on the top floor.

Chief of operations, the photographer supervised everything from receiving the clients to assisting and instructing them during their sitting. A veritable director on the set, the photographer chatted, gave advice, and dressed and undressed the customers, composing details and rearranging their hair.

A variety of other employees worked behind the scenes: laboratory technicians, set designers, and assistants whose job was to prepare the velvet-lined cases made of gutta-percha or leather manufactured in the United States, in which daguerreotypes, ambrotypes, and tintypes were placed.[24] Later, they would cut pages and insert tintypes and card photographs into albums.

But we must not forget the artists! From time to time, Rodolfo Jacobi, who resembled an impresario more than a photographer, would announce having acquired the services of "notable foreign artists." These "artists" joined the studio's employees, where they were engaged in retouching a figure, straightening a nose, erasing an unsightly protuberance . . .

In addition to the conventional formats, photographers and studio owners offered novelties to their clientele. These included new ways to carry or display photographs, which could be mounted on precious heirlooms of silver or gold, the lid of a cigarette case, a bracelet, or even a ring. Andrés Martínez specialized, among other occupations, in these miniature portraits, some barely one and one-half centimeters in size. Others offered portraits printed on a great variety of supports:

Valleto y Cía.
Wedding Portrait, ca. 1900

Gelatin silver print, Imperial mount
Center for Southwest Research, General Library
University of New Mexico No. 986-026-0044

portraitist Hermenegildo Bustos, of Guanajuato, used photography to compose his often touching depictions of his compatriots' physiognomy. Along with Octavio Paz, I am inclined to think that he frequently painted from photographic cartes-de-visite. This might explain certain odd and suggestive anatomical deformations of his subjects, as well as the emphasis placed on the sitter's gaze, so like that seen in many photographic studio portraits.

canvas, rubber, wood, plates, trays, and porcelain cups.

In 1906, somewhat later, an American traveler named Theodore Mason described the luxurious studio that the Valleto brothers operated in Mexico City:

The Valleto brothers—Guillermo, Ricardo and Julio Valleto—are, perhaps, the three kings of Mexican photography. Certainly they would rank as high artists in any of the most famous photographic *salons* of Europe or America. Of long experience in the business and possessing that culture and knowledge which comes alone from foreign travel, they are men of large intelligence and of whom any capital may be proud. To visit their galleries and especially to converse with them is a treat to be enjoyed and remembered. They are all three true art lovers, not only of photography but of art in its general sense. This is manifested in the disposition of their reception room, a salon worthy of the best galleries of Paris or London. To the curio lover, the man who delights in old-fashioned furniture, historic relics or faithful replicas of ancient things, the Valleto reception room is "the place of places." Nothing like it exists in Mexico. Its polished floor, made of yellow inlaid wood, is a part of Maximilian's famous castle of Chapultepec; around its walls the wainscoting is of carved and gilded mahogany, fashioned, I am told, from benches used in the Inquisition chambers of New Spain. Its single table is a priceless gem, older perhaps than the Conquest, and justly treasured by its present owners. About the room are chairs and benches of old Holland make, the seats and backs of stamped and figured leather. On the walls are replicas of ancient weapons, a genuine sword of Philip IV, with gilt handle and Toledo blade; and copies of daggers and poignards of the twelfth and fourteenth centuries. A steel target, weighing 25 pounds, and worn in the fourteenth century, is another article of cherished care . . .

This reception room is on the second floor of a large building on San Francisco Street. On the floor above, the entire space has been set aside for the various departments of the Valleto galleries. Here, too, are the posing rooms, lighted like most Mexican galleries from the side, and equipped with the most modern instruments and with the apparatus for artificial (electric) lighting.[25]

There was no school, much less academic training, for photographers.[26] Apprenticeship took place in the studio, following the artisanal custom. In family-owned enterprises, knowledge was often transferred from husband to wife, from parents to children.

Sometimes an assistant managed to surpass the teacher, ingratiating himself or herself with the clientele and replacing the master. For example, Miguel Rodríguez advertised in *El Heraldo* in 1856 that he had

the honor to announce to this respectable public that, having perfectly learned this beautiful art from Mr. Halsey of the photographic firm La Gran Sociedad with whom he worked for many years, and now encouraged by the requests of many distinguished persons and confident in the protection that the public of this capital has always extended to persons of his profession, he has the honor to offer his services to the Mexican public . . . whom he will attend with great care, guaranteeing a perfect portrait every time and assuring those concerned that no work will be delivered until they are completely satisfied . . .[27]

The predominance of studio-trained photographers continued through the first decades of the twentieth century, in spite of the establishment of schools of photography in some centers of learning. One of the earliest was a class offered at the Colegio Civil of the State of Mexico in 1880, under the direction of the photographer Felipe Torres. Likewise, Carlos Ritchie gave classes at the Institute in Veracruz. A number of photographic workshops were also held before the end of the nineteenth century at the Hospicio de Pobres and Porfirio Díaz Military Industrial School, both in Mexico City, as well as at several girls' schools.

Photography was a family business. This situation was not exclusive to Mexico, but more prevalent there, perhaps, since it corresponded so closely to patterns of Mexican society. "Uncle and Nephew" was the eloquent name of the Mexico City studio opened by Manuel Rizo, a studio photographer in Puebla. The Valleto Brothers; Veraza and Sons; Julio Michaud and Family; and Elías Ybáñez, Wife, and Sons (Spanish photographers who settled in Veracruz) are some examples of these family industries.[28]

After a time, a photographer might turn his studio over to his wife or daughters, as Romualdo García did

in the first decade of this century.[29] In this way, the profession gradually began to be transformed into a feminine vocation.

The Hermanos Torres, who had a studio in Toluca, were actually two brothers and a sister, Victoria. Around 1890, they opened another studio at 2, Calle de La Profesa, in Mexico City, where Victoria Torres worked. In 1899, they advertised in the newspapers the "novel note [lent to the studio by] the presence of a woman engaged in the tasks of the photographic art."

> Sres. Torres are the first in our country to introduce this felicitous innovation, which benefits not only the studio, but the public—principally the ladies. In fact, if there is an occupation suitable for women, it is photography. They have an extraordinary aptitude and manual dexterity, and, above all, can serve—better than a man—the ladies whose portraits they make, arranging their appearance and pose with a confidence and attention to detail impossible for persons of the opposite sex.[30]

The photograph that accompanied the announcement shows Victoria Torres in an austere Victorian black silk dress, leaning heavily against a camera that occupies the center of a disorderly (and thus typical) nineteenth-century studio with pictures on the walls, utilitarian furniture, animal skins, and Oriental carpets.

The work of Natalia Baquedano, owner of Fotografía Nacional at the corner of the Calles 5 de Mayo and Alcaicería in Mexico City, is somewhat better known. This is largely due to the preservation of some of her commercial photographs as well as fortuitous "photo reportage" on the life of her sister Clemencia that Mexican critic Raquel Tibol has called a "visual biography" that "advanced the concept of sequence."[31]

An Art of Representation

In 1984, the French historians of photography Jean François Chevrier and Jean Sagne proposed an original reading of the anonymous and semi-anonymous portraits, cartes-de-visite, cabinet cards, and tintypes and of the amateur photographs that people often collect simply because they contain some strange or interesting detail. To a certain degree, according to Chevrier, we can consider the "author" of these images to be the sitter, who imposes his or her postures and poses, jokes, and disguises on the photographer. In these cases (more numerous than one might think), the "author" of the (self-)portrait attempts to pass for someone else. Placing himself in a position of representation by exaggerating or disguising his (true) personality, he shows himself, in fact, as he is *not*. The rich collection of images with which these authors illustrate their study includes amusing "self-portraits" of celebrated figures from literature and the arts. Chevrier and Sagne have noted a consistent feature of these images. In almost every case, the "authors" have chosen a flamboyant guise that identifies them as "exotics," something they surely were

Compañía Internacional Fotográfica (CIF)
Portrait of Nelly Fernández, ca. 1925

Gelatin silver print
Private collection, Mexico City

not: Pierre Loti or Gustave Flaubert dressed as Egyptians, Toulouse Lautrec as a Chinese mandarin, etc. Likewise, in the only known self-portrait of the Guanajuato photographer Romualdo García, he presents himself dressed as a classical soldier. In the studio of Pedro Guerra, a photographer who worked in Mérida at the turn of the century, an individual had his portrait made as some sort of exotic wildman armed with kitchen utensils.

Chevrier and Sagne wrote:

Just as photography reduces geographic distances, it also reduces psychological ones: men dress as women, animals, monsters. With the infinite artifices of the mise-en-scène, a technique dedicated to recording facts became a means of projection. Identities gave way to the invention of hybrid beings. Individuals created new faces, transformed their anatomy, anticipated their own death. The staged self-portrait introduced the excesses of fantasy into the world of identities and objective facts.[32]

Chevrier and Sagne do not limit themselves to deciphering a few carnivalesque extravagances. Their aim is to prove, using a number of extreme examples, that the practice of portraiture can be understood in nearly every instance as a discourse on identity or, conversely, the lack and/or transformation of identity.

In this vein, a number of contemporary photographers have constructed visual fictions using theatrical artifices or photographic manipulations. This practice derives, in part, from Dada and Surrealism, as a brief examination of the respective photographic documentation confirms. This preference for disguise, ambiguity, and concealment of the self under the appearance of another is characteristic of a moment in the history of modern art and, above all, of some countercultural practices. The most celebrated case is that of Marcel Duchamp in the persona of Rrose Selavy, as photographed by Man Ray, another artist obsessed with alter egos and transvestism. These buffooneries have been taken quite seriously by some contemporary artists, who, not coincidentally, have adopted photography as the ideal medium in which to examine and disclose transvestism. Pierre Molinier—for most of his life a librarian, amateur photographer, and self-portraitist in Bordeaux—carried this "self-exoticization" to its cruelest consequences. For his photo montages, he used studio portraits made when he was twenty-five years old, to which he added women's bodies wearing sadomasochistic paraphernalia: corsets and leather stockings. More recently, the American photographer Cindy Sherman has worked in this vein, adopting postures, poses, and disguises with reference to stereotypes from films made in the forties and fifties or well-known images from the history of art. In yet another vein, Mexican photographers Adolfo Patiño and Eugenia Vargas have also sought to alter reality and the way in which they are perceived.

These experiments are based in the intrinsic ambiguity of photography, a simple instrument of represen-

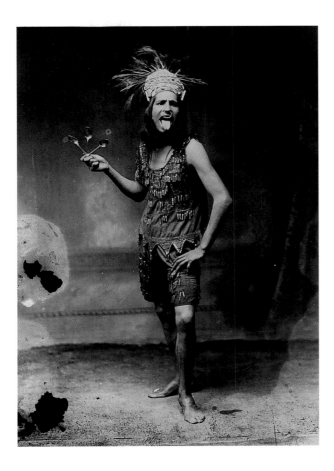

Pedro Guerra
Portrait [costumed], ca. 1910

Collection, Facultad de Ciencias Antropológicas
Universidad Autónoma de Yucatán

tation, after all, that takes on (absorbs) the form of reality. They demonstrate that, ultimately, all photography—and particularly portraiture—is a trick or, more accurately, a ploy.

From this perspective, a rereading of the body of photographic portraits produced in the nineteenth century can be not only entertaining but quite educational. Enrique Fernández Ledesma, inveterate sentimentalist and collector of old photographs, did just that in the 1930s. In a precursor of Mexican photo histories, *La gracia de los retratos antiguos*, Fernández Ledesma analyzed the photographic medium less than the postures, poses, and dress of a sector of Mexican society that wished to portray itself. In doing so, he produced a pioneering semiology of these behaviors. He was quick to discover the fantastic aspect of these portraits, the pronounced taste for disguise and presentation that ultimately revealed the unconfessed ambitions and intimate desires of the sitter.

> Images of persons who, through their poses, dress, and stylish affectations . . . even the physiognomy of their faces and their gestures, portray a particular way of being that defines the intimate character . . . of the civil and political life of a Mexico that has been lost, inevitably, from the national memory. One foreign to our ideas and sensibilities. Thus, we contemplate their effigies and, thus, they present us with the unforgettable appearance of their now remote charms. This is how we see them in the photographs that have been left us, a precious heritage. Photographs from the end of the [eighteen] forties or beginning of the fifties: daguerreotypes by Balbontín, Halsey, and Jacobi, as unique in their singularity, as a [painted] miniature . . . charming daguerreotypes in which the image, captured in a sheet of silvered copper, seems to emerge from the polished surface of a lake or a mirror.[33]

Bound in embossed leather or cloth, the family album was an indispensable object in homes after 1865, when the carte-de-visite facilitated the circulation, in multiple copies, of photographic images. The album became the repository of family memory and had its place of honor in the parlor in a reading stand on top of the shawl-draped piano or in the library shelved between the classics of literature and the encyclopedias. It served as a mnemonic device that was exhibited from time to time, unleashing personal stories and family anecdotes. Recognized faces paraded past: the country uncle, the married cousin, the deceased grandfather. Page after page, a complete genealogy was inserted within the windows of the heavy leaves decorated with floral borders. Further on were the group portraits: one evoking a particular celebration where, for once, the whole family was together. (Beside it, someone placed the lone pho-

Fotografía Daguerre
Portrait of Josefina Audiffred, ca. 1900

Gelatin silver print, cabinet card
Center for Southwest Research, General Library
University of New Mexico
No. 986-021-0131

tograph of a nephew who had gone to Europe and was not able to attend the gathering.)[34] In time, the albums became filled with the figures of the deceased. Grandchildren and great-grandchildren would pass idle afternoons trying to recognize family traits in these faces.

With the distance imposed by the passage of time, the repetition of poses has conferred a kind of anonymity on these portraits. This contradicts their original intention: to identify and permanently preserve their subjects as recognizable, distinguishable individuals. Much has been written about the rapid development of photography as a mechanism of social affirmation, instrument of exacerbated individualism, and complement to other "signs of election" recognized by the burgeoning middle class during the nineteenth century, as well

Octaviano de la Mora
Portrait of the Reverend Rafael Calderón, ca. 1890

Albumen print, boudoir card
Reproduction authorized by the Fototeca
del INAH-CONACULTA
Pachuca, Hidalgo

as the repressive and conformist nature of that group. In his celebrated diatribe of 1859, Charles Baudelaire interpreted the vogue for photographic portraits as an expression of the puerile narcissism of a society in ecstasy over its new powers. But the social practice of portraiture also indicates an urgent and almost desperate search for immortality, the product of an existential anguish. It did not arise from a relation to others, but as a way to see oneself in time and through time. This self-satisfaction expressed a crisis of personality, linked, undoubtedly, to a realization of the inevitability of one's own death.

The nineteenth-century bourgeoisie invested an enormous amount of sentimental energy in images of fiancées, relatives, family groups, public figures, beloved landscapes and favorite summer resorts, travel and tourism, honeymoons, moments of intense happiness or pleasant idleness, anything that varied from the routine. Photography channeled the eschatological hope of the century: to survive, as images fixed on sensitized paper, to overcome the horror of disintegration, to affirm an unreal or unrealizable happiness.

No one, perhaps, knew how to capture the total fascination the portrait held for nineteenth-century society better than José Carlos Becerra. In his only, yet splendid, work of prose, written at the end of his brief literary career, Becerra recounted "the last coquetry" of his uncle, the Tabascan poet and politician Andrés Calcáneo Díaz, who "stole his death" from the Carrancista army one humid October morning in 1914, in the cemetery of San Juan Bautista (today the city of Villahermosa), on the banks of the Grijalba River:

Someone, probably the lieutenant in command of the firing squad, asked him to pose in front of the rifles under a dry lemon tree. The poet saw a tulip tree and, beyond it, the paddle-wheel steamboat that arrived each morning. "There"—he said, indicating the tulip tree—"it must be there," and explained, in passing, his final conceit: the tulip tree was his favorite flower. Soldiers and poet moved toward the site. Thus it was that Calcáneo Díaz arranged the scene for his last photo, perfecting it as he would polish a poem, after it became clear that there would be no more poems, no collection of poems for the book he always spoke of. So at that moment, he took great care with all the details, chose the tree and the

light. Acquiescing to this spirit of style, the soldiers advanced, adjusting their formation, while at the entrance to the cemetery, the curious milled about craning their necks, struggling to see everything. "Get back, get back," shouted the soldiers who had remained in the doorways to block off the passage.

Under the tulip tree the poet composed himself. He took off his watch chain and rings. "Please, give these to my wife." Then, he adjusted his spectacles [and] added "don't shoot me in the face."[35]

Becerra's text is structured with repeated images that, by analogy, link its various parts, the multiple images that make up the itinerary of a life. The recuperation in extremis of the captive poet's autonomy, at the moment he was delivered to his fate, confirmed the dignity manifest in the numerous photographs that Calcáneo Díaz sent his mother and wife during his years of exile. Andrés Calcáneo Díaz faced the firing squad the same way, in earlier times, he had faced the photographer's lens. A man of the nineteenth century, he affirmed his personality through self-representation and the photographic *mise-en-scène.* He used costuming to manipulate his appearance, transforming his portrait into self-parody and the photograph into a sort of tableau-vivant.

Perhaps for this reason and because of the period in which he happened to live, he paid with his life, the structure and ultimate meaning of which were fulfilled . . . by the poet's seizing control of his death from his victimizers and directing it with the intensity of a masterpiece, in the style of his finest poetic works. [In doing so,] he recalled other moments of self-possession in his life: the voluntary exiles, the precipitous entrances and exits of the political scene in San Juan Bautista, the periods when he joined the actors of traveling theater companies, the ten months in prison, his audacious arrivals at the open-air concerts in the Plaza de Armas; and all this done to the rhythm of costume changes and elegant appearances that the camera recorded in minute detail, thanks to the poet's eagerness to be photographed . . .[36]

In several of the carte-de-visite albums that have been preserved in Mexico—such as those in the collections of the Museo Nacional de Historia and in the Fototeca

del INAH—portraits of family members mingle with those of public figures, creating a familiar "private universe" that situates itself ideologically. Within this civil hagiology appear politicians—of every persuasion—and their families (for example, Benito Juárez, his wife, and daughters; Maximilian, Carlota, members of the Austrian Imperial family; and military leaders of the French Intervention: Achille Bazaine with his wife, Pepita, Miguel Miramón and Carmen Lombardo de Miramón; Porfirio Díaz and Carmen Romero Rubio, etc.). In some instances, portraits of intellectuals, philosophers, and poets were collected: most frequently Guillermo Prieto, but also Ignacio Manuel Altamirano and Victor Hugo, the defender of Juárez.

Aubert & Cía.
Portrait of Gen. Bazaine and Wife ("Pepita"), ca. 1864–1867

Albumen print, carte-de-visite
Center for Southwest Research, General Library
University of New Mexico
No. 997-013-0025

In 1874, Cruces and Campa published their celebrated collection of portraits, *Galería de gobernantes con los retratos de los personajes que han ejercitado el poder en México desde la Independencia* (Gallery of Political Leaders with Portraits of Persons Having Exercised Power in Mexico since Independence). This initiative was immediately imitated by a number of other photographers, with increasing success, who extended the range of famous personalities to include representatives and senators, literary figures, the clerical hierarchy, and every other kind of public figure that could be considered somehow heroic.[37]

These historical images—including those in the *Álbum de Cortés* of 1868 dedicated to the leaders of the War of the French Intervention, as well as published views of famous buildings and landscapes, such as those in the *Álbum fotográfico mexicano* of 1859, with photographs by Claude Désiré Charnay, the *Álbum orizabeño* by Manuel Castillo,[38] and the *Álbum veracruzano* (the latter two from 1872)—seem to have played an important role in defining a national historical identity. The portrait, however, with its highly subjective content, established a visual formula for the way of life consecrated by the Mexican middle class at the end of the nineteenth and beginning of the twentieth centuries.

Affirmation of oneself necessarily includes recognition of the margins, the localization of that which falls outside the boundaries, in this case, of "polite society."

Prisoners and Prostitutes, Masters and Servants

The order imposed by the liberals was based, among other things, on the idea of private property, and there existed groups that threatened this order by not organizing themselves along the guidelines recognized by the liberal government. Such was the case, for example, with indigenous or urban groups for whom the notion of social organization based on property was foreign.[39]

From the beginning, photography served class interests.[40] In doing so, certain "gaps" in the social record were filled, empirically, to provide useful documentation of these "informal sectors."

Unable to establish efficient means of control over the population (due both to corruption and to the geographic and ethnic complexities of the country), the Mexican government adopted methods that were then considered avant-garde. In 1855, laws implemented the use of photography for the identification of criminals, an idea originally proposed by a number of European writers, but applied quite literally in Mexico. The practice was only adopted by "civilized countries" after 1870, largely as a result of the events surrounding the Paris Commune of 1871.

Although only superficial, this practice was an attempt to solve the deficiencies of the Mexican prison system. This is clearly revealed in a letter from city councilman J. M. Cervantes Ozta to the governor of the Federal District, Antonio Pérez de Bonilla, dated April 22, 1856:

> For some time we have attempted, without complete success, to introduce an improvement in the National Prison: . . . making . . . portraits of the most notorious criminals.
>
> Obviously, the object of this precaution was to have, by means of the portrait, a record of the physical description of these criminals which would provide more than a simple written document . . . should some prisoner escape, he would be more easily apprehended since multiple copies of the prisoner's photograph [are] made and distributed to police agents both within and outside the capital.
>
> Moreover, . . . useful information can be gathered for criminal statistics, since the police records, imperfect up to now, that the photographer has begun to compile include a photograph of each criminal with his description, . . . making the file the most accurate possible.
>
> The Commission . . . therefore requests that Your Excellency grant his explicit support to an improvement that is among the advancements of civilization.[41]

The "improvement" had actually been instituted a year earlier by presidential decree of General Antonio López de Santa Anna, at the suggestion of Miguel Hidalgo y Terán, inspector of City Jails. The regulation of March 14, 1855, to verify the identity of criminals whose cases

are processed in Mexico City stipulated, among other clauses:

> From now on, the identification of defendants . . . called to appear before the criminal courts will be verified by means of photographic portraits . . .

> Four copies of each criminal's portrait will be made, to be distributed along with other information, a description of the crime, the evidence against him, etc. . . . to the Ministry of the Interior and the Superintendent of Police, with the other two copies remaining with the records of the trial and City Hall, respectively.

> Mayors will place the criminals' portraits in a book, numbering them in the same order as their criminal records, in such a way that said book can be related to the arrest records, permitting rapid access to the complete record for each criminal . . .

> The portraits of criminals whose trials have been judged cannot be published without prior permission of the Inspector General of Prisons, who will examine the record and decide if publication would be appropriate.[42]

From 1855 to the beginning of the Revolution, six photographers were employed by the Mexico City jails. The first was Colonel José Muñoz, who held the post between 1855 and 1860. Although the images were still referred to in contemporary documentation as "daguerreotypes," salted paper prints were apparently used. A number of images attributed to him have been found glued or sewn inside trial records now located in the War Archives at the Archivo General de la Nación.

The position was officially posted in 1860, during the brief administration of President Miguel Miramón. Between 1860 and 1861, the first person to occupy the position of "jail photographer" at the Belén Prison (which occupied parts of what is now the Clautro de Sor Juana) was José de la Torre. Later, in February 1861, the well-known photographer Joaquín Díaz González was named to the post. He remained there until 1880, except for a period during the French Intervention and Empire of Maximilian when the post was initially eliminated, then occupied by Dámaso Híjar for few months in 1866. Because of an incident in 1880 that revealed the need for better control over the prisoners (who frequently escaped), Díaz González was fired and the post

given over to Hilario Olaguíbel, who, in turn, was dismissed in 1896.

These modifications to the system of identification of prisoners and later attempts to achieve better and more useful photographic records—in effect, greater control over individuals—in Mexico coincided with periods of political crises and elections, usually accompanied by civil uprisings in the provinces.

A constant provision in the regulations restricted the circulation of prison photographs, ideally respecting the privacy of the criminals and permitting publication only under certain conditions. This was true even though, for several years, the specific procedures and authority for making and distributing prisoners' photographs remained undefined. (Beginning in 1896, criminals were channeled through the offices of the prison director, who then took on the task of sending copies to the other administrative agencies.) Nevertheless, the legal restrictions were infringed on countless occasions. For ex-

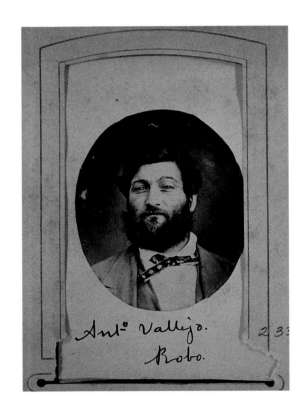

Joaquín Díaz González (attributed)
Antonio Vallejo, Robo, ca. 1880

Albumen
Reproduction authorized by the Fototeca del INAH-CONACULTA
Pachuca, Hidalgo

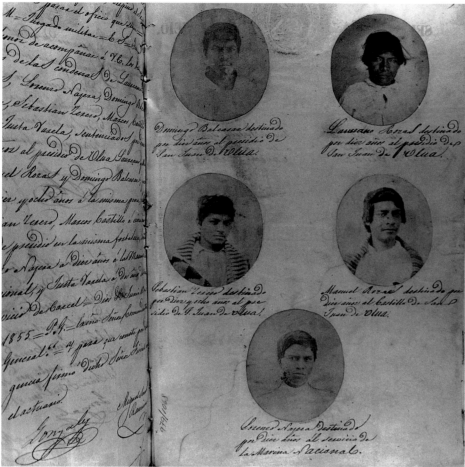

José Muñoz (attributed)
Domingo Balcázar, Laureano Rosas,
Sebastián Cereso,
Manuel Rosas y Lorenzo Nájera,
Arrested for a Crime
Committed in Mexico City in 1854.
First Prisoners
Photographed, ca. 1859

Salted paper print, Archivo General de la
Nación, Centro de Documentación Gráfica,
Mexico City

ample, Carlos Roumagnac included many such portraits in his study of criminology published in 1905. Some of the images were particularly crude, showing the prisoners' sexual organs and physical deformities (implicated as the origin of their real or alleged criminal behavior). Years before what is known as "yellow journalism" existed, images of this type satisfied the morbid curiosity and sensationalist bent of those who saw them. When Jesús Arriaga, the legendary criminal known popularly as "Chucho el Roto," escaped from prison in 1882, three hundred copies of his portrait were printed for sale to a captivated public. And, in 1886, a journalist associated with *La Ilustración Americana* expressed his shock over the poor taste of certain European ladies who collected portraits of criminals.

And how did the curious album of prisoner photographs preserved today in the Fototeca del INAH in Pachuca ever fall into the hands of the collector Felipe Teixidor? Research into the prison records located in the Archives of the City of Mexico reveals that these images were made between approximately 1875 and 1885. Departing from the prescribed procedure, the prisoners appear here without their identification numbers. Only a name and (in some cases) a brief mention of the crime were recorded.

As one would expect, these portraits are quite different from those made in the commercial studios of Mexico City. The prisoners, characterized by their ragged appearance, came primarily from the lower classes; this was their first encounter with a camera. José María Flores, who appears in one of the first salted paper prints attributed to José Muñoz and whose "proceedings" survive in the Archivo General de la Nación, seems to challenge the lens with a proud and sarcastic expression (even when he already knew the unfavorable sentence passed against him). Cayetano González—the only person who seems to have been acquitted in 1859—is seated with his hands crossed and a faint smile

on his face. Despite his poor dress, he communicates a certain dignity. On the other hand, Marcos Castillo and Justa Varela, perhaps the first to be photographed in 1855, express their intimidation through stooped posture and frightened expressions. Yet these are not standard "mugshots." They are simple—and simply—portraits. Neither the photographer nor the administrators had yet decided what an "identification picture" should be. To some degree, a mere resemblance to the photograph was considered proof enough.

Soon, however, things became more complicated. In 1876, Joaquín Díaz González complained to the city authorities that "this kind of portrait is very difficult. Because the criminals understand the importance of the photograph, they use every possible means (and there are many) to ensure that the photograph does not resemble them, which makes it more difficult to produce a good result . . ."[43] The photography sessions appear to have become a farce: in 1873, the same Díaz González requested that a studio be constructed, an atelier, as he called it. At the time of his request, he was working "in the hallway, that being the only suitable space . . . [There] the curious crowd around to see the criminals, upsetting them or distracting their attention, causing them to move and ruining the photographs."[44]

When the post of prison photographer was transferred to Hilario Olaguíbel in 1887, the authorities stipulated that he make both frontal and profile portraits of the criminals. "The purpose of this change in procedure is to render ineffectual the determination of some criminals to disfigure their faces, affecting extreme expressions that changed as soon as their pictures had been taken . . . This imperfection appears clearly in the frontal view, making identification difficult . . . This problem is eliminated in the profile view, which is much harder to deform through artificial means."[45] This leads us to wonder, then, about the real value of these images. A look through the album at the Fototeca del INAH confirms that, in spite of their supposed realism, the portraits allow a great number of "imperfections" to filter through: Antonio Vallejo, accused of theft, looks like a minor civil servant in his frockcoat and poses as if he were in a downtown studio. A certain García Brito, accused of defrauding the City Treasury, had his picture made holding a cigar between his fingers. On the other extreme of the social scale, there are the portraits

of Luz García, with her deeply sad expression, and the comic expressions of Guadalupe Ramírez, "The Drum," who inflated her cheeks in order to deform the appearance of her face.

The authorities themselves complained repeatedly about the ineffectiveness of the identification photographs, noting their poor quality. In 1873, the Prison Supervisory Board stated that the book of identification photographs was "totally useless since [the photographs] are generally very bad and one can hardly even recognize the criminals they supposedly portray." This accusation was reiterated in 1876 before the Sixth District Court, when it was claimed that "it is nearly impossible, in every case, to find a trace of resemblance between the photograph submitted [to the Court] and the criminal to whom it refers."[46]

Shortly thereafter came the reforms, the strict rules, the codes that defined once and for all the way to behave before the camera. When it was discovered that the monthly list of prisoners photographed did not correspond to the number of orders issued by the city, Hilario Olaguíbel was dismissed, and a competition was announced to name a new photographer. Antíoco Cruces, the dean of Mexican photographers, won (although, apparently, the post was actually occupied by one of the many employees of his firm). He left the post when he took charge of the studios at the Ministry of War.

In 1892, at the request of Doctor Ignacio Fernández Ortigosa, an Office of Anthropometrics was created, in accordance with the teachings of Alphonse Bertillon, founder—with Cesare Lombroso—of modern criminology. Bertillon had defined a "clinical method" for photographing prisoners: they should be seated, using the same head support that had enabled sitters to remain immobile back in the first years of photography. Ironically, this attempt at modern standardization resorted to the oldest practices and technologies used in portraiture.

In Mexico, the practice of photographic identification seems to have had deep racial undertones. This can be surmised from the following affirmation by Manuel F. de la Hoz:

Crime recruits the great majority of its perpetrators from the lowest classes of our population, the indig-

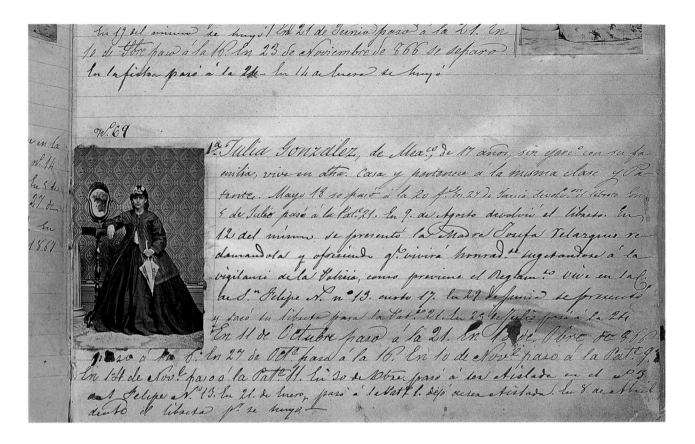

Anonymous

Julia González, 1ª clase, número
69, ca. 1865 *Registro de mujeres públicas*

Albumen print, Instituto de Salud, Secretaría de Salud, Mexico City
Courtesy Jaime Sepúlveda Amor

enous class, which is composed of individuals whose features are characteristic of a type that is quite uniform, with little variation. The identification of criminals from this class . . . is null, since the description and even the photograph of the accused, could, in fact, match a number of persons . . .[47]

This racial "uniformity," already noted by Díaz Gonzales—"since [the prisoners] are usually dark-skinned, it takes longer to print their pictures"[48]—may help explain the early establishment of a "progressive" measure in Mexico several years before its general acceptance in European countries. One can draw a parallel, to a certain degree, with the "caste paintings" made in the eighteenth century, which also intended to define, normalize, and differentiate the various elements of a heterogeneous society in constant mutation through

multiple interracial exchanges. Yet this "paper prison" was also a laboratory, since the data obtained by the photographer could eventually be used to define the geographic and social territory of crime in a specifically Mexican context. For this reason, photography was applied, early on, to the task of classifying, situating, defining, and controlling certain sectors of society.

Besides the early use of photography for the identification of prisoners in Mexico, there was an attempt during the French Intervention to use the medium to control prostitution and limit the ravages of venereal diseases among the military. Sergio Gonzales Rodríguez was the first to point out, a few years ago, an extraordinary register in the archives of the Ministry of Health. Compiled in 1865 by order of Maximilian, it contains the police and clinical records of Mexico City's prostitutes and includes their photographic portraits.

These photographs, made in a number of different commercial portrait studios in Mexico City, exhibit a range of formats, techniques, decors, and clothing. Even when they resemble society ladies (some are extremely well and expensively dressed), they reveal themselves through a hint of nudity of the arms and legs, a certain tilt of the head, a slightly exaggerated coiffure and abundance of jewelry. In the photographs of the poorest women, there is an odd look of austerity and tension that results from the simultaneous effort to flirt and yet seem acceptably middle-class, often overly meticulous in appearance. This rare precursor of the public health record, established several decades later under the administration of Porfirio Díaz, allows us a glimpse into a world that was both scorned and never truly seen.

A remarkable and fascinating case for historians of photography concerns the city of Oaxaca, in southern Mexico. There photographic records of minor public employees and others whose occupations were highly regulated—water carriers, bootblacks, coachmen, housekeepers, patrolmen, porters, and prostitutes—were collected in an extensive series of volumes, from the 1870s through (amazingly) the 1960s. These recently have been analyzed, published, and exhibited. Although it is known that similar records were compiled during that period in other provincial cities (including Zacatecas and Guadalajara), the fact that Oaxaca's were preserved—or zealously hidden—is uncommon, as was the devotion of the clerk in charge of these records.

Since the late 1890s, if not before, an unnamed photographer (using the generic term here, even though some "signed" their works)[49] entered the service of the citizenry of the "civilized" bourgeoisie of Oaxaca. Together with the town clerk, he wrote the history of the city. Like the clerk, he really was not conscious of what he was doing. And, also like the clerk, or alongside him, he had a little fun with it. Life in Oaxaca, after all, was boring: a little spice—salt, pepper, or chile—always adds flavor to the food.

This "distinguished" employee, the city's "official" photographer, had personal entrées into the brothel of Virginia Zayas, at 25 Calle Porfirio Díaz, and the house run by the Cuban Elena Sánchez.[50] Like the clerk, the photographer knew—quite well—the "charges" who were obliged to pass before the lens of his camera.

Initially, the sitters went to his studio. There they posed before the frenchified backdrops and curtains that adorned the studio set (and that also appeared in portraits of the city's patricians and their upstanding wives). Perhaps it was like a holiday for the girls when the portraits were made. All the young women of a particular house would pose in front of the same backdrop, in the same pose, right hand placed on the same book, all with the same coiffure (or using the same wig). In their way, they express—not between the lines, but "between the photos"—their enjoyment of this entertaining break.[51] The photos were treated very seriously, lined up in the official "books" of the Ayuntamiento, bearing on the cover only the inscription: *Prostitución*. Yet, inside, flirtatious glances and smiles appeared here and there, revealing—if not irony—at least the possibility of a shared joke.

Unlike the city's volumes dedicated to porters, coachmen, water carriers, or bootblacks that also contain identification records and photographs, those covering prostitution seem to have received special attention. That attention included the mutilation or "extraction" of some images with a scalpel, probably to protect the "reputation" of a young girl later elevated to the status of society woman or, perhaps, just mother. Almost all the photographs that remain in the books were delicately adorned with vegetal or geometric borders, carefully drawn in ink. But the face of Soledad Cortés was mutilated, viscerally, by the scribe who added smallpox scars to her image.[52]

Then there are the life histories that should be also be read between lines and photographs—this one, for example, that recounts a precarious existence, a whole life:

Juana Osorio, native of Miahuatlán and resident of this city: 1.48 [meters] tall, fourteen years of age, single, white, black eyes, black hair, rounded nose, large mouth, with no distinguishing marks. Registered May 2, 1892.

Note. [Works] in the house of Adelaida Peres and lives at 5 Calle "Reforma" No. 37. Replies, No. 4.

item) Left the profession on December 21, 1893, naming Sergeant 2nd class Jesús Nájera of the 1st Regiment as responsible party.

item) On February 9, Nájera appeared and withdrew his responsibility.

item) On June 27, 1894, she left the profession, giving Lieutenant Jesús Pacheco of the 7th Battalion as responsible party.[53]

Further on, the clerk added the brief, undated note in red ink written across the photograph and part of the page: "Died."

Perhaps these should be compared with the photographs of homosexuals (probably also arrested for prostitution) compiled in a "prisoners' album" at the Fototeca del INAH. Here the approach of a single photographer (probably Joaquín Díaz González) disallowed the variations that appear in the previously mentioned Oaxacan records. While the men's "offense" is not specified, it becomes obvious through a number of details: the feminine nicknames (La Martina, La Jarocha, for example) and a distinctive way of behaving in front of the camera. In one instance, an adolescent with dyed hair and a fancy shirt, closer to a romantic ephebe than to the homosexuals depicted in the yellow press of the period, seems to make fun of the photographer and flirt with the camera.

Beginning in 1872, "vagrants" were registered in a similar manner. The problem of vagrancy, related to the inability to "situate" (at either a psychological or purely physio-geographical level) certain marginal individuals, had concerned the authorities in Mexico since colonial times. A broad sector of the population of New Spain and, later, the young nineteenth-century Republic never fit into the Eurocentric social categories that were imposed on the country. The term "vagrant," with its imprecision and connotation of mobility, was used to lump together all those whom the authorities desired, unsuccessfully, to eradicate. To this end, laws and authoritarian projects were initiated. According to an imperial regulation of the 1860s, "all individuals who have no fixed residence, possessions, or income sufficient for their subsistence, or do not exercise an honest and gainful profession," were considered vagrants.[54] Newspaper reports reveal that servants began to be photographed for security purposes in 1871 and coachmen in 1881. By the end of the *porfiriato,* this practice had been extended to schoolteachers, mental patients, and—on

Emilio Lange
Portrait of Pedro Santacilla, ca. 1890

Albumen print, boudoir card
Reproduction authorized by the Fototeca del
INAH-CONACULTA
Pachuca, Hidalgo

the eve of the Centennial Celebrations of 1910—all journalists who received a permit giving access to the commemorative ceremonies. Thus, they became entries in a register of faces: citizens who, because of their way of life, had to be identified, known, or—more precisely—recognized by the class in power.

To serve their designated purpose, identification portraits had to be made in accordance with strict rules that, like anthropometric photographs, employed techniques and conventions dating from the earliest years of photography. While static norms were established for bureaucratic identification portraits, the social portraits made by competitive commercial studios remained in a state of stylistic evolution, in search of ever-greater refinement, distinction, originality, and expressiveness.

New Photographers, New Styles

In his 1906 article, American Theodore Mason observed the evolution of the Mexican public's taste in photography at the turn of the century:

> Of the Valleto work there are three notable examples here, a portrait of President Díaz, a masterpiece of photographic art, a group of girls' heads on convex glass, colored, and a woman's face in profile. . . .
>
> It is of this . . . [apparatus for electric lighting] that I would like to speak, or rather of the work produced by it. Two examples may be seen in the Valleto galleries that are masterpieces in their way. One of these represents a girl kneeling at a *prie dieu,* attired in a flowing gown and veil; in one hand she holds a lighted candle, in the other a book of prayer. The light from the taper falls upon her upturned face and on the page before her, touching here and there her veil and robe, the surrounding room in shadow. Nothing could be more masterly than the handling of the soft taper light which floods the figure and gives emphasis to the supplicating pose.[55]

Toward the end of the nineteenth century, increased competition obliged photographers to find ways of distinguishing their work. Everyone developed a personal style: one imitated the dramatic chiaroscuro of Rembrandt, another rendered flesh in the manner of Rubens, yet another introduced shaded vignetting around the face to emphasize the spirituality of the sitter. The themes and poses were the same, but the look of the photograph changed with the use of gum bichromate, toned and platinum prints, and theatrical lighting effects. This aestheticizing, neo-romantic, and somewhat affected preciousness introduced a feeling of irreality to the raw realism of the photographic image. Mexican filmmaker Gabriel Figueroa recalled that some of these pictorialist photographers produced extremely sophisticated work—among them: those old veterans the Valleto Brothers; the fashionable Antíoco Cruces (now separated from his partner, Luis Campa); the recently arrived Swedish photographers Emilio Lange[56] and Wolfenstein; the Mexican Martín Ortiz; the mysterious Ocón, by whom there are only four known images; and, above all,

Constantino Sotero Jiménez
Baseball Player from Juchitán, ca. 1930

Gelatin silver print
Collection, Instituto de Artes Gráficas, Oaxaca, Mexico

Gustavo F. Silva, preferred photographer of the intellectual class during the twenties, who introduced dramatic poses "like those used in oil portraits."[57]

Silva, with his delicate lighting effects and subtle tonalities, prepared the terrain for Enrique Semo, perhaps the last of the great studio portraitists. In the forties, Semo made promotional portraits of actors and actresses, the Mexican equivalent of the Harcourt Studio in Paris, whose aesthetic was analyzed at length by Roland Barthes in *Mythologies.*

Still, in provincial cities and certain suburbs of Mexico City—particularly those that attracted large crowds, such as the Villa of Guadalupe, Chapultepec Park, the Alameda, and Xochimilco, where temporary studios and itinerant photographers sought out a clientele of modest means—the nineteenth-century practice of making full-body portraits of their subjects in front of painted backdrops, staring directly into the lens, lasted through the twentieth century.[58] Then came those anachronistic photographers whose work has recently been reappraised by some nostalgic critics—for example, Romualdo García of Guanajuato and Constantino Sotero Jímenez of Juchitán. The latter worked up to the forties without changing his style, creating odd contrasts between the stereotyped poses and studio decor of an earlier period and the modern dress, accessories, and activities of his clientele (as in the case of his photographs of jazz musicians or baseball players). This curious tension between an obsolete manner of representation and details that reveal the passage of time has been exploited for expressive purposes by several contemporary photographers, such as Graciela Iturbide, Carlos Somonte, and Flor Garduño.

Not all provincial photographers remained isolated from modernizing currents. This can be seen in the work of those who, in an effort to update their style, adopted and adapted the photographic purism of the 1930s, sometimes with bold and spectacular results.

In an article published in 1933, Agustín Aragón Leiva concluded:

The Mexican has an uncanny ability to use the machine as his toy. The Mexican dominates the toy, masters the machine. Thus, his joy at drilling in the mine, speeding down the highway, operating tools in the mill or workshop.

Photography in Mexico has always been something more than a mechanical product. The portraitists who worked in fairs, poor neighborhoods, and public parks were creators in their own way, but with the additions brought to their work by the participation of the sitters. The professional photographers went too far to meet the demands of business. The public's bad taste, influenced by fashionable frivolities, actually created an environment where artistic photography could not exist.[59]

A Profession in Crisis: *Helios* Magazine

The photographic portrait business underwent a crisis at the end of the twenties, at least in the capital and principal cities of Mexico. This resulted, most likely, from the dissemination of hand-held cameras among the upper classes. The continually increasing space occupied by Kodak advertising in the popular press is testimony of this trend.[60]

The snapshot vogue (made possible by the development of roll film by Eastman Kodak) arrived in Mexico in 1901, introduced by the American Photo Supply Company. This diverted a large and growing sector of the studios' former clientele, who with the exception of special events, such as weddings, now made their own photographs.

Studio photographers began to work in other areas or to focus their practice on clients of more modest means, who lacked the independence afforded by owning a personal camera. The number of official documents requiring identification photographs made it possible (and continues to make it possible) for some photographers to survive by making these images in the familiar variety of established formats, known as *infantil, mignon,* and *pasaporte.*

After 1910, portrait photographers became relegated to the suburbs and outlying areas of the city. During the same period, there was a great increase in the number of street and itinerant photographers who served the rural population, Sunday visitors to Chapultepec Park, and pilgrims at Chalma and La Villa de Guadalupe.

A muted controversy bears witness to this rapid evolution and to the decadence and transformation of a profession.

On January 1, 1929, the first issue of *Helios, Revista Mensual Fotográfica,* edited by Luis G. de Guzmán, appeared.[61] The name of the magazine was not entirely new. Between 1895 and 1907, another *Helios* was published in Mexico, this one the organ of the Spiritualist Society of Mexico. Apparently, there was no link between the two publications. Moreover, *Helios* was not even a very original name for a photography magazine. The first weekly dedicated to amateur daguerreotypists, published in 1851, was entitled *La Lumière,* and the great

Antonio Garduño

Untitled, ca. 1920–1925

Gelatin silver print
Center for Southwest Research, General Library
University of New Mexico
No. 998-018-0006

majority of nineteenth-century photography magazines sought to legitimize themselves by using and abusing names with references to sunlight. *Helios* was a relatively luxurious publication, according to the standards of the time, but not of the same quality as literary reviews in Mexico, such as those published by the Talleres Gráficos de la Nación or the Editorial Cultura, owned by the Loera y Chávez family. There were, however, abundant advertisements, a sign that business was good. The names of such firms as the American Photo Supply Company on Avenida Madero, La Rochester on 5 de Septiembre, Foto Mantel on Calle de Capuchinas, Kodak Mexicana, and the studios of Hugo Brehme and Aurelio Loyo filled several pages.

The offices of *Helios* were located at 72 Avenida Madero. The editorial board included some of the most prominent studio photographers of the period, several technicians (Ignacio Reyes and Enrique Galindo), and a specialist in cinema (Enrique Bert, in partnership at that time with Eugenio Latapi, long one of the important postcard producers in the country). Rolf (Rudolf) Rüdiger, Agfa's representative in Mexico, and Hugo Brehme were listed as translators from German, while Antonio Garduño did translations from Italian, since the magazine basically reproduced technical articles taken from foreign publications.

In the first issue, the magazine announced the founding of the Asociación de Fotógrafos de México, presided over by Macario González, and the creation of a monthly contest, open to readers, with a prize of ten pesos. The names of Mexican photographers who had participated in a competition organized by Antonio Garduño the previous year to select a national representative to the International Fair in Seville were also listed.[62] Among the members of the jury were a number of notable artists associated with the Academy of San Carlos: Alfredo Ramos Martínez and the elderly Germán Gedovius, along with the photographers Antonio Gómez, Enrique Solís, and Montero de Collado.[63]

The winners of the Seville competition were Antonio Garduño, Hugo Brehme, Roberto Turnbull, Librado García, Ignacio Gómez Gallardo from Jalisco (successor to Octaviano de la Mora), and Tina Modotti. Manuel Álvarez Bravo received an honorary diploma. The jury awarded nine gold medals and one silver medal (to Pedro Guerra from Yucatán). Besides Modotti, there were two other women on the winners' list: Eva González and, from Jalisco, Eva Mendiola.

Up to this point, there was nothing unusual about *Helios.* Like other magazines of photography throughout the world, it organized contests and sent its staff members to international competitions.

The second issue appeared in September 1930—more than a year and a half later. The cover was illustrated with a large logo showing a Graflex camera with its bellows extended, in front of the volcanos of Popocatépetl and Iztaccíhuatl. *Helios* now presented itself as the official organ of the Asociación de Fotógrafos de México, under the direction of Juan de la Peña.

Beginning with the third issue, published in October 1930, the tone of the articles became more polemical. At the same time, much of the advertising disappeared and, with it, the magazine's scant photographic reproductions. From this point on, the editorial column of *Helios*—which one has to assume was written (or at least endorsed) by the director, de la Peña—devoted itself to lashing out against a sector of the photographic industry.

> Who is the great enemy of the photographer? . . . the distributor . . . The competition could not be more disgraceful nor more immoral . . . There are firms such as La Rochester, owned by the Jew Hakenberger, who distribute circulars insulting and denigrating photographers in order to buy their work more cheaply.[64]

Next the pamphleteer accused Thomas Crump, founder of American Photo Supply, and the firm of Francisco Lavillette of "killing" the postcard business, particularly that sector called "Performers' Portraits," which appears to have been quite lucrative. This series included photographs of vaudeville stars, such as Celia Montalbán, Lupe Rivas Cacho, and María Conesa. These can still be found by the heap in antique fairs and flea markets, demonstrating—if not their popularity—at least the large quantity in which they were printed.

Issue by issue, the tone of the editorials reached new depths. De la Peña complained successively about a manager of the Agfa firm (who had handed the business over to Rafael Limón), the La Rochester Company (which sold off its postcard business and gave a start to

a group of street photographers—unfair competition!), and Rodolfo Mantel (who copied Christmas cards with Mexican landscapes "invented" by Garduño and "hired a bunch of unemployed little Germans to run around to all the offices selling them"). He made fun of the Schultz firm, representative of Zeiss-Ikon, and of the new management at Agfa Mexicana: "even though it's Mexican, it seems more like a *china poblana* wearing a pointed Prussian helmet, or . . . like Mexican Kodak, a *tehuana* in a cowboy hat . . ."[65] He took the side of the Oaxacan photographers Cano and Ojeda, who were forced out of business by competition—from Russians . . .[66]

In a mid-year 1931 issue of *Helios,* de la Peña launched his final attack. These "Russians" and "little Germans," and even the gringo owners of photographic firms in the Mexican capital, were all, in fact, Jews:

Only 4 years ago, our profession was still productive . . . At the initiative of many members, a standard price was established for the only [type of] work that could be considered essential, the so-called "mignon" format portrait, or identification photo. It was then that we encountered the first Russian Jew who did not want to accept the rise in price. Faced with the refusal of Levin, the Association established "Foto México" to meet the competition.

Another Jew, Radoch, went to Europe and invited many of his countrymen to work in photography [in Mexico]. Garduño sounded the alarm, without receiving an echo. Some only made a joke of it, saying that there would be enough Jews to reach the top of the Cathedral . . . Unfortunately, the avalanche occurred . . . Filthy competition . . . All Mexicans and useful foreigners clamored for the expulsion of these men who brought only shame . . . [President Pascual] Ortiz Rubio has just formulated a decree for the expulsion of these bad elements.[67]

Was this a thinly disguised pro-German, violently antisemitic "Nazi connection" posing as a photographic association in a Mexico that had barely emerged from four years of religious civil war?[68]

Helios continued to publish technical articles translated from English or German (occasionally from French or Italian), while its editorial pages—ever more numerous—had a transparent political orientation. Only the

association's logo on the cover remained the same. The association itself became a front for a "nationalist federation" that organized "huge demonstrations" petitioning the president for the expulsion of the "undesirable Jews." In the next issue, the editorialist published a poem signed by one Dionisio Coria:

UNDESIRABLE MERCHANTS

Arabs, Czechoslovakians,
Syrio-Lebanese, Russians,
All opportunists, intruders
like Polish Jews,
like thieves
they have stocked the markets
with their cast-off goods;
and still they shout and curse,
their ambition still unquenched,
they wander in vain through the countryside . . .[69]

After Antonio Garduño replaced de la Peña as editor of the magazine in October 1931, its aggressive tone lessened. However, it still took aim at Foto Chic, which had established some two hundred and fifty agents in the principal avenues of the city, "with portrait stands, hawking their merchandise at the top of their lungs, as if they were selling tomatoes or tortillas" and, of course, "constituting a blight that the Society of Photographers must eradicate."[70]

Helios continued publication until 1936. The exacerbated antisemitism of 1931 was reduced, but never entirely disappeared. For example, in the spring of 1934, the magazine supported the creation of a Pro-Race Committee that, in its name alone, reeked of pro-Nazi sentiment. While the editorialist maintained that the Jews had indeed ruined business several years earlier, he felt that "they were no longer providing competition."

The directors of the magazine boycotted the big American consortiums, Kodak Mexicana and American Supply Company, that distributed photographic chemicals, papers, and equipment in Mexico. *Helios* openly supported the German enterprise Agfa and the Defender brand of photographic papers manufactured in England. (Aside from the magazine's motivations, both companies, in fact, produced excellent products.)

In 1935, the magazine organized the establishment

of the Sindicato Patronal de Fotógrafos del Distrito Federal (Union of Photographic Employers of the Federal District) at the initiative of one of the century's most famous studio photographers, Adolfo de Porta, better known by his professional name, Napoleón.

This was symptomatic of a profound malaise in the photographic profession and marked the beginning of the end for the large studio firms. The luxurious "palaces" of Cruces and Campa and the Hermanos Valleto had withstood the impact of the Mexican Revolution, but could not survive the democratization of the clientele (and accompanying rise in competition and decline in prices) or the technical revolution of the twentieth century, especially the widespread availability of personal cameras. The modern, sophisticated photographs of Lange, Wolfenstein, Silva, and Martín Ortiz enjoyed the final bonanza days of "artistic" studio portraiture. Photography had changed course.

4
Pastorale

Hugo Brehme
Erupción del Popocatépetl, 1920

Gelatin silver print
Collection, Gregorio Rocha, Mexico City

The Natural Landscape and the Sublime

As a genre within the plastic arts, landscape reached its peak of popularity at the end of the nineteenth century, focusing on the physical environment and imbuing it with emblematic meaning. Photography adopted this as one of its principal subjects.

Landscape is that which we see. It exists only in our vision. Yet, something exists independent of our vision. Therefore, there is something to see and someone who sees. Let us consider this "something." It is a set of objects and these objects exist in relation to each other, having been "produced" through their arrangement. Landscape is the result of an action, of multiple actions, and is the fruit of social practices—widely referred to now as the *praxis*. If we learn to read it, it can teach us a great deal: it is filled with signs, pure signs. The much-discussed culture of landscape consists, above all, in learning how to read it and to interpret its signs.[1]

Landscape refers to geographic features (or, perhaps better said, to choreographic features) and includes a subtle notion of temporality. Roger Brunet has pointed out that it conforms to the golden rules of classical drama: spatial unity, unity of action, temporal unity. Whoever elects to photograph a landscape—as Edward Weston did upon arriving in Mexico, when he photographed a cloud-filled sky—intends to present a view of the here and now: Here I am, alone before a particular space, and this is what I see. Click.

This idea leads us to treat landscape as a sensitive, almost hypersensitive, space that impels the photographer to make pictures inspired by some kind of elusive "poetic conscience." The photographic landscape is almost always "inspired." For this reason, it is difficult to interpret. Its reading necessitates placing oneself in, or mentally recreating, a situation in order to reconstitute the "aesthetic moment." The photographic landscape becomes an existential revelation, the awareness of a sensibility in front of the void which the image will attempt to fill. Because of this, even the emptiest landscape is invested with emotions and transformed into a genuine medium of expression.

Early on, certain photographers attempted to bring this out in their work. Following the example of painters, they stressed the emotional character of landscape representation and imbued it with an almost religious quality, creating a kind of photographic classicism and thus the antithesis of portraiture—a short piece with two actors (the photographer and the photographed) that, with sympathy or antipathy, creates a dialogue. Landscape photography is a one-person performance, with the photographer as soloist. The artist's liberty is considerable, and the score is always changing. The landscape photographer can and must take the attitude and freedom of a Baudelairean *flaneur* and approach things with what Lola Álvarez Bravo referred to as "nonchalance": a heightened poetic feeling and the "liberty to see."

Landscape photographers "invented" the "art of photography." Their photographic works equaled the noblest expressions of a particular poetic sense already represented by the older visual arts. Peter Galassi and Jean François Chevrier demonstrated, some years back, how much the invention of photography owed to the romantic painters of *vedute* (Italian landscape views), many of whom—starting with the most celebrated, Canaletto—were already using the camera lucida by the end of the eighteenth century.

Although originating in Europe (particularly in Germany as a derivative of Romanticism, and later in *fin-de-siècle* symbolism), this phenomenon was particularly marked in the photography of the United States during the last third of the nineteenth century. There the sublime poetic of landscape photography corresponded with the ideology—one could almost say mysticism—promoted by the federal government in regard to the land and the expansionist move westward. This "school" lasted, in its variant forms, until approximately the mid-1950s. The exaltation of virgin landscape had its golden age in the works of the Hudson River School (Thomas Cole, Frederic E. Church) and the "photographers of

the frontier." They transferred the quasi-religious attitude toward a "sublime Nature" manifest in the works of German romantic painters such as Caspar David Friedrich to the virgin wilderness of America.

After 1864, a number of government agencies in the United States—notably the War Department, museums, and scientific institutions—commissioned the most prestigious photographers of the period to carry out photographic surveys of those still largely unknown territories west of the Appalachians. Much of this "last frontier" consisted of lands seized from the Republic of Mexico in 1847 that remained to be "discovered." Timothy O'Sullivan, William Henry Jackson, and Carleton Watkins, among others, headed for the rug-ged terrain west of the Mississippi and the line of Euro-American settlement. They headed west across the 100th meridian, traveling along the 40th parallel and the area of the old Camino Real from the Rio Grande, past the Big Bend in Texas, through the pueblos of New Mexico to the former colonial city of Santa Fe. Others traversed the Indian country of Arizona, the arid badlands of Utah, the deserts of Nevada, and the treacherous rapids of the Colorado River, which eventually reached its delta just north of Baja California.

The purpose of these reconnaissance surveys was both to obtain a record of these territories in order to study the possibilities of economic integration (above all, the construction of railways and development of

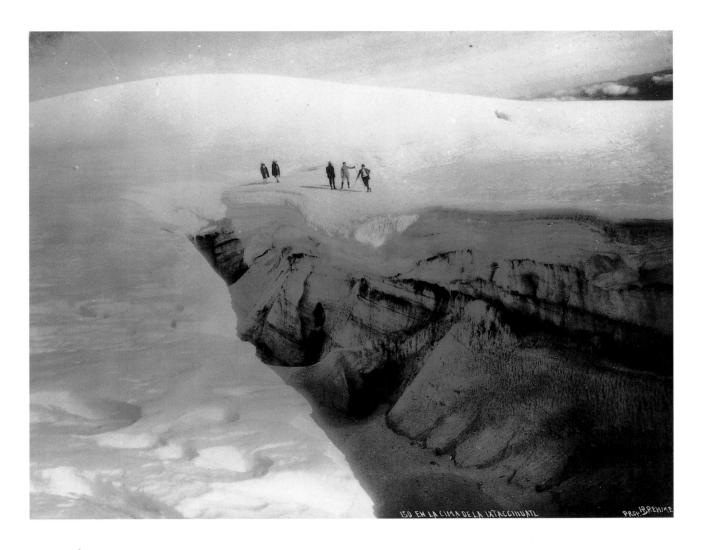

Hugo Brehme
En la cima de la Iztaccíhuatl, ca. 1920

Gelatin silver print
Center for Southwest Research, General Library
University of New Mexico No. 998-018-0032

mining and stock-raising) and to encourage emigration and settlement in these regions. They were propaganda missions, really, ideologically linked to expansionist policies.

The photographers surpassed the expectations of the politicians in Washington and the scientists of New England, creating a mythology as well as an aesthetic. They, and the painters of the western landscape, constructed a territorial conscience and a national pride.

The theory of the Sublime was . . . essential to the creation of landscape art. It had been formulated by the English philosopher Edmund Burke in a work published in 1757 and was characterized by an aesthetic rooted in the most turbulent emotions: anxiety, terror, etc. He stated its principle as the Infinite, the Unknown . . . Nature, thus, took on all the attributes of a divine force: disproportion, imbalance between man and nature, and uncertainty were transformed into potent factors of a new aesthetic based in subjectivity. In the United States one century later, Emerson, Thoreau, the Transcendentalists of New England, established the principles of a new sublime that differed from Burke's. "Luminism" harmonized with the celebrated discovery of the great wild and Edenic landscapes of the West. Geologists fascinated with theology, Clarence King (U.S. Secretary of War in the early 1870s and patron of these photographic missions) and F. V. Hayden encountered in [this theory] justifications that comple-

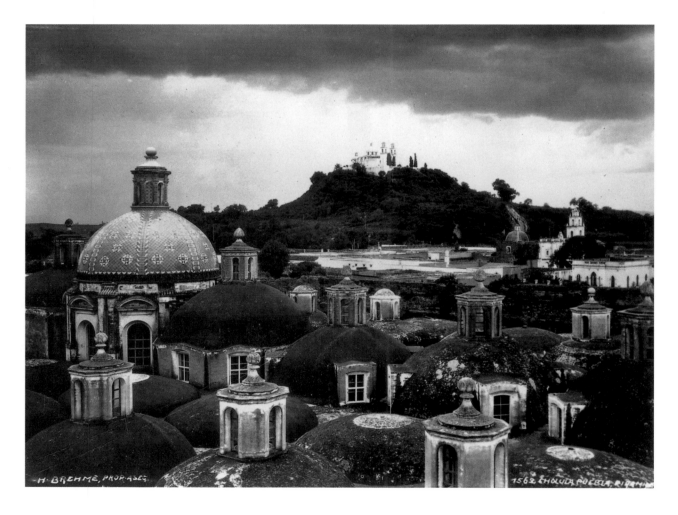

Hugo Brehme
Cholula, Puebla, Pirámide, ca. 1920–1925

Center for Southwest Research, General Library
University of New Mexico No. 998-018-0015

mented their projects of exploration. Art attained the status of science and religion, monumentalizing the adventurous spirit and the necessity of utilitarianism.[2]

The confrontation with desolate landscapes and mountains, whose rugged forms were apparently inaccessible, inspired more than theological responses. Another interpretation placed humankind before a series of challenges, from the conquest of nature—be it scaling incredible mountains to attain Olympian heights beyond the reach of ordinary mortals (a theme that often appeared in the literature and cinema of the first third of the twentieth century, particularly in Nazi Germany) or dominating these through human effort. In both cases, the implicit discourse is the confrontation of human will with the divinity, an archetypal, deterministic idea of Anglo-Saxon Protestantism.

In the twentieth century, this sublimation of the landscape became a veritable school of photography in the United States. Its leaders were Ansel Adams, Eliot Porter, and, to a lesser degree, Paul Strand. Excessively formalist, this school emerged in part as a reaction to the loss of wilderness and the destruction of the natural environment. Their work promoted a certain pseudo-ecological tendency, the same impulse that had transformed the remaining wild areas of North America into national parks where the endangered natural world is artificially preserved, part of the same ideological universe as the Indian reservations of the American West.

Ansel Adams, more than anyone else, developed this sensibility in his work. He presented not only the monumental aspects of nature, but the poetry of the empty plains and green valleys stretching from Ohio to California. He invented the "zone system," to control the exposure and development of his negatives in order to compose prints with a gray scale equivalent to a musical scale for light. These manipulations translated into dramatic effects: areas of intense light and zones of shadow, exaggerated contrasts that delineate the forms of nature to impart an element of mystery to the images.

But what does this have to do with Mexico? A couple of things. The most obvious is that several of the photographers of the North American frontier, starting with William Henry Jackson, crossed the Rio Grande and worked in Mexico. More importantly, they invented a particular way of seeing that, while it may not have directly influenced Mexican photographers and painters, found an equivalent there. For the history of landscape photography in Mexico can also be read as a nationalistic construct.

Building upon the earlier work of Justino Fernández, art historian Fausto Ramírez established a critical foundation for the understanding of a pictorial school of Mexican landscape. This expressive mode began in the work of a number of romantic foreign traveler-artists (Johann Moritz Rugendas and Baron Gros, in particular), continued in the work of Mexican artists José María Velasco and his disciples, and culminated in the work of Dr. Atl [Gerardo Murillo], who brought it to its logical consequences. Not surprisingly, there have been no recent disciples working in this genre.

The emotional element within the practice of landscape photography must be the point of departure for our analysis. Here we move in the terrain of the purely aesthetic, its idealism, and its underlying ideological implications.

One sector of Mexican photography adopted landscape as the obvious genre, inspired by the physical grandeur and variety of the country. It was also a form of nationalism linked and confused with the promotion of tourism. From nineteenth-century stereograph series to the photographs of the amateur camera clubs of the forties and fifties—by way of Hugo Brehme, José María Lupercio, and to some degree Edward Weston—a certain "Mexicanist" flavor can be traced in the choice of recurring motifs: the snow-capped heights of Iztaccíhuatl and Popocatépetl (dominant in the paintings of Velasco and Dr. Atl), as well as particular botanical and geological features.

Hugo Brehme's *Picturesque Mexico*

On the occasion of an exhibition of Hugo Brehme's photographs at the Museum of the Basilica of Guadalupe in 1989, Raquel Tibol discussed at length the work of this undervalued artist, whose influence on modern Mexican photography has not been adequately recognized, even at a time when his images are being rediscovered.[3]

Hugo Brehme was born in Eisenach, Thuringia, in 1882 and died in Mexico City in 1954. He became a photographer early in his life, making his first pictures in Africa. After contracting malaria, he returned to

Dresden, where he operated a photographic studio until 1908. A second trip took him to Panama, to Costa Rica, and finally to the coast of Mexico. He remained in Veracruz for several months, where he made photographic views of the city, port, and nearby villages.

After a brief trip back to Germany, Brehme returned to Mexico with his wife, Augusta Carolina Hartmann, and opened a photographic studio in Mexico City in 1910, at 27 Avenida 5 de Mayo. In 1928, he bought the luxurious establishment of Emilio Lange, at 1 Avenida Madero, complete "with everything, all the equipment, and even . . . Lange's collaborator Luis Quintero."[4]

The outbreak of the Revolution, apparently, did not disrupt the career of this photographer, who quickly became one of the most popular in the Mexican capital. In 1911, he joined the Agencia Fotográfica Mexicana founded by Agustín Casasola and participated in the photographic exploits of the Revolution. Under circum-

stances that remain unknown, Brehme came into contact with the Zapatistas in Morelos, where he made the now-celebrated portraits of Emiliano and Eufemio Zapata. Ever since they were first reproduced in the popular press, they have inspired generations of artists, starting with Diego Rivera, who incorporated several elements from the image in his Cubist work *Zapatista Landscape,* painted in Paris in 1915.

An indefatigable traveler, Brehme covered a large part of the Mexican Republic during the turbulent years of the Revolution, compiling a rich collection of negatives that he printed primarily in the form of postcards. In 1923, he assembled 197 of his best images to compose a book which was published in Germany by Ernst Wasmuth and was so successful at the time that it was reprinted shortly thereafter with texts in Spanish and, in 1925, in English.

Brehme's *Picturesque Mexico* is characterized by the deliberately idyllic vision of art books aimed at a public that preferred evasion to confrontation with crude "realistic" images, a position that Brehme enunciated in the prologue to the Spanish edition.

Hugo Brehme
Jarabe Tapatío, ca. 1920–1925

Gelatin silver print
Center for Southwest Research, General Library
University of New Mexico
No. 986-013-0017
Photo courtesy Throckmorton Fine Art, New York

> The photographs that illustrate the present work are clear proof that the Mexican Nation has a glorious and venerable ancestry and deserves to be placed among the peoples who march at the front of Humanity . . . In "tourist guides," descriptions of the Indians are nearly always unfavorable. In general, they are depicted as dirty, lazy, addicted to pulque or alcohol, without any ambition to improve their primitive lives . . . alleging that Mexican peasants work only as much as is necessary to satisfy their very modest daily needs . . . The Indian, as a being born and raised in Nature, thinks differently: he doesn't count the hours, he has unlimited time on his hands . . . In general, it can be said that the Indians who live in rural areas are very clean, at least wherever there is abundant water, especially on the coast and in the so-called hot country . . . In his primitive dwelling, frequently quite small for his large family, the Indian lives very happily and contently with his wife . . .[5]

Brehme's romantic and bucolic view—a quintessentially German view, perhaps—refused to acknowledge, in effect, the dust storms in the village streets or puddles of

muddy water that so often appear in the photographic views of Charles Waite or Abel Briquet. Brehme almost situates the Indian within the context of a monumental landscape that might be qualified as "Andean." The Indian is merely an added element, an exotic but dispensable note except when employed—as in certain of Velasco's monumental landscapes—to provide a sense of scale and local color. The portraits of human types that appear at the end of the book—a *tehuana* and a *china poblana*—are, in fact, attractive models dressed for the occasion, precursors of the typologies of Luis Márquez.

What interested Brehme, evidently, was the sublime: "the most sublime thing that this country, so rich in beautiful landscapes, can offer is its mountains covered with eternal snow."[6] In the prologue of his book, the photographer dedicated ample space to his description of volcanos and to the difficulties of making these "sublime" images that "pass before our eyes like an artistic cinematographic film."[7]

Even when everything has gone well and the entire group has reunited at the summit [of Popocatépetl], bad luck can deprive us of the possibility of registering on the photographic negative the full extent of the sublimity that surrounds us. Every minute is precious and must be used to the fullest. One who has never attempted it cannot appreciate the difficulties that must be overcome in order to obtain good views. For example, it was necessary to place the apparatus at the edge of the slope, a very risky undertaking considering the glacial wind that blew furiously. In the decisive moment, the light filter slipped from numbed fingers and began to roll down the slope . . .

William Henry Jackson
Popocatépetl, ca. 1883

Albumen print
Center for Southwest Research,
General Library
University of New Mexico
No. 996-013-0002

in the nick of time, a walking stick managed to halt the deserter.

The panorama changed constantly before us. New cloud formations, new light effects offered themselves to our view. Our good photographer is all activity, forgetting everything: time, cold, hunger.

"We have to descend, it's getting late," the majority say. But our artist-companion, who in normal circumstances has a conciliatory enough attitude, is in his "photographic furor" and becomes indignant with such a proposition. "Go to Hell, all of you, if you don't want to wait; I have to stay here!" If the project is not completed, what difference does it make if darkness catches them halfway through the descent or they miss the return train. "There'll be another tomorrow!" It's a question of bringing back, as a trophy, a good collection of views. All else is secondary.[8]

Dramatic clouds at sunset over the Laguna del Carmen in Campeche, over Lake Chapala, or over the canals of Xochimilco; foreshortened shadows that erase the presence of man in the ravines of Teocelo, near Xalapa, along the Temasopa River in San Luis Potosí, or at the falls of Juanacatlán in Jalisco; vegetation that frames and isolates the Gaugainesque female figure in *Idyll in Tierra Caliente,* the huts in *Atoyac, Plantanal,* or the vast space of the volcano scenes: the traditions of romantic painting are here reunited and translated to photography. Hugo Brehme occupies the position of first photographer of a Mexican "pictorialism."

The English-language edition, issued two years later by the New York publisher Brentano, included the images used in the German and Mexican editions of 1923, plus forty others of inferior quality (some appeared to have been retouched) "made available by Miss Cäcilie Seler-Sachs," two by Teobert Maler (the famous picture of Isla Mujeres in which Maler himself appears and a view of the temple of Kivic in Yucatán), and seventeen new images by Brehme, substantially different from those in the first edition. This version had a greater number of portraits of indigenous people photographed in their natural environment, such as the eloquent image of the laughing women captioned *Cooking Corn Tortillas* and the now well-known depiction of the *tlachiquero.* Some of the images that appeared in ear-

lier editions (*Idyll in Tierra Caliente* and several landscapes) were not, however, included in the New York edition.

Brehme introduced the modern "pictorialist" photographic style to Mexico, as well as the use of toners,[9] gum bichromate, filters, and in particular the process for making exquisite platinum prints which he taught to his friend the engineer Fernando Ferrari Pérez and a young disciple of his who regularly accompanied them in their Sunday photographic excursions through the Valley of Mexico around 1920–1921: Manuel Álvarez Bravo.

The time came when the lyrical images of Hugo Brehme went out of style, replaced by those of "modernist" photographers who quickly abandoned the pictorialist way of perceiving and presenting the world through the conventions of romantic painting. Instead, they sought a more direct and less grandiloquent approach to objects. Despite his (ambiguous) participation in the later racist polemics of the magazine *Helios* and his bucolic—and ultimately reactionary—view of the country, Brehme can be considered both the first modern photographer of Mexico and the last representative of its old guard and of a certain nineteenth-century vision.

The Photographer's Paradise

Mexico is literally a photographer's paradise. Each tree, cactus, and flower, the thousands of Indians, *campesinos,* heavily loaded burros—patient little animals—fields of maguey, the clouds, mountains, rocks, markets, gardens, parks, historical buildings, arches, monuments, all attract the photographer. These are different from anything in the United States, and little has been photographed by a million people before you, as is the case with most subjects north of the Rio Grande.[10]

Mexican photographers were not very prolific writers: a few letters, some technical notes in the Archivo General de la Nación, brief notices in the newspapers, the occasional brief and sudden debate. This situation did not change until the 1960s, when Mexican photographers began to affirm their status as "creators" and to

defend their work both verbally and in their writings.

This lack of information, description, and appreciation demonstrates the position that photography held within the arts: merely an honorable commercial occupation that considered itself removed from aesthetic issues even when these were, in fact, the unacknowledged concern of the photographers. Yet the lack of supportive or critical texts also denotes a freer, more "innocent" practice and a wealth of unexpected, implied meanings.

The itinerant photographer, in contrast, who discovered new worlds—landscapes, climates, societies—with every step of his journey, wanted to communicate his impressions. The difficulties he encountered and his heroic exploits—why, these were the very reasons he traveled!

An article by Eugene Witmore, published in translation in *Helios* in 1935, includes a number of interesting facts and statements. Above all, Witmore summarized the stereotypes common to photographs that had been made by foreigners in Mexico since the nineteenth century. His original article, obviously, was directed to tourists and amateur photographers and merits extensive citation:

Half an hour after leaving the train in Juárez, we began to encounter landscapes, people, and houses that made the photographer's heart skip a beat. But the Pullman conductor, a paternal Mexican with a grandfatherly face, advised me not to take photographs from the station platform in small towns. He had seen too many tourists have their cameras confiscated and assured me that any police guard would take it away from me.

This being the case, I contented myself with the occasional snapshot of the mountains and cactus-covered countryside as the train headed south . . .

The law governing the use of cameras in Mexico was surely a response to the irresponsible tourists who laughingly took photographs—apparently with the sole purpose of showing Mexico as a dirty country, infested with beggars and thieves. The border towns of Juárez, Matamoros, and Agua Caliente [*sic*] were constantly flooded with tourists who had no genuine interest in Mexico and who made fun of Mexican customs, photographing the vilest details in the cities, which are not typical of the country as a whole.

The photographer who demonstrates a certain degree of courtesy and respect, who wishes only to photograph the beautiful landscape, picturesque buildings, and fascinating human subjects, will find no obstacles placed in his path. The government will not make it difficult for you to make pictures of typical street vendors that abound throughout the Republic, nor object if you photograph markets, burros with their heavy burdens, gardens and flower markets, and public buildings (except, naturally, jails, forts, or military bases).

The Indians, in most cases, will hide their faces if you point a camera in their direction. They are quick as lightning and seem to be able to smell a camera a block away. In some cases, a few centavos or a swig of pulque will dispel their timidity.

Among the most interesting human types in Mexico are the charros, famous horsemen and ropers. They are seldom seen in their traditional costumes. However, on a Sunday morning during the horsemen's ride through Chapultepec Park in Mexico City, you will encounter dozens of wealthy men, mounted on thoroughbreds, dressed in full charro regalia: the gold-embroidered hats that cost nearly a thousand pesos, their tight-fitting jackets and pants embroidered with gold and silver, not to mention the pistols and machetes overlaid in silver. You must remember that the wide-brimmed sombreros cast shadows on the faces, many of which are beautifully modeled versions of the Spanish aristocracy, and consequently you must first of all take these shadows into account when making your exposures.

Which reminds me: in Mexico the light at high altitude is extremely brilliant and the shadows extremely deep. But in spite of the sun's brilliance, it seems to have no greater actinic quality than that which one encounters in the midwestern states on a bright, sunny day. I used the same exposures that I generally employ in Illinois during the summer and obtained good results.

You will constantly curse the telegraph and telephone companies when you try to photograph churches and public buildings in the various cities. Particularly in Mexico City, where the telephone and

José María Lupercio
Lago de Chapala, ca. 1905

Modern copy from collodion negative
Archivo General de la Nación, Centro de Documentación Gráfica
Mexico City

telegraph wires are hung from posts along all the streets . . . The narrow streets, certainly, call for a wide-angle lens. But, fortunately, there are lots of plazas where . . . one can retire far enough to have a good perspective . . .

The clouds over every part of Mexico are incredibly beautiful. You will probably have to employ all your will power to refrain from photographing clouds from dawn to dusk. Nowhere have I seen such spectacular clouds. For this reason, you mustn't forget your filters.

Naturally, you will attend a bullfight! And don't leave behind your camera. I got some good snapshots with super-pan film, at a fortieth of a second, aperture at F8. If the action is close, open the lens a bit more and increase the shutter speed. Tickets for the bullfight are priced according to whether the seats are on the sunny or shady side . . . but since they don't begin until four in the afternoon, it doesn't make much difference . . . You might even have more interesting, though less well-off, neighbors on the sunny side . . .

A final word of advice: don't make little jokes in English like mocking an ancient structure or elderly Indian carrying a load on his back while you are taking a photograph. In most cases, you are never out of earshot of someone who understands and speaks English. More than a few tourists have lost their cameras, not because of the way they use them, but for what they said while they were using them.[11]

In 1951, Rosa Castro, the Venezuelan reporter and co-founder of the magazine *Hoy,* asked ten photographers what they thought of Mexican photography and if anything existed that could be properly called a school of Mexican photography. In their responses, Lola Álvarez Bravo, Gabriel Figueroa, Luis Márquez, Faustino Mayo, Cándido Mayo, Ismael Casasola, Luis Santamaría, Manuel Madrigal, and Enrique Díaz all agreed on one point (as recorded by Lola Álvarez Bravo): "The work of photographers on behalf of Mexico has been magnificent, as propaganda promoting Mexico." Echoing Eugene Witmore, Luis Márquez added: "Mexico is an absolutely photogenic country [with] its archaeological ruins, colonial monuments, and unusual landscape. The development of photography as experienced [here] is based in this."

"Our function as photographers has consisted in revealing, by means of our cameras, the true Mexico, its customs, landscapes, and other features that make up this country and that are so misunderstood outside its borders," declared Manuel Madrigal. Luis Santamaría stated it even more clearly: "photography . . . has contributed . . . to the development of tourism."[12]

The Cult of Landscape

In 1904, the amateur photographer Luis Requena created the Asociación Fotográfica de Profesionales y Aficionados (Association of Amateur and Professional Photographers), dedicated to promoting photography through organized excursions to make pictures of landscapes, buildings, and ruins.[13] It was the forerunner of the Club Fotográfico de México (Mexican Photographic Club), which was founded during the Second World War and became a formal institution in 1949. Modeled on similar associations in the United States, the Club Fotográfico de México was, first of all, an amateur group. Yet, because of the lack of institutions or schools dedicated to photography in Mexico, it soon became the principal organization for all photographers, including professionals.

A decade earlier, *Foto* magazine (which replaced the defunct *Helios* in 1936) had already prepared the groundwork for a photographic style that could be qualified as "virtuoso," in the sense that it placed greater emphasis on display of technical mastery (perfect exposure, the precise play of light and shadow) than on content. Still-lifes and studio portraits (including the sculptural portraits known as *foto-esculturas*) and landscapes were practically the only acceptable genres.

Enrique Galindo, technical director of *Foto* since its creation in 1936, was the spokesman for this tendency, about which he wrote numerous articles and offered "formulas." His own photographic work included a series of rather affected portraits that are reminiscent of the style of the portraitist Gustavo F. Silva.[14]

Perhaps the most interesting contributor to *Foto* was the Frenchman F. W. Butterlin, another devotee of "pictorismo" (as he called it), whose interesting composition entitled *Railroad Wheels* recalls the early work of Paul Strand.[15] *Foto* published the work of a number of amateur photographers who later joined the Club Fotográfico: the German B. Elimbecke, Luis Meade,

Miguel Ángel Rico, Ruiz Bolland, and Antonio Rosali Jaime, as well as that of professionals like Manuel Carrillo and Agustín Jiménez. Manuel Alvarado Veloz "portrayed teenagers, that sensual part of early adolescence that borders between innocent nudity and eroticism."[16] Manuel Carrillo was more interested in still-life subjects.

On the fortieth anniversary of the Club Fotográfico de México, José Fuentes Salinas recounted the history of the institution:

February 8, 1949, is an important date for the history of photography in Mexico: at that moment the Club Fotográfico de México was baptized and confirmed . . . On several occasions, it has been branded a club of elitist photography, one that did not concern itself with the nation's problems . . . yet we felt that reality is more than what is written in pamphlets, that the street also reached into our beds and unconscious fantasies from whence creativity bursts forth.

In the beginning, it was a club of friends looking for a mutual praise, a place to have coffee and pass the time under the pretext of [discussing] photography. There were people who had achieved great economic success in their respective fields. This is understandable if we take into account that at that time it was more difficult to own a good camera than it is today when the 35mm reigns supreme.

Looking at archival photographs, we can appreciate the comfortable cafe restaurant at 8 Avenida San Juan de Letrán. At first, according to Mr. Beto Rossete, who worked for the Club since 1955, the [organization] was better-off economically. But after 1962, it began to suffer from a decline in membership.

Before 1970, they organized international exhibitions where the best photography in the world was

George Hoyningen-Huene

Statue of Christ . . . Church of La Profesa, Mexico City

Reproduced as double-page layout in *Mexican Heritage* (1946)

shown and which gave a cosmopolitan context to the work of Mexican photographers. These were organized by don José Lorenzo Zacani, an internationally known film producer and photographer of Spanish origin.

Like other branches of culture, Mexican photography was the beneficiary of the Spanish exiles . . . in the case of the Photographic Club, the benefit was made more notable by the contribution, not only of Zacani, but of José María Gómez, José Arturo Carol, José Pla Miracle, and Andrés González Ortega.

Since the time of Manuel Ampudia, the first president, one thing has characterized the Club: a constancy in its methods of teaching and promoting the practice of photography . . . Rummaging through the archive containing the Club's bulletins, it becomes apparent that as early as 1948 the operating format was essentially the same as today's: the photographic excursions, the contest for photo of the month, the monthly exhibit, the bulletin, the obligatory themes.

Between 1948 and 1950, the dominant themes were forests, churches, children, faces of the elderly, cactus, architecture, cats, flowers, windows, typical streets, nudes in sculptural poses, dunes, and the still-life . . . The contrasting themes suggest that the aesthetic of Weston's cactus and Modotti's lilies and the abstractionist concepts that sustained them were engaged in a struggle against the Kodak aesthetic of calendars, puppies, and children . . . ufff!

. . . In the majority of cases, the photographic activity [of the Club] was essentially a playful act in support of tourism and the enjoyment of free time. Nevertheless, it is fair to say, there was a strong concern for technical aspects.

The origins of the Club Fotográfica de México reflected a variety of factors, disciplines, and aesthetics . . . yet their historical mission was clearly defined: to move Mexico into the twentieth century as regards graphic reproduction. This was only possible with the support of a middle class seduced by the fetish that would facilitate their transcendence and that of their "moments of happiness." When they made views of poverty, they did so while maintaining a comfortable distance or from the perspective of the Tourist-Missionary Syndrome. It couldn't be otherwise; [after all,] the middle class had developed

its perception within the melodrama of its own space and time.

Yet this was the sector [of the population] that could spend freely enough to form organizations of this kind.[17]

The aesthetic promoted by the members of the Club Fotográfico was, in fact, very similar to that of many "tourist photographers," who, upon returning to their own countries, published albums that for many years were the most widely available photographic images of Mexico.

Pierre Verger: *Mexico*

In 1938, the editor Paul Hartman published a book of photographs by Pierre Verger (which also included several images by Lola Álvarez Bravo and others by "amateurs" such as Fernando Gamboa and Jacques Soustelle). The production of this genre of books had come to a halt after the publication of Hugo Brehme's *Picturesque Mexico*. Verger's *Mexico* was the first such work to appear in nearly two decades.

For a number of years, Verger's remained the only book of its type available in the country, and it was reprinted, unrevised, in 1952. Doubtless, the prologue by French archaeologist Jacques Soustelle greatly contributed to its relative success.

The work of Verger—a successful "reporter" who spent most of his life in Bahia, Brazil, where he recently died—represents the paragon of a certain type of touristic photographic books, a genre which has evolved into the luxurious "coffee table books" commonly published in Mexico today. Recent examples, such as *México visto desde las alturas,* produced by Fomento Cultural Banamex—perhaps the most expensive photographic book in history, due to the cost of hours of helicopter flight—or *México lindo,* are direct descendants of this line of publication.

Verger's *Mexico* (simultaneously published in Paris and Mexico City) was also, perhaps, the first "photo editor's book" on that subject in the sense that the order of the images and its pagination suggest a particular "reading." This visual discourse is derived in part from the cinematographic editing that relies upon a sequenced reading of the images. In several instances,

this layout plays on a series of contrasts. Until Pablo Ortiz Monasterio launched the Río de Luz series on Mexican photography (published by Fondo de Cultura Económica) in the early 1980s and substantially modified these conventions, photographic books about Mexico were constructed to reflect the old axiom: "Mexico, land of contrasts." The arrangement of the images was, therefore, established according to polar oppositions: rich/poor, modern/archaic, civilized/savage, etc. Verger's book is arranged to suggest free associations, evident in the photograph of a bullfight, where the violence in the arena is juxtaposed with the innocent expression of an Indian child, or that of a modern skyscraper in Mexico City placed across from an image of an Aztec sculpture embedded in the foundation of a colonial palace.

George Hoyningen-Huene: *Mexican Heritage*

Son of a German baron, George Hoyningen-Huene was born and educated in Central Europe during the final years of the Romanov dynasty. In 1918, he escaped Estonia with his brothers and joined the White Russian army. After contracting typhoid fever, he was sent to London and later moved to Paris, where he studied drawing with the Cubist painter André Lhote and learned photographic techniques from Man Ray. In 1925, he began his career as a fashion photographer, working for *Vogue, Harper's Bazaar, Vanity Fair,* and *Fairchild Magazine.* Hoyningen-Huene introduced a new style of fashion photography, influenced by the innovations of the European avant-garde: off-center images, austere backdrops, radically stylized poses, etc. He exhibited his work at the Salon Indépendant de Photographie in Paris in 1928. In 1930, he moved to Tunisia and from this new base produced travel books that sent him successively to Greece, Southeast Asia, and Australia. He also collaborated as cinematographer on G. W. Pabst's film *Atlantide.*

Hoyningen-Huene visited Mexico for the first time in 1946. Fascinated by the country, he considered moving there. During that trip, he produced *Mexican Heritage,* which was published the same year.[18] Finally, he decided to settle in California, where he worked as a cinematographer, carrying out important studies on color cinema that had an impact on several of George Cukor's films (including *A Star Is Born*). He became one of the most famous photographers of movie stars and a professor of photography at the Art Center School of Los Angeles.

Although *Mexican Heritage* is arranged chronologically, beginning with several images of Precolumbian objects and views of monuments, its reading is somewhat more complex than that of its antecedents. This is, in part, because Hoyningen-Huene was less interested in "scientifically" discovering these objects than in offering suggestive plastic juxtapositions and orchestrating complex light and shadow effects. Perhaps more revealing are the images of natural forms—rocks, mountains, and vegetation—that make up the second and more extensive part of the book. There Hoyningen-Huene gives free reign to his creativity, using their volumes in an almost abstract manner and creating visual analogies. This can be seen in the expressive, tormented tree roots that spread across an interesting double-page layout and in the visual correspondence between the ash-strewn landscape of Popocatépetl and a sea of clouds from which only the summit of the Peak of Orizaba emerges. The final section of the book is dedicated to colonial architecture. There Hoyningen-Huene employed more double-page layouts, linked by the continuity of quasi-geometric elements.

Eliot Porter: *Mexican Celebrations*

Eliot Porter is one of the most famous North American landscape photographers of the twentieth century. His work was among the first to be exhibited by Alfred Stieglitz in his gallery An American Place, in 1938, and has been validated by the successive directors of the Department of Photography at the Museum of Modern Art in New York. In spite of this early recognition, however, he never achieved the kind of fame that Ansel Adams enjoyed. Born in 1901, Porter was the contemporary of Manuel Álvarez Bravo and, like him, was influenced by the work of Edward Weston. However, Porter worked almost exclusively in color after the invention of Kodachrome film in 1935.

Living in Santa Fe, New Mexico, and a friend of Stieglitz, Mabel Dodge Luhan, and Georgia O'Keeffe, Porter specialized in landscape photography. Although

his work maintained a relationship with the "frontier spirit" of the nineteenth century, he both prolonged and modified it by his focus on the details of nature. Closer to Weston than to Adams, Porter found in the virgin wilderness rocks and vegetation whose strange forms, colors, and textures he presented in sensual detail—at times to the point of abstraction. Obviously, Porter's work participates in the landscape mystique, but here the sublimity of vast spaces is replaced by a closer view, a precision of focus that reveals an ecological mentality long before the idea of preservation of nature became a common theme. In this sense, Porter's nostalgic and romantic evocation of nature is inseparable from the radical transformation of landscape that occurred during the course of the twentieth century and is ideologically opposed to the conservative idealizations of Hugo Brehme, for example. Its revindication of spontaneous, natural forms is (as Joseph Wood Krutch points out in the prologue to Porter's book on Baja California) very close to the aesthetic preoccupations of the Abstract Expressionists.[19]

During the winter of 1951, a little weary of his professional life, Porter and his wife decided to cross the nearby border into Mexico. Georgia O'Keeffe accompanied them from Laredo to Mexico City. "It was in Oaxaca that I had my introduction to Mexican cathedrals and village churches and saw for the first time the naive iconology and colorful decorations that expressed simple Indian reverence."[20] It was then that Porter conceived the idea for a photographic book on Mexican churches. Finally, in 1955, he convinced the photographer Ellen Auerbach to accompany him on a far-reaching tour through Mexico that took them from Hermosillo to Tepic and Guadalajara, from San Miguel de Allende to Atotonilco, from Mexico City to Oaxaca, Chiapas, and Yucatán.

The images from this first trip were not, apparently, well received at the time and only appeared in the 1980s when the University of New Mexico Press published *Mexican Churches* and, later, *Mexican Celebrations*.[21] Porter and Auerbach made the decision not to use artificial light, preferring to use a tripod and very long

Lázaro Blanco
Untitled, ca. 1970

Gelatin silver print
Courtesy, Lázaro Blanco

exposures in order to preserve the original atmosphere of the churches and their suggestive semidarkness.

> . . . we decided to use only the existing illumination, however dim and unsuitable it seemed from a photographic viewpoint. I saw more and more how important it was not to use additional light. The candles or colored glass were imperative in creating the atmosphere we wanted to retain . . . Often the exposure meter showed no reaction at all, and we literally worked in the dark. But, because photofilm can accumulate light through time, some of the resulting pictures show more than met the eye. This method meant a great effort in time and patience, but it seemed the only way to catch some of the atmosphere and essence of what we saw.[22]

Oddly, these color images do not betray the fact that they were taken so long ago. Unlike so many other photographers, Porter and Auerbach were not interested in architecture for its own sake. Rather, they sought to obtain certain coloristic effects from the façades of churches, such as that of Ocotlán in Tlaxcala. They concentrated on details of interior decoration, particularly the ephemeral adornments on the altars and in the lateral chapels, on the dressed statues of saints and Christ, on the stucco motifs and painted murals. This was a deliberate stance, since the photographers were not attempting to prove anything, but to present, as picture makers, suggestive and poetic images that were in no way "didactic." This view was simultaneously respectful, affectionate, and distanced, like that of Mariana Yampolsky when she photographed Mexican houses and old haciendas or of Pablo Ortiz Monasterio in his 1989 series of church interiors bathed in light.

In 1962, Porter organized a photographic trip through the Baja Peninsula commissioned by the Sierra Club, which had already published a number of his other works. The "wild peninsula," as Porter called it, offered variations on the arid landscapes that had inspired and motivated Edward Weston before him. The book that came out of this experience (and included poems by Octavio Paz) clearly expressed the anxiety Porter felt in this region. Bizarre forms of cacti, mosses, and fungi struggling for survival against heat, dryness, and winds; rocks emerging here and there from dunes petrified through time; rare oases of vegetation beside rivers or hidden bays—all these appear transfigured in his close-up images of natural details.

Curiously, among these immobile stones, tentacular cacti, and green expanses of ground cover that indeed look like Abstract Expressionist paintings, Porter inserted images showing an offering of plastic flowers, candles, a Virgin of Guadalupe made of painted plaster, the ruins of a desert mission, and a wooden cross adorned with a light bulb, painted blue . . . Odd traces of human presence, the almost archaeological remains of an absent humanity. These images, a small minority among those in the Baja book, refer back to the church interiors and Mexican fiestas that Porter made during his first trip in 1951.

Unlike the documentary photographers, who were typically more interested in faces and poses, dedicated to capturing folk dances, pilgrims with bloody knees, children with sad expressions, and women hiding behind the folds of their *rebozos*—motifs derived, perhaps, from the paintings of Diego Rivera—Porter only depicted objects. In the rare instances where he includes people, they are shown from the back, in the shadow of a church or behind a pile of fruit in the market, if not masked. The cover of *Mexican Celebrations* is a typical example: a street photographer's booth with its painted backdrop and wooden horse, the old camera on its tripod, the developing box, the clothing furnished by the photographer hanging from a peg . . .

Recuerdos de la Media Luna

In September 1980, the Instituto Nacional de Bellas Artes organized an homage to Juan Rulfo in the Palacio de Bellas Artes, celebrating the work of the writer who had ceased to produce after the publication of *El llano en llamas*.[23] The lack of texts was compensated for on this occasion by a collection of photographs that Rulfo had made, almost in secret, throughout his life, but particularly in the 1950s.

Although people appear in a number of Rulfo's photographs, it is appropriate to discuss his work in this chapter on landscape since the latter seems to have been his principal interest (but this may also be due in part to Fernando Gamboa's selection of images that seemed to "illustrate" the author's fiction). The feelings evoked by the abandoned ruins in his books—the ghostly vil-

lage of Comalá frozen in time and forgotten in the mountains of southern Jalisco, between whose stone walls echo the sighs of Susana San Juan and cries of Juan Preciado—had their visual equivalent in the static photographs of Rulfo. Drought-parched land, burning buildings, an orchestra with instruments left untended on the mountainside, stones and more stones in the mule paths, and an apparently empty house, its door closed, with the words "Earthquake of April 16, 1928" written in large letters on the façade . . . All these bear witness to the desolation and aridity of the Mexican plateau which haunts the photographs of Rulfo and also leaves its mark on the work of Manuel Carrillo.

Juan Rulfo's obsession with mute stones can be compared with Lázaro Blanco's fixation on forgotten objects and whitewashed walls. Blanco was one of the most active architects of the renewal of interest in photography during the 1960s and 1970s. Dissatisfied with the Mexican Photographic Club, he and José Luis Neyra founded the ephemeral Grupo 35, 6 × 6 in 1968. Five years later, he created the Taller de Fotografía de la Casa del Lago, an alternative school where many young photographers received their training. Blanco also mounted numerous photographic exhibitions. The earliest of these was *Imagen histórica de la fotografía en México,* in collaboration with Eugenia Meyer in 1977.

Lázaro Blanco appeared to resist an overly facile approach to photography and avoided an overabundance of picturesque elements, instead isolating objects from their environments and emptying his photographs of any colorful or folkloric human types. This manner of "depopulating" his images evolved into a virtuosity that culminated in a style. Blanco photographed environments, atmospheres, the simplest objects: a bucket of water, tires, an abandoned tub, the door of a jail cell, some baskets, or—even more austere and yet more difficult—a metal fence with its geometric shadows on a whitewashed wall. By isolating these banal and available objects, he was able to construct his minimalist "visual poems" (a sort of photographic haiku). Blanco is not the only Mexican photographer to resist the facile picturesque. The same sensibility and poetic rendering of objects, still-lifes, and static landscape detail can be seen, for example, in the delicate palladium prints of Colette Álvarez Urbajtel.

Pál Rojti
Palacio Nacional, 1859

Salted paper print
Fototeca de la Dirección General del Acervo Histórico Diplomático
de la Secretaría de Relaciones Exteriores
Mexico City

5
Oratorio

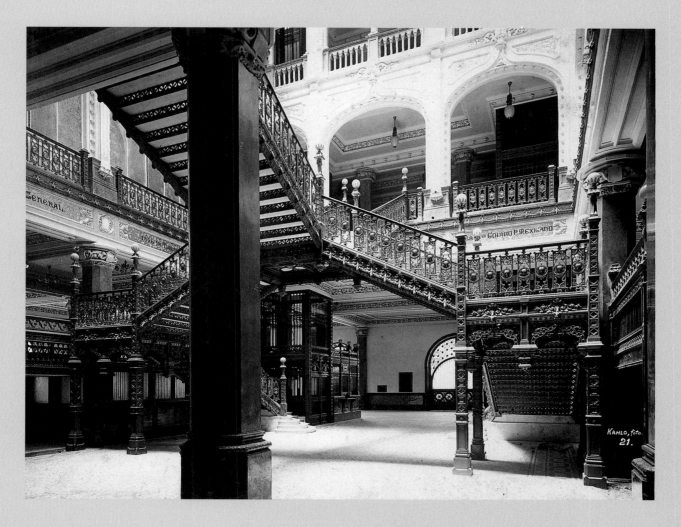

Guillermo Kahlo
Interior del Correo Central, ca. 1910

Gelatin silver print
Reproduction authorized by the Fototeca del INAH-CONACULTA
Pachuca, Hidalgo

Landscape and the Culture of Progress

In 1868, one year after the restoration of the liberal Republic in Mexico and less than thirty years after the arrival of the daguerreotype in America, Ignacio Manuel Altamirano exclaimed:

In Europe and the United States, there is hardly a famous spot that has not been depicted in photography, engraving, and painting. A battle is barely over before thousands of artists arrive on the spot where it took place to make a variety of views that are then multiplied by means of photography until they are known the world over. Thus, historical publications are easy to illustrate, artists having a wealth of information available to them.

But not in Mexico. Only a few famous places are known, those being near the capital or other heavily populated cities; but most are unknown . . . It's easier to find a view of any little village in France than of the most celebrated locales in our history. For example, there isn't a battlefield from Napoleon's time that is not widely known today and depicted with the greatest exactitude, since artists record these scenes on the very spot where the events they are immortalizing occurred . . . Nor is the terrain of these most celebrated battles unknown here, since photographic reproductions of the battlefields at Sadowa and Mentana can be found anywhere. Even more common are views of towns in Abyssinia where English artists recently entered with their army. But look all over Mexico for a view of the battleground at San Jacinto, Coronilla, Miahuatlán, or Querétaro and you won't find it. No one has taken the trouble to visit these sites that recall so many moments of glory for the Mexican people and to content themselves with portraying these in their own manner. The only good image made is one of the Cerro de las Campanas,[1] and that only because the imperial tragedy took place there. But the outskirts of the city, where important things happened and bloody encounters took place, have not attracted the attention of artists. Photographers dedicate themselves exclusively to portraiture and ignore everything else.[2]

In spite of this apparent lack of views in Mexico at that early date, an enormous number of Mexican landscapes were produced in the nineteenth century—and later—by foreign photographers, who typically took their work back to their own countries. An analysis of these images displays a generic dichotomy that, ultimately, reveals a variety of interests, emphases, and concerns. The traveler-photographers—Claude Désiré Charnay, Teobert Maler, Augustus and Alice Le Plongeon, Lord Alfred Percival Maudslay, and Laura Gilpin as late as the 1930s—concentrated on photographing archaeological ruins. Léon Diguet, Frederick Starr, and Carl Lumholtz specialized in a different branch of scientific photography: ethnology. The work of another group of travelers is less known. Without pandering to the "touristic vision" of Mexico or recycling stereotypes, they disseminated other views of the country, yielding in some degree to the interests of their patrons: the Mexican government and foreign investors. Pál Rojti, Benjamin Kilburn, William Henry Jackson, Abel Briquet, Charles B. Waite, and (in some of his work) Guillermo Kahlo presented countless images of modern Mexico that promoted the government of Porfirio Díaz. Photographers of progress, they portrayed landscapes in transition and views of public works (the installation of telegraph lines, the drilling of tunnels, the construction of railways, bridges, drainage canals, and dams) or elaborate and luxurious public buildings. Guillermo Kahlo rendered the Churrigurresque façades of colonial churches, the decorative cast-iron interior of the Central Post Office, and the new Legislative Palace with equal determination and clarity of detail.

Pál Rojti

In 1859, at almost the same time as Désiré Charnay, the Hungarian Pál Rojti arrived in Mexico. He remains little known, despite an exhibition of his work organized in the 1980s by the Consejo Mexicano de Fotografía with the support of the National Museum of Budapest.

Pál Rojti (or Rosti) was born in Pest (now Budapest), Hungary, which had come under the authority of the Hapsburg Empire in 1830. Son of a family of intellectuals, he took part in the unsuccessful revolution for independence in 1848 at the age of eighteen and was forced to emigrate, like many of his compatriots. He went first to Germany and then to France, where he learned photography while completing his studies in geology. Rojti next traveled to America, visiting successively the United States, Cuba, Venezuela, and Mexico. Upon his return to Hungary at the end of 1859, he compiled his photographs in an album which he presented to the Academy of Sciences in Budapest along with a series of articles about the countries he had visited. This earned him admission to the institution as a researcher in 1861. Rojti remained a prominent member of the Hungarian scientific community until his death, in Dunapentale, in 1874.[3]

Rojti's images can be compared with those made by Désiré Charnay during the same years and in the same places. Both photographers were primarily interested in colonial architecture, still well preserved at that time and obviously characteristic of the country. Like Charnay, Rojti photographed key sites in Mexico City, including the beautiful baroque fountain known as the Salto del Agua, the arches of the colonial aqueduct at Belén, the entrance to Alameda Park, and the church of San Fernando. The two photographers chose different vantage points, however. With the unique exception of his view of the plaza and church of Santo Domingo, Charnay always placed himself at street level, where he could obtain good architectural views that emphasized the buildings' masses. Rojti took a more daring and—in a sense—more modern approach. From the rooftops, he sought angles that, while obscuring detail, gave a much better view of the buildings within their context. He photographed the Salto del Agua with a view of the Arches of Belén and the surrounding buildings in this manner, as well as the National Palace from the towers of the Cathedral, which produced an interesting foreshortened effect. This perspective also allowed him to include the Congreso de la Unión, the original site of the Mexican congress (built in one of the patios of the National Palace in the 1830s and razed by fire in 1872).

However, the major difference between these two photographers lies in their choice of subjects. Rojti

Pál Rojti
Factories at San Rafael, 1859

Salted paper print
Fototeca de la Dirección General del Acervo Histórico Diplomático
de la Secretaría de Relaciones Exteriores
Mexico City

seems to have avoided the merely picturesque. In one instance he photographed a house constructed in the then-modern "French style." An even more radical departure is his image of the San Rafael sawmill ("property of the Rothschilds of London" according to the caption on the original print). A photograph of a manufacturing plant was rare for the time and can only be compared to the daguerreotype of a cotton mill in Durango owned by the Germans Stahlknecht and Lehmann, taken by an anonymous photographer during the U.S. invasion of 1847.[4] These are the earliest appearances of the industrial landscape in Mexican photography.

The Mexican images of Pál Rojti also include the Aztec calendar stone, the Cathedral of Cuernavaca seen from what is now the Borda Gardens, a picturesque shot of the San Antón Falls (also in Cuernavaca), and the first known photographic views of the ruins of Xochicalco. Although perhaps fewer in number than the images in Charnay's album, Rojti's Mexican series reveals a more modern point of view and a broader thematic range.[5]

Inventories and Commemorations

In 1858, Andrew J. Halsey advertised an album of twenty-four views entitled *La ciudad de México y sus alrededores* which could be purchased for the sum of twenty-four pesos at his studio at number 8 Puente del Espíritu Santo.[6] In 1861, Joaquín Díaz González published *México tal como es,* a series of lithographs based on his own daguerreotypes.[7] Unfortunately, no daguerreotypes by either Halsey or Díaz González are known to have survived.

A large series of unattributed albumen paper prints dating from approximately 1875–1880, found in a private collection by Guillermo Tovar, shows commercial storefronts along the streets of downtown Mexico City. In fine condition and incredibly sharp, they reveal in great detail the buildings and their architectural ornamentation, street signs, window dressings, and interiors of several stores, cafes, and restaurants—a gold mine for the historian of everyday life.[8]

With the notable exception of Pál Rojti, traveling photographers in Mexico before 1880 all had other professions. They were diplomats, naturalists, archaeologists, or ethnologists. The few who left written accounts or travel diaries admitted using photography solely as a useful tool for recording data. Not until the end of the nineteenth century—with the arrival of Briquet, Waite, Sumner Matteson, and Brehme—would there be photographic professionals in Mexico versed in sophisticated techniques and using technologically advanced equipment. Some of these would also become small-scale manufacturers and distributors of photographic supplies.

The use of photography to document transformations in the country's infrastructure was institutionalized in 1876. In that year, the Ministry of Development, headed by Vicente Riva Palacios, adopted photography as the ideal means for illustrating its annual reports and built a photographic studio that began operations in 1877 under the direction of Ignacio Molina. The ministry justified establishing such a studio by noting that "the excessive cost of lithography and the scarcity, if not total lack, of engravers make it impossible to produce illustrated publications in Mexico."[9]

Molina also recognized the commercial photographers' predilection for portraiture and recommended the establishment of photographic studios in the principal cities of the country since:

> The importance of photography today, obviously, does not lie in its role as a novelty of the moderately educated classes and even less in its vulgar application to the reproduction of their appearance but, rather, in the rapidity of its technical development and, even more so, in the expansion of its applications within various branches of science and industry.[10]

The photographic illustrations that Ignacio Molina included in the ministry's *Annual Report* of 1876 are quite surprising: the asphalt mixers and steamrollers look strangely familiar. Our image of the past is distorted by the fact that such objects were not usually photographed. The construction of the tunnel at Tajo de Tequisquiac (part of a continuing project to drain the Valley of Mexico) was a monumental undertaking during the early years of the Díaz regime.

During the 1880s, with the establishment of railways and the growth of an incipient industrial sector, the government of Porfirio Díaz needed to attract capital. As an instrument of the demagogic politics promoting the so-called Pax Porfiriana, an era of supposed stability and progress, photography was used to interest, seduce, and attract the "tourist" as a potential immigrant and, more importantly, as an investor. Many series of Mexican photographic views were made for this purpose, some in large format, printed by the hundreds and distributed in craft and souvenir shops, post offices, and bookstores in Mexico and abroad. Several photographers worked exclusively in this rapidly growing field.

William Henry Jackson

In his autobiography (not published until 1986), William Henry Jackson dedicated only one paragraph to his two trips to Mexico in 1883 and 1884, which seems to indicate that he gave this commission little importance.[11] Jackson had been hired by the Mexican Central Railway Company to accompany the train on its inaugural trip between Ciudad Juárez and Mexico City

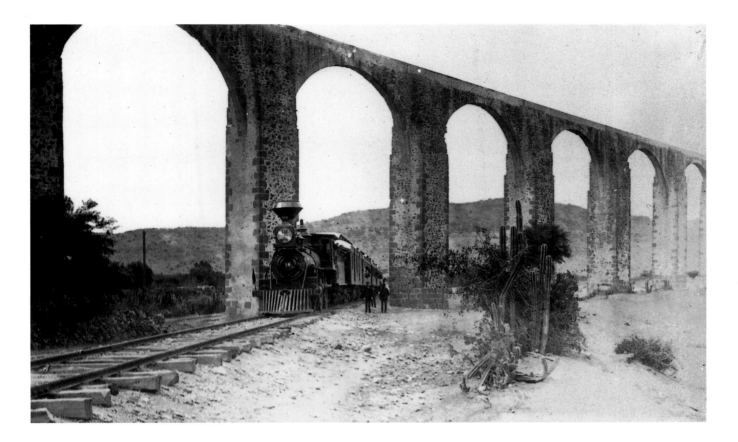

William Henry Jackson

Train under Aqueduct, Mexican Central Railway, ca. 1883–1884

Albumen print
Center for Southwest Research, General Library
University of New Mexico No. 986-037-0017

and to make a collection of publicity photographs. These were to be displayed in the platform areas, railway cars, and stations, where they might attract the attention of foreign travelers. In El Paso–Ciudad Juárez, the Mexican Central connected with the Santa Fe Railroad, which followed, approximately, the route of the old Santa Fe Trail taken by the first Anglo-Saxon settlers to the New Mexico Territory. The Mexican Central then continued south through the deserts of Chihuahua to Torreón and Aguascalientes and on to Mexico City by way of Querétaro. Several branch lines came together in the capital: one from Guadalajara and the West, another from Tampico and the Gulf Coast. In 1884, a new southern line, the Ferrocarril Transístmico, was inaugurated to link Oaxaca, Tehuantepec, and Salina Cruz.

The Mexican Central (which enjoyed considerable capital and technological support from the United States) contracted Jackson, possibly since he had al-

ready made a widely publicized series of photographs of the U.S. Southwest. As early as 1869, he had photographed the completed Union Pacific Railroad route across the Rocky Mountains. His later images of Coulter's Hell (now Yellowstone National Park), the Grand Canyon of the Colorado River, and Mesa Verde had attracted favorable public attention after being seen on the east coast of the United States. From then on, Jackson was considered one of the great photographers of the American West and a potent creator of mythologies.

Yet something in this photographer's way of looking changed when he crossed the border. He made more than five hundred photographs on his two trips, and his original negatives have been preserved in the Prints and Photographs Division of the Library of Congress. Following his employers' instructions, Jackson took primarily landscape views along the railway, as seen from the locomotives or railcars. As he had done earlier in Colorado, he chose the most spectacular stretches—

William Henry Jackson

Mexican Children, Cactus, ca. 1883–1884

Albumen print
Center for Southwest Research, General Library
University of New Mexico
No. 996-013-0001

such as the Temasopa River Canyon in San Luis Potosí—where he photographed a locomotive emerging from a tunnel constructed on an artificial embankment along the steep gorge. Thematically and compositionally, this image recalls the famous contemporaneous painting by José María Velasco, *La barranca de Metlac* (1889), that depicts the railway bridge that had conquered a spectacular natural obstacle on the route between Veracruz and Mexico City. Jackson also selected more picturesque views. A tropical landscape on the coast near Tampico, a banana plantation in the Isthmus of Tehuantepec, the aqueducts in Querétaro, and the pyramid at Cholula were among the Mexican scenes that could be observed from aboard the company's steam-powered trains.

Like drama, landscape depictions are governed by the triple unity of action, time, and place. These considerations led Jackson to emphasize contrasts in his work. He sought these effects when he juxtaposed unspoiled nature, exotic landscapes, or elements of colonial architecture with those modern networks of transportation and communication whose black, metallic, almost baroque forms began to invade the countryside. This is particularly notable in the image of a locomotive in the hills outside Querétaro: the horizontal lines of the train parallel the rooftops of the city, and the heavy shapes of the engine's smokestacks form an odd relationship with the cupolas of the colonial churches.

Jackson's railroad images are, without doubt, the most interesting of his Mexican work. Nevertheless, he did make photographs of other subjects during his trips in 1883 and 1884. The Fototeca del INAH in Pachuca has three hundred original albumen prints of various Mexican subjects, acquired in the 1920s and 1930s by the collector Felipe Teixidor. These follow the itinerary of Jackson's travels and allow us to observe the evolution of his work.

One notable series of images shows the extreme poverty in which the inhabitants of the village of El Abra lived (and perhaps still live). Located along the rail line that traversed the Sierra Norte Divide in the state of Puebla between Tulancingo, Hidalgo, and Huauchinango, El Abra's adobe houses are hardly differentiated from the earth itself. Children and old people dressed in rags appear frightened by the photographer. In these photographs, Jackson reproduced the stereo-typed vision of Mexican poverty propagated by many other travelers. In Chihuahua, Aguascalientes, and Tehuantepec, he photographed women washing clothes along the banks of rivers or ditches. *Mexican Laundry* is the "humorous" caption beneath one of these photographs. In Aguascalientes, he portrayed water carriers at a fountain. In Iztacalco, he photographed the palm huts and the Sunday afternoon visitors from Mexico City to the shady banks of the Viga Canal, as well as the ubiquitous *pulquerías* and their customers, street beggars, and—in his travels through Cuautla, Cuernavaca, and Tehuantepec—Mexican burros.

Two of these images merit special mention: an exceptionally fine view of the volcano of Popocatépetl taken from Tlamacas with a "mammoth" format camera that produced glass-plate negatives 20 × 30 cm in size and another of the arched portals of the market at Aguascalientes with its vendors of sombreros and baskets and one of the colorfully dressed Mexican cowboys known as *chinacos* in the foreground. A copy of the latter, delicately hand-colored, is located in collections of the Library of Congress in Washington.[12]

Abel Briquet and Charles B. Waite

The Frenchman Abel Briquet arrived in Mexico for the first time in 1883. Sent to Mexico on commission like William Henry Jackson, Briquet was contracted by a French shipping firm, the Compagnie Maritime Transatlantique, to photograph Mexican ports. Two years later, Briquet (who had taught photography at St. Cyr, the French military academy, and who had been a studio photographer in Paris) opened a studio of his own in Mexico City. It is not known if Briquet made portraits in Mexico. However, a great number of fine cityscape and landscape views and a series of commemorative albums commissioned by the Díaz government have survived.

Briquet could be considered the first "commercial" photographer in Mexico, in the modern sense of the word. His series of 8 × 10 inch photographs—made between 1890 and 1910 and carefully numbered and dated—encompass a variety of themes, including landscape, flora and fauna, "typical" scenes, buildings and monuments from Precolumbian, colonial, and mod-

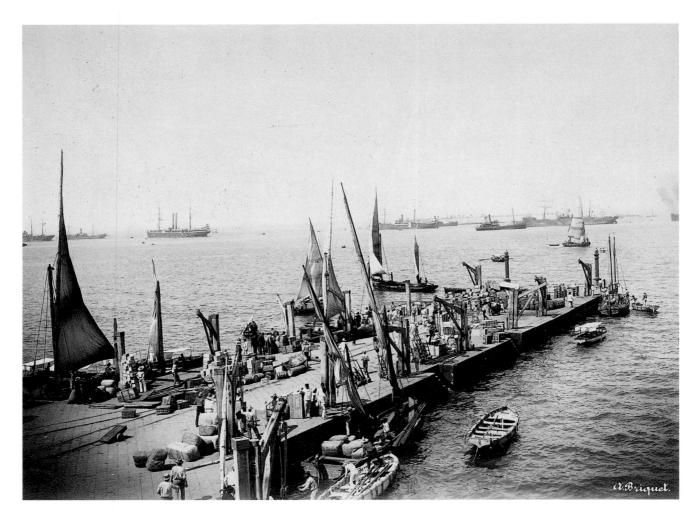

Abel Briquet

Harbor, Veracruz, ca. 1890

Albumen print
Center for Southwest Research, General Library
University of New Mexico No. 998-010-0014

ern times, inaugurations, etc.[13] Some of these images were sold through the Mexico City handicrafts and souvenir shop of D. S. Spaulding, a North American.

Unlike earlier foreign photographers who worked in Mexico making views of "typical" Mexican scenes, Briquet also made many images of factories and other modern structures that introduced technological advancements to the country. Among these is a view of the inauguration of telephone service in Chalco that was included in the album *Rumbo de México* (1890), dedicated to modernization projects in the State of Mexico. On the nearby hillsides of Tlalmanalco, the Porfirian aristocracy proudly enjoy a picnic near the site of the newly installed telephone posts. For this same

album, Briquet also photographed the construction of the railway through the state. For no apparent documentary reason, he obliged the railroad workers to stand between the rails, taking up poses that are affected and conventionalized to a point bordering on comedy.

Briquet's images of modern hotels, of the enlargement of the port at Veracruz, of the new streetcar station at the Zócalo, of the Metlac railroad viaduct and the bridges at Atoyac and Infiernillo, of the factories of Río Blanco near Orizaba and Hercules near Querétaro, and of the improvement of the Paseo de la Reforma show aspects of Mexico unlike the more traditional and commonplace views made by other photographers for the tourist market: the Pedregal de San Ángel (where

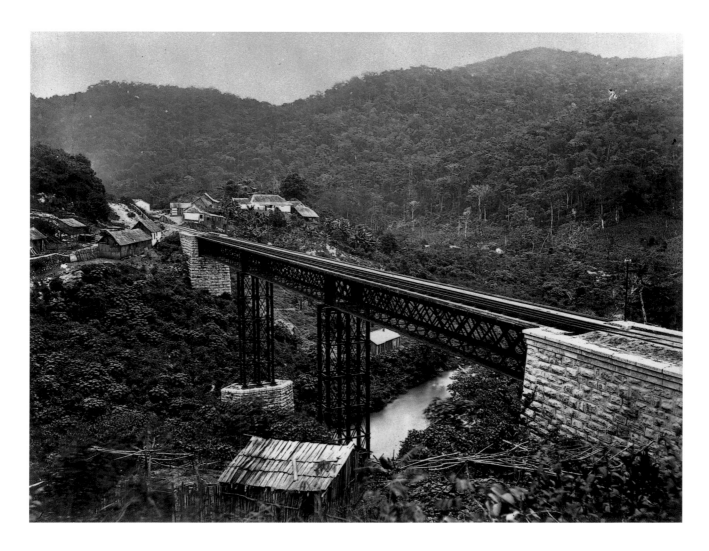

Abel Briquet
Railroad Bridge, Mexican Central Railway, ca. 1908–1910

Albumen print
Center for Southwest Research, General Library
University of New Mexico No. 986-037-0081

elegant ladies went strolling), the rustic mud huts of Tierra Caliente, or the heights of Maltrata or Popocatépetl from Sacaromonte.

In 1909, on the eve of the Revolution, Briquet made one of his most interesting albums, in which he presented a facet of the country little shown before. *México moderno* contained photographs of the most luxurious private residences, built of brick and stone in the "French style," of the new Colonia Juárez section of Mexico City. The album was a clear indication of the impression of Mexico that the Díaz government wished to disseminate. These images of broad, palm-shaded streets linked by traffic circles adorned with bronze statues, gardens, and plazas with fountains are not, perhaps, that surprising. Nevertheless, this album was the first complete *reportage* of the westward growth of the

city and the first photographic series that deliberately departed from the clichés of Mexican photography

Charles B. Waite was a Californian photographer who worked for a time in El Paso before going to Mexico in 1896. He opened a studio in Mexico City, where he remained until approximately 1913. Unquestionably, Waite was the most prolific commercial photographer of his time in Mexico.[14] Although varying in quality, his incredibly large photographic production covers the same subjects as Briquet without the latter's emphasis on modernization. In contrast, Waite's work addressed the more traditional themes: views of flora and fauna, monumental landscapes, panoramic cityscapes and locales of tourist interest, actresses posing in regional costumes—in short, everything that was considered to be distinctively and characteristically Mexican.

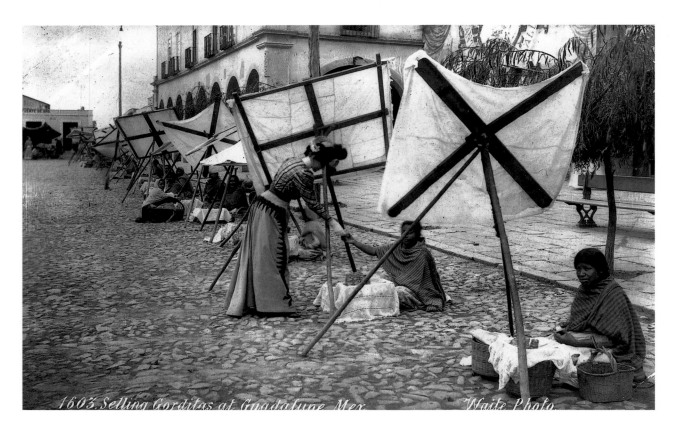

Charles B. Waite
Selling Gorditas at Guadalupe, Mex., ca. 1900

Gelatin silver print
Center for Southwest Research, General Library
University of New Mexico No. 996-003-0020

Photographer David Maawad found, at the Fototeca del INAH, a glass-plate negative by Waite showing a peasant wedding, apparently in the mountains of Oaxaca. The men, with obvious Indian features, wear the suits of middle-class "citizens," perhaps rented for the occasion. In contrast, the women are dressed in traditional full skirts and embroidered blouses and partially hide their faces within the folds of their shawls. This image eloquently reveals the desires and aspirations of a Mexico in transformation.

One of Waite's best-known series was made just after the turn of the century for the U.S.-owned Chiapas Rubber Company, whose plantations were located near the ruins of Palenque. In a style that recalls the photographs Eadward Muybridge made on Guatemalan coffee plantations in 1875 and 1876, Waite depicted the arduous labor of the rubber-collectors in the dense tropical forest while drawing attention to the modern machines employed to transform the raw material into a highly valued commodity. One image in this series is particularly noteworthy: payday in the company offices. A blond administrator is seated behind a heavy desk totally covered with towering piles of coins while the workers, forming a line between the door and window, look on enviously.

The Vogue for Stereographs

Stereograph views, which satisfied vast commercial and entertainment markets, have not, perhaps, received the attention that they deserve, given the fact that they were

No. 1073. A Missionary's Home, City of Mexico.

Kilburn Brothers

A Missionary's Home, City of Mexico, 1873

Albumen prints, stereograph
Center for Southwest Research, General Library
University of New Mexico No. 996-034-0010

the most common format for cityscapes and landscapes prior to the massive production of postcards at the turn of the century. According to Mario de la Garza, the sensation of depth that distinguishes stereographs

> derives from the obvious fact that the eyes are separated by a distance of some 6.5 centimeters, with the result that each eye perceives the world in a slightly different manner. The brain, that almost incomprehensible mass of binary connections and electrochemical acids, utilizes this difference to create an impression of distance. If we place the lenses of a camera the same 6.5 centimeters apart . . . it becomes possible to view a scene in exactly the same manner that the eyes perceive it. The photographs, mounted beside each other on a cardstock support and observed through a stereoscope, are sent separately to the brain, which then fuses them [into a single image], creating the impression of three-dimensionality.[15]

The "fusion" of slightly out-of-register images had been employed before the invention of photography, but only as a kind of carnival curiosity, like the magic lantern. Daguerreotypists, however, soon added it to their practice. Francisco Reyes Palma found an early daguerrean stereograph in a stall at La Lagunilla, the flea market in Mexico City, although nothing indicates that it was made in Mexico. The features of the persons portrayed suggest, rather, that they might be English or North American. First used for "galant" daguerreotypes (no doubt for its ability to suggest depth and realistic volume that added to the eroticism of the images), the stereograph enjoyed an unprecedented popularity after 1864, when it was used for views of monuments, landscapes, and famous sites. Some European firms exclusively manufactured stereoscope viewers and stereograph images mounted on either cardstock or glass, in which case they were viewed as transparencies.

Some of the earliest examples of this new industry in Mexico date from the French Intervention. Guillermo Tovar owns several perspective views of the Zócalo taken during the celebrations staged for the arrival of Maximilian and Carlota in Mexico. The French publisher Julio Michaud was possibly the first to issue a stereograph series of Mexican landscapes and monuments. These were probably produced for sale to specialized foreign distributors. Apparently, some of these

were made in the early 1860s by Désiré Charnay, in addition to his larger-format views of the capital.

Between 1870 and 1880, a number of Mexican studios opened stereographic divisions, including those of Lorenzo Becerril in Puebla and Cruces and Campa in Mexico City. Vicente Contreras in Guanajuato and his German-born associate Hafs in Jalisco appear to have worked exclusively with stereographic images of the Bajío region. It seems that each photographic firm specialized in a different area. Here, as in other cases, the authorship of the images is difficult to establish. The same photographs—typically portraits of famous political or artistic figures—sometimes appear bearing the stamps of different studios.

"The stereograph brought photographic production on a grand scale to Mexico, similar to what had occurred earlier with the cartes-de-visite."[16] Production further intensified after 1880, and new firms appeared that were dedicated solely to this type of "entertainment." In large part, these were U.S. enterprises, and they can be considered immediate precursors of the photo agencies that proliferated in the first decades of the twentieth century, especially during the Revolution. Underwood and Underwood, Keystone Views, Kilburn Brothers, and Continental Stereoscopic Company were among the most important of these agencies that began to send photographers to Mexico and other Latin American countries to make view series. A number of William Henry Jackson's Mexican views were also published as stereographs, some by the Detroit Publishing Company. Subjects included panoramic cityscapes, colonial buildings, picturesque locales, and an occasional demonstration of the country's efforts to modernize, such as the iron bridge over the Barranca de Metlac. Benjamin Kilburn went to Mexico in 1873 and made some two hundred stereographs in the northern and central states.[17] In addition to his many landscapes and views of the city of Puebla there are some unusual images of wax figurines depicting "Mexican Types."

The production of stereographs continued until around 1940, paralleling that of postcards (indeed, they were often published by the same companies, which eventually discontinued their stereograph lines). While most of the photographers employed by these firms have remained anonymous, a few (in addition to Jackson and Kilburn) have attained a certain level of recognition. One of these is the Italian Philip Brigandi, who

worked for the U.S. firm Keystone Views between 1920 and 1940. He made several trips to Mexico, taking stereographs that are among the most interesting of this genre. Brigandi not only emphasized landscapes and monuments, but also provided his agency with some more interesting images of a sociological nature. Among these is a stereograph image of prisoners in the jail at Culiacán.

Photographic archives contain enormous numbers of stereographs.[18] In general, this mass production does not merit detailed analysis and is only mentioned in passing in most histories of photography. Apart from the characteristic sensation of three-dimensionality that is striking in certain cases (especially in architectural images), these photographs can be tediously banal, and their stock subjects are notable more for their repetition than for their originality. Moreover, the same images are frequently seen both as stereographs and as single images, enlarged to approximately cabinet card format (6½" × 4½").

6 *Requiem*

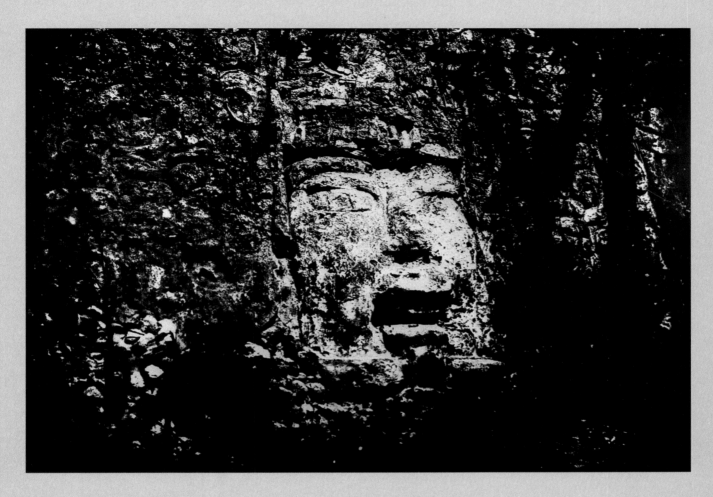

Claude Désiré Charnay
Izamal, 1860

Albumen print
Cités et ruines américaines (1862)

The Lost Cities

Only months after the announcement of its development, daguerreotypy was employed in the reproduction of ancient and little-known monuments that were isolated and on the brink of disappearing altogether. Inspired by his friend the U.S. diplomat John Lloyd Stephens, Baron Emmanuel von Friedristhal, head of the Austrian diplomatic corps in Mexico and an amateur archaeologist, used a daguerreotype camera on his expedition to the Yucatán in 1841.[1] Shortly thereafter, on his second journey to the Yucatán peninsula, Stephens himself—along with a company of adventurers that included the English draftsman Frederick Catherwood—attempted to make daguerreotype images of the Maya architecture of the Puuc region: Uxmal, Kabah, and Labná. It was Catherwood, however, who generally operated the camera.

In 1841, Stephens and Catherwood discovered the traces of red hand prints on the stones of the ancient temples at Uxmal. These images of a small hand, like that of a child, reappeared here and there in isolated locations on cave walls and monuments covered over with vegetation. The prints were not found on the exterior decorations of the buildings, but rather were located in remote places: on the sides of hidden basements, on stones that had been disengaged from their original locations by the effects of weathering or even by the "discoverers" themselves as they opened passages through the labyrinth of ruined chambers. "Often as I saw this print, it never failed to interest me. It was the stamp of the living hand; it always brought me nearer to the builders of these cities, and at times, amid stillness, desolation, and ruin, it seemed as if from behind the curtain that concealed them from view was extended the hand of greeting. There is something vital about it," wrote Stephens, "that excites the imagination, as if the ancient inhabitants were walking among the buildings."[2] Désiré Charnay also photographed one of these hand prints. It appears quite clearly, on the side of a doorway in the House of the Turtles at Uxmal, in a print reproduced in his album *Cités et ruines américaines* (1862).

Catherwood and Stephens and, somewhat later, Désiré Charnay inaugurated a specific genre of Mexican photography whose origins can be found in late-eighteenth-century Romanticism. The ruins of America inspired these poetic souls, who (in the words of Charles Baudelaire) found moral value in "old things." This was especially true of the Maya area, where cities were hidden in the dense jungle, covered over and nearly devoured by undergrowth: great difficulties had to be endured in order to reach them.

Despite their "scientific" intentions, these early explorers photographed like "artists," less interested in precise description than in awe-inspiring effect. In this sense, their work is ambiguous. For while they initiated the practice of archaeological photography, in the final analysis their impact was greater as creators of a particular vision of Mexico.

The publication of Stephens's book in 1843, shortly after his return to the United States, inspired a number of other careers, particularly that of Claude Désiré Charnay, a young Frenchman from a well-established family.

Désiré Charnay and the American Cities

Désiré Charnay, "sent by the [French] government on an artistic mission,"[3] was perhaps the most talented of a series of amateur traveler-photographers who journeyed through Mexico between 1860 and 1900.

Fascinated by his adolescent readings of Stephens's *Incidents of Travel in Yucatan* (1843), Charnay was twenty-nine years old when he asked to be sent on a mission by the French Ministry of Public Education. His idea was to make a scientific and photographic tour of the world, following the model established by François Lerebours, publisher of the very successful *Excursions daguerriennes*.

Charnay's arrival in the "New World" began in North America. He traveled first to the United States and from

there to Mexico, arriving with his companions Armand Phalipan and Eugène Camus in late November 1857, at the outbreak of the Three Years' War.[4]

In late 1858 or early 1859, Désiré Charnay finally began his delayed archaeological explorations. From Mexico City, where he had lived for several months, he apparently headed toward Yucatán, although the chronology outlined in his accounts is rather confusing.[5]

Charnay related his adventures in the states of Oaxaca, Chiapas, Yucatán, and Campeche in *Le Mexique*, published in 1862, at the same time that the government of Napoleon III was involved in a military intervention in Mexico. This mix of travelog with ethnological reflections, description of customs, and personal anecdotes owes much to Stephens's work. It also conforms to a particular nineteenth-century literary genre exploited by many travelers to the Americas (including Claude Brasseur de Bourbourg) as well as many twentieth-century North American tourists. To Charnay's credit, he was able to bring together his images and text in a way that allows us to understand his intentions and motivations.

Contemporaneously with this publication, Charnay published an album of forty-nine photographs of Precolumbian monuments, accompanied by an odd text by Eugène Viollet-le-Duc, official architect of the Second Empire in France and promoter of the nineteenth-century neo-Gothic style. In his extravagant prologue, Viollet-le-Duc proposed a number of cross-cultural comparisons that marked the beginning of an incipient American archaeology.

The Mapoteca Orozco y Berra in Mexico City preserves a large-format copy of this album that was probably given to the Mexican historian Manuel Orozco y Berra shortly after its publication. Most of the images are of Mitla (in the state of Oaxaca) and Uxmal and Chichén Itzá (in Yucatán). Only two are of Palenque.

The photograph of the House of the Priest at Mitla (residence of the local parish priest who occupied one of the ancient palaces) is particularly noteworthy for the way in which Charnay framed his composition and for the very modern play of light and shadow. Other photographs of Mitla draw attention to the austerity of the surrounding countryside and the heavy, brooding forms erected on the hilltops.

In his book, Charnay relates how, after being stuck in Oaxaca for months while awaiting the arrival of three

Frederick Catherwood
The Palace of the Governors at Uxmal, 1844

Lithograph based on a daguerreotype
Reproduced in *Incidents of Travel in Yucatan* (1844)

hundred kilos of equipment, lost somewhere between Mexico City and Tehuacán, he was forced to photograph in five days what should have taken fifteen. Then a faulty solution of protective varnishing totally ruined his glass-plate negatives.[6]

At Palenque, Charnay had even greater difficulties:

My expedition to Palenque was a deplorable failure. I should have had ten times more supplies when [in fact] I had even less than before; I lacked glass-plates and collodion and had only iodized paper whose exposure is enormously slow and success always un-

certain and whose development requires distilled water that I did not have and careful handling that was impossible in the wilderness. While I had anticipated that difficulties awaited me, these increased daily . . .

I set up my darkroom in an underground chamber; there I prepared my papers in the morning hours. But the water from the canal—which seemed so pure and clear—created thousands of stains in my washes that I was unable to prevent. I photographed during the day and (yet another difficulty!) it was so humid in those forests that my camera, badly worn from two years of travel, collapsed to the point that it broke apart at the joints, so that it became impossible to move the standard. Later, around midday, the heat was so intense that the wood contracted forcefully, exposing everything to daylight. So I had to wrap the instrument from one end to the other in fabric and clothing torn into rags for this purpose . . .

At nightfall, exhausted by these perpetual tasks, I had to start developing the negatives, an operation that lasted until midnight or one o'clock in the morning.[7]

Nevertheless, two of Charnay's surviving images of Palenque—details of carved monuments—are among the most expressive examples of his approach to photography. While the matte surface and exposed fibers of the salted paper prints that he used on this occasion reduce the sharpness of his images, they also impart an ambiguous air of mystery.

The series of forty-nine plates in *Cités et ruines américaines,* grouped by site and itinerary, allow us to see how—from Mitla to the Yucatán—Charnay's perception began to change from archaeology (the site) to architecture (the monument), mastering the play of monumentality with detail, finally achieving by the end of his trip the plasticity and great evocative power seen in his views of Chichén Itzá and Uxmal. An American ruin, Charnay seems to tell us, is a confusion, a mix of architecture and vegetation, the stone ruin emerging from vegetal chaos. For the first time, unlike archaeological views that photographers brought back from Egypt, Italy, or Greece, the monument belongs to an untamed universe, a time without history—from the European perspective—that of the tropical jungle which appears as the archetype of primitive nature. In photography, a new category of the monumental was born: the archaic, rather than the antique.[8]

The publication of *Cités et ruines américaines* was probably the French public's earliest introduction to Mexican archaeology. The book enjoyed an immediate success, motivated in that year of 1862 by the "great dream" of Napoleon III, who had embarked upon his own conquest of America.

The French press echoed this new interest, publishing a series of articles on the subject. Cited below is the central argument of a controversy raised by Count Frédérick de Waldeck, who, in 1834, had been one of the first to excavate Palenque. In 1862, at the ripe old age of ninety-five (he would live on another eighteen years), Waldeck impugned photography as a faithful medium of representation. He first attacked the author of the prologue to Charnay's book, Viollet-le-Duc (who had suddenly become a fervent admirer of Mexican antiquities), refuting out-of-hand his precipitous assertions concerning the origin and antiquity of the Maya. Then Waldeck turned his criticism to the author of the photographs:

We have arrived at the principal object of his little book, these photographic plates that M. Charnay proposes to present to the public. First I will allow myself some reflections on photography in general, particularly its application to archaeology.

The speed with which one obtains the photographic proofs and their perfect verisimilitude are two excellent qualities. (I dismiss the reproach that . . . they do not long endure. Recent discoveries seem to disprove this accusation.) What will always render photography immensely inferior to graphic arts is the former's inability to reproduce colors, exterior details that remain in shadow, dark interiors . . . that it requires . . . conditions of distance and placement that are often very difficult to satisfy and—above all—that one cannot render either the plan or perspective of a monument, things of great importance for archaeological studies. As regards the execution itself, the draftsman has a great advantage over the photographer in that he may lin-

ger over small details with care and—thanks to the comparison that such reflection on detail engenders—often discover or observe things that would otherwise escape less sustained attention.

Having said that, I recognize the part that photographic science can play in enterprises such as that of M. Charnay . . . Yet I am obliged to say that what this instrument can achieve in skillful hands seems to have been accidental: all the images appear to have been taken in passing, at first glance, and if some are successes it seems to have been by chance since he did not concern himself in the least with the way in which the sun shaded his models.[9]

Charnay returned to Mexico three times. Thanks to his literary-scientific successes, he had the resources to publish, in addition to his books on archaeology, a novel of Mexican customs and a biological study entitled *El papel de los infinitamente pequeños* (1911).

Charnay's work reveals a mentality changed with the passage of time and a perception marked more by scientific Positivism than by Romanticism. Moreover, technology had advanced considerably by the time of his later trips of 1881–1882 and 1886. Although cameras continued to be heavy, fragile, and difficult to move, their operation was now simpler and faster, and the results more certain. Nevertheless, technical and environmental considerations continued to limit the number of images that Charnay printed on site.

The Mexico that Charnay visited on his second trip had also changed, and the conditions under which he traveled were quite different from those encountered on his earlier journey. By that time, many curiosity-seekers had visited the ruins. Charnay's 1859 itinerary was becoming a route traveled not only by scholars, but by a large number of tourists.[10]

Mexican archaeology had become increasingly invested with ideological intentions. This was clearly reflected in contemporary legislation and research. For example, archaeologists and photographers now had to be accompanied by an official representative of the government, and the (frequent) looting of ancient objects was passionately denounced in the press.

Science assimilates these reconstructions of the past. The photographs are no longer seen as unique images. Instead, they have become transformed into genres, series documenting a variety of things—some quite un-

intended by the photographers, such as the surrounding environment, the fauna, the inhabitants, etc. During his second trip, Charnay made—in addition to images of the monuments—ethnographic portraits of Indians (front and profile views), scenes of villages, panoramas of certain cities (Mérida, Valladolid, Campeche), and picturesque views that demonstrate his broader interests but, above all, a much less poetic point of view.

At the Musée de l'Homme in Paris, Désiré Charnay's plaster casts of the Maya sculptures are still on exhibit beside the main staircase. With the passage of time, they have acquired a patina that makes them appear authentic.

Alice Dixon and Mr. Le Plongeon

Between Charnay's trips, two archaeologists from the United States arrived in Yucatán, Augustus Le Plongeon and "his young and intelligent wife, Alice Dixon," as Vicente Riva Palacios described her in his *Memorias de la Secretaría de Fomento*. In that book, he also related the discovery at Chichén Itzá in 1875 of the famous Chacmool sculpture now housed at the Museo Nacional de Antropología in Mexico City.

Count Auguste de Coquerville, commonly known as Augustus Le Plongeon, was the North American descendant of a French family. Educated in France, he devoted himself after 1861 to the study of "comparative iconology."[11] His attempt to take the Chacmool to the Philadelphia Centennial Exposition in 1876 sparked one of the first and most widely known controversies regarding the plunder of Precolumbian objects. This practice had been condemned as early as the second decade of the nineteenth century by the liberal Mexican journalist Carlos María de Bustamante, whose warning had gone unheeded.

In 1881 and 1886, respectively, Le Plongeon published two books in New York in which he proposed to prove—following Viollet-le-Duc—the Asiatic then Assyrian and Egyptian origins of the Maya civilization, as well as their relation with Masonic rituals "that pre-date the construction of the Temple of Solomon."[12]

The archaeological work of Le Plongeon is now completely discounted and forgotten, unlike the numerous stereographic photographs that he and Alice Dixon

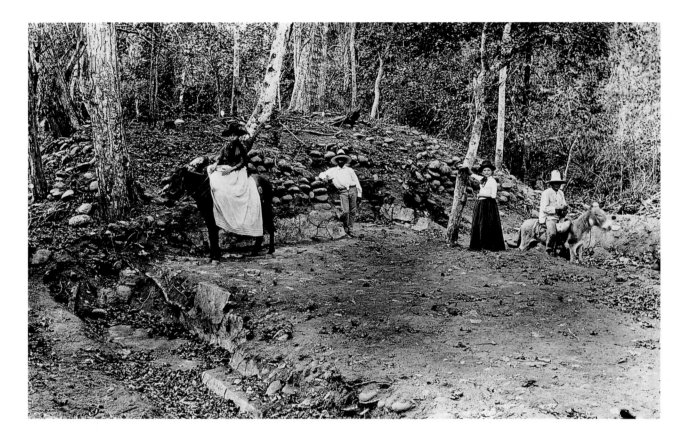

Teobert Maler
Ruins of Cempoala, 1891

Modern copy from collodion negative
Reproduction authorized by the Fototeca del INAH-CONACULTA
Pachuca, Hidalgo

made—mostly of Chichén Itzá—during their two trips there in 1873 and 1876. Although very inferior in quality compared to Charnay's, their works are considered (especially in the United States) prototypical of the photography of American antiquities.[13] Despite their lack of general interest, it is worthwhile to note those that show the scaffolding raised by the incipient archaeologists in order to make frontal views of the structures and thus avoid the distortions of extreme foreshortening.

La Commission Scientifique du Mexique

Established by order of Napoleon III and directed by the French minister of education Victor Duruy, the Commission Scientifique du Mexique brought together in Paris the most prominent scientists of the day and first Americanists, including Eugène Boban, Joseph Alexis Aubin, Désiré Charnay, and Claude Brasseur de

Bourbourg. Located within the ministry itself, the commission held weekly sessions between 1862 and 1867. As might be expected, France hoped to send colonists to Mexico during the Intervention, and to facilitate this the commission issued reports on health issues in the country, such as information on tropical diseases and their eventual cures. If the reports of these discussions reveal the specific interests of the invading government, the minutes are even more explicit about the curiosity of the scientists, who debated with equal interest subjects as diverse as the possibility of producing *pulque* in the south of France, cases of *mal de pinto* (a type of pigmentation disorder), and the utility of having the now famous Codex Vidobonensis, a Precolumbian manuscript, reproduced photographically.

Photography served the purposes of the scientists brought together in Paris, who wanted to see with their own eyes the objects, monuments, and landscapes that had been so thoroughly described and discussed. The commission contacted a number of professional pho-

tographers and also received unsolicited images sent by amateur photographers, ranging from common soldiers in the French army to local representatives of the commission, such as Eduardo Hay.

Brasseur de Bourbourg brought a draftsman-photographer named H. Bourgeois on his journey through the Yucatán peninsula in 1864–1866. Unfortunately, Bourgeois soon fell ill and had to return to France at the end of 1865.[14] In 1865, the commission solicited the photographic services of Léon-Eugène Méhédin and sent him on a special mission to Mexico.

Méhédin, an architect from L'Aigle, was a fervent admirer of Napoleon III and was quickly promoted in his career in the emperor's service. In 1851, he erected two triumphal arches in his native city to celebrate the successful coup d'état of the president-prince. Shortly afterward, in 1855, he won an architectural award with his project for a train station in the Italian city of Civitavecchia. The same year, he was sent on a photographic mission to the Crimea with a Colonel Langlois in order to compile visual documentation for a panorama of the battlefield at Sebastapol. In 1859, he accompanied Napoleon III to Vallegio, where he made the emperor's portrait. He also compiled an archaeological report on Egypt that includes a very odd album of photographic memorabilia, now housed in the Municipal Museum in Rouen.[15]

In 1865, Méhédin photographed objects in the Museo Nacional in Mexico City for the Commission Scientifique du Mexique in Paris. He was sharply criticized for the "artistic" way in which he carried out this commission, for it was considered useless from a scientific point of view. A little later, he "discovered" (in his words) the ruins at Xochicalco in the state of Morelos,

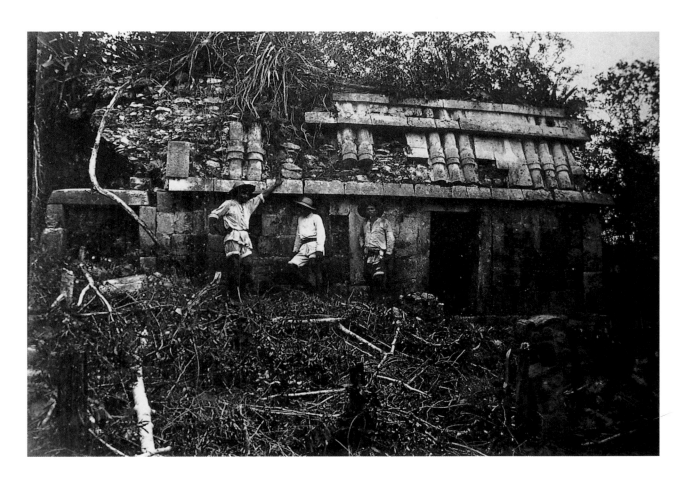

Teobert Maler
Xlabpak de Maler, ca. 1890

Albumen print
Collection, Facultad de Ciencias Antropológicas
Universidad Autónoma de Yucatán

where he made not only photographic views of the monuments, but papier-mâché casts of the principal pyramid. His intention (which he hotly defended in front of the commission after his return to France) was to mount a facsimile of the monument on the grounds of the 1867 International Exposition in Paris. However, the events in Mexico—the withdrawal of the army of Napoleon III and the execution of Maximilian in 1867—dashed these hopes. Some of the casts of Xochicalco, slowly turning to dust, are still housed in his archives at the Rouen Museum. His photographs, including those taken for the Commission Scientifique du Mexique during his tenure there, have never (to date) been found.

Xlabpak: The Old Walls

Teobert Maler was a German, born in 1842 in Rome, where his father worked in the administration of the grand duke of Baden. Maler studied architecture and engineering in Karlsruhe and at the age of twenty-one moved to Vienna, where he worked as an architect and adopted Austrian citizenship.

In 1864, he enrolled as a cadet in the First Company of Pioneer Volunteers, arriving in Mexico aboard the Austrian frigate *Bolivian* at the beginning of 1865. When his original detachment returned to Europe under the orders of Napoleon III, Maler decided to remain in Mexico; he joined the Imperial Mexican forces and participated in the guerrilla activities led by the fierce Leonardo Márquez.

Even after the execution of Maximilian, the young Captain Maler stayed in Mexico. He traveled widely throughout the Republic, from Jalisco (1873) to Guerrero and the Mixteca Baja (1874). Apparently, he took his first photographs—portraits of coastal Indians—in Pinotepa, Oaxaca. Following the itinerary established by Charnay, in 1875 Maler went to Mitla, where he photographed the mosaic façades of the temples. How or when he learned to make photographs is unknown.

In Tututepec, Oaxaca, in 1876, Maler participated in the discovery of a tomb and took what can be considered his first scientific archaeological images. The following year, he headed for Palenque. His first contact with Maya culture would prove decisive. Then, upon notification of his father's death, Maler returned to Europe and took possession of an inheritance that would allow him to finance his future explorations.[16] Seven years would pass before he returned to Mexico.

Maler made many photographs during his first trip to Mexico and used them to illustrate lectures at the Société Géographique in Paris, where he became recognized as an eminent scholar of American antiquities.[17] During his stay in France, he frequented the Bibliothèque Nationale, reading and studying the Precolumbian and early colonial codices preserved there, as well as books about Mexico in general.

As a member of the Mexican expedition, the name of Maler is surrounded by a certain romantic splendor. Besides the accounts of his travels, we are also aware of his success in the field of photography, success that did not come to his great French colleague Désiré Charnay. As a result of these accomplishments, Maler found doors opened to him everywhere. Despite his modest demeanor (testified to by a contemporary), Maler had contacts with the most renowned members of French scholarly circles . . . [He] established relations and friendships with a number of these [scholars] that he would maintain for decades.[18]

In 1881, postponing his dream to return to Mexico, Maler left for the Middle East: Tiflis, Istanbul, Armenia . . . Although he returned briefly to France in 1884, Maler was back in Mexico by the middle of the year. There he established himself in Mérida and then Tikul, some fifty kilometers from the capital of Yucatán. His intention was clear: from now on, he would dedicate himself to the study of the Maya ruins.

To recount the many expeditions of Captain Maler (known by this time as "*don* Teobert Maler") through the Maya region would be too lengthy an undertaking and falls outside the scope of this study. Suffice it to say that he was the first to make systematic inventories of many archaeological sites, most of which were then (and perhaps still remain) hidden in the forests and jungles of the peninsula. He surveyed Piedras Negras and the sites now known as Yaxchilán and Bonampak, on today's border with Guatemala. He sailed up the Usumacinta River to the little-known region of Río Lacanjah in the Petén. There he visited Tikal and a number of sites along Lake Petén-Itzá, the last refuge of the Itzá people. The Peabody Museum of Harvard University financed his explorations through Chiapas in 1898, 1899–1900, and

1904–1905, during which he made photographic inventories of a number of unknown archaeological zones.

Maler ended his association with the Peabody in 1905, as a result of problems related to the publication of his expedition narrative in the Peabody Museum's *Memoirs:* according to Maler, his text had been mutilated and left incomplete by the impatient editors. Lurking behind the disagreement with the Peabody, one can discern his profound antipathy for the U.S. consul in Mérida, Edward J. Thompson, archaeologist and owner of the hacienda of Chichén Itzá.[19]

Don Teoberto died in poverty, forgotten by the world, in a borrowed house in Mérida in 1917. Fortunately, his archives were acquired by the Ibero-American Institute in Berlin, and Dr. Gerdt Kutscher began publishing some of this material in the 1970s. A large number of Maler's photographs can be found in various archives around the world: the original glass-plate negatives at the Ibero-American Institute and the prints in the Peabody Museum in Cambridge are the best known. In Mexico, only the small Maler Collection at the Fototeca del INAH that covers his trip to Veracruz in 1891–1892 and three original albums bearing his handwritten notations at the University of Mérida survive. His images can also be found in the collections of the Bibliothèque Nationale de Paris, the Musée de l'Homme, and the Museum für Völkerkunde in Hamburg. Besides his many photographs, Maler's oeuvre also includes numerous lectures, articles, notes, sketches, drawings, maps, and inventories of decorations, glyphs, and stelae.

Although Maler's images are extraordinarily sharp and insightful, and aim toward scientific objectivity (in contrast to the romantic taste displayed by Catherwood and Waldeck in their earlier depictions of Maya sites), they contain a certain picturesque quality that reveals his personal perception and approach to his subjects. For example, Maler almost always placed one of his Indian guides in the picture. In some cases, there is a certain incidental erotic touch in the way in which they imitate the poses of the sculptures. Maler, writing in a formal third person, described his way of seeing in these terms: "Teobert Maler always endeavors to have his views present a picturesque and poetic aspect, never eliminating adornments to the view, so long as they in no way compromise the architectonic features."[20]

Perhaps the most interesting quality inherent in Maler's photographs is a certain deliberate distance and sobriety. This can be interpreted as a certain reticence toward interpretation on his part and demonstrates an uncommonly respectful attitude. There can be no doubt that Maler took a strong position as one of the most avid and outspoken advocates for the defense of Mexico's national patrimony. In doing so, he denounced many of the archaeologists, as well as the tourists and the numerous looters active in that period. In a log book that had originally been intended for the Peabody's *Memoirs,* but was ultimately published in Mérida in the 1930s, Maler wrote:

In the year 1888, a group of Americans—a so-called commission from Harvard College in Boston—arrived and were introduced by the American Consul in Mérida as "artists" who came to make drawings and watercolors of the beautiful ruins at Labná. Those

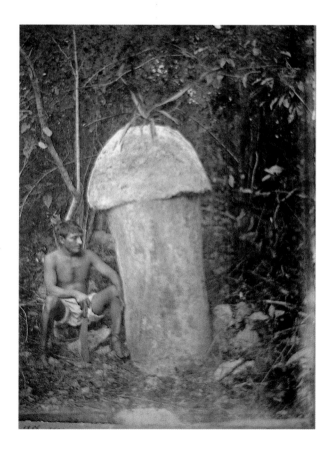

Teobert Maler
Phallic Monolith, ca. 1890

Albumen print
Collection, Facultad de Ciencias Antropológicas
Universidad Autónoma de Yucatán

very ruins we ourselves had discovered. Yet these "artists" sent some forty men, not to Ticul, where they would have been observed, but to remote villages and to Oxkutzcab, where no one would know what they were doing. They worked at the ruins for three months.

What did they do, then, these men? First they attacked the large pyramid that served as the base for the great temple, undermining it in the belief that the buttresses and structural elements placed by the ancient peoples in earlier times to reinforce the foundation of their temple were mere rubble. Nothing of importance resulted from this destruction; they found nothing more than ordinary walls and rooms filled with stones . . . yet the result is that today the superb temple of Labná, weakened at its base, may collapse at any moment.

Not content with this feat, the "artists" then directed themselves toward the great avenue of the temple, digging up an area the size of the plaza in Mérida, always in search of antiquities . . . Having left that part of Labná in such a state that it looked as if the catastrophe that blew up the island of Krakatao [sic] had been repeated there in front of the temple, they left . . . evaporated . . . without, ever once, anyone from the Government intervening to see just what kind of "watercolors" those "artists" had made using forty men with pickaxes and crowbars.[21]

Further on, Maler again raised his voice in warning:

Uneducated visitors amuse themselves in scratching their machetes along every cleared wall and interesting design that they find [in the ancient temples]; while the educated visitors inscribe their precious names everywhere using pens or charcoal, scraping away a little part of the design to make a blank space. Even the lady "professors," as they prefer to be called these days, have felt the itch to immortalize themselves on these walls; such that we have our priceless paintings, covered by the excrement of flying mammals, machete scratches, names of distinguished and undistinguished men, and . . . women.[22]

One of Maler's most frequently reproduced photographs shows him beside the graffiti-covered walls of Chichén Itzá: an archaeology of archaeologists.

In an effort to produce photographs with sharp enough detail to be scientifically useful, Maler sometimes had to move stelae to positions where the lateral rays of the setting sun would fall upon them. After 1890, he was able to resolve this problem through the use of magnesium flash lighting, which meant that he had to work mainly at night. He surrounded each stela or monument with a series of lights carefully placed to illuminate the bas-reliefs. He also reconstructed a number of fragmented stelae in his photographs, shooting the separate pieces from an equal distance with the same lighting and then reconstructing the elements in a technique resembling photomontage. This was an extremely useful exercise, given that—in many instances—he was the first visitor to these sites in modern times. Moreover, through his photographs he was able to record and preserve elements that are no longer extant: many of the monuments he photographed were subsequently looted or damaged by weathering or vandalism.[23] Maler's images of the sculptured stones (as well as those taken by Alfred Percival Maudslay) have served as the principal source of documentation for epigraphers currently engaged in deciphering the glyphs and reconstructing the Maya past.

Teobert Maler even left his name in Yucatán: an archaeological site outside Muna, in the Puuc Region, is called Xlabpak de Maler: Maler's Old Stones. An old Maya roadway in Tikal is also called the *sacbe* Maler, a discreet homage paid by the archaeologists who followed him.

The English botanist Lord Alfred Percival Maudslay organized a number of expeditions to Copán, Quiriguá, Tikal, Palenque, Yaxchilán, and Chichén Itzá between 1882 and 1891. Unlike Charnay and Maler, Maudslay was a true scientist with a solid background in geology, botany, and zoology. In 1882, Charnay and Maudslay competed in a kind of mad race through the jungles (reminiscent of a novel by Jules Verne) to be the first to "discover" the city now known as Yaxchilán, on the banks of the Usumacinta River. Maudslay won the wager by two days. In spite of this, the Frenchman and the Englishman worked together during their stay at the site.

Maudslay not only took a great number of photographs during his expeditions, images that are among the sharpest and most beautiful of the period, but also realized how difficult it was for the Western eye to ap-

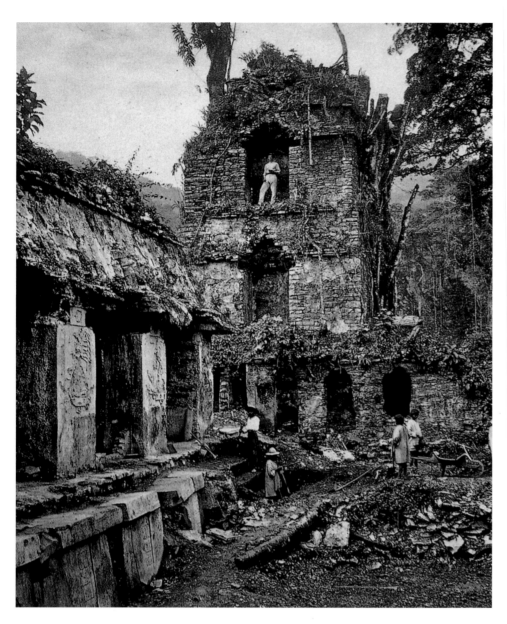

Alfred Percival Maudslay
*Western Patio and Tower of
the Palace at Palenque,* 1899

Reproduced in
Biologia Centrali-Americana
(1889–1902)

preciate and understand the designs and glyphs of the
Maya. Maudslay understood that reproductions could
never substitute for direct vision. For this reason, he
went to the trouble to make plaster casts of the monu-
ments that he photographed. Upon returning to Lon-
don, he managed to have these copied, with great pre-
cision, by draftsmen especially trained in this type of
work. He included these drawings alongside the pho-
tographs in his monumental work *Biologia Centrali-
Americana, Archaeology* (1882–1902).[24] In addition to a
large number of photographic reproductions of stelae
and carved stones, Maudslay also made documentary
photographs of the fauna, the flora, and the life of the
Indians.

The Pyramid of the Sun

Few Mexican photographers have followed in the foot-
steps of those European amateurs—part-archaeologists,
part-adventurers—who distinguished themselves by
their enthusiastic, almost loving view of the "old stones,"
as if they sought to penetrate their mysteries and reveal
their secrets.

At the turn of the century, Mexican anthropologist
and archeologist Leopoldo Batres photographed his
excavations in the Valley of Mexico and Oaxaca exten-
sively, often assisted by his son Salvador. Together, they
compiled a large body of documentation that is valu-
able to archaeologists, but holds little interest as pho-

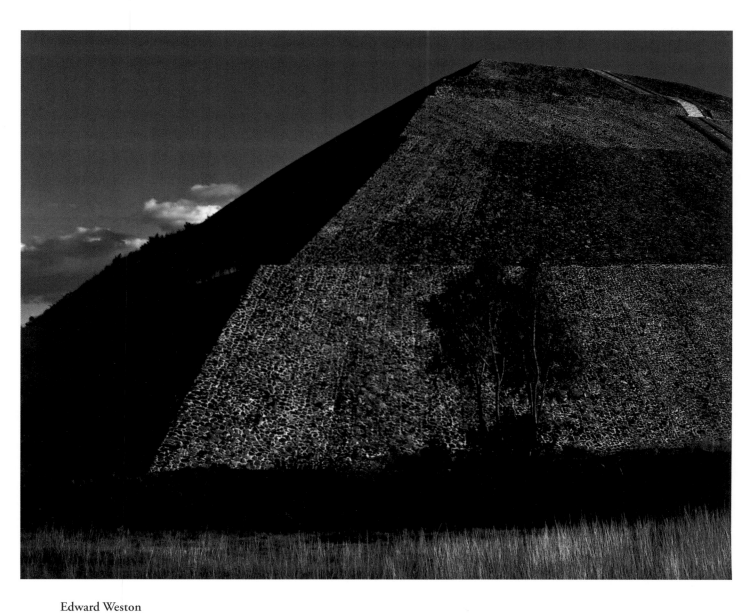

Edward Weston
Pirámide del Sol, 1923

Gelatin silver print
Collection, Center for Creative Photography,
The University of Arizona
© 1981 Center for Creative Photography, Arizona Board of Regents

tography. The vast majority of their images are of site excavations and collections of carefully identified objects, placed side by side on shelves in a sort of "group portrait" (as if to save on photographic supplies).

As time passed, however, the quest for greater precision in archaeological research forced photographers to adopt a more Positivist approach. The demystification of a number of accepted ideas (such as the origin of the Maya, which had been disputed since the nineteenth century) was gradually penetrating the aura of mystery surrounding the ancient constructions. Contributing to this was the use of aerial photography. Of unquestionable utility from the archaeological point of view for its geographic precision and ability to reveal the presence of structures otherwise invisible or difficult to reach in the dense vegetation of the Maya region, the technique has also been used on occasion for aesthetic ends. The aerial view, obviously, annuls the monumental aspect of the buildings.

Among the first to make aerial photographs of the Precolumbian ruins was the North American aviator Charles Lindbergh. During his second trip to Mexico in 1929, Lindbergh married Anne Morrow, daughter of U.S. ambassador to Mexico Dwight Morrow (who, incidentally, had financed Diego Rivera's murals in Cuernavaca). Lindbergh was then commissioned by the archaeologist Sylvanus Morley to photograph Chichén Itzá from his famous plane *Spirit of Saint Louis.* Widely reproduced in *National Geographic,* these photographs are of relatively little scientific interest, although they served to inaugurate the age of aerial archaeological reconnaissance.

Twentieth-century archaeologists continue to use photography to document their research. The facility offered by modern technology—hand-held cameras, industrialized photographic development and printing—has now placed them on an equal basis with amateurs, since it is no longer necessary to master the difficult techniques associated with the photography of the past. Most collections of archaeological photography, however, are of poor quality, falling into disuse only a few years after being taken.

The rigorous and demystifying approach of the archaeologists banished the romantic effects sought by the earlier scientist-photographers. Paradoxically, several artistic photographers would exploit these again during the first half of the twentieth century.

In November 1923, Edward Weston visited Teotihuacán with Tina Modotti and their friends Rafael and Mona Salas. Weston made an image (which he did not particularly like at the time) of the Pyramid of the Sun at dusk.[25] This impressive, compact mass of stone with its granular texture would, nevertheless, become an icon, almost an emblem of the Mexican period of this California photographer. Its decentralized composition and insistence on flattened volumes and heavy diagonals were innovations in photographic representation. It was the first expression of a curious analogy between modern forms derived from Cubism and Precolumbian architectural stylization and decoration, particularly that of Teotihuacán. Weston sensed—even if he only realized it later, in the darkroom—the visual possibilities of these same tensions that would later influence other important creators, including the English sculptor Henry Moore and the U.S. architect Frank Lloyd Wright (not to mention the popular "Maya-Deco" style, found in works as disparate as Manuel Amábilis's Parque de las Américas in Mérida and Francisco Cornejo's Mayan Theater in Los Angeles). Here—as in Weston's photography—the composition rests on the broad horizontal base of Mesoamerican constructions, so different from the tendency toward verticality typical in the West, as Paul Westheim demonstrated years ago. This emphasis on the horizontality of volumes, their forms placed firmly upon the earth, makes them less like monoliths than "eruptions."

In *Pyramid of the Sun,* rigor substitutes for effect; there is less concern for monumentality than for proportion, at the risk of losing a sense of scale or, eventually, detail. Despite the trees in the foreground (whose texture, in any event, is confused with that of the stone), the pyramid seems to be made of a single block of sculpted stone, floating in the air.

Josef Albers had been a colleague of Walter Gropius, Hannes Meyer, and Mies van der Rohe at the Bauhaus in Dessau during the 1920s. In 1933—shortly after the closing of that preeminent school—Albers emigrated to the United States. He and his wife, Anneliese Fleishmann, began to spend their summers in Mexico in 1935—a custom they continued for the rest of their lives. For the German refugee, this was a way of preserving certain links with visual traditions that he may not have found in the United States. During these visits, Albers took photographs: the snapshots of a tourist

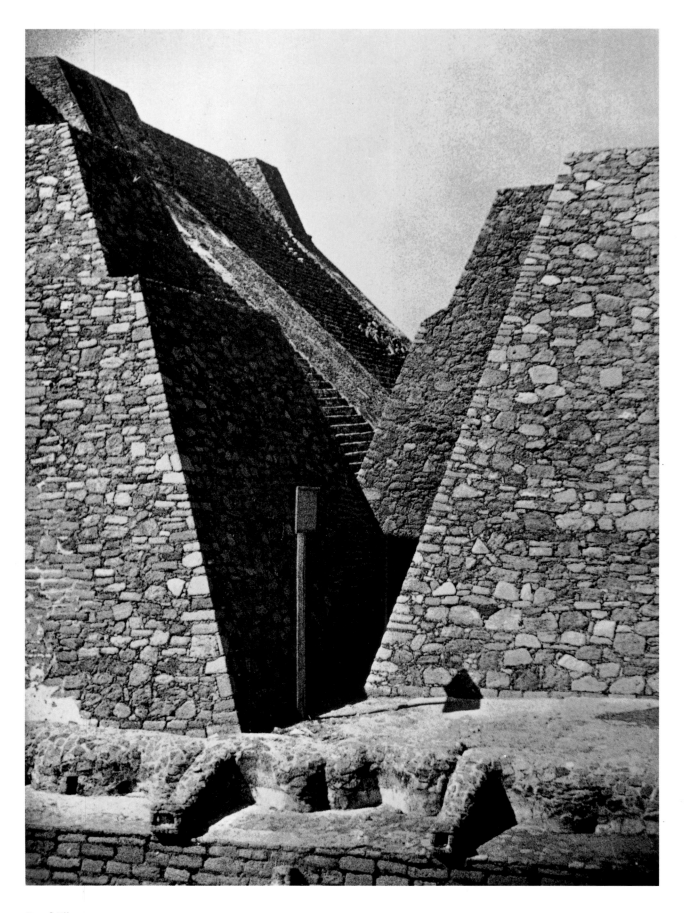

Josef Albers

Untitled, ca. 1936

Gelatin silver print
© 1999 The Josef and Anni Albers Foundation/Artists Rights
Society (ARS), New York

dazzled by Precolumbian architecture, "popular types," and exotic landscapes. Some of these images, with their asymmetrical angles, recall the photographs of his contemporary Anton Bruehl.

Albers never published these private souvenirs of his vacations. Nevertheless, he used images of Precolumbian monuments, in whose geometric forms he found (as Edward Weston had before him) a direct relation with the geometric-abstract designs of his paintings. Working from photographs of the pyramid of Tenayuca and of the palaces at Mitla, he worked out the preliminary sketches of his famous and influential *Homage to the Square*. The series of studies for a finished painting entitled *Tenayuca* (1938), in particular, are straightforward translations in pencil of certain forms and angles of the Aztec pyramid against a sky blue background.

Albers's photographs reflect an interest—shared by Weston, Laura Gilpin, and Paul Westheim (another German refugee)—in the heavy masses, flattened volumes, and precise geometry of Precolumbian architecture, as analyzed from a modernist angle. The ancient yet atemporal character of these stones, carved out against the sky by an implacable sun, are one more demonstration of the telluric-primordial vision of America fostered by important photographers and abstract painters from Edward Weston to Joaquín Torres García and Barnett Newman.

Less influenced by pictorial theories, but equally sensitive to the geometry of Precolumbian architecture, the U.S. photographer Laura Gilpin made two trips to Mexico, in 1932 and 1946. In 1948, she published one of her most important books, *Temples in Yucatan*.

Laura Gilpin: Solitary Photographer

Born in Austin Bluffs, Colorado, in 1891, Laura Gilpin was the niece of the Western photographer William Henry Jackson. Through this relationship, she became familiar with photography back on the cattle ranch in Colorado Springs where she spent her childhood. In 1915, Laura Gilpin "discovered art" at the Panama-California Exposition in San Diego. In 1916, she decided to go to New York to study photography at the studio of Clarence White. Her teacher was the pictorialist Gertrude Käsebier, a member—like White—of Alfred Stieglitz's circle.

Starting out her career as a modern photographer in contact with the New York intelligentsia of the period, Gilpin made portraits and still-lifes in autochrome, the first commercial color process. She soon returned to the Southwest, however, with the intention of working at archaeological sites in Arizona, and this led to her fruitful contact with the Navajo.

Following in the footsteps of other photographers who had worked extensively in the southwestern United States—notably Edward Curtis, Jackson, and Timothy O'Sullivan—Gilpin photographed Indians, although not from the perspective of an ethnologist or anthropologist. Possibly she was too sensitive and empathetic to subject her models to scientific inquiry.

Her New York contacts permitted her entry into the artistic circles of Taos, New Mexico, that nurtured an erudite culture, a "modernism in the desert." Often stopping off on their way to Mexico, many famous artists and writers were guests at the house of Mabel Dodge Luhan and participated in her Taos salon, including Marsden Hartley, Paul Strand, and Paul and Jane Bowles. Contemporary critics compared Gilpin's photographic work to the paintings of Georgia O'Keeffe.

In 1932, Gilpin applied to the Guggenheim Foundation for a grant to make a series of photographs of Maya temples. She did not receive the award, but decided to go to Yucatán anyway. There she met Sylvanus Morley, who was working on the excavations and reconstructions at Chichén Itzá, financed by the Carnegie Institution of Washington.

The ruins at Chichén Itzá were a logical choice of subject for Laura since she had a long-standing interest in architecture and sculptural form and a growing interest in cultural artifacts. In Yucatán, as at Mesa Verde and the other ancient and contemporary Navajo and Pueblo sites in the Southwest, she wanted to see how ancient life related to contemporary life. She wanted to explore the meaning of an American past to which she and her contemporaries were linked through a common landscape, cultural artifacts, and the accumulated knowledge of historical memory.

In her photographs of the ruins at Chichén Itzá, Laura strove for an effect that was at once decorative and historically evocative. "One difficulty in photographing these great temples," she wrote, "is to retain their remarkable proportions and decora-

Laura Gilpin

Sunburst, Kukulcan, The Castillo, Chichen Itzá, 1932

Silver bromide print, P1979.95.13
© 1979 Amon Carter Museum, Fort Worth, Texas, Gift of Laura Gilpin

tions and the beautiful surface qualities of the material, and at the same time retain the austere and barbaric qualities which are also present."[26]

In fact, Laura Gilpin sought less to emphasize the spectacular aspects of the monuments than, like Pierre Verger, their picturesque qualities. Even when she photographed the shadows of the equinox on the steps of the Castillo at Chichén Itzá (an event that currently convokes masses of New Age enthusiasts), it was less for the curious visual effect than for the artistic value, for the evocative geometry of the patterns of light. The decentralized composition of the monument against the sky in *Steps of the Castillo, Chichén Itzá* recalls Weston's *Pyramid of the Sun.* In both cases, the architectural lines dominate, organizing the directional lines of the composition. This is even more obvious in *Top Platform of the Castillo, Chichén Itzá,* which demonstrates the way in which the ancient Maya constructed buttresses. This manner of showing decorative elements or angles of the structures in the foreground, with a glimpse of other parts of the buildings and the landscape in the distance, is typical of Gilpin and successful as expressive composition (see *The Great Serpent Columns of the Temple* and *The Umpire's Box above the Ring on the West Wall*).

Laura stressed the monumentality of Mayan culture with illustrations of closeup views that emphasized the grand scale of the ruins and downplayed the destruction wrought by time. She further suggested the vitality of the culture with pictures of lively shadows flickering across the face of the ruins and closeup shots of the animated carvings of serpents and human figures, all pictures that give ample evidence of her talents as an architectural photographer and intuitive skill with light. Several photographs of traditionally dressed Mayans posing in the temples suggest the continuities of Mayan history, just as Laura's earlier pictures of Indians in the ruins at Mesa Verde had emphasized cultural continuities of Southwestern Indian life. Some of the pictures of people, particularly of the Mayan women, whom Laura photographed in the soft, filtered light of their stick-and-thatch homes, have the feel of her Navajo portraits. Among both people, Laura found evidence of a dignity of bearing, great resourcefulness, and manual dexterity.[27]

The silhouette of a sisal plant with its lower leaves cut back to the stalk, Maya women in the entrance of a hut, a Maya child "in the house of his ancestors," and a group of Indians looking at the sacred well or *cenote* at Chichén Itzá completed the images made on this first trip. In 1946, with a book in mind, Gilpin returned to the Yucatán.

Temples in Yucatan, though not widely known, is one of the most interesting photographic books of archaeological ruins of the first half of the twentieth century. Gilpin's accent was clearly placed on the plasticity of the architectural forms. Moreover, she did not yield to the stereotypes and commonplaces of touristic visions.

The archaeologists' austere, scientific view did not capture the imagination of the general public during the twentieth century. Like the earlier, nineteenth-century amateur photographers, they remain much more sympathetic to the "magic of the old stones," the beauty of the forms of Maya art and architecture. Some later "artist-photographers" also preferred more evocative images. Their goal was obviously different from that of the archaeologists, who required an immediate, faithful record of their discoveries. In almost every instance, these artist-photographers worked for publishers or for agencies that promoted tourism.

The Last Adventurer: Armando Salas Portugal

In the 1930s, Armando Salas Portugal blazed a new path. In the tradition of the adventurers of the previous century, Salas Portugal entered the jungle weighed down with his photographic equipment. He traveled through the mountains of Tabasco and Chiapas in search of little-known monuments, including some that were not yet officially "discovered." Like Charnay seventy years before, Salas Portugal was fascinated by the ruins buried in the jungle, encased in the exuberant vegetation, and in growing danger of disappearing.

This is how he depicted Uxmal, Chichén Itzá, Palenque, Bonampak, and Yaxchilán: gigantic trees envelop stones emerging from cloaks of leaves. Even the tallest, most complete and spectacular structures seem diminished by the turbulent skies. In contrast to his predecessors, from Charnay and Maler to Weston in Teotihuacán and Gilpin in Chichén Itzá, Salas Portu-

gal was not concerned with the visibility of the structures and their ornament. He was an outdated pictorialist photographer (in the same way that the Mexican painter Joaquín Clausell was an Impressionist decades after the movement had run its course in France). Salas Portugal made panoramas in which nature prevailed over human constructions. More than any other Mexican photographer, he was a "poet of the lens," to use a term common in the 1930s and 1940s.

The best-known photographs of Salas Portugal are his large, hand-colored prints. He typically tinted them in great detail, including every leaf and branch, using red, violet, silver, and gold to create the effect of sunset on a stormy day. He was severely criticized at the time by the "purist" photographers, but the Tabascan poet Carlos Pellicer was seduced by his images and created complementary elegies in verse to the humid tropics that "fill our hands with color." Pellicer was also an avid admirer of Precolumbian cultures. An amateur archaeologist, he built a park using monuments from the Olmec site of La Venta—endangered by an oil refinery—on the banks of the Laguna de las Ilusiones in Villahermosa.

Unlike Teobert Maler, who tinted some of his photographs in an attempt to convey—based on scientific data—the original coloring of the painted bas-reliefs of Maya temples, Salas Portugal left the grayish color of the stone (even augmenting its austerity in some cases with a light ochre wash) and instead colored the backgrounds, effacing the monuments even further.[28] His romantic interpretation corresponded to accepted ideas, to the mythology of the "discoverers" favored even by certain archaeologists who continued to present themselves as successors to the nineteenth-century Egyptologists: Alberto Ruz at Palenque, Alfonso Caso at Monte Albán, and Giles Healey at Bonampak.

Gerardo Suter
From the series *En el álbum del profesor Retus,* 1978

Gelatin silver print
Courtesy Gerardo Suter

In time, Salas Portugal abandoned hand-coloring for the facility of Kodacolor. His late work lacked the delicate mystery of the tinted prints of the 1930s and 1940s. As a nature photographer, Salas Portugal also made studies of mountains, volcanos, and the Valley of Mexico. He was also the favorite photographer of architect Luis Barragán. His experience photographing the ruins allowed him to recreate the great purity of forms of that founder of a modern style of Mexican architecture.[29] In 1968, Salas Portugal and Abel Cárdenas Chavero published a strange photographic album "of thoughts" in which the prologue stated:

> In numinous photography, if we may refer to it as such, the marvelous phenomenon that allows a photographic image to be obtained without exposure to light has been frequently verified . . . substituting mental concentration [for the light], in total darkness, in front of, or in contact with, an unexposed, sensitized film that can then be developed in a darkroom.[30]

A worthy descendant of the nineteenth-century spiritualists who used photography to "reveal" the aura of deceased persons summoned during seances, Salas Portugal used conventional negatives to create prints that show formless, gray spots, used to "represent" the dreams of five individuals, identified by texts in the margins.

In the Archive of Professor Retus

Postmodernism proposed a return to the origins of photography. Beginning in the early 1980s, Gerardo Suter photographed sculptural works, mixing everything: the sculpture garden at the Ciudad Universitaria in Mexico City, the pillars and atlantid figures at Tula, Hidalgo, and the weathered bas-reliefs at Palenque.

Gerardo Suter is among those contemporary photographers who have worked extensively with a variety of photographic processes. Like the earlier traveler-photographers, he is skilled in the use of the collodion and salted paper techniques. In the late 1980s, he created a nostalgic homage to those expeditionary amateur photographers of the nineteenth century. Suter adopted a mythical persona for this project: Professor Retus, a European archaeologist supposedly lost in the jungles of Chiapas at an undefined date, in the 1920s, perhaps, or during the Second World War. Periodically, the professor sends photographs proving his continued existence to his "widow" at her rambling house in Mexico City's Colonia Roma. Suter (and Alfonso Morales, his cohort in this parody) thus prepared the conceptual terrain for the reading of a series of photographs taken in Palenque and Uxmal. In these images, made with discolored emulsion and "aged" by the action of certain corrosive acids, appear fragments of stelae, details of carvings, and the forms of the ancient stones—as if emerging from a mythical epoch.

> These displaced rhetorical, symbolic, and mythological signs attempt to contain the photographic images within a kind of archaeological atlas. Stone is hard and, because of this, noble; it endures scratches, decipherments, battles, totemizations . . . fear in the presence of the sacred and its magnetic zones, profound and unknown.[31]

At the end of the twentieth century, the photographic expedition becomes phantasmagoric.

Renata von Hanffstengel

Jilotepec, 1976

Gelatin silver print
Courtesy Renata von Hanffstengel

7 Capricho

Claude Désiré Charnay
Convento de la Merced, ca. 1857–1859

Albumen print
Álbum fotográfico mexicano (1860)
Fundación Cultural Televisa–Centro de Cultura Casa Lamm

Vanishing Mexico

In addition to photographing Precolumbian monuments and landscapes, a number of photographers demonstrated an interest in the architectural monuments of the colonial period, both religious and civic. The first of these was Désiré Charnay, who compiled an album of Mexico City views in 1859 or 1860. Other nineteenth-century traveler-photographers interested in baroque religious architecture (a few buildings in particular) were William Henry Jackson and Charles B. Waite. These "old walls" apparently required a different approach. Not only did their forms preclude the geometricizations that would inspire later modernists, but the celebration of the colonial past had very different ideological connotations. In brief, while the validation of the Precolumbian period promoted the idea of continuity between the first inhabitants of Mesoamerica and modern Mexico, the celebration of the colonial period evoked a nostalgia that served conservative interests by reaffirming Mexico's links with the motherland (Spain) and the Catholic Church.

During his stay of just over a year in Mexico City and before traveling to the southern part of the country, Désiré Charnay established relations with several prominent intellectuals, including the geographer and historian Manuel Orozco y Berra. Mexico was in the midst of a bloody civil war, and, given the difficulty of travel, it may have been then that Charnay began making the images for his (very rare) *Álbum fotográfico mexicano*. This compilation of excellent views of the monuments of Mexico City and its outlying areas was published in 1860 by the firm of Julio Michaud. A photographer himself, Michaud had already published a collection of lithographs by the Italian artist Pedro Gualdi, *México y sus alrededores,* in 1842.

Guillermo Tovar has located two copies of Charnay's album. One of these, a complete and exceptionally well-preserved copy, allows the viewer to fully appreciate the quality of Charnay's work.

Each photograph, carefully printed on albumen paper, accompanied by a brief text by Orozco y Berra, was originally sold separately, to be assembled into a complete album. With the exception of the open chapel at Tlalmanalco (one of the most photographed colonial sites in the nineteenth century), the photographs were all taken in the capital. Of particular interest are views of the plaza of Santo Domingo, in which the carriages can be seen waiting in front of the old customs building and, beyond, the famous "portal of the evangelists," where scribes were hired to read or write letters for the illiterate. The monuments that Charnay photographed were selected by Orozco y Berra for their architectural qualities and included some of the most interesting examples of Mexican baroque architecture:

Antonio Garduño
Untitled, ca. 1920

Silver bromide print
Courtesy Throckmorton Fine Art, New York

the Casa de los Mascarones, a heavily ornamented palace; the Salto del Agua, a municipal fountain; the Metropolitan Cathedral; the façade of the church of San Francisco; a view of Alameda Park.

The Mapoteca Manuel Orozco y Berra, which houses that historian's archives, possesses an extraordinary 180-degree panorama of Mexico City, made up of six large-format prints on albumen paper, joined together and mounted on fabric to open and close like an accordion. These images were probably taken from the towers of the church of San Francisco, looking north. The panorama extends from the western side of the Alameda, where the former church of San Diego (now the Pinacoteca Virreinal, a museum of colonial painting) is located, to the Zócalo or main plaza, between the Metropolitan Cathedral and the National Palace.

Mexican photographers were relatively slow to show interest in colonial architecture. The photographic record of colonial churches made in the beginning of the twentieth century by Antonio Cortés, an amateur photographer and head of the Department of Ethnology at the National Museum, was one of the first local attempts to address this subject.[1]

In this context, an undertaking such as that of José Ives Limantour, finance minister during the administration of Porfirio Díaz, who commissioned Guillermo Kahlo to make a photographic record of Mexico's colonial churches in 1904, demonstrates a renewed interest at the turn of the century in evoking a particular aspect of the country's cultural past.

Guillermo Kahlo: Colonial Churches

Wilhelm Kahlo—who changed his name to Guillermo soon after he moved to Mexico—was born in Baden-Baden in 1872. As the result of a series of personal problems with his father, he set out for Mexico in 1891, at the age of nineteen.

Kahlo had come into contact with photography early in his life. His father, a Hungarian jeweler who emigrated to Germany, also sold cameras and photographic supplies. Yet Guillermo Kahlo showed no interest in the medium until after his second marriage, to Matilde Calderón, daughter of a Oaxacan studio photographer named Antonio Calderón. During the first six years of

his residence in Mexico, Kahlo worked as a clerk at a number of foreign-owned businesses: Cristalería Loeb, a glass store; Claudio Pellandini's frame shop, where imported works of art and art supplies were also sold; and a jeweler's, the Joyería La Perla.[2]

With the aid of his father-in-law, Kahlo was finally able to establish a portrait studio on the top floors of the La Perla shop. In 1904, he was awarded the government contract that allowed his growing family to escape the threat of poverty; it was then that he built the famous "Casa Azul" in the Mexico City suburb of Coyoacán, which the most famous of his daughters, Frida, would turn into a center of international attraction in the 1930s.

Between 1904 and 1908, Guillermo Kahlo traveled across the country to make the photographs for the albums that Limantour planned to publish in 1910 to celebrate the centenary of Mexican Independence. However, the albums did not appear until 1923, when, at the initiative of the Mexican painter Dr. Atl, then-secretary of public education José Vasconcelos finally paid the costs of publication.[3]

> Indeed, Limantour had chosen well: Guillermo Kahlo was a fastidious technician with a stubbornly objective approach to what he saw; in his photographs, as in his daughter's paintings, there are no tricky effects, no romantic obfuscation. He tried to give as much information as he possibly could about the architectural structure he recorded, carefully selecting his vantage point and using light and shade to delineate form.[4]

In Kahlo's images of colonial buildings, there is a feeling of coldness and an excessively distant scientific objectivity that recalls, to a certain degree, the precision of Teobert Maler. The large plates in Kahlo's albums are, no doubt, useful for the study of architectural history; and while many viewers find the insistent repetition of angles annoying, some have seen in this a stylistic trait and a certain modernity *avant la lettre*.

Kahlo also produced an album to commemorate the inauguration of the neo-Gothic central post Office in 1904; in several images, the strong directional lines of the ornamental iron and marble interior are depicted with the same cool distance that lends monumentality

CATEDRAL DE MEXICO - INTERIOR DEL CORO - VISTA CO... — MEXICO

Guillermo Kahlo
Catedral de México—Interior del coro—Vista completa, ca. 1905

Center for Southwest Research, General Library
University of New Mexico No. 998-010-0002

to modern architecture.[5] Indeed, in 1931, he photographed something even newer: Juan O'Gorman's international-style studio complex, designed for Diego Rivera and his recent bride, Frida Kahlo.

Kahlo was also a portrait photographer (a couple of self-portraits and images of Frida are known), but most of these glass-plate negatives were destroyed: one story is that his family used them to construct a greenhouse. Those of colonial churches are now preserved in the archives of the Secretaría de Educación Pública at the Fototeca del INAH.

Kahlo's colonial images might be compared to those made by Henry Ravell in 1916, which were published by *Harper's* magazine under the suggestive title "Vanishing Mexico." Ravell—like Hugo Brehme in Cuernavaca—photographed "mysterious spots": a staircase leading nowhere, the church in Chimalistac reflected in the river . . . While these pictorialist effects evoke feelings of romantic nostalgia, they do not allow the viewer to understand the relationships of the architectural forms.[6]

Relevant here as well is the work of two more recent photographers who have specialized in colonial architecture: Agustín Maya and Renata von Hanffstengel. Maya was a photographer for the Instituto Nacional de Bellas Artes and illustrated countless books on the history of art and architecture, including those of Justino Fernández and Jorge Alberto Manrique. His collection is one of the largest photographic archives depicting colonial monuments, some of which are no longer extant. Unlike Kahlo's, Maya's precision is directed not only toward the large masses of the structures, but toward their profusion of decorative detail, permitting a closer and more complete appreciation of the work of architecture. In contrast, von Hanffstengel gives free reign to her emotions. Her images are suggestive compositions, packed with interesting objects.

Paul-Èmile Miot
Indian Woman, Veracruz, ca. 1869–1870

Modern copy from glass-plate negative, C.4945
Collection, Musée de l'Homme, Paris

8
Toccata

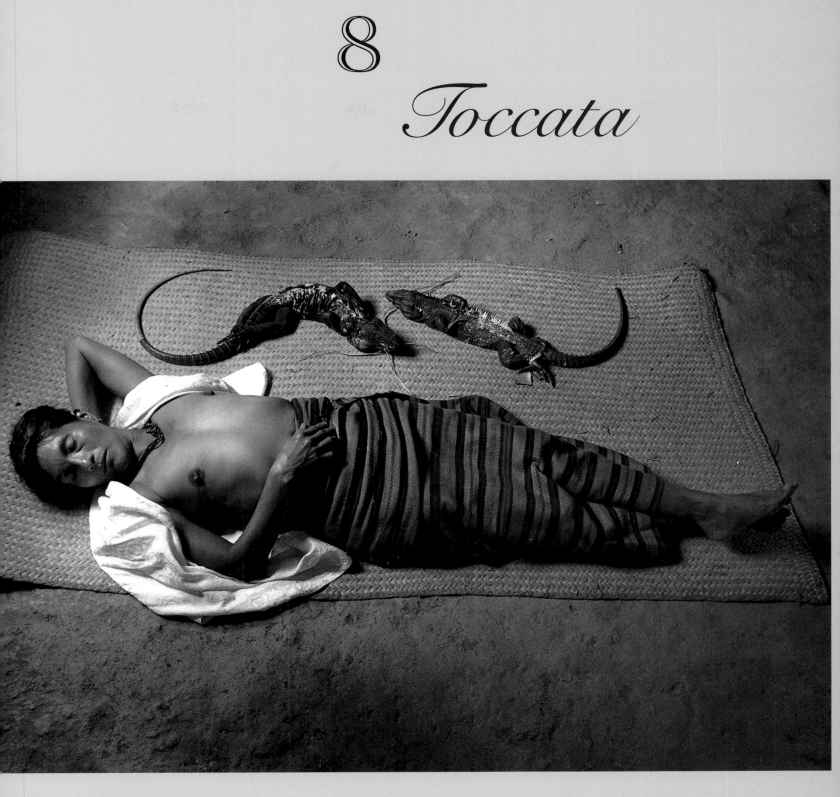

Flor Garduño

La mujer que sueña, 1991

Gelatin silver print
Courtesy Flor Garduño

Indian Woman . . . Skin Nearly Black

Among the glass-plate negatives in the Désiré Charnay collection at the Musée de l'Homme in Paris are six images of the port of Veracruz that were actually taken by French admiral Paul-Èmile Miot (1827–1870). Miot made the photographs during a brief stopover on his scientific voyage around the world in 1869–1870, which took him from France to Peru, Chile, and the Marquesas Islands.

One of these images is particularly revealing: a young woman with Indian features is seated on a bench leaning against the raised foundation of a typical Veracruzan house, made of wood and open to the street. Her hair is loose, and she wears only a dirty skirt, revealing her bare torso and breasts. The unpaved street and general disorder (wooden beams, assorted junk) contrast with Miot's other photographs documenting the construction of drainage and paving projects at the port. The picture seems to have been taken in the slums, possibly in a red light district of Veracruz, in which case the woman probably would have been a prostitute. This is unique: I know of no similar images of partially nude women in an urban setting, photographed in the streets of a Mexican city.[1]

The earliest known images by Teobert Maler (now in the Museum für Völkerkunde in Vienna) are card photographs of Mixtec Indian women from Jamiltec and Tutupec posed in front of a painted backdrop. They also pose bare-breasted (one holds a lacquered gourd bowl from Tehuantepec). Later, at the turn of the century, Elías Ybáñez, a Spanish photographer who settled in Veracruz, also made studio portraits of semiclothed Indian women in poses similar to those in Maler's images.

These pseudo-ethnological portraits are related to a concept of primitivism and tropical exoticism that was common throughout the nineteenth century. This popular fantasy was exemplified by the "Orientalists"—from Delacroix and Ingres to Manet—and by Matisse in the twentieth century. These artists depicted "the beautiful natives" (seminude indigenous women) in that curious mixture of eroticism and idealization of the

Other that we call exoticism and that constitutes a genre in its own right.

Criticized for its obvious links to the ideology of nineteenth-century colonialism, exoticism is also a way of seeing and understanding the world, not indifferently—but sensually. In some instances, the sexual qualities of exoticism appear in a less literal manner, existing as a subtext in numerous works of literature, music, or visual arts. In these, exoticism and eroticism are often fused, discomforting viewers who vaguely sense the mix of genres.

In the same collection at the Musée de l'Homme is an unusual series of cartes-de-visite, accessioned in 1866 as a donation from Father Emmanuel Domenech. The photographs, captioned *Types du Mexique*, depict "popular types": children with baskets, hat sellers, a flower vendor, an Indian mason, Chichimeca Indians from the state of Guanajuato, and—of particular interest—one entitled *India de Durango, piel casi negra* (Indian Woman from Durango, Skin Almost Black). The subject poses holding a prayer book, like a well-dressed middle-class lady. There is nothing to indicate that Father Domenech was the author of these images, taken in a variety of formats, framings, and styles.[2] It seems more a compilation of images by several photographers, perhaps commissioned by the clergyman and classified as "ethnological" photographs.

The photographic studio, according to André Rouillé, "was almost exclusively reserved for the tailcoat, high hat, and crinoline . . . the blouse, cap, and apron were excluded."[3] Yet, in some cases, subjects were forced to pose for the camera. Such was the case of the early "ethnological" photographs of "native types," considered first exotic objects of curiosity then subjects of scientific research. Rouillé describes some (rare) examples of "working types" made in France during the Second Empire:

. . . the techniques of individuation employed in portraits of the middle class are absent . . . [In these images] people are merely a pretext and necessary

condition for a type of photography modeled on genre painting, which was very fashionable at the time. From this approach (whose final objective was not to create a portrait, but to make an image that conformed to certain formal conventions), the concrete referent of the photograph is less important than a global referent to both the world of labor [in general] and the . . . specific occupation of the sitters . . . This can be difficult to identify since the composition is organized from preexisting images, rather than from an actual situation.[4]

Father Domenech's portrait collection is situated at the border between nineteenth-century portraiture—codified by the rising middle class—and imagery of the Other, charged with certain intentions and obligating the photographer to conform to certain preestablished codes of representation. The sitters had no voice in the matter; they were only models (even paid, perhaps), mere objects placed before the indiscreet and supposedly objective lens of the camera. The poses that they adopted (or that were imposed on them) single them out as essentially "different." This process of exoticization, paradoxically, has an implicitly erotic aspect. The flower vendor and, particularly, the *India de Durango, piel casi negra* are eloquent in this respect. Both are shown in a typical studio setting, dressed as respectable ladies of the mid-nineteenth century. The decor is the same, yet something in their bearing reveals an inversion of conventional values: the basket of flowers on the flower vendor's apron, the surprising pose of the *India de Durango,* her expression fixed somewhere between fear and seduction, her hands on the prayer book . . .

Africa and Oceania, above all, provided their quota of nude women, men, and children (particularly women) during the nineteenth and early twentieth century for the satisfaction of readers of travel accounts, adventure books, and—later—*National Geographic.* Mexico, or at least certain regions of the country, offered its own tropical odalisques, simple and shameless market vendors, *chinas* and *tehuanas* dressed in elaborate lace and embroidered dresses designed to seduce, adolescent Indian boys made effeminate by their white, light-weight cotton clothing and affected poses. Later came the mestizos with their big mustaches and tight pants adorned with silver buttons down the legs and flies, their broad sombreros hiding dark expressions, and, of course, their swords, rifles, or whips.

The travel accounts and "scientific" paintings of the early "ethnologists," thus, soon codified the way in which native peoples were understood. In contrast to the way that "First World" countries defined themselves, Mexico—a nation always at the edge of civilization—developed a strange sense of "internal exoticism" and adopted the codes established by foreign travelers for its own national self-definition.

Teobert Maler
Mujer de Pinotepa, 1873

Albumen print, carte-de-visite
CONACULTA-INAH
Reproduction authorized by the Museo Nacional de Antropología e Historia

Mexicans: A Self-Portrait

In 1839, Fanny Calderón de la Barca sent a figurine of a Mexican tortilla maker to her mother in New York, so that she might "judge a little of the perfection in which the commonest *lépero* works in wax." In the same letter, she stated: "A valuable present was sent lately by a gentleman here, to the Count de ——— in Spain; twelve cases, each case containing twelve wax figures; each figure representing some Mexican trade or profession or employment. There were men drawing the pulque from the maguey, Indian women selling vegetables, tortilleras, venders of ducks, fruit men, lard-sellers, the postman of Guachinango, loaded with par-

Julio Michaud
Wax Figurine of Mexican Popular Type, ca. 1865

Albumen print, carte-de-visite
Center for Southwest Research, General Library
University of New Mexico No. 986-026-0020

rots, monkeys, etc.—more of everything than letters—the Poblana peasant, the rancherita on horseback before her farm-servant, the gaily dressed ranchero, in short, a little history of Mexico in wax."[5] In his saga of nineteenth-century Mexico, *Los bandidos de Río Frío,* Manuel Payno recalls that "the Condesa de Zuchy, like many other noble and distinguished persons who came to Mexico during Maximilian's reign, acquired a large collection [of wax figurines] in the Portal that are to-day found in museums and considered to be among their most interesting curiosities." The statuettes depicted "bull throwers, Indian fruit sellers, meat smokers, monks, matadors, Indian tortilla makers, in short: all the popular types found in the country. Perfectly rendered."[6] These costumed wax figurines that so attracted mid-nineteenth-century travelers were derived from a pictorial category (a subcategory of "genre painting" or what is called *costumbrismo* in Latin America) whose origins can be found in sixteenth-century France. "Since in France men, women, and sometimes children roamed through the streets, calling out to announce their wares and services, [the depictions] were called *cris* ('Street Cries'). In the sixteenth century, artists began to draw, engrave, and paint them . . . in popular imagery they appeared in almanacs and inexpensive prints."[7]

In the mid-seventeenth-century, the engraver Abraham Bosse made a series of prints that attempted to describe some of the complexities of French social structure, portraying street vendors in "poses from Italian comedy."[8] A century later, Edmé Bouchardon published a series entitled *Études prises dans le bas peuple; ou Les cris de Paris* (Studies Conducted among the Lower Classes or the Street Cries of Paris). The realism and details of his work reveal a more truly documentary intention than do the engravings of Bosse.

At the onset of the French Revolution, social conscience demanded new definitions and the formulation of new stylistic rules and approaches. As an instrument of social classification, the "street cries" and "popular types" employed the conventions of portraiture (a full frontal view of the standing subject, placed at the center of the composition) and genre painting (the candid, "snapshot" composition using stereotyped, even theatrical, poses) to characterize and distinguish the various trades depicted. The baskets, jugs, crates, and wheelbarrows in which they transported their mer-

chandise were no longer sufficient. The illustrator also captured the peddlers' "cries" or portrayed the encounter between the merchant and the client through a brief, but eloquent, gestural relationship. The later prints are even more truly documentary, and resemble, in concept, botanical and zoological plates—which were sometimes made by the same illustrators. This is not surprising: after the publication of the Linnaean classification schemes, biological theories of social organization replaced the old theological definitions. Individuals could now be distinguished by postures and dress, which denoted their particular ethnic or cultural identity. In these new systems of individuation, physiognomy and gesture became determining factors. This

approach culminated, during the nineteenth century, in a number of attempts at ethno-physiological social and racial classification (Morgan's model of evolution, Gall's phrenology, etc.)—the earliest manifestations of the new discipline of ethnology. A society that was fascinated by the external forms of things (e.g., phrenology) and that attributed defining values to them would naturally find in photography the ideal instrument to capture these "significant appearances."

Images of popular types enjoyed an enormous success in the nineteenth century. They were reproduced in engravings, in etchings, and finally in lithographs by the hundreds and thousands on playing cards, Spanish lottery tickets, French tarot decks, porcelain dishes and trays, printed cloths, calendars, almanacs, posters, etc. Cut-out figures featuring popular types were distributed in series by the commercial printers of Épinal, in northeastern France. Serialized publications such as the French Bibliothèque Bleu and its German, English, Brazilian, and Mexican equivalents (the last published by Murguía, Maucci, and Vanegas Arroyo) often used images of popular types as illustrations for children's books, lives of saints and heroes, and short stories about travel and exotic adventure; some were even compiled into narrative sequences in the manner of modern comic books.

But just who were the "popular types" used to represent Mexican society, and where did they come from? They express an urban consciousness and define a social division that was relatively new during the period of industrialization that replaced the guild system and necessitated a global reorganization of society (and/or that society's self-image). The people typically portrayed in these *costumbrista* microscenes were very rarely contemporary common farm laborers (these would appear somewhat later, always gripping the reins of an archaic ox team) and never aristocrats or (future) bureaucrats. There were no businessmen, professionals, doctors, bankers, much less women of high society.[9] The upper classes would appear later, and then they were almost always portrayed satirically, as if derived from the caricatures of the popular press. As a general rule, the "types" depicted were overwhelmingly from that part of the lower class whose numbers and way of life were difficult to understand fully in societies on the brink of urbanization. They were those people who never really attained the full status of citizenship, but who, nonethe-

Hugo Brehme
China poblana, ca. 1920

Gelatin silver print
Center for Southwest Research, General Library
University of New Mexico, No. 996-018

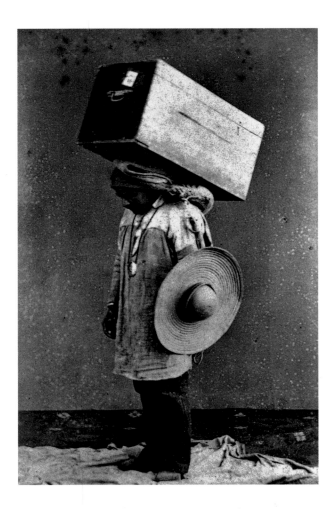

Mérille
Cargador, ca. 1876

Albumen print, carte-de-visite
Private collection, Mexico City

bor; as direct sales persons, temporary and migrant workers, they have no "fixed domicile"), they became defined by their function or trade. For this reason, perhaps, it became necessary to fix and recognize them by means of their image, and because they were impossible to identify as individuals, they were iconographically organized into typologies. The depictions of street vendors distinguish certain trades without granting them *a priori* a class connotation; indeed, as classifications of an ill-defined group, fluctuating and extremely adaptable, they change vocations as the country modernizes and new products appear. Paradoxically, this is the most responsive sector of the economy and, for that reason, the most dynamic. Some trades disappear as the economy changes, while others emerge according to the needs, demands, and means of the clientele. The traditional vendor of *chía* water would open a stall in Chapultepec Park in the 1950s selling Coca-Cola and Orange Crush; the street musician would get a Walkman, put on headphones, and sell cassette tapes at the entrance to the Insurgentes Metro station.

Street life in continual transformation: the time factor—nostalgia for bygone days, a lament for the degree and speed of change in our lives—plays a part, perhaps, in the urge to convert archetypes into images. Classification and typology employ metonymic elements selected for their crucial value as signifiers then turned to expressive purposes and raised to the rank of attributes. In this way, the *charro's* sombrero, the beggar's *huaraches,* the petticoats and shawl of the *china poblana,* and the water vendor's leather apron alone become sufficient to distinguish and define the person as a recognizable type. Mixed references, stylistic confusion, appropriation of genres filtered through a globalizing vision that acts as a common denominator: these are typical devices of exoticism. The Mexican watercolors of French artist Èdouard Pingret of the 1840s, for example, destined for a European audience, are identical to those he made years later in Spain and similar to Italian, Moroccan, and Egyptian images of "popular types" that circulated in Europe, as both lithographs and photographic collectors' cards.

For once, a visual genre influenced literature: between 1830 and 1890, a number of writers—particularly liberals who sought to define the shape and nature of the nation—used these prints as sources for their descriptions of social strata. Thus, a new literary genre

less, were indispensable to the functioning of the city: the essential link between the urban bourgeoisie and the rest of the world. They represent a vague, tertiary sector that still exists and is currently referred to in Third World countries as "the informal sector" (a term that reveals sociologists' difficulties in defining it).

These street vendors are remnants of a vanishing economic system in which the producers and distributors of goods were often the same. The duck seller in François Aubert's photograph also raised the animal. Later, and current, versions of these vendors include door-to-door salespersons, knife sharpeners, chimney sweeps, and one-man bands that play their music on street corners for the entertainment of passersby. Since they had no clear identity in society (they occupy no prescribed space within its specialized divisions of la-

emerged, a successor of the eighteenth-century *cuadros de castas* (caste pictures). José Tomás de Cuéllar (who signed his work "Facundo") was a hero of the battle of Chapultepec against the U.S. invaders and an engraver, photographer, journalist, and novelist who published a series of carte-de-visite portraits of governing officials (one of several of this type). In 1869, he began publishing La Linterna Mágica, a series of short novels of manners that attempted—in the style of a Mexican Balzac—to describe the social strata of the country. According to the author, each of the novels was an *instantánea;* Cuéllar basically took texts that had previously appeared in scientific reviews, such as *El Museo Mexicano,* in the mid-1830s and expanded these literary vignettes to book length. Among the authors of these earlier texts were Ignacio Manuel Altamirano, Guillermo Prieto, and Manuel Orozco y Berra. In 1871, Joaquín Gómez

Vergara published *Fotografías a la sombra, retratos en silueta de las muchas caricaturas sociales que nos salen al encuentro por todas partes, escritas en prosa desaliñada por Demócrites* (Photographs in the Shadows: Silhouette Portraits of the Many Social Caricatures That We Encounter Everywhere, Written in Slovenly Prose by Demócrites). Around the same time, Rafael López de Mendoza published *Los empeños de México, cuadros de costumbres escritos en versos, fotografías instantáneas* (Mexican Endeavors: Genre Pictures Written in Verse, Snapshot Photographs), a variation on the theme elaborated earlier in *Los mexicanos pintados por sí mismos* (1854). This seminal work was parodied at the end of the twentieth century by José Joaquín Blanco in *Los mexicanos se pintan solos* (1984). These vignettes recount "things seen" around the incomprehensible capital of Mexico and are illustrated by some of the best photo-

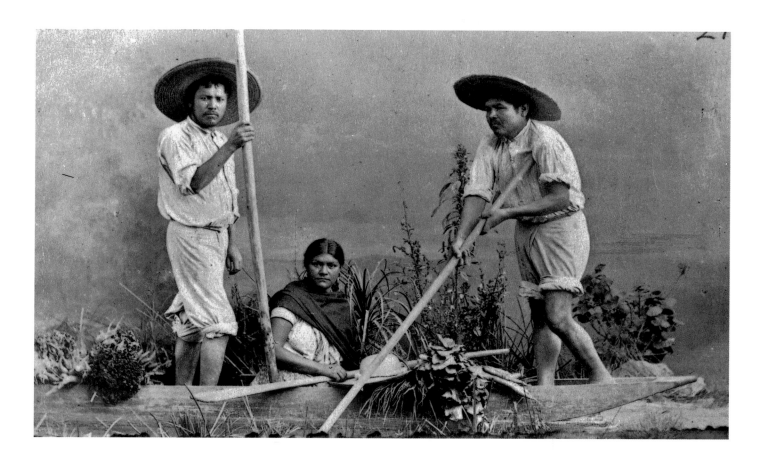

Cruces y Campa (attributed)
Remeros, ca. 1876

Albumen print, carte-de-visite
Center for Southwest Research, General Library
University of New Mexico No. 986-037-0058

journalists of recent years: Francisco Mata Rosas, Guillermo Castrejón, Christa Cowrie, Jesús Fonseca, Andrés Garay, and Fabrizio León, among others.

Tipos mexicanos: Albums of Mexican Popular Types

In 1865 or 1866, François Aubert made a series of portraits of popular types, photographed in his studio on Calle San Francisco. These consisted, primarily, of market vendors who posed with the goods that they traditionally sold on the plaza: chickens, fruits and vegetables, manufactured articles, etc.

The original glass-plate negatives of these rare images are housed today in the Musée Royal des Armées in Brussels, part of the collection of photographs that may have been brought back to Europe by the former empress Carlota. Aubert was the first (as far as we know) to use photography to portray "popular types" in Mexico, and his images are not very sophisticated. A long canvas was stretched across the studio as a backdrop, and the subjects posed as they would be seen in the market with their goods, with no other decor or studio prop. It seemed as if the photographer simply brought the market stall to the studio, as a convenience.

Antíoco Cruces and Luis Campa made a series of cartes-de-visite depicting Mexican popular types for the Philadelphia Centennial Exposition of 1876. These were enthusiastically received by the public and awarded honors by the judges.

Photographed in the studio on Calle de Empredrillo, the Cruces and Campa images were designed to be extremely realistic, recreating the atmosphere of the Mexican streets in small-scale, theatrical stage sets. For this, Cruces and Campa had commissioned a number of beautifully painted *trompe l'oeil* backdrops. One of these depicts a street corner in the city: a peeling wall with posters for theatrical events or bullfights and a stone post that served—according to the occasion—as a seat, backrest, or mere decoration. Gravel and rocks were strewn on the floor. *The Broom Seller, The Noise-Maker Seller, The Coffee Seller, The Military Band,* and *The Feather Duster Seller* are pictured in these images, dressed in their distinctive costumes and posed in settings that are sometimes quite spectacular. The photographer even reconstructed, using freshly cut plants and cut paper, the market stall of the vendor of *aguas frescas,* those typical Mexican beverages made from fresh fruits, seeds, and flowers. What had been the straightforward representation of market vendors in Aubert's images was transformed by Cruces and Campa into drama. In some cases, the documentary aspect of their images of popular types was subsumed by the expressive content of their theatrical *mise-en-scènes.*

The *Tlachiquero*

The *tlachiquero*—the rural laborer who used a long gourd to suck the sap from the maguey, a variety of agave from which the popular alcoholic beverage *pulque* was made—was perhaps the most widely known and successful of the images of Mexican types. He usually represented the only *campesino* among the urban figures that populated the series. Nevertheless, his trade was tied to an industry that was flourishing in the nineteenth century, the production of *pulque.* The use of this inexpensive alcoholic drink, popular among the poor and working classes, was marginalized and condemned on "moral grounds" as a social vice. (The immorality actually lay in the production of the drink, by the so-called pulque aristocracy, who made their fortunes using peasant labor on their vast estates.) A mixture of Precolumbian traditions and modern technological advances, the production of *pulque* is unique. It begins with the culture of maguey in a limited area of the arid central Mexican highlands, continues along the railway to the customs houses of Pantaco and Nonoalco in Mexico City, and ends in the *pulquería,* decorated with imaginative and crudely painted murals. These popular paintings (which appear in the Mexican photographs of Edward Weston) often depict the cultivation and production of *pulque,* which was criticized by *criollo* society and celebrated as exotic and picturesque by foreign visitors, beginning with Fanny Calderón de la Barca and Carlota of Belgium.

The *tlachiquero* acts as the first link in a complex chain of production. With his *acocote*—a long, hollow gourd—he sucks the juice from the split-open heart of the mature maguey.

Cruces and Campa prepared a special studio set in

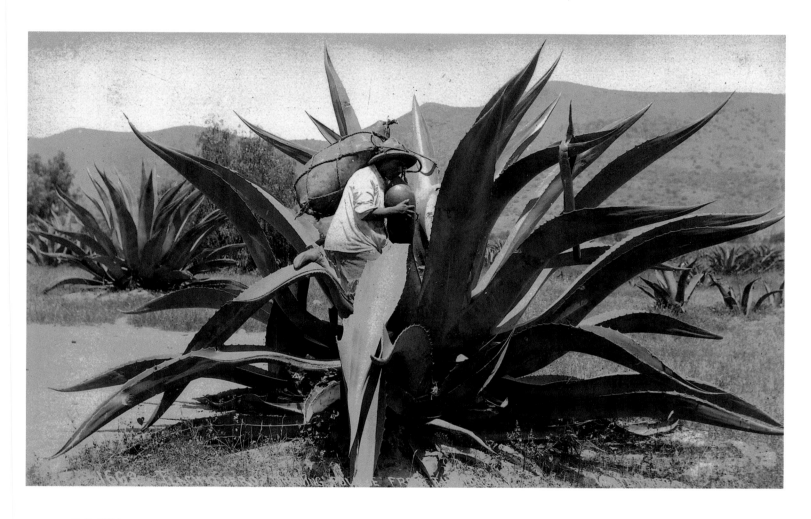

C. B. Waite

Tlachiquero Drawing Pulque from the Maguey, ca. 1900

Gelatin silver print
Center for Southwest Research, General Library
University of New Mexico
No. 000-170-0015

Edward Weston
Pulquería Interior, 1926

Gelatin silver print
Collection, Center for Creative Photography, The University of
Arizona
© 1981 Center for Creative Photography, Arizona Board of Regents

order to show this process for the first time in a photograph. They painted a majestic backdrop of volcanos, covered the floor of the studio with earth and straw, and brought in a maguey, adding real bushes and dry branches as if to hide the defects of their composition. The *tlachiquero* is the only person among the series of Mexican popular types to be seen from the back: his face, evidently, was not important. Yet the calloused soles of his feet confirm his identity: he is not an actor,

but a real *tlachiquero* brought to the studio in Mexico City by order of the photographers.

From that time on, the *tlachiquero* became the paragon of the Mexican popular type. Cruces and Campa were not the creators of this mythology; they simply gave it new form. Charles B. Waite, Abel Briquet, José María Lupercio, Hugo Brehme, Sergei Eisenstein, and Èdouard Tissé, among others, would all represent this figure, characteristic of a segment of agricultural soci-

ety in Mexico that was vanishing. Twentieth-century photographers did not add much to the image created by Cruces and Campa. They did, however, go to the effort of bringing their cameras out to the plains of Hidalgo and making their photographs on site at the maguey plantations. From the back or in profile, the *tlachiquero* would continue to be anonymous, the perfect "type."

From the *tlachiquero* in the field to the *pulquería* on the corner, the culture of *pulque* fascinated foreign travelers as well as a number of Mexican photographers. Hugo Brehme portrayed the *tlachiquero* inside the maguey, its sharp, pointed blades forming a kind of radiant halo around his head, captured in motion, emerging from a tumultuous sea of spikes. Sumner W. Matteson traveled through Hidalgo at the end of the nineteenth century and photographed the fermentation rooms in use, the heavy forms of the vats covered with whitish foam, and the brutal working conditions of the laborers who lived just outside the hacienda's walls.

In the 1920s, Edward Weston and Tina Modotti, accompanied by Mona and Rafael Salas, Felipe Teixidor, and Miguel Covarrubias, also visited the haciendas of Apan, Hidalgo. Seduced by the form of the maguey, silhouetted against a "typically Mexican sky," Weston created one of his best-known images . . . and, with it, an icon. Manuel Álvarez Bravo, Lola Álvarez Bravo, and Mariana Yampolsky, among others, used the maguey to compose near-abstract images, charged with symbolism. It is not surprising that Weston, Eisenstein, and Manuel Álvarez Bravo saw something masculine in the form, with its aggressive, stiff, upright leaves. Conversely, Lola Álvarez Bravo and Mariana Yampolsky peered into the heart of the maguey and found a feminine aspect. Lola discovered inside the plant a *vagina dentata,* its whitish pulp armed with sharp teeth. Much later, reacting against this symbolism, Adolfo Patiño would celebrate *La muerte del maguey* (Death of the Maguey), the end of a myth.

Weston also made a number of photographs of *pulquería* façades, whose popular murals likewise inspired decorative works by Gabriel Fernández Ledesma, Roberto Montenegro, and Diego Rivera.

If Picasso had been in Mexico, I should feel that he must have studied the pulquería paintings, for some

are covered with geometrical shapes in brilliant primary colors to excite the envy of a European modernist. These paintings which include every possible subject, beautiful women, charros, toreadors, "Popo" and Ixtaccíhuatl, engines and boats, are the last word in direct naive realism.[10]

Weston also collected the names of the *pulquerías,* recording them in his diary in the form of an *estridentista* poem.[11]

Charros no Fifis	Cowboys not Dandies
Los Hombres Sabios sin Estudio	Men Wise without Study
La Hermosa Ester	The Beautiful Esther
Mis Ilusiones	My Illusions
Las Fieras	The Fierce Ones
El Gallo de Oro	The Cock of Gold
Alegría del Amor	The Ecstacy [sic] of Love[12]

In 1931, Sergei Eisenstein chose the *pulque*-producing hacienda of Julio Saldívar in Tetlapayac, Hidalgo, as the location of one segment of his film *¡Que Viva México!* More or less finished, it was edited and released without his consent as *Thunder over Mexico* in 1933. A symbolic-allegorical evocation of the Revolution, the film tells the brief story of a *campesino* couple living in the shadow of the hacienda. When María and Sebastián ask the owner's permission to marry, a drunken guest decides to exercise the land-owning class's traditional *droit de seigneur* and deflower the pretty and innocent peasant girl (played by Isabel Villaseñor, wife of the painter Gabriel Fernández Ledesma). Sebastián and his friends then try to free María and take revenge against this humiliation and injustice. After the daughter of the hacienda owner (who participates in the sport of running down the insubordinate peasants) is killed in the crossfire, her father has the trio of Christ-like rebels put to death in the cruelest manner. The story is constructed as a sexualized metaphor for the Mexican Revolution, presenting it as a popular response to the rape of the peasants by the landowning class. The cinematography of Edouard Tissé, Eisenstein's cameraman, exalts in the flat landscape, the turbulent skies of the rainy season, and the aggressive spikes of the maguey—all of which add visually to the drama of the story.

In his memoirs, Eisenstein gives a revealing account

of how he constructed images. He describes one of the most important scenes, the arrival of Sebastián with his friends carrying the *torito* (a papier-mâché bull covered with fireworks) which they used to set fire to the hacienda:

It is recognized, by people who have a thorough knowledge of Mexico, to be one of the more successful photographic recreations; to have captured the physiognomy of the country particularly profoundly . . . Probably because of the impression these compliments have had on me, I immediately at-

tempted to analyze it, to see what made the substance if this photograph is typically Mexican . . .

And so Martín Fernández, playing Sebastian, stood before us in straw hat and white sarape of the peons . . .[13] In the background was the portico of the same hacienda where *pulque*—Mexican vodka—was distilled in huge bullhide vats. Everything was purely Mexican. But what was it that linked all the elements together, in that combination, within the frame of a single photo? It should be further noted that the scene itself is intermediary. The chief subject—with the *torito* which the rebellious peons used

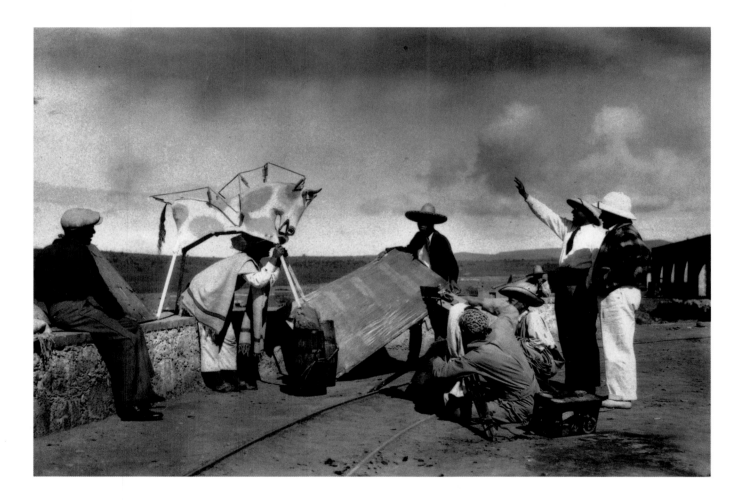

Anonymous
Filming the "Torito" scene in ¡Que Viva México! 1931

Martín Fernández as Sebastián (under *torito*), Edouard Tissé (with camera), Gregory Alexandrov (background), Agustín Aragón Leyva and Sergei Eisenstein (at right)
Gelatin silver print
Private collection, Mexico City

to burn the hacienda down—went further . . . The key compositional combination for the *torito* and the hacienda block at Tetlapayac turned out to be a reconstruction of a very old memory from childhood.

I remember when I was a young child that my room was hung with tinted photographs. Father brought them back from his travel abroad: Venice with the Doge's Palace and the Lion of St. Mark. Somehow, when I was young, they formed a familiar pattern. So much so that twenty-five years later I had only to see a lancet window, a portico and a cardboard bull, with a vague semblance of wings on his back, to feel an insuperable longing to combine them all into a single composition. Characteristically, there was even a stone barrier in the foreground, reminiscent of an embankment. This is a clearly "Venetian" motif: the building rising up sheer on the edge of the embankment. This inevitably made me want to place the *torito* at the top—it had to break the skyline. The new exigency was dictated by the Lion of St. Mark, silhouetted against the sky.[14]

The filming was never completed, for economic and political reasons. *¡Que Viva México!* was finally dismembered and parts of the material used in other films, including several shorts promoting tourism. Yet some images remain fixed in memory as enduring visual clichés. Eisenstein and Tissé captured something of the "national soul," which was quickly co-opted. Stills from Eisenstein's film were used to illustrate the folkloric magazine *Nuestro México* (an elegant contemporary of *Mexican Folkways*), which published only eight issues during the early 1930s. The fragment released as *Thunder over Mexico* premiered in New York in October 1933 amid great controversy.[15] This film served as the model for a series of socially committed films and had a particularly strong influence on the unfinished cinematic series undertaken by Narciso Bassols during the presidency of Abelardo Rodríguez, which included Paul Strand's *The Wave* (1934). It also defined the style of many subsequent movies in Mexico.

As late as the 1970s and 1980s, Mariana Yampolsky fixed her camera on the ruins of the *pulque* haciendas that were destroyed by land reform in the 1930s and by moralizing campaigns whose hidden agenda was to increase the consumption and production of beer. How different are the hectic activities of the hacienda distilleries that appear in Matteson's photograph of 1899 and these tranquil, rather cool and distant images, so characteristic of Yampolsky's respectful view. Hers is a nostalgic documentation of this forgotten world, the austere walls of the haciendas constructed like medieval forts, the rusty metal fixtures of a dead industry. Elena Poniatowska wrote in her text for *Estancias del olvido,* the published compilation of these photographs:

> If whispers inhabit the haciendas today and only broken porcelain fixtures remain—a lavatory brought from Rotterdam, wash basins and a couple of bidets—many of the chapels are still in use and the descendants of those who were masters of the land celebrate their marriages there. The grandchildren and great-grandchildren of the peons who were once lodged there also attend the religious services.[16]

Yampolsky photographed a great variety of objects: peeling walls, broken windows, furniture turning to dust, chickens roaming the abandoned rooms with their painted walls. Only a few old people who persist in remembering a tradition remain there, solitary figures in the gray landscape of the ruined vat rooms. Mariana Yampolsky is an assiduous photographer of cemeteries; she photographed the forgotten haciendas as if they were tombs.

Photography and Ethnology

Cruces and Campa's series of Mexican types portrayed only residents of the capital and the surrounding areas. The *tlachiquero* and the *remera* from Iztacalco, who brought food into the city by canal, were marginal figures and exceptions. Although they were *campesinos,* their trades were related to the urban economy.

In the early twentieth century, José María Lupercio—bullfighter, racecar driver, aviator, painter, and photographer from Jalisco (and successor to the famous portrait photographer from Guadalajara Octaviano de la Mora)—made a commercially successful series of "popular types" in stereograph that proved the durability of the genre.

But Mexico is so large, complex, and varied that to comprehend it requires more than the "panoramic" vision proposed by Cruces and Campa in the tradition

of the eighteenth-century caste paintings. A revision was needed, a more detailed explanation of the social, ethnic, and socio-ethnic variants. This was undertaken by a number of scientists whose progressive vision would determine definitions to be formulated in the twentieth century. During the late nineteenth century, ethnologists used photography to complement their documentation (in several cases, extremely incomplete) of the customs, rites, and legends of several Indian groups.

The Scientific Expeditions of Léon Diguet

Léon Diguet was born in the French port of Le Havre in 1859. He studied industrial chemistry at the Musée d'Histoire Naturelle in Paris, later switching to research in the natural sciences. He first traveled to Mexico in 1889, as a chemist with a French company that exploited the iron mines at El Boleo in Santa Rosalía, Baja California. (Iron from these mines, incidentally, was used in the construction of the Eiffel Tower.)

Soon after his arrival, Diguet began his travels through the Mexican Republic in search of geological, zoological, and botanical specimens which he regularly sent, year after year, to the Musée d'Histoire Naturelle, in crates that accompanied the regular shipments of iron. In 1890, the museum mounted an exhibition of his finds; several photographs of this show have been preserved and reveal an eclectic collection of stuffed animals, stones, and archaeological fragments.

The French Ministry of Public Education later sent Diguet on six scientific missions between 1893 and 1914. Diguet journeyed successively through Baja California; Jalisco and the territory of Tepic (where he studied the Huichol and Cora Indians at length); San Luis Potosí,

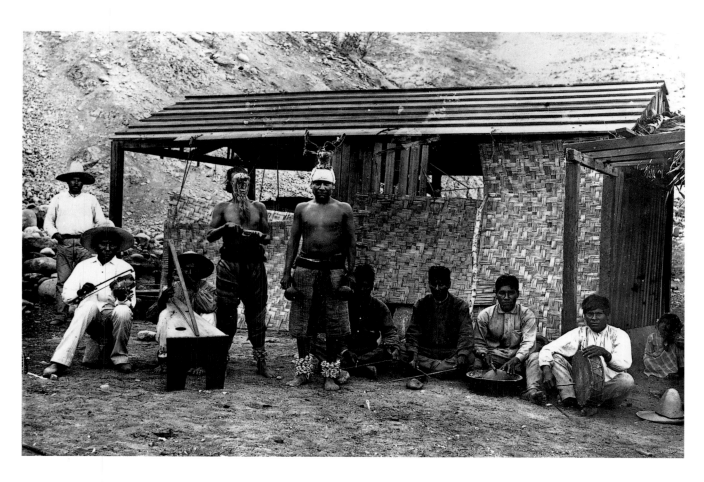

Léon Diguet
Huichol Indians, ca. 1896

Modern copy print from glass-plate negative, C.3225
Collection, Musée de l'Homme, Paris

Colima, and the northern part of Jalisco; Puebla, Oaxaca, and Tehuantepec; Michoacán and the State of Mexico; and once again through Baja California and Jalisco.[17]

Eclectic in his interests, Diguet simultaneously did research on insects, orchids and cacti, minerals and crustaceans, living Indians and archaeology. He worked extensively at archaeological sites in the Mixtec-Zapotec region and at Ixtlán del Río, Nayarit. He also studied the Huichol language, the cultivation of pearl oysters in Baja California, the history of cochineal, even the indigenous uses of the fly spider in the production of fly eggs. He investigated the properties of jojoba and analyzed in depth the multiple varieties of agave in the northern part of the country. This tireless scholar published innumerable scientific reports on these subjects, many of which were accompanied by his photographs. Diguet died in Paris in 1925 after receiving many honors for his work.[18] His collections, including a great number of negatives, are housed today—totally forgotten—in the storage vaults of the Musée de l'Homme in Paris.

For the purposes of this study, Léon Diguet is interesting as a typical nineteenth-century scientist who employed photography as a research tool. While he did not have the sensitive perception of Carl Lumholtz (who also photographed the Indians of northeastern Mexico), Diguet's images are characteristic of nineteenth-century Positivism. The followers of this philosophy proposed to present "objective proof" of their theories, but in reality they combined distanced observation with a lingering, underlying interest in the picturesque. (This is even more pronounced in the photographic work of Frederick Starr.) For example, even when his subject was a cactus plant, Diguet would include an Indian in the image. Although he did this in part to clarify and emphasize the scale of the plants (as Teobert Maler had done by including his guides in views of archaeological structures), the inclusion of such colorful "incidental" subjects as *campesinos* in typical costume or shark fishermen in threadbare trousers simultaneously transformed the botanical display into a picturesque image. In addition to photographs directly illustrating the subjects under discussion, his books include contextual images: landscapes to show the physical environment, village views, portraits of the inhabitants of a particular region that seem isolated from the texts, which are largely arid descriptions of the specimens gathered in each location, written in an academic tone that also marks the late writings of Charnay.

Diguet's most interesting photographic work is his comprehensive study of the Huichol Indians living in the mountains of Nayarit, completed in 1896—the same time that Lumholtz was working in that area. In his book *Idiome Huichol: Contribution à l'étude des langues mexicaines* (Huichol Idiom: Contribution to the Study of Mexican Languages)—in which he sets himself up as a philologist—Diguet includes views of the village of Santa Catarina, in addition to a large number of photographs of Indians dressed for the peyote ceremonies. These include frontal and profile portraits of men and women whose bodies have been ritually painted with mineral and vegetal dyes, and others more eccentric in appearance: shamans dressed in rags and women with their eyes bulging, perhaps from ingesting peyote. Diguet also shows details of their dwellings and adobe temples adorned with offerings of painted gourds and turkey feathers intertwined with braided cord. Diguet's report is extensive, representative, unindulgent, and, in the end, not terribly interesting in spite of a few visual discoveries. Among these are a photograph of the small stone temples, covered with palm fronds and clinging to the side of a steep cliff and one of a rural school in Cora territory, perhaps Diguet's best-known image. In the latter, the students obviously posed for the photographer, showing textbooks that bear the image of Benito Juárez. One student, in the last row, holds the book at eye level, as if it were more important than his face. The teacher, who stands in front of a blackboard inscribed "School No. 6," raises a rod. We might ask what motivated Diguet to take a photograph that is so obviously "Porfirian." Nevertheless, the image is intriguing, bordering, as it does, on propaganda. The bare feet of the Cora children that appear below their simple plank desks, the mortarless stone wall stretching behind them, and the traditional leather-backed chair of the teacher are details whose apparent incongruence distorts our first perception of the image. Diguet posed these Indians with pragmatic intent: to show the maximum number of elements in a single image. *La orquesta para la danza del venado de los indios cahitas yaquis de Baja California* (Musicians for the Deer Dance of the Cahita Yaquis of Baja California) is another example of this. Although static and emotionally

distant, frozen by the photographer, the subjects are impressive: nine proud expressions return the coolness of the photographer's lens as they look into the camera, staring fixedly at the same point.

Frederick Starr: *Indians of Southern Mexico*

Frederick Starr (1858–1933) earned his Ph.D. in 1885 from Lafayette College, where he studied geology. Between 1889 and 1891, he classified the collections of the Department of Ethnology at the American Museum of Natural History, moving in 1892 to establish the Department of Anthropology at the recently founded University of Chicago, where he served on the faculty until his retirement in 1923.

Starr organized numerous ethnological expeditions to Mexico, Japan, Korea, the Philippines, Africa, and the southeastern United States and prepared a number of ethnological exhibits. Among the most important of these was the *Collection of Objects Illustrating the Folklore of Mexico* that was shown in London in 1899 and a show about Japan at the Louisiana Purchase Exhibition of 1904 that included "live specimens" of Ainu people.

Frederick Starr traveled to Mexico several times and was familiar with a great number of the indigenous tribes there, from the nomadic groups in the north to the Otomí, Mixtec, and Zapotec peoples of the central and southern zones. As a turn-of-the-century Positivist ethnologist, Starr was concerned with describing and classifying artifacts, costumes, tools, ritual objects, etc. This can be seen in the organization of the catalog of the London exhibition, in which the collections are categorized into fifteen different themes, rather than by ethnic group or region.[19] According to James Oles, "Starr used the race of the artisans to distinguish be-

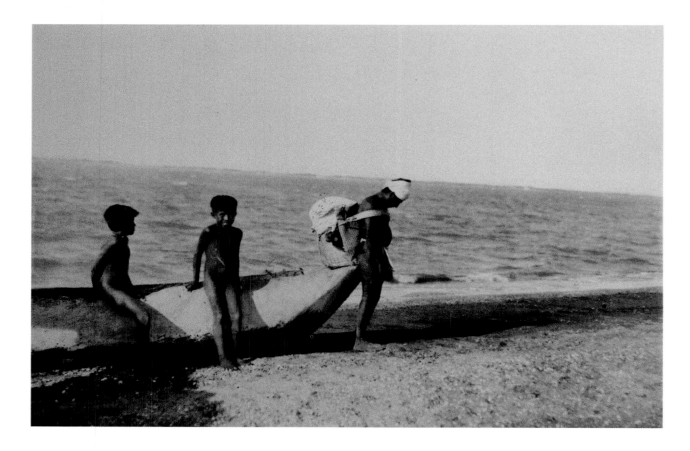

Frederick Starr and Bedros Tartarian
San Mateo del Mar, Oaxaca, ca. 1891

Gelatin silver print
Indians of Southern Mexico (1899)

tween ethnographic and folklore objects: the former were produced by Indians, the latter by mestizos . . . Starr was only interested in the latter: the materials he collected were from the less isolated Northern and Central Regions of Mexico."[20]

In 1899, Frederick Starr published an album of ethnographic photographs entitled *Indians of Southern Mexico* that can be compared with his London catalogs: the point of view and arrangement are, in fact, the same. The indigenous groups that he discusses (Otomís, Tarascans, Aztecs, Mixtecs, Triquis, Zapotecs, and Huaves) are grouped by affinities and compared using an unacknowledged scale of values defined by the excellence of their handicrafts, architecture, and other manifestations of their material culture, rather than by geography, social organization, or cultural systems.

Dedicated to Porfirio Díaz and Manuel Fernández Leal, the minister of development, Starr's book contains photographs taken by himself and one Bedros Tartarian during the course of three trips to Mexico (1896, 1898, and 1899). Like Diguet, Starr (and/or Tartarian) adhered to rules of representation that were purportedly scientific—placing the Indians in the center of the frame, in profile or staring straight into the camera—in order to record and transmit as much visual information as possible, with little interest in the "realism" of the image or the poses. Yet, in some cases, he tried to capture something more diffuse and, perhaps, essential about the people in their daily lives. He particularly excels when depicting their objects, handicrafts, methods of construction in stone, adobe, and palm, and the simple decorations of their houses.

Carl Lumholtz's *Unknown Mexico*

The photographic work of the Danish naturalist and anthropologist Carl Lumholtz is better known than that of Diguet or Starr. This is due, in part, to the success of his travel account *Unknown Mexico*. (In fact, *México desconocido,* the Spanish translation, is still used as the title of a luxurious Mexican variant of *National Geographic*.) More importantly, in 1979 Pablo Ortiz Monasterio published an album of Lumholtz's photographs from northeastern Mexico, printed from his glass-plate negatives housed at the American Museum

of Natural History in New York.[21] Ortiz Monasterio's carefully printed edition allows us to rediscover a photographer of considerable sensitivity.

Lumholtz had worked with the Aborigines of Australia, living among them for several years without contact with "civilization." After returning from that expedition, Lumholtz took an interest in the Indians of the southwestern United States, working with the Navajos, Zunis, and Hopis of Arizona. In the course of his research, he crossed the border between Arizona and Sonora in September 1890, beginning his long journey among indigenous populations of Mexico: Tarahumaras, Seris, Huichols, Coras, Tepehuans, Tarascans, and Otomís.

Lumholtz spent twelve years in Mexico, making only brief trips to New York during that period to deliver

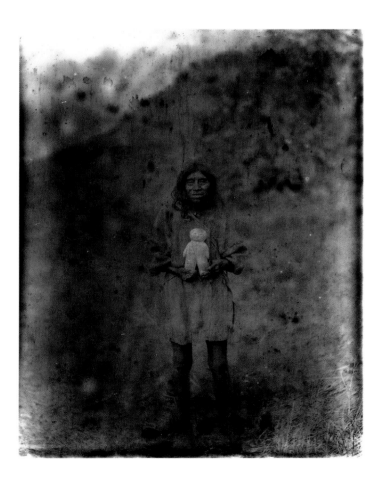

Carl Lumholtz
Felipe, Principal Maker of Idols among the Huicholes, 1890

Modern copy from collodion negative, No. 43503
Courtesy Dept. of Library Services, American Museum of Natural History, New York

lectures at the American Geographical Society, which had financed his work. Just as he had done with the Aborigines, Lumholtz spent long periods, at times years, among the Indians of Mexico. He shared their way of life, learned their languages, and became initiated in their rituals. A good singer, he used this talent to gain the trust of the Huichols with his songs. All of this he recorded in the countless reports that he published in scholarly journals in the United States.

Few nineteenth-century ethnologists devoted themselves so entirely to their research and with so much sympathy for the objects of their study. Perhaps the only comparable case in Mexico is that of Teobert Maler. Quite naturally, this approach is reflected in photography. For the first time, an ethnologist photographed more than his native subject standing stiffly beside a measuring stick—from the front, from the side, from the back—the way Désiré Charnay had done in Chiapas, Diguet in the north, and Starr throughout central Mexico. In contrast, Lumholtz recorded the Indians' everyday life in great detail. For him, a modest shrine in a cave, the Huichols' *marakämé* (shaman), and their cult objects—woven feathers, mysterious gourds—were sufficient as subjects.

Lumholtz also photographed fiestas and dances that honored the *jicuri* (the sacred peyote), corn, and the deer. The degree of confidence achieved by Lumholtz allowed him to enter holy spaces, to photograph close-up, without prejudice, his Indian friends and "relatives."

Sumner W. Matteson

Sumner W. Matteson provides an interesting example of the transition from amateur to professional photographer. This *enfant terrible* was born in Decorah, Iowa, in 1867. In 1895, following the death of his father, Matteson abandoned his studies and a banking career in the family business and moved to Denver, where he became a cycling fan. He not only sold bicycles, but used them as a means of transportation to travel through the Indian territories of the southwestern United States, an unusual feat for that, or any other, period. "Throughout the summers of 1898 and 1899 Matteson did indeed travel. He pedaled his Victor out to Fortification Rock, 22 miles north of Craig and 250 west of Denver.

There, equipped with stovepipe armor and his Kodak No. 5, he spent several weeks investigating the rattlesnake caves."[22]

Matteson spent a number of years journeying through the rugged, semidesert regions of Arizona, Colorado, and New Mexico until, in 1904, his taste for adventure led him to take a ship from New York to Havana, where he traveled—as always by bicycle—from Pinar del Río to Baracoa and the mouth of the Umari River. Matteson published articles—much in the style of *National Geographic*—in a number of U.S. publications and gained a certain fame, enabling him to finance his expeditions through the Rocky Mountains and the Sioux Indian reservation.

At the end of December 1906, Matteson went to Mexico, intending to spend three months visiting the country. In a letter to a friend, he wrote that Mexico "beats anything I've struck yet for subjects."

What Matteson "struck" in Mexico was indeed a wealth of photogenic adventures. Shortly after his arrival, he spent a week at Amecameca, photographing the rites of Holy Week during which thousands of pilgrims climbed on their knees to the top of Sacro Monte. The next month Matteson attended the winter bullfights in Mexico City. He recorded not only the glitter and courage of Bombita and Fuentes, two popular matadores, he also went behind the scenes to photograph the realities of gored horses, butchered bulls, and overweight picadores.

That spring Matteson toured the major markets of central Mexico. Rising at dawn, he set up his camera amidst the rows of fruits and vegetables, documenting the dress and demeanor of Mexican peasants, maids, and middle-class merchants. For the ethnologist or historian, Matteson's sequences on the markets of Cuernavaca, Puebla, Toluca, Morelia, Ocotlan, Patzcuaro, and Uruapan create an invaluable record of provincial life on the eve of Mexico's great Revolution.[23]

In the end, Matteson spent ten months in Mexico in 1907, traveling from Oaxaca to Colima, photographing not only scenes in the markets and on the streets, but archaeological ruins and landscapes. He returned to the United States with more than two thousand nega-

tives, which he used to publish a number of profusely illustrated articles.

Matteson's career was interrupted, for reasons that are somewhat unclear, shortly after this trip. Although he settled in Milwaukee, he continued to write about his travels.

Then, in 1920, Matteson took up photography once more, deciding, first of all, to revisit Mexico. On October 23, Matteson and several friends climbed Popocatépetl, which had very recently erupted, attracting curiosity-seekers and alpinists (among them Hugo Brehme). Apparently, Matteson stayed too long at the volcano's crater: his lungs froze. He had to be carried down from the summit and died of pulmonary edema in Mexico City on October 26.

The images that Matteson made in Mexico—portraits of children in the markets, street scenes, popular types—are presented as documentary, but are not scientific in the manner of Diguet, Starr, or Lumholtz. Rather, Matteson's photographs are situated somewhere between scientific interest and touristic curiosity, a genre that would be further developed during the 1920s.

Founding Fathers

In 1923, the recently created Sindicato de Obreros Técnicos, Pintores y Escultores (Syndicate of Technical Workers, Painters, and Sculptors) announced in its manifesto: "The art of the Mexican people is the great-

Sumner W. Matteson
Pulque Production at a Hacienda, ca. 1890

Gelatin silver print, No. M-93
Courtesy The Science Museum, St. Paul

est and healthiest spiritual manifestation in the world and its indigenous tradition is the finest of all." Although this position had been anticipated as early as 1917, if not before, the tone was set: from this moment on, Mexican intellectuals, the founding fathers of a new postrevolutionary nation and culture, would throw themselves enthusiastically into the discovery of the land, its men and women, its myths, legends, and traditions, all assumed to have been buried and forgotten during the periods of colonial and Porfirian oppression. In order to understand and appreciate Mexico— the authentic and essential Mexico—it would be necessary to investigate this "new world" that had emerged from the armed struggle. While the intelligentsia of the Porfirian period had found cause to celebrate certain heroes that predated the Conquest (as demonstrated by the statue of Cuauhtémoc erected in the Paseo de la Reforma in 1886), the new culture promoted by José Vasconcelos and the former members of the Ateneo de la Juventud of 1909 found its heroes at the margins of urban society, where they had survived by unimaginable sacrifice and struggle all the horrors and all the conquests. Without previous training, artists took the role of anthropologists: Roberto Montenegro, Dr. Atl, and Miguel Covarrubias collected and exhibited folk art; Fernando Leal, Diego Rivera, and Fermín Revueltas depicted traditional fiestas; Jean Charlot and Anita Brenner discovered idols behind altars; Adolfo Best Maugard invented a method of drawing based on the "seven primary elements" of Mexican popular art; Frances Toor compiled *corridos* and *huapangos* (Mexican popular ballads and dances) and described the popular dances of the Old Men and of the Moors and Christians; Salvador Novo and Xavier Villaurrutia discovered forgotten colonial and nineteenth-century painters in the provinces. What in the early 1920s was only an anarchic tendency (the success of which owed more to enthusiasm than to any profound knowledge of the subject) was eventually transformed into myth. In the 1930s, Carlos Chávez and Silvestre Revueltas incorporated ancient prehispanic rhythms and instruments in their compositions. In the 1940s, Miguel Covarrubias, after a long stay in New York, headed for the back roads of southwestern Mexico, where he discovered the Olmec culture: the sophisticated young caricaturist who had worked for *Vanity Fair* transformed

himself into a prominent and respected archaeologist and anthropologist. And in the 1950s, Diego Rivera ordered the construction of Anahuacalli, a Neo-Teotihuacán style museum to house the collection of Precolumbian objects that he had amassed after his returned to Mexico from Paris in 1921.

The distanced, scientific approach of the non-Mexican nineteenth-century ethnologists was superseded by an internal analysis that revalidated and aestheticized these marginal areas of the country's society. Out of this process, a unified national identity would be forged.

From the time of Cruces and Campa, Lorenzo Becerril, Sumner W. Matteson, Hugo Brehme, José María Lupercio, and Edward Weston, Mexican photography had remained fundamentally "indigenist." Cloaked in the aura of anthropology, these photographers attempted to "capture the national soul," something as inconsistent and volatile, as ephemeral and variable, as the intellectual and ideological fashions that sustained it. The photographers' works serve to validate and sustain these theories: in them, the "national soul" appears to have left its mark on the objects and in the faces, infiltrating and saturating every aspect of daily life.

The indigenous—an accumulation of rites, myths, legends, traditions, songs and dances—was incorporated into this new national self-definition. Photography became one of the principal instruments of this ideal construction called "Mexico." Like the painters and sculptors, writers and philosophers, certain photographers became converts to *mexicanismo,* while some Mexicanists became photographers. Indeed, the close relationship between Mexican photography and anthropology between 1920 and 1950 has not been sufficiently recognized. While many important works of anthropological photography were created outside the context of scientific expeditions and studies, these remained the principal vehicle of their diffusion. Among the photographer-anthropologists who worked in Mexico were Doris Heyden (second wife of Manuel Álvarez Bravo), Rosa Rolando (wife of Miguel Covarrubias), Donald Cordry, Ursula Bernath, Evelyn Hoffer, Henri Cartier-Bresson,[24] Gertrude Duby Blom, Irmgard Groth, Berenice Kolko, Laurence Salzmann, Ruth Lechuga, Eva Sulzer (companion of surrealist artist Wolfgang Paalen), and the Italian Marino Benzi, who illustrated

Fernando Benítez's *Los indios de México*. The anthropologists' curiosity also manifests itself in certain works by Mariana Yampolsky, Flor Garduño, Nacho López, Rafael Doniz, Pablo Ortiz Monasterio, Pedro Meyer, and Graciela Iturbide.

Between 1977 and 1980, Lourdes Grobet made a study of the Purépecha Indians of Michoacán in order to determine, using photography, "the effects of social change on the use of handicraft and ritual objects in indigenous celebrations."[25] A wide spectrum of nuances exists between the indulgent and essentially picturesque approach of an indigenous authority such as Gertrude Duby Blom and the perceptive and honest view of anthropological "amateurs" such as Henri Cartier-Bresson or Mariana Yampolsky.

Cartier-Bresson and Manuel Álvarez Bravo shared an interest in the anthropology of the urban landscape that was unusual in Mexican photography in the 1930s. During the fifteen months that he lived in Mexico, Cartier-Bresson shared quarters in the La Merced district of Mexico City with the American poet Langston Hughes. Cartier-Bresson's famous photographs of the prostitutes of Cuauhtemotzin Street—emerging through openings pierced in the door or their bodies entwined in bed—and the beggars or humble market vendors in passive poses have left their mark on more recent Mexican photography. This influence may extend to the works of Héctor García and Nacho López, who in the late 1940s began to photograph people on the streets of Mexico City. With his camera, López traced the displacement of elements of vernacular culture from their original environment in the suburbs into the heart of the capital itself. His work, thus, reflects what was happening in the country as more and more people migrated to the cities, and especially to Mexico City.

The street people of contemporary photojournalist Fabrizio León are, in the final analysis, descendants of Héctor García's habitués of the dance salons and the grandchildren or great-grandchildren of Hugo Brehme's *tlachiqueros* and firewood vendors. Ethnological photography has changed, yet it continues to offer—as it did in the nineteenth century—a view of Mexico from the periphery. While these images are capable of stimulating a certain "aesthetic" interest, they continue to be "curiosities" that reaffirm by contrast the validity of the bourgeois standard. They are charged with elements of magical realism (the garbage collectors of Jesús Sánchez Uribe, the ephemeral lights of Gabriel Figueroa Flores, the montages of Lourdes Almeida, Rubén Ortiz's Virgin of Guadalupe), the grotesque (Pedro Meyer's Coyoacán wedding couple), the poetics of poverty (Graciela Iturbide's women of Juchitán, José Hernández Claire's scavengers and blind people, Eniac Martínez's emigrants), or disorientation and alienation (punks photographed by Fabrizio León, Yolanda Andrade, and Pablo Ortiz Monasterio or the *braceros* of Ángeles Torrejón and Herón Alemán).

In a little-known article published in 1983, Carlos Monsiváis noted this tendency toward aesthetic anthropology in Mexican photography. While it may have originated in the work of the documentary photographers employed by the U.S. Farm Security Administration during the 1930s, it had taken a turn, in Mexico, toward a kind of "contemplative examination."

[Photographers] know that a "Mexican aesthetic" is neither possible, nor desirable. Nevertheless, they attempt to give visual definition to a collectivity [the Mexican people], to synthesize their perception of beauty, the landscape, accidents in the street, monstrosities, or the enormity of contrasts. They construct very personal visions, yet "originality" is not their primary concern.

To a concept dominant in Latin America that mystifies and denigrates poverty, democracy, and art, a photographic aesthetic has been added that, by assigning certain aspects of reality to the sphere of "contemplation" or "magical realism," neutralizes political and emotional judgments and fabricates melodramatic or dreamlike appearances. The taste of the client, lyrical desolation, and poetry all conceal a world of deprivation. This process of "photographic prestidigitation" is evident, and complex. Why, faced with corruption, the denial of law, and the barbarism of a patriarchal culture, hasn't a dedicated, strongly creative branch of photography emerged to confront these shameful conditions? First, because it is difficult to define what a photographic denouncement consists of: is it the accumulated frustration of individuals and communities? Is it exposing acts of repression or the degrada-

tion of everyday life? Is protest possible through photography? Second, because of a prevailing tendency that disdains any "aesthetic of shock or ugliness" and takes the position that, in every situation, photography is a medium for expressing beauty and achieving harmony in contexts overtly desolate and inharmonious.[26]

Paul Strand or the Creation of an Aesthetic

> In photographing native types, it is well to remember that a ragged urchin will stand just as still for 25 cents as he will for a peso.
> *Terry's Guide to Mexico* (1930)

Paul Strand was part of a distinguished group of dissident photographers that Alfred Stieglitz brought together at 291, his gallery in New York. There Strand exhibited for the first time, in 1917, a series of images that broke with the pictorialist vision of the turn-of-the-century "artist-photographers." More a disciple of Lewis Hine than of Edward Steichen or Gertrude Käsebier, Strand included urban views in his show: buildings and factories emerging from the wintery mists of the industrial city, the passage of pedestrians along Fifth Avenue and Wall Street, a blind woman wearing an enormous sign across her chest. A little later, in 1922, Strand began to photograph highly polished pieces of machinery, in a formalist mode that paralleled Weston's work in Mexico and that of Laszlo Moholy-Nagy and the Bauhaus photographers in Germany.

Apparently tired of the city, Strand left New York in 1929 and traveled west, eventually joining the artistic circle in Taos, New Mexico, the southwestern appendix of Stieglitz's artistic circle. He spent several months in New Mexico and made numerous photographs of the landscape. Then he crossed the border.

Mexico, such a short distance away, offered a means of escaping the industrialized world. In 1931, Stuart Chase had published his best-selling *Mexico: A Study of Two Americas,* in which he compared a rural Mexican village (Tepoztlán, Morelos) with a city in the midwestern United States. As might be imagined, Tepotzlán emerged triumphant in the comparison:

there, in the shadow of a sacred mountain called Tepozteco, the sounds of machines and loudspeakers and the buzz of radios were not heard. The "Aztecs" lived a happy and simple existence that had been forgotten in North America, then overwhelmed by economic crisis.

As the industrial nations began, in the early Thirties, to experience the social repercussions of the Depression, Mexico was seen by many as the model for an alternative way of life, one which stressed communal organization and ancient traditions, rather than individual competition, mass production, and effervescent fashions.[27]

As soon as he arrived in Mexico, Strand contacted Carlos Chávez, then director of the Department of Fine Arts of the Ministry of Public Education, whom he had previously met at Mabel Dodge Luhan's house in Taos. Chávez invited him to make a photographic record of folk art production in the state of Michoacán and organized an exhibition of his photographs of New Mexico in the new Sala de Arte in the as-yet-unfinished Palace of Fine Arts in Mexico City. This was the first exhibition of photography in a government-owned gallery space in Mexico. (Two years later, in March 1935, the works of Manuel Álvarez Bravo and Henri Cartier-Bresson were shown together in the same locale.) Strand's show received favorable reviews in the press and, according to the photographer himself, was visited by three thousand people in the course of ten days.

Strand was next invited by the Ministry of Public Education (then headed by Narciso Bassols) to make a series of documentary films about Mexico.[28] Strand had some background in the field, having used a movie camera experimentally in New York in 1920, when he made a short film entitled *Manhatta* in collaboration with painter-photographer Charles Sheeler. However, this early experience was not enough to allow Strand to make the Mexican film alone, and he sought the help of U.S. filmmaker Henwar Rodakiewicz, with whom he wrote the first draft of the script for a film entitled *Pescador,* later rebaptized *Redes* (Nets) and exhibited in the United States as *The Wave.* The collaboration with Rodakiewicz did not work out, and Strand was obliged to call on the well-known Hollywood director Fred Zinnemann,

Paul Strand

Cristo with Thorns, Huexotla, 1933

Gelatin silver print
© 1940, Aperture Foundation, Inc., Paul Strand Archive

who went to Mexico . . . only to learn that the Ministry of Public Education had named another director, Emilio Gómez Muriel. Strand was now to serve as cameraman. This he did, attempting to construct a film conceptually based on a series of still images.

With this antagonistic crew in place, the filming of *The Wave* began in Alvarado, Veracruz, in mid-1933 and went on for several months.

Despite the multiple directors, the film is generally attributed to Strand, and with reason. The strength of the images and the accompanying musical score by Silvestre Revueltas somewhat compensate for the faults of a typical social realist film script. The story recounts the struggle of a group of fishermen against the abuses of a capitalist fish broker and his politician-ally, despite dissent within their own ranks.

The cinematography of *The Wave* was the culmination of a style already employed several years before by the team of Eisenstein and Tissé in *¡Que Viva México!* This style would be adopted, extended, developed, and made into a simplistic cliché in other Mexican films by Emilio "El Indio" Fernández and Roberto Gavaldón, Alex Philips, and Gabriel Figueroa. Yet in 1933 it was still legitimate to exalt the muscular bodies of the fishermen, their figures registered against the intense black skies (in a kind of unreal, eternal dusk), and to juxtapose these by means of extensive cross-cutting with the near-abstract forms left in the sand by the sea's recession or formed by the nets on the beach.

Critical reception of *The Wave* in 1936 was largely indifferent. Yet Robert Stebbins wrote in *New Theater:*

I thought of Paul Strand's still photographs, perhaps the most beautiful created in our time. It seemed strange. How could a man who had spent most of his life arresting the fugitive nobility of real things, whose photographs arouse such elusive ideas and feelings in the onlooker, how could this man give voice so completely and unerringly to the forthright statements of *Redes?* [29]

Paul Strand had this response:

We assume that these pictures are not being made for subtle and sophisticated people or even very sensitive minds accustomed to follow the intricacies of esthetic nuance. On the contrary, we assume that these films are being made for a great majority of rather simple people to whom elementary facts should be presented in a direct and unequivocal way. [30]

In *The Wave,* Strand pays aesthetic tribute to Sergei Eisenstein and to Robert Flaherty, maker of the documentary film *Nanook of the North* (1922), about the austere life of the Eskimos. *The Wave,* in fact, falls somewhere between these two problematic film productions, situated between fiction and documentary. In spite of its documentary aspect, there is something of a shared Expressionist aesthetic that has probably contributed to the critical survival of *The Wave,* as well as F. W. Murnau's *Tabu* (1931), Flaherty's *Nanook of the North* and *Man of Aran* (1934), and Eisenstein's *¡Que Viva México!*

In an interview with Carolina Amor in Mexico City in 1933, a few days after his exhibition at the Sala de Arte, Strand stated that "up to now, I haven't taken any photographs of the country, waiting for the first, overwhelming impression to pass, in order to choose among so many subjects." [31]

Strand returned to New York and published a luxurious portfolio entitled *Photographs of Mexico* in 1940 that included twenty large-format photogravures, selected from the hundreds of shots made during his two-year stay in the country. [32] Paul Strand's vision of Mexico is, up to a certain point, similar to that of Eliot Porter. Perhaps this is because they came out of the same cultural setting and same photographic tradition. In a letter written from Alvarado in the fall of 1934, Strand stated:

For six months I worked at still photographs of Mexico, made about sixty platinum prints, completed and mounted them. Among other things I made a series of photographs in the churches, of the Christs and Madonnas, carved out of wood by the Indians. They are among the most extraordinary sculptures I have seen anywhere, and have apparently gone relatively unnoticed. These figures so alive with the intensity of the faith of those who made them. That is what interested me, the faith, even though it is not mine; a form of faith, to be sure,

that is passing, that has to go. But the world needs a faith equally intense in something else, something more realistic.[33]

Of those photographs, two that appear in his portfolio—*Cristo, Oaxaca* and *Cristo with Thorns, Huexotla*—are among the most expressive of his Mexican period. Anguished forms of intense suffering emerge from the semidarkness of the churches with an emotional force that is comparable, if not superior, to that of his image of twisted roots of a desiccated tree in Canada (*Driftwood, Gaspé Coast,* 1929).

The formal qualities were the important thing. Strand photographed a doorway in Saltillo, the whitewashed arch of a church in Hidalgo against an intensely black sky, isolated buildings in a plaza at Puebla . . . all

Anton Bruehl
Dolores, 1933

Collotype
© The Estate of Anton Bruehl, courtesy
Howard Greenberg Gallery, New York

treated as pure volumes, textured surfaces. Although the subjects are different, these images recall in their formal purity the machine photographs of 1915.

In the final analysis, Strand's most memorable Mexican works may be those that depict the peasantry. In a way, they extend and recall his "popular types" captured on the streets of New York between 1915 and 1919. Lola Álvarez Bravo remembered the unusual reflex camera that Strand had fabricated with a false lens in front. The actual lens was set in the side of the camera, allowing him to photograph his "subjects" unaware. This was a small, innocuous trick, yet not without importance since it violated the strictures of "pure photography" and photographic ethics. More importantly, though, this device had an effect—subtle but not insignificant—on the appearance of his work.[34]

The people in Strand's photograph are not surprised in the course of their daily activities—like those in the images of George Brassai, Robert Doisneau, Henri Cartier-Bresson, or Lola Álvarez Bravo—nor are they posing like the "types" of José María Lupercio, the Germans of August Sander, the woman carrying a fish by Manuel Álvarez Bravo, or the *tehuanas* of Flor Garduño. Rather, they look at the photographer, who (apparently) is photographing something else, but might next turn the camera in their direction. Although they have already begun to assume a pose, basically the people in these photographs are waiting. Thus, his subjects are centered in the image as if they were posed, yet appear relaxed: in *Man with a Hoe, Los Remedios* and *Boy of Hidalgo,* the subjects casually look straight into the lens of the foreign photographer working among them, but apparently paying no attention—a dubious method, yet perhaps this technique allowed Strand to avoid banality and the kind of stereotyping that was so blatant in *The Wave.* He imparts to his images a gentle tranquillity that is neither remote nor cold. It is, rather, the visual expression of that same sense of Mexican calmness and peacefulness described by Stuart Chase.

Anton Bruehl

Anton Bruehl's photographs of Mexico deserve greater attention than they have received. They appeared in an elegant—and expensive—book published by Alma

Reed's Delphic Studios in New York in 1933 entitled, like Strand's portfolio, *Photographs of Mexico.* As a result of the high price and relative rarity of this edition, the photographs were seldom seen and little known and have only recently received scholarly and commercial attention. Bruehl was born in the southern Australian province of Hawker in 1900 and was trained as an electrical engineer. In 1919, he and his brother Martin emigrated to the United States. In New York, he studied photography with Clarence White, one of the most famous pictorialist photographers in the country. Between 1910 and 1925, some of the most important photographic artists of the first half of the twentieth century attended White's New York school: Margaret Bourke-White, Minor White, Laura Gilpin, Paul Strand, Paul Outerbridge. Anton Bruehl must have been considered one of the most trusted of White's disciples since he was placed in charge of the school following his teacher's death in Mexico in July 1925, during a "photographic excursion."

After 1925, Anton Bruehl devoted himself to fashion photography, advertising, and society portraiture. In 1927, he and his brother Martin opened one of the most important photographic studios in New York.

Working primarily in the studio, he produced images remarkable for their unusual lighting effects and angles of view; their strong, simple graphic organization; their meticulous craftsmanship; and their understated humor. Although he was best known for his stylish still life and table-top arrangements for advertising illustration, Bruehl was equally adept at the celebrity portraiture and fashion photography he contributed to *Vogue.*

In 1932 *Vogue* published the first of the color photographs Bruehl produced in collaboration with the color technician Fernand Bourges. Bourges, drawing upon his knowledge of color dyes, had devised a method of making near-perfect color transparencies to guide the Condé Nast Publications. His own work represents some of the most effective color photography used in advertising and editorial illustration in that decade.[35]

Anton Bruehl's book on Mexico contained twenty-five of his images, reproduced in collotype with extreme care. (It is, to date, the best-printed book of Mexican

photographs.) Almost all the images are portraits of Indians. In a brief introductory note, the author states:

> These photographs were taken within a few hundred miles of Mexico City. They show nothing of Mexican cathedrals, public buildings, or ruins. They do not undertake to present Mexico.
>
> To me, the beauty of this country lies in the people of the land and their simple mode of living. Their faces are exciting with a strange beauty, a beauty that has in it centuries of suffering. Their eyes sparkle with a strange pride.
>
> Everywhere I found the people friendly and patient with the mechanics of the camera, and so completely unaffected that anything but a direct presentation of the scene before me seemed insincere.[36]

In market scenes, children, women, and old people appear to pose for Bruehl, unsurprised by the camera. There is considerable dignity in this approach, compared to the ruses of Paul Strand. The incredible sharpness of Bruehl's photographs illuminates details that add subtle meaning. In *La criada, Cuautla,* a woman with a stoic, embittered expression wears a medallion on her blouse with the photograph of a young man, perhaps her son, and holds a candle adorned with ribbons. Unlike the others, she does not look toward the camera, but allows herself to be photographed without losing her dignity or concentration. In *Madre de las Montañas,* another woman, her child wrapped in her shawl, seems bent under the heavy burden of her poverty, with her tense expression and lowered head. Children, on the other hand, smile and play before the camera. In the black pupils of *Dolores,* a reflection of the photographer and his tripod is visible, a curious—perhaps intentional—*mise en abîme.*

Bruehl ends his book with the sole landscape image in this series: *On the Road to Toluca,* depicting an enormous and aggressive-looking cactus, backlit before a mountainous background.

In a talk given at Delphic Studios in October 1933, José Clemente Orozco declared:

> Anything that may be expected from the art of painting is there; perfection of craftsmanship—perfection of plastic organization. And this is certainly Mexico as revealed by great photography . . . How many painters have tried to reproduce those faces, those scenes, those rhythmic movements. All in vain . . . Mr. Bruehl's work is more than reproduction.[37]

Fritz Henle

Born in Germany and naturalized a U.S. citizen, Fritz Henle lived in New York and worked for *Life* and *Harper's Bazaar.* His photographic assignments took him to Italy, Holland, China, India, and Japan. Henle first went to Mexico in 1936. During the Second World War, he worked for the U.S. Office of War Information and, in 1943, returned to Mexico "at the invitation of the government" with his wife, the Dutch dancer Atty van den Berg. On that trip, he amassed material for his book *Mexico,* published in Chicago in 1945 with a layout designed by Alexey Brodovitch, art director of *Harper's Bazaar.* The book contains images organized by contrasting pairs: urban Mexico and rural Mexico, colonial architecture and modern architecture, a helmeted pilot with an Aztec sculpture of an "eagle warrior." Diego Rivera . . . and a monstrous head from Teotihuacán, José Clemente Orozco next to an image of torturously twisted tree roots. Without doubt, the best image in the book is a portrait of Diego Rivera's model Nieves Orozco, her hair braided with yarn like a *tehuana,* her face half-hidden by the enormous leaves of a banana plant. Henle's documentary book has the look of a typical product of the period directed to the general reading public. It is a kind of souvenir, like a selection of enlarged postcards.

Luis Márquez: *Mexican Folklore*

The son of a theatrical agent, "Luis Márquez was born into show business."[38] He started making photographs in 1921, at the photographic workshops of the Ministry of Public Education, where, like many intellectuals and artists of the period, including Miguel Othón de Mendizábal and the musicologist Francisco Domínguez, he received anthropological assignments, including one that sent him to the pilgrimage center of Chalma:

> That obligatory excursion signaled his destiny: he

Fritz Henle
Untitled

Reproduced as double-page layout in *Mexico* (1945)
Courtesy Maria Henle

was dazzled by the festival at Chalma with its seventy groups of dancers, to the point of faintness . . . he was completely overcome . . . [experiencing simultaneously] an anguished sensation that he was profaning something, a feeling of tenderness, and a sense of urgency to appropriate and possess the splendor he had witnessed . . . Following the experience in Chalma, Luis Márquez decided to explore Mexico photographically.[39]

A man of the theater and collector of vernacular costumes, Luis Márquez carried stereotyping, the dramatization of "lo mexicano," to an extreme level of hyperaestheticization that would not be seen again until the video clips broadcast when Mexico hosted the World Cup in 1986. The antecedents for such imagery can, however, be traced back to the nineteenth-century iconography of the "popular types."

In 1933, at the same time that Strand was working on *The Wave,* Márquez made a film entitled *Janitzio,* directed by Carlos Navarro with cinematography by Jack Draper. Márquez shared Stand's taste for stylizations and sharp angles that isolated elements and ge-

ometrized the effects of late-afternoon light; the film's aesthetic should, perhaps, be attributed more to Márquez, as producer-photographer, than to the director or cameraman.

After this brief incursion, Márquez left film-making. Like many photographers of his generation, he devoted himself to book illustration and magazine work. He also made many photographs destined for production as postcards by the Eugenio Fischgrund company, for whom he also made the images published in *Mexican Folklore,* an album of photographs that has become, in many respects, an archetype.

A Tarahumara Indian with greased skin, staring at the empty plains, leans lightly against his bow. His perfectly pleated loincloth might have be painted by Andrea Mantegna. On the next page, the same chief wraps himself in his sarape, in a pose that might be called "Napoleonic."

Márquez's Indians are recontextualized, sometimes in the most fantastic and absurd ways imaginable. A Huichol Indian from Jalisco poses in front of the cupola of a colonial church, brandishing his bow as if he were about to shoot . . . at what? The church bells? A

girl from Janitzio seems to be tanning herself, eyes shut, at the edge of Lake Pátzcuaro as though she were in Acapulco. Márquez's subjects exchange looks, their repeated profiles like those that appear in Roberto Montenegro's *Maya Women,* a painting of 1923. The Indian always appears with head held high, chin firm, indicating the promising future of this country that the camera has transformed into an idyllic, if kitsch, scenario. We are closer here to the calendar art of Jesús Helguera than to the paintings of Saturnino Herrán; we are made hyperconscious of what the revindication and aestheticization of the Mexican Indian has meant. Even when carrying baskets or jugs, Márquez's Indians observe the world with a lofty disdain.

Among Márquez's simplest and most poetic photographs is one showing a harpist from Guerrero, seated languidly on the edge of a fountain, wearing leather cowboy chaps, looking down with a sweet, sad expression. As in many of Herrán's models, a certain homoeroticism can be detected. This is also visible in Márquez's portraits of seminude fishermen on the Oaxacan coast: easy prey for a ready camera.

Agustín Jiménez and Ricardo Razetti

The aestheticization and theatricalization of the Mexican Indian had its origins in the contradictory contributions of Edward Weston and Sergei Eisenstein, which became misunderstood and distorted with the passage of time. Although the photographic works of Luis Márquez may represent the paragon and culmination of this trend, he was not the only defender of this ideal/unreal vision of the country. During the 1930s, many members of the Club Fotográfico de México—in particular Agustín Jiménez, an early disciple of Manuel Álvarez Bravo and a close friend of that inveterate defender of the popular arts Gabriel Fernández Ledesma—also contributed to the consolidation of national myths, by means of symbolic reconstruction.

At the time, the film critic Agustín Aragón Leiva noted:

> Agustín Jiménez is an extrovert. This defines him. I admire his aggressive, almost brutal, nature . . . very photographic: his well-calculated tonalities, interesting subjects, and the fluidity of his discoveries.

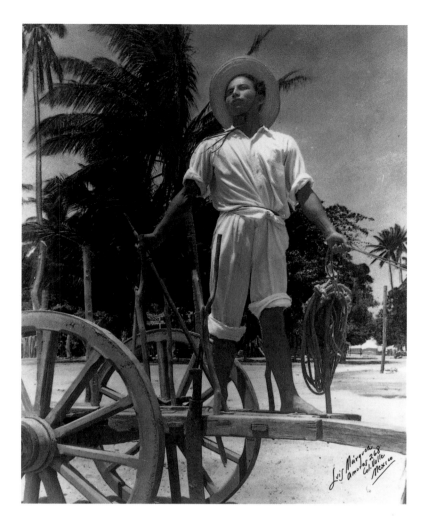

Luis Márquez
Campesino de Tehuantepec, ca. 1945

Gelatin silver print with applied color
Center for Southwest Research, General Library
University of New Mexico No. 998-010-0003

> He has sailed the seven seas; it is not surprising that he has discovered new worlds.[40]

Although primarily a photographer of the 1930s, Jiménez began working in the late 1920s, commissioned by various art magazines. His portrait of the painter Máximo Pacheco as "the art worker," with a stevedore's cap and a red star on his shirt, was first published in *Mexican Folkways,* along with photographs by Tina Modotti and Manuel Álvarez Bravo. In 1931, he had his first one-man show at the Galería Moderna, organized by his close friend Gabriel Fernández Ledesma and supported by a lapidary statement from Sergei Eisenstein: "I believe that Agustín Jiménez is a great photographer and I appreciate his excellent work."

A few weeks later, Jiménez was invited by Agustín Aragon Leiva to the Hacienda of Tetlapayac, where

Eisenstein was living, filming his epic of Mexican history. There he took a series of remarkable portraits of the Soviet filmmaker playing with a Day of the Dead sugar skull bearing the word "Doly" (perhaps an anagram for "idol" and a cryptic reference to Anita Brenner's book).[41]

No evidence has been found to support the assertion, by some, that Jiménez worked as an assistant to Eisenstein, although he may have been strongly influenced by the work of Russian photographers and by Eisenstein's ideas on composition. Later that same year, Jiménez was awarded third prize in the Tolteca cement company's competition to celebrate the inauguration of the British-run factory in Mixcoac, a suburb of Mexico City. His image of the tall double chimneys of the factory, elongated through a cloudy sky, recalls Aleksandr Rodchenko's compositions using trees and architectural elements. The Mexican photographer may also have been influenced by Edouard Tissé, Eisenstein's celebrated cameraman. Jiménez worked in cinema himself and, in the 1930s, filmed Adolfo Best Maugard's movies *Humanidad* (a documentary on orphans in Mexico City) and *La mancha de sangre,* a sexy thriller that initially failed to pass the censors. In both cases, his camera work strongly resembles Tissé's. In *La mancha de sangre,* for example, he systematically shoots the cabaret tables from above, showing only the hands of the drinkers moving atop the debris of the banquet.

Foto magazine published a cover photograph by Jiménez of a demonstration that recalled, in its composition and multiplicity of planes, the organization of certain of Diego Rivera's murals and Tina Modotti's photographs of 1927–1929. Based on his characteristic use of extreme close-ups, tending to abstraction, which recalls the early work of Paul Strand, as well as the work of Moholy Nagy and Rodchenko, Jiménez might be considered one of the truly "modernist," even avant-garde photographers in Mexico.[42]

Ricardo Razetti was one of the leaders of the Venezuelan student movement that opposed the dictatorship of Juan Vicente Gómez in 1928. As a result of his militant stance, he was exiled and spent one year in Madrid. He returned to Venezuela in 1936 and founded the Caracas newspaper *El Popular.* Once again, he was forced to emigrate, going to Bogotá, where he enrolled in the School of Fine Arts. In late 1937, he joined his mother and sister in Mexico and entered the National School of Fine Arts (Academy of San Carlos), taking classes with Lola Álvarez Bravo. In 1940, he worked with Manuel Álvarez Bravo on the production of movie stills. His work was included in the exhibition *Mexican Art Today* at the Philadelphia Museum of Art in 1943, along with that of Álvarez Bravo, Doris Heyden, and Antonio Reynoso. Returning at last to Venezuela in 1946, he worked to promote the recognition of photographic arts in that country until his death in December 1961.

Forgotten for many years, his work—very similar in conception to that of Agustín Jiménez—recently has been rediscovered in his native country. Razetti's work shows the influence of Lola Álvarez Bravo more than Manuel Álvarez Bravo, particularly in his manner of framing an image, as well as his choice of subjects. One portrait, of Isabel Villaseñor leaning against a tree on the beach at Cihuatlán, Jalisco (*Mujer sobre un raíz*), has created some confusion, since it is almost identical (there is only a slight variation in the framing) to an image by Lola Álvarez Bravo entitled *El ensueño* (The Daydream).

For 25 Cents . . .

The Polish photographer Berenice Kolko, who published two books of Indian portraits in the 1970s, has worked in this same vein. As Lázaro Blanco pointed out:

> Her images, all of a documentary nature, are at times resolved in a mannered style and sometimes are defective in technique. They belong to a kind of photography that does not reach the fullest expression possible in the medium, but one which is simplistic in its aesthetic concepts, emphasizing illustrative qualities rather than the intrinsic potential of the subject.[43]

Poorly reproduced in a few books and in cheap magazines, Kolko's images cannot be fully appreciated. Nevertheless, her work has been praised by some critics, in recognition, perhaps, of her being one of the very few women photographers working in Mexico at the time.

A full discussion of the many photographic studies of faces, gestures, and poses which have multiplied in

Mexican photography since the 1970s is outside the scope of this book. Suffice it to say that these form a panorama, however incomplete, of the Mexican condition. In their way, they continue the series of "tipos mexicanos" initiated by François Aubert and Cruces and Campa and remain the principal theme of photographers. This is particularly true of those—such as Tina Modotti, Paul Strand, Henri Cartier-Bresson, Manuel Álvarez Bravo, and Lola Álvarez Bravo—who have sought to depict Mexico as broadly as possible, discovering the unexpected while reaffirming the "exotic" and "fantastic" qualities of the country and its inhabitants.

These works range from the stereotypes presented by Rafael Doniz in his series *Homenaje a August Sander* (in which, like the German post–World War I photographer, he poses his subjects—butchers, masons, intellectuals, etc.—in front of a neutral backdrop in coldly calculated poses) to studies of indigenous groups by Nacho López, Doniz, Pablo Ortiz Monasterio, Mariana Yampolsky, Flor Garduño, and others. More recently, a younger generation of photographers has used Mexican lottery cards in the images and made updated series of urban "popular types" living at the margins of society: hustlers, prostitutes, etc.

The broad outlines of two major tendencies related to the photographers' attitudes toward their subjects/objects can be detected in this visual material. Mariana Yampolsky, perhaps, most clearly characterizes the distanced and respectful, somewhat cool gaze of the mid-twentieth-century anthropologist-photographer who attempts to show reality as it is. At the same time, she is aware that she has not completely effaced her point of view or some degree of aestheticization of her subjects. Nacho López, essentially an urban photographer, shares with Mariana Yampolsky and Flor Garduño a certain distance and defines his position as mere observer. In the prologue to his book *Los pueblos de la bruma y el sol,* Nacho López clearly expressed this preoccupation:

> To place your eye on the viewfinder, frame the subject, and press the button is easy if you consider the folkloric your principal motif. They are behind bars, we are on the outside. Reversing the image, we become the captives.
>
> Trapped in another reality, we conceive an imaginary world according to the prejudices of a social class that does not enter into this "magical" world (a pretentious, poetic idea) that in reality consists only of injustice, hunger, repression, and isolation.
>
> In order to reclaim an ethnic nationalism, historians and anthropologists have written lengthy essays about the cultural richness of the country. Sociologists and economists create projects to correct the situation of marginalized groups and a bureaucracy that has forgotten its own class origins carries out these programs according to the bosses' political dictates of the moment. For true Mexicans, only the hope remains that one day they will own their land; for now they have withdrawn to the mountains.
>
> The delegation of filmmakers, photographers, and researchers arrives on the scene and is received by the mayor . . . "We want this and that, you are important and will see yourselves in magazines, books, and films . . ." The silent Mexicans exchange sidelong glances and consent . . . "if the government asks, it must be an order . . . we'll lodge them, but what good are films and photos if nothing changes? . . . We worked in cooperation with the 'explorers' and three days later they left us, satisfied . . ."
>
> I haven't managed often to spend long periods of time in communities and villages. For this reason my photographic vision of them remains limited. The images in this book are only a timid approximation with the Mixe people who allowed me to share something of their lives, always at a respectful distance. It is obvious that many aspects of their lives are not pictured here: indications of the repression and violence that these people have suffered in defending their lands. My photos are but a record and a hope, divested of any trace of folklore.[44]

Nacho López was wrong: his photographs are folkloric because they are so distanced, respectful, and timid. Never denigrating, they reflect López's concept of anthropological photography and are indeed absolutely correct from an ethnological point of view.

At the other extreme, some photographers do not require such distance. They assume, outright, the ironic hypocrisy of their presence as witnesses. By doing so, they are freer with their subjects, even when this liberty sometimes leads to a renewed stylization (employed here as a vehicle of communication and a supposed

Mariana Yampolsky
San Miguel de las Tunas, Hidalgo, 1980

Gelatin silver print
Courtesy Mariana Yampolsky

Pablo Ortiz Monasterio
Popocatépetl—Gregorio, 1993

Gelatin silver print
Courtesy Pablo Ortiz Monasterio

Lorenzo Becerril
Woman of Tehuantepec, ca. 1876

Albumen print
Private collection, Mexico City

recalls Anton Bruehl's Mexican images. Ortiz Monasterio was not interested in idealizing the fishermen in themselves, in glorifying (like Strand) their heroic efforts, or in situating them in a fictitious cultural horizon. The landscape of his photographs is filled with trashbins and plastic bags, cans, oil drums, and barbed wire. San Mateo del Mar might as well be a suburb of Mexico City, since, in the final analysis, the fishermen here also live in a world linked and defined by radio and television. Pablo Ortiz Monasterio is basically an urban photographer who makes no attempt to forget his origins (including his upper-class origins) or to suppress them in a futile quest for "purity." With these images, Ortiz Monasterio takes up the thread of Mexicanist photography introduced by Manuel Álvarez Bravo. This interpretation has been accepted by critics, particularly in the United States, as an exhaustive definition of the work, often to the detriment of other and more profound readings. By assuming this aestheticizing manner, Ortiz Monasterio rejects direct testimony, the photographic document per se, in order to create a representational photograph at the border of fiction.[45] This is not unintentional. Pablo Ortiz Monasterio's work has evolved from a kind of anthropological photography to sophisticated photographic compositions in which narrative elements are emphasized.

Women of Juchitán

In 1873, Lorenzo Becerril, who had operated a studio in Puebla since the 1860s, began producing a series of picturesque "types." Unlike his contemporaries Cruces and Campa, Becerril photographed his subjects *en plein air* in the various regions that he visited. The best-known of these were taken in Tehuantepec and portray women in fiesta dress, with their fanlike headdresses of starched white lace that the artist Saturnino Herrán made famous—almost mythic—in a portrait of his wife painted in 1914.

Becceril made an odd portrait in Tehuantepec: a *tehuana* in costume, standing in a luxuriant garden with banana trees behind her; on the ground, a branch suggesting the Edenic serpent appears to slither forth. Just as the *tlachiquero* is defined by his pose (head hidden among the blades of the maguey plant), the *tehuana* is defined by her costume.

dignification of the natives). This is the approach taken by a several of the present generation of photographers: Graciela Iturbide, Flor Garduño, and Carlos Somonte. More than anyone else's, the work of Pablo Ortiz Monasterio is characteristic of this current.

The book *Los pueblos del viento: Crónica de mareños* (1981) from the series of anthropological monographs that he edited for the Instituto Nacional Indigenista provides the perfect counterpoint to Nacho López's work. On that occasion, Ortiz Monasterio worked with the Huave fishermen of San Mateo del Mar, in the municipality of Juchitán. His photographic essay is distinguished by a systematic use of the wide-angle lens and profound depth-of-field, sepia toning on grainy prints, and low vantage point. Aesthetically, the work

It all began around 1854, when Brasseur de Bourbourg was sent as a sort of spy to Mexico by a French company. His mission: to investigate the possibility of digging an interoceanic canal in the region. The Isthmus of Tehuantepec was already a locale for commercial transit as well as U.S. tourism. It was relatively easy to cross the continent from the town of Coatzacoalcos to Salina Cruz using canoes along the various rivers that flowed into the Coatzacoalcos River. Published after his return to France, Brasseur's observations enjoyed a measure of success and in a positive way influenced public opinion regarding Napoleon III's interventionist plans for Mexico.

However, many decades and projects for canals and monumental railway networks to carry the ships from one ocean to the other as well as other schemes would come and go before Tehuantepec was fully admitted into the mythology of Mexico. The eccentric costume of the women contributed greatly to the popular image of the region, with the *tehuana* gradually attaining the exotic status of the *china poblana*. Naturally, this unusual and elaborate costume also attracted the attention of photographers. The attire of the women of Tehuantepec, after all, is absolutely novel and belongs to no other culture. Spanish (or Gypsy) in concept, it possesses both Asian and Precolumbian elements and, simultaneously, something of the European Baroque.

An interesting comparison can be made between the late-nineteenth-century images of Tehuantepec and those by twentieth-century photographers: Edward Weston and Tina Modotti, Manuel Álvarez Bravo and Lola Álvarez Bravo, Sergei Eisenstein and Edouard Tissé, Flor Garduño, Rafael Doniz, Pablo Ortiz Monasterio, and Graciela Iturbide, among many others. Between the first wave and the second lies the mythification.

In 1884, the North American photographer William

Winfield Scott
Mexican Girl with Harp, ca. 1900

Gelatin silver print
Center for Southwest Research, General Library
University of New Mexico
No. 000-170-0019

C. B. Waite

Tehuantepec Woman. Velvet and Gold, ca. 1900

Gelatin silver print
Center for Southwest Research, General Library
University of New Mexico
No. 998-010-0001A

Henry Jackson followed the route of the Mexican Central Railroad to its new terminal at Salina Cruz, on the Pacific coast at Tehuantepec. Specializing in landscapes and panoramas, Jackson was not really interested in the inhabitants of the Isthmus. Instead, he focused his camera on the natural environment and works of engineering that enabled the railroad to move its trains south from Oaxaca to the new port on the Pacific. Nevertheless, he made several images of *tehuanas* bathing along

the banks of the rivers, thus introducing a theme that would be repeated time and again by other visiting photographers, evoking a certain sensual, Gaugainesque vision of the region.

Charles B. Waite and Winfield Scott,[46] North American photographers who were very active in Mexico during the late nineteenth and early twentieth centuries, also traveled to the Isthmus. Scott made an extensive visual record of life in the villages around Oaxaca. Some of these images can be found today, pasted into albums housed in the library of the old Academy of San Carlos in Mexico City. They depict *tehuanas* (not a single male appears) carrying out daily activities: washing clothes in the river, feeding animals, and—of course—grinding corn, one of the favorite, stereotypical themes of photographers and some painters working in Mexico (including Rivera and Siqueiros) until well into the twentieth century. Scott identified the women by their names (Gloria, María, etc.)—something new—but did not indicate where the photographs were made. Centered, and sometimes quite candid, these images can be considered archetypal examples of a particular manner of depicting Mexico photographically. By including something of the natural setting (the disorder of the dirt yards, the corrals made of sticks) under strong and unrelenting sunlight, Scott gave an indication of the poverty in which the Mexican *campesinos* live. These photographs might be compared with the brief series of images made by Jackson in the village of El Abra. Scott seems to delight in emphasizing the dusty surroundings and the conditions of life, rather than describing—as did more educated travelers (Brasseur de Bourbourg being the first)—the benevolent climate, the exuberant vegetation, the characteristics that allowed these women to live outside, half-naked.

Waite, too, made photographs in Tehuantepec, less direct and showing less squalor than those of Scott. Yet the themes are more or less the same: women in the river, washing clothes, etc. He also made photographs of actresses dressed as *tehuanas* at his studio in Mexico City, an easier way to affirm the myth.

The Revolution was a cultural watershed. In 1920–1921, *tehuanas* appeared for the first time on stage, in reviews at Mexico City's Teatro Lírico. In one of the earliest of these, in late 1920, Dolores Martínez del Río (the future Dolores del Río) incarnated the role in a

production with scenery painted by Roberto Montenegro. Diego Rivera went to Tehuantepec in mid-1922, on the advice of José Vasconcelos, and from this experience came the images for his murals in the Patio of the Fiestas at the Ministry of Public Education, not to mention a certain contagious fascination with the region that manifested itself in Frida Kahlo's style of dress after her marriage to the painter in 1929. The self-creation of Frida as *tehuana* is merely the culmination of a long process.

A number of myths have been created about Tehuantepec that impart to the region a certain reputation as a place of encounters: its benign climate, its (supposedly) matriarchal and sexually liberated society, and—of course—the geographic possibility of intercoastal, interoceanic communication.

In the days following the death of Julio Antonio Mella, Tina Modotti went to Juchitán. Deeply hurt and perhaps in shock, Modotti saw—as had other photographers before—the women bathing in the river, washing their clothing, nursing their children, smiling. Yet there is something pathetic in her few photographs which is entirely absent in the images made by Eisenstein there the following year: the virgin wilderness, the jungle, wild animals, parrots, monkeys, even a jaguar, provide a "Tarzanesque" backdrop to the lascivious life of the women of the Isthmus, who apparently, if we are to believe Eisenstein's script, only care about self-adornment. On the steps of a church, on a Sunday in Tehuantepec, a mass of *tehuanas,* the wind gently blowing their lace . . . With that one spectacular scene, Eisenstein and Tissé synthesized the poetry of the Isthmus.

Then, in 1934, Manuel Álvarez Bravo, Lola Álvarez Bravo, and Henri Cartier-Bresson traveled to the same region. There Manuel Álvarez Bravo made *Tehuantepec,* his only—and unknown—film. He also made at least two portraits of Juchitec women (Señorita Juaré and Señorita Baudelia) that in their soft focus and frontal point of view are somehow reminiscent of the posed portraits by Constantino Sotero Jiménez, whose studio was located in Juchitán.[47]

Lola photographed two women embracing in a doorway. *La visitación* (The Visitation) is a beautiful image, comparable in its use of chiaroscuro and tender eloquence to Manuel's *Retrato de lo eterno* (Portrait of the Eternal). During this same trip, Lola also made one of her most interesting portraits: of the mother of writer Andrés Henestrosa.

Rosa Rolando offered a radiant vision of Tehuantepec, where she traveled in the early 1940s with her husband, Miguel Covarrubias, and the anthropologist Donald Cordry. The couple had recently returned from Bali, where Covarrubias had carried out anthropological studies with a grant from the Guggenheim Foundation. He was planning a new project, which culminated in his *Mexico South: The Isthmus of Tehuantepec* in 1946.

In her own photographs, Rolando, a former dancer and artist's model, portrayed the women of the Isthmus wearing their costumes, always smiling—when not bursting with laughter. Some images seem to express surprise at the casualness of the local customs: two men walk down the street holding hands; the women of Ixtepec, their trays filled with sweets and fruit, move toward the cemetery on the Day of the Dead while others dance among them or prepare food for the fiestas without ever ceasing their flirting.

Yet Rolando also saw and captured other, more political aspects of life in the region and thus served as a sort of precursor to what happened during the 1980s, as a result of the situation there following the electoral success of the Ayuntamiento Popular de Juchitán (Popular Council of Juchitán) and the creation of COCEI (the Worker-Peasant-Student Coalition of the Isthmus).[48] Back in the 1940s, Rolando had photographed General Heliodoro Chariz delivering a speech in Zapotec in the Juchitán City Hall at a march in honor of a labor leader, a young *tehuana* carrying a textbook . . .

In 1982, the election of Leopoldo de Gyves, COCEI's candidate for mayor of Juchitán (which had the first socialist city council in Mexico), unleashed a broad popular movement that was met by acts of repression and violent demonstrations. The presence of the famous Mexican painter Francisco Toledo assured that the Mexico City press would give ample coverage to the political situation in the distant southern city. Many photographers were also attracted to Juchitán by these events, among them Rafael Doniz, Flor Garduño, Graciela Iturbide, and Pedro Meyer. Each spent a several weeks there and returned on a number of occasions, working in direct cooperation with the people of the region. Many of their images, particularly of the marches and demonstrations, are similar and can be

Graciela Iturbide
Mujer de cera, México D.F., 1972

Gelatin silver print
Courtesy Graciela Iturbide

considered photojournalism. Iturbide and Doniz, in particular, took several images in the same place, at the same moment. In recent years, the photographer who has worked most in Juchitán is Graciela Iturbide.

Graciela in Juchitán

Unlike many photographers who seek an immediate and coldly impersonal visual record (as a sign of objectivity) or those who station themselves as observers of the passage of time and await what Cartier-Bresson called "the decisive moment"—that instant in which several elements (framing, vantage point, light, movement) come together to make a composition, a pic-

ture—Graciela Iturbide plays, subtly, with appearances in a way that delicately reveals the ambiguities of the photographic medium.

One early photograph by Graciela Iturbide offers clues as to her particular way of working. A woman (probably a prostitute) smokes a cigarette on the terrace of a café. The woman seems caught at a meaningful moment, with an unbecoming look on her face, a fixed expression, a slightly upraised hand. One can only applaud the photographer for choosing this exact moment to shoot the picture. Yet the image seems too routine, almost banal, and for this reason, perhaps, it is surprising in a way that is difficult to explain. There is something remote and tough about it that lends it an air of unreality, as if something were lacking. Looking

Graciela Iturbide
Lagarta, from the series
Juchitán de las mujeres

Gelatin silver print
Courtesy Graciela Iturbide

more closely, one notices the absence of smoke from the cigarette.

In fact, the photograph was taken in Mexico City's wax museum and the woman is just a mannequin. The black-and-white photograph decontextualizes the sculpture, giving it a "life" it never had in that attic of fetishes, the Museo de Cera.

While many choose to ignore the ambiguity inherent in the photographic medium (preferring to believe in the absolute adherence of the image to its referent), Graciela Iturbide strives to reveal it in subtle ways—sometimes almost invisibly—and makes it central in her work. This is more than a way of seeing: the photographer uses ambiguity to introduce a deliberate dis-

tance. This game of appearances is characteristic of much of her photographic work. She often portrays people in costume or making faces. They seem to be trying to express—through their accomplice, the photographer—something that they would like to be, but are not.

Juchitán de las mujeres, published in 1989, is the result of ten years of work, countless trips to Tehuantepec, and long periods living with the people of the Isthmus. It is the product of an attempt at understanding, of sympathy and friendship with those photographed. Graciela Iturbide not only went to Juchitán, she lived there. In the broadest sense, she was in the place and of the place, was loved and hated there, as she discovered

and was discovered by the town and its inhabitants. That made all the difference. She took her time, and her images are free of that sense of "opportunistic ambush" so typical of photojournalism. We find no "decisive moment" here, no synthetic or shocking image. No one is here by chance; everyone arrived prepared for the photograph to be made. They look into the lens, flirting with the camera. They enjoy being photographed. One woman turns her back, wanting to show the long hair that she combs with care every morning. Another, sick or perhaps dying, allows her portrait to be made in bed, but we do not get the feeling that Iturbide has violated her privacy: the photograph is a dialogue between two women. The fat woman laughs, clutching her beer bottle, and the iguana vendor seems

to defy us from beneath her reptilian crown. A child plays hide-and-seek: if-you-see-me-take-my-picture. Even a goat, at the top of a ladder, opens its eyes wide and seems to pose.

Another image in *Juchitán de las mujeres* shows two women standing on either side of a wooden alligator. At the edges of the photograph, surprisingly, appear hands. They belong to people who, although not included in the picture, still wanted to manifest their presence.

Beyond their purely descriptive aspects, these photographs offer themselves as a sincere (if cautious and modest) exercise in reflection on how, when, and why to make a photograph.

Detritus Federal

The "popular types" of Aubert, Cruces and Campa, and Lupercio represent marginal people in a Mexico City undergoing continual transformation and, for this reason, are symptomatic of the modernization of the country, as Luis González has pointed out. Many of the policies that were extended to the rest of the country had, since the beginning, been drawn up in the city, by the city, and for the city.[49] The unbridled growth of the metropolis, controlled from the close of the *porfiriato* through the first decade of the postrevolutionary period, began to overwhelm the government's resources around the mid-1930s, became a serious problem in the 1940s, and accelerated greatly in the 1950s and 1960s—finally booming to a state of anarchy. In 1973 or 1974, long lines began to appear at bus stops, making it necessary to reevaluate public transportation systems and plan better routes, stations, boarding platforms. As a result of the oil boom during the administration of President José López Portillo, Guadalajara, Toluca, Cuernavaca, Tijuana, Acapulco, and Villahermosa began to share these problems with the capital. Then, in the 1980s, things became apocalyptic.

November 19, 1984: San Juanico, State of Mexico. A gas tank explodes, killing the inhabitants of the neighboring slum.

September 19, 1985: Mexico City is paralyzed by an earthquake and fear. The city counts its dead and reemerges from its partial destruction.

Héctor García
Navidad en la calle, 1948

Gelatin silver print
Courtesy Héctor García

To the quickening rhythm of changes that have transformed a city into a phenomenon, the inhabitants of the capital emerge in Mexican photography. We are also transformed from the moment that we accept living in this amorphous Federal District of smog and limitless trash dumps, endless lines, death, solidarity, and solitude. More aggressive than Henri Cartier-Bresson's 1933 photographs of prostitutes and pimps on Calle Cuauhtemotzin, the images made in Mexico by New Yorker Helen Levitt in 1941 could be considered precursors of a way of representing urban poverty, without yielding to the bucolic and complacent vision of "Old Mexico." Her images of children playing in open streets, of figures caught between gasoline pumps, trucks, and Coca-Cola signs (in some ways reminiscent of Lola Álvarez Bravo's work), are quite distinct from other photographs on Mexican themes during that period and more akin to late-twentieth-century photojournalism.[50] A sense of ecology (first vague, then overt by the early 1990s), along with an intention to recognize, define, and even reform the city from within, motivated a number of photographers—in particular photojournalists working in the style of Nacho López, Héctor García, and Pedro Valtierra—to disseminate their images thorough space made available to them in newspapers, especially *Unomásuno* and *La Jornada*.

Nuevas grandezas mexicanas

Salvador Novo's *La nueva grandeza mexicana* is a nostalgic text in which the former chronicler of the 1920s reminisces about the evolution of the city, about the changes—still subtle—in how it looked. The first edition was not illustrated, but Héctor García was commissioned to take photographs for a new edition in 1954, and, several years later, photographer Pedro Bayona used another text by Novo in his own book of Mexico City photographs, entitled *Imagen de una ciudad* (1967). García included views of the city and, most notably, images of dancehalls where virtuosos danced the *danzón* and cha-cha-cha. There is still a certain "provincial" languor in these evocations of the postwar metropolis. But Bayon's images represent accumulation, a city of masses who are no longer peasants. The book emphasizes contrasts through juxtapositions: faces on the street of dolls in the flea market

(the cover image), feet in San Juan de Letrán and shoes in a shop window, hats in the market and on Avenida Madero, cars on Avenida de la Reforma and carousels in Chapultepec Park, bureaucrats in Sanborn's and decorative lights hung for the Independence Day celebrations on September 16. Already, in the late 1960s, there are too many people, too many buildings, too many poor people on the benches, too many signals, and too many lights in Bayona's photographs, and Novo's prose has also become more nervous, less nostalgic. This time, he offers no defense of things past.[51]

The city is transformed and transforms its habitants. It is no small paradox that the new generation of photographers, like those of the nineteenth century, chooses to reveal the marginal aspects of the city: Ciudad Neza, the hills of Tacubaya, and the already decrepit outlying industrial zones of Tlalnepantla and Emiliano Zapata, where Jesusa Palancares, Elena Poniatowska's heroine, took refuge in her old age. With the notable exception of Pedro Meyer, who focuses his attention on the private vices of the middle class, Mexican photographers continue to be anthropologists in search of an ever more improbable identity (national, urban, resident of the capital, or whatever). Some travel through the darkness of night (Héctor García, the late Agustín Martínez Castro), or breach the borders of acceptability (Fabrizio Léon, Sarah Minter, Adrián del Angel, Pablo Ortiz Monasterio, Yolanda Andrade), or pick at the perimeter of dilapidated identities (Francisco Mata Rosas, Armando Cristeto, among many others). The genres have become confused: imagery that in 1960 still pertained to photojournalism is now considered part of a "photographic essay" and enters through the front door of galleries and museums. Pedro Valtierra, Christa Cowrie, Frida Hartz, Francisco Mata Rosas, and Víctor León Díaz (all former photojournalists) now ignore the news, devoting their energies almost exclusively to roaming the streets in search of that element of daily life that will represent, in the broadest sense of the concept, the tensions characteristic of the here and now.

Pedro Meyer—aggressive, irreverent, even violent, "abrasive and belligerent" according to Spanish photographic historian Joan Fontcuberta—has since the 1970s portrayed other residents of Mexico City, characters who do not fit within an image of street life that has quickly become clichéd, even banal.

Meyer is a promoter of Mexican photography and

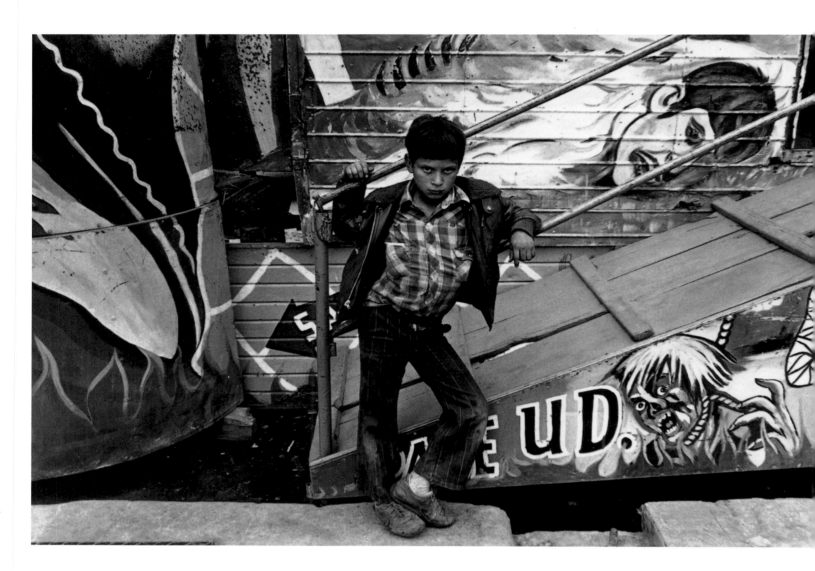

Yolanda Andrade

El niño y el infierno, 1985

Gelatin silver print
Courtesy Yolanda Andrade

one of the principal persons responsible for the creation of the Consejo Mexicano de Fotografía (Mexican Council on Photography), an organization he directed in its early years. He has earned a special place within the panorama of Mexican photography and, with it, a certain amount of jealousy among his peers. In fact, he encourages this and the polemics it engenders (including a particularly memorable one with Venezuelan Paolo Gasparini). Like Manuel Álvarez Bravo, Meyer has selected Mexican photographs for exhibition in the United States and Europe. He also held "literary-photographic salons" at his house in Coyoacán, encouraged disciples, financed Rogelio Villarreal's acidic magazines *La Regla Rota* and a *La Pus Moderna,* and championed new photoelectronic reproductive technologies, caring little for the opinions of technical "purists." Recently, Meyer has moved to digital technology, extensively using image manipulation software, special printers, and CD-ROMs to create sophisticated works: in particular, an extremely "classical" series of images on CD-ROM about his mother's death. In reusing some of his more "classic" and celebrated images of the 1970s, Meyer seems to have lost some of his aggressiveness. Blending modern and ancient technologies, he also employs traditional *amate* (a bark paper used in prehispanic times in Mexico) with modern ink-jet printers. In addition, he administers an important photographic website: www.zonezero.com.

The personality offends, and so do the photographs: Pedro Meyer is a "direct" photographer in the purest tradition. He photographs what he sees, where he goes, without seeking out original subjects, as others do. Meyer's originality lies in his personal take on a subject and manifests itself beneath the seemingly banal surface of his portraits. He is the photographer of bureaucrats and secretaries, those who blend—largely unnoticed—into the urban panorama. Indistinguishable from their counterparts in the United States, France, or Japan, they wear the same suits and ties, paint their nails and cheeks with the same Elizabeth Arden or Revlon cosmetics. The world that Meyer observes is difficult to aestheticize and is really only superficially "Mexican." Romanticizing it is the least of his concerns. On the contrary, he insists—with a certain mean-spirited perseverance—on revealing its petty brutalities.

Pedro Meyer's work begins at home: in the 1970s,

he portrayed his mother having tea in the shady garden of her luxurious home in the Las Lomas district, surrounded by domestic servants. There is something sordid about the photograph, exaggerated by the wide-angle lens, recalling the monstrous banalities of Diane Arbus. With this (self-)criticism, the tone of his work was set. Meyer then subjected the outside world to his intrusive glance, directing it at subjects he encountered in the streets and restaurants, at parties, nightclubs, and discotheques. (What horror to find oneself in his company in the now defunct Bar 9, feeling his scrutiny, and knowing that someday that photograph would be published . . .) His famous image of the wedding party in Coyoacán is a perfect example of his caustic nature, his genuine cruelty. The atrocious newlyweds seem to suffer too much . . . *La dama del lunar* (The Woman with a Mole and Her Friends) is the least conventional and, consequently, the most "real" (whatever that much-abused word means) image of a Guadalupan pilgrimage ever made. *Cantores en gira* (Singers on Tour)—a line of boys sleeping on a bus station bench—contains an element of pathos, an uncommon density.

With equal sarcasm, Meyer has observed Sandinistas in the restaurant at Hotel Managua (recalling the famous image of Zapatistas in Sanborn's), North Americans camping beside the Grand Canyon, and a dilapidated, fenced-off Statue of Liberty that has dominated the huge slum of Ciudad Nezahaulcoyotl since it was erected for the making of a science-fiction film.

Borders

In 1949, Laura Gilpin made a long trip following the course of the Rio Grande. Known as the Río Bravo in Mexico, the river flows south and then east from its source in New Mexico and demarcates the U.S.-Mexican border from El Paso–Ciudad Juárez to Brownsville-Matamoros. In the course of her work, she crossed the border, photographing the Mexican side of the river and the people living along its banks. *The Rio Grande, River of Destiny* was her most ambitious book, published just three years after *Temples in Yucatan*; she was the creator not only of the photographs, but of the captions and layout as well. Lyrical in its own way, the book shows the physical aspects of the terrain and a

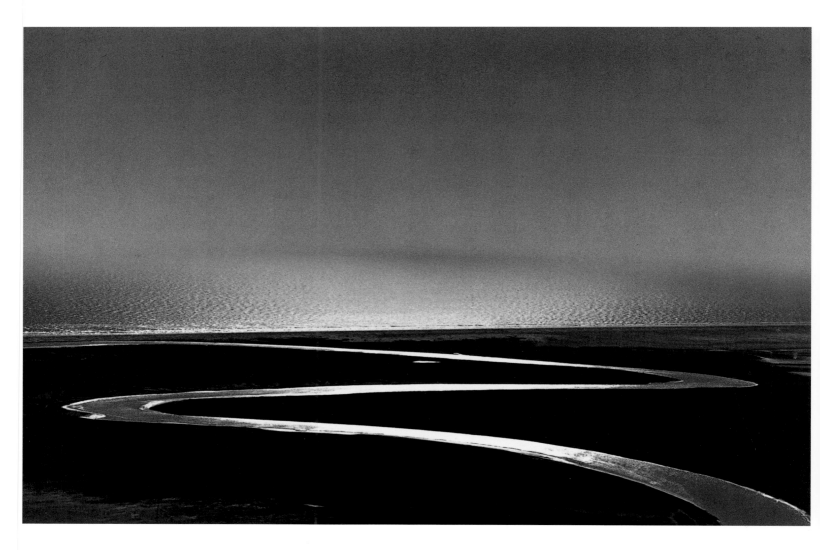

Laura Gilpin

The Rio Grande Yields Its Surplus to the Sea, 1947

Gelatin silver print on Gevaluxe paper, P1979.95.35
© 1979 Amon Carter Museum, Fort Worth, Texas, Gift of Laura
Gilpin

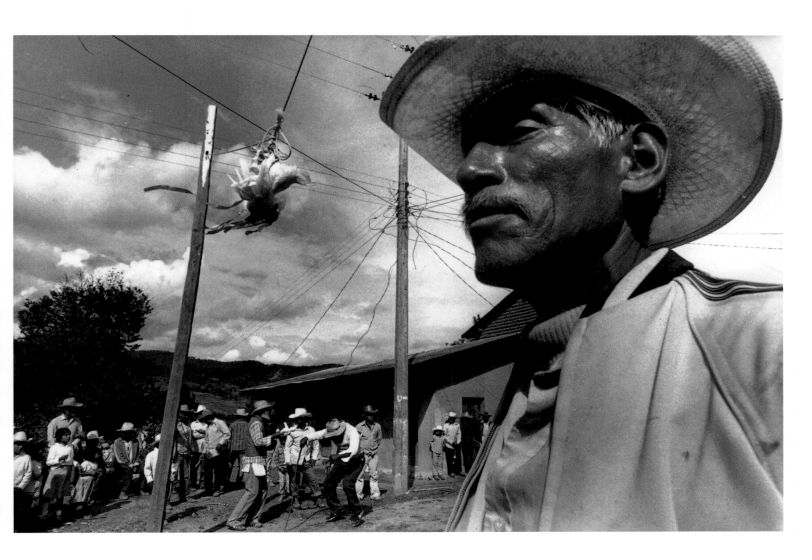

Eniac Martínez
Día de San Juan, Mixtepec, Oaxaca, 1968

Gelatin silver print
Courtesy Eniac Martínez

few views of the residents of the area, including Native Americans, Mexican agricultural workers, and Anglo ranchers, emphasizing the benefits that accrued from the modernization of agriculture and the public works constructed on the river (such as the construction of the Falcon Dam, east of Laredo). Gilpin's quintessentially postwar view reveals her confidence in the advances of technology and can be contrasted with that of Dorothea Lange, who had made a brief photographic report about Mexican migrants in the El Paso–Ciudad Juárez region when she was working for the Farm Security Administration some ten years earlier.[52] Lange depicted the harsh conditions of life endured by Mexicans living in labor camps along the border, from which only a certain number were taken to work as peons on citrus and vegetable farms in the region.

In 1966, Laurence Salzmann, a North American who specialized in anthropological photography, made the first photographic report about the Mexican *braceros* (migrant workers) and illegal aliens living and working along the border between Texas, Tamaulipas, and Coahuila.[53] Salzmann called attention to the precarious conditions of life in the improvised encampments on both sides of the line, living for several months with the same group of families from Michoacán (as Eniac Martínez Ulloa would later do), describing their attempts to cross the border, and eventually going with them under risk of arrest by the U.S. Border Patrol.

Perhaps the most interesting characteristic of Salzmann's work is his "urban" viewpoint, his minute description of groups that are "ethnic" in name only, since the basic necessities of their lives, their tastes, and their desires have already been "contaminated" by modernity. Salzmann had earlier worked in Hungary with Gypsy groups whose lives, like those of the Mexican migrants, are characterized by a tension between traditional structures and radical modifications to their environment. These ruptures obliged the photographer to adopt a far less complacent stance than that of traditional anthropological photographers in search of authenticity and purity among remote populations without access to urban centers or outside communication.

The rise in social tensions along the U.S.-Mexican border during the 1960s and 1970s is parallel in many aspects to another contemporary phenomenon: the rural emigration within Mexico that transformed the landscape and living condition in the capital and certain industrial cities. Many photographers, both Mexican (Lourdes Grobet, Pablo Ortiz Monasterio, Ángeles Torrejón, Herón Alemán, Eniac Martínez) and North American (Louis Carlos Bernal, Jay Dusard), have worked in this area, some concentrating on the border zone itself, others extending their territory from central Mexico at one extreme to Los Angeles at the other—but always in relation to the border.

Lourdes Grobet, for example, spent several months in Tijuana in order to photograph Tijuana "baroque" (or "gothic"): a way, *sui generis,* of living (or representing) "Mexicanness." Playing with the photographic medium, Grobet made images of the pseudo-colonial architecture of the city, fake Precolumbian buildings, and countless "picturesque" types who seem to have emerged from a Mexico of the 1920s. In contrast, the late Louis Carlos Bernal meticulously documented "Latin interiors" and aspects of the daily life of the Chicanos and Cholos, with their "low-riders," and of the Mexicans who had arrived relatively recently in the border areas of New Mexico, Arizona, and California. Bernal, who suffered a serious accident in 1989 that eventually took his life, had begun to delineate the cultural confluences, the absorption of the "American way of life" by groups that, nevertheless, still retained their Latin traditions.

Between 1984 and 1986, North American journalist Allan Weissman and photographer Jay Dusard traveled along the border, in somewhat the same manner as Laura Gilpin. The people that Dusard portrayed in interior scenes recall Bernal's work to some extent. Dusard's images, however, are often juxtaposed with urban panoramas and landscape views that supplement the photo essay in the published version of this project, *La Frontera: The United States Border with Mexico.* In spite of their considerable formal clarity, Dusard's somewhat distanced images do not possess the strength of those taken in the same places by Don Barleti, Pablo Ortiz Monasterio, Susan Meiselas, Antonio Turok, Liliana Nieto del Río, Graciela Iturbide, and Elisabeth Sisco for the *Vecinos* exhibition, organized by Arthur Ollman at the Museum of Photographic Arts of San Diego in 1989. *Indocumentados: San Diego County/ Municipio de Tijuana,* Dusard's photograph of Zapata Canyon, shows (future) migrants waiting for the Border Patrol to "permit" their crossing. Bathed in the late afternoon light, this very lyrical photograph, among

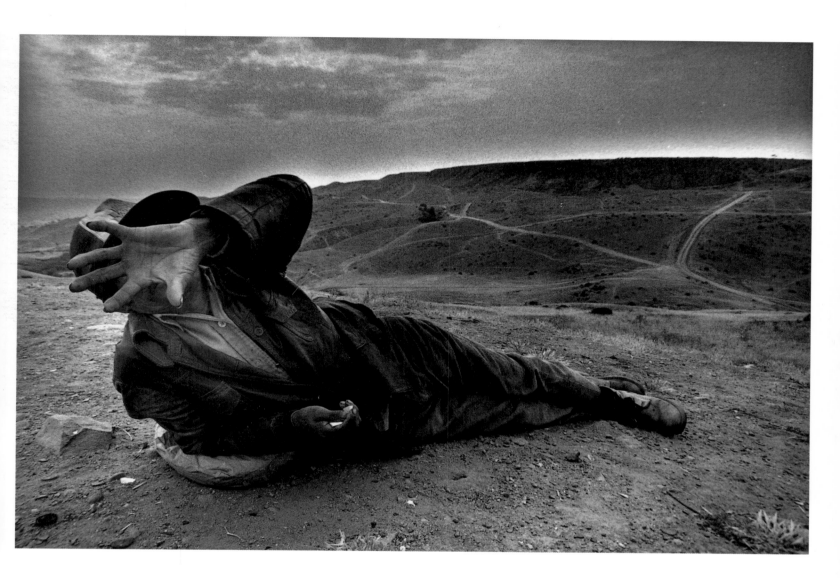

Elsa Medina

Cañón Zapata, frontera norte, 1987

Gelatin silver print
Courtesy Elsa Medina

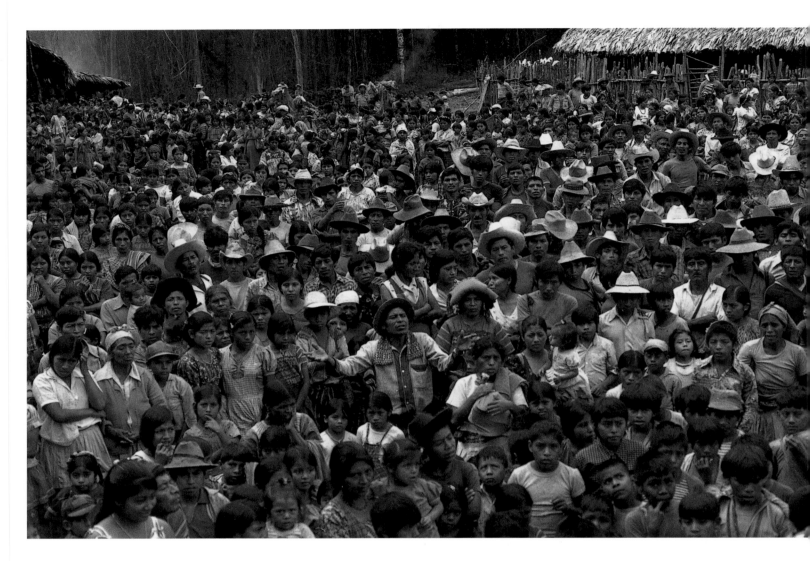

Antonio Turok

Guatemalan Refugees, Selva de Ocosingo, Chiapas, 1982

Gelatin silver print
Courtesy Antonio Turok

others, lacks the force of Elsa Medina's Zapata Canyon image of a *bracero* crawling under the wire fence and trying to cover the lens of the camera.

In 1986, Eniac Martínez began a photographic essay in collaboration with a community of migrants from the Mixtec area of Oaxaca. He followed them along their journey for months, by foot, to San Quentin Valley in California and published the results in several versions, including *Mixteca: Fin de siglo* (1991).[54] In repeated return trips, he has continued to observe the changes experienced both in the original community in Mexico (to which some of those who have settled in the United States faithfully return) and in the new community, reestablished with some modifications in the suburbs of San Quentin. Eniac Martínez's essay on this social rupture is doubly interesting for the way in which he includes not only his own photographs, but others taken by the Indian migrants themselves, as well as official documents and letters. In this way, he compiles a truly conceptual photo essay, similar to the North American Peter Beard's work on big game hunters in Africa and, more recently, on the extermination of turtles in Tehuantepec.

Martínez points out the inherent contradictions involved in crossing the border, not only for the transplanted community, but for the original one as well, in part because of the radical shift in social relationships engendered by objects. (The relics of their past life, including old family photographs, recall the "ancestor bundles" filled with bones that Precolumbian tribes carried on their migrations.) Several of his images possess a rare force, particularly those showing the religious rituals practiced during the long trek north and reenacted with variations several years later beside the ocean, in the hills of San Quentin.

On the other side of the country in the dense jungle of the Petén region, along the banks of the Usumacinta River, another migratory phenomenon occurred during the 1980s. Although different from the Mexican emigration to the United States, it was not unrelated, as shown in Gregory Nava's film *El Norte* (1983). The intense guerrilla warfare in Guatemala and, above all, the brutal repression of Maya groups in that region forced various populations living along the Central American border to withdraw into Mexican territory, sometimes under the protection of international organizations, but more often at their own risk. Antonio Turok, Marta Zarak, and José Ángel Rodríguez made several journeys to this area between 1980 and 1983 under conditions that were sometimes quite dangerous. Their work has still not been published in its entirety. Refusing the idea of authorship, the trio combined their images in the creation of a single sensitive narrative.

9

Counterpoint

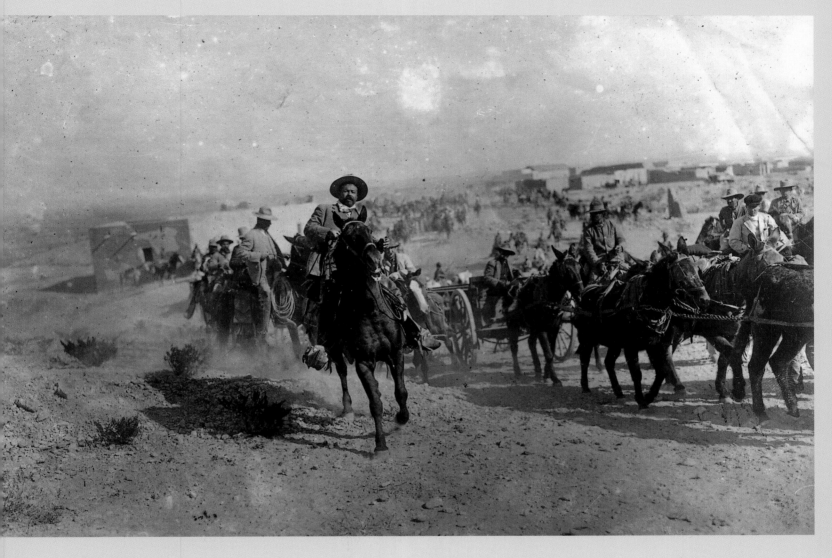

Mutual Film

Francisco Villa's Cavalry, ca. 1915

Modern copy print
Brown Brothers, Sterling, Pennsylvania

Photography was used for geographical reconnaissance and scientific research; it aided the efforts of a social class, the nineteenth-century bourgeoisie, to raise its status and situate itself within a historical perspective. finally—and this is its broadest function and the one which concerns us here—photography has served to write history.

At some point, it became so important as an instrument of verification, as evidence, that no news could be considered accurate and reliable unless it was accompanied by an image. The press photographer and especially the globetrotting photojournalist became near-legendary personalities, adventurers in a world in which there was little left to discover. For the past half-century, photojournalists have confronted danger directly, risking their lives on battlefronts or in search of a story. In doing so, they have not only supplied images for the pages of the newspapers and magazines that employed them, but inspired a literature (and a paraliterature) that celebrated their exploits in autobiographies, first-person narratives, even comic strips and films.

First radio then television largely supplanted the photojournalist in providing rapid and credible information. Yet there is a lingering nostalgia about this chapter in the history of photography, often rendered as homage to the photojournalists' daring and dangerous feats.

Daguerreotypists at War

In March 1846, following the annexation of Texas, war broke out between the United States and Mexico and attracted a number of itinerant daguerreotypists. They were not "photojournalists" in the modern sense of the word, but daguerreotype portraitists who happened to be operating near the fields of battle. There they photographed the soldiers, who were accustomed to sending their photographic effigies to their families back home. Apparently the first was a Mr. Palmer. Leaving

New Orleans, he arrived in Matamoros in June 1846, when it was still under the control of General Arista. His business did not prosper, however, and he abandoned it shortly after the occupation of the city by the troops led by General Zachary Taylor. In September, another daguerreotypist appeared in Matamoros, Charles S. Betts, who moved into the top floor of Resaca House, the headquarters of the invading army.[1] Soon afterward, he announced that he was leaving for Monterrey, possibly to follow Taylor's army. Yet when December came, he was still in Matamoros.

In 1981, a group of thirty-eight daguerreotypes was fortuitously discovered in a Connecticut barn—mainly portraits of officers in Monterrey and views of Saltillo and Parras. These, together with twelve others found in 1927 by H. Armour Smith, have been carefully studied by photohistorian Martha A. Sandweiss, who has traced the activities of the daguerreotypists who operated in Mexico during the conflict.[2] Although it is impossible to come to a definitive conclusion, I believe that the majority of these images were taken in Saltillo shortly after the battle that took place in the Gorge of La Angostura (which the U.S. troops called Buenavista, after a nearby hacienda) by one or more North American daguerreotypists.[3] Perhaps this unnamed photographer was one J. H. Wm. Smith of Philadelphia: a lithograph of President Zachary Taylor, published in New York, is credited as a copy of a full-length daguerreotype portrait made at Buenavista by Smith.

Sandweiss's research revealed the presence of another professional in Saltillo during the same period: Doctor (and renowned southwestern writer) Josiah Gregg, who accompanied the U.S. Army into Mexico and witnessed the Battle of La Angostura (Buenavista). He was stationed in the capital of the state of Coahuila, where he practiced medicine and fraternized with the officers whose portraits appear in the above-mentioned collections.

After Veracruz fell to General Winfield Scott's army in March 1847, the theater of war moved into central Mexico. By this time, it was obvious that the North

Americans intended to surround Mexico City. Antonio López de Santa Anna, commander-in-chief of the Mexican army, concentrated his troops around Jalapa in order to block the U.S. troops.

At this point, a curious incident occurred. Santa Anna prepared an attack from El Encero, his personal hacienda located on the Camino Real between Veracruz and Jalapa, and entrenched his troops on the slopes of nearby Cerro Gordo. With him was a medical surgeon—probably Belgian in origin—Pedro Vander Linden, then inspector general of the Military Medical Corps.

From the Central Hospital in Jalapa, Vander Linden organized a field hospital service that was relatively efficient, considering the scarcity of medicine and supplies. A number of supply centers and mobile hospital units were set up at Cerro Gordo. The enemy troops began firing artillery on the Mexican defenses on April 11, 1847. By the evening of the seventeenth, defeat was imminent. Vander Linden and his team carried the wounded from the battlefield:

> At six in the morning on the eighteenth, as the enemy advanced, surrounding Cerro Gordo, few of the wounded were able to reach my field hospital. Moreover, two rockets, one which fell near my tent and another that landed without exploding in the munitions dump only a pistol shot away, led me . . . to move my hospital further up the Camino Real some three rifle shots distance to a straw hut in front of the commissary, where at the moment there were several wounded, among others militia sergeant Antonio Bustos, whose left foot had been shattered by a number four bullet . . . We placed everything necessary for the amputation in the hallway. Señores Tarbe and Verde served as assistants; Domínguez and Rivadeneyra aided me in the rest. I had begun to cut through the patient's flesh when a rain of bullets came from the direction of the woods behind the little house and, penetrating the flimsy walls, forced all our cavalry to withdraw toward Corral Falso . . . But Honor would not allow us to abandon the half-amputated sergeant, despite the fact that our death seemed inevitable. However, Divine Providence saved us. I continued through the various steps of the amputation amidst bullets and the shouts of the enemy and finally finished the operation, which seemed to have lasted a century to me. I cannot ad-

> equately describe the admirable calm and resignation of my companions throughout this incident . . . And just when we were raising our eyes to heaven in thanks, believing ourselves spared, a new danger terrified us. Several [enemy] soldiers appeared in the doorway and, seeing our uniforms, shouted "Death to the Mexican officers!" pointing their rifles to our chests . . . I do not know what emotion led me to throw myself in front of their rifles, displaying my hands still dripping with blood and [holding] the mutilated foot, shouting, "Have respect for humanity, for an operating room; we are surgeons! . . ." My words worked magic. At that moment, placing himself between them and us, an officer named (I later learned) Captain Pion lifted their rifles with his sword and these men, excited by victory and enraged with a thirst for vengeance because (as we later found out) their general had been mortally wounded, became—from that moment on—our friends and protectors![4]

This moment is commemorated in an unusual and spectacular halfplate daguerreotype. For years, it was located in the collections of the Museo Nacional de Historia, where it was accessible to the public. Today, badly deteriorated, it is preserved in the Fototeca del INAH in Pachuca. It is one of the few known group portraits from this stage of daguerreotypy's development.

An extraordinary situation: the heroic feat of Pedro Vander Linden and his assistants must have been reenacted only hours after the battle, as shown by the condition of Sergeant Bustos (the only person who looks away and demonstrates no interest in the presence of the camera). Moreover, the mutilated foot that Vander Linden displays exhibits no signs of decomposition. The scene is reconstructed in minute detail, composed like a painting: one of the protagonists raises the stump and a sign indicating the place and date. Sergeant Bustos, held by the assistants, has been placed at a diagonal across the composition, unifying it, consistent with the pictorial conventions of death scenes. Pedro Vander Linden, the central figure of the composition, simulates the moment in which he confronted the invaders, his "hands still dripping with blood and [holding] the mutilated foot," before the enemy bayonets that emerge abruptly from the right side of the image, while at the same time turning to face the lens of the daguerreotypist.

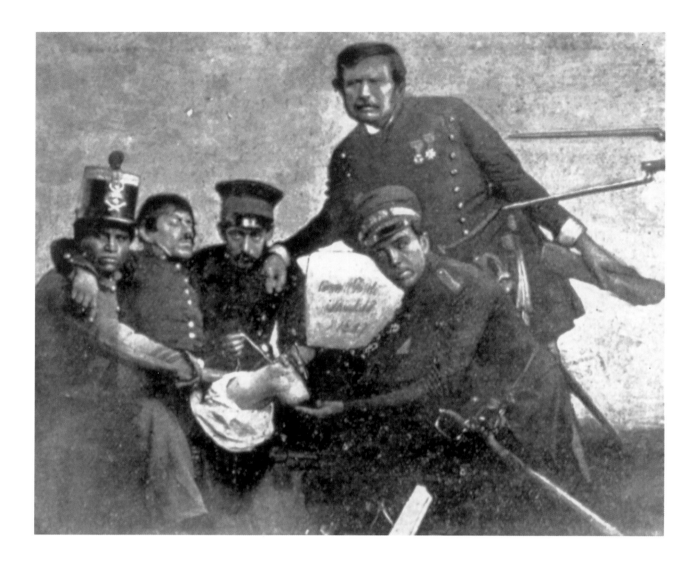

Anonymous

Amputation, Mexican-American War, 1847

Daguerreotype
Reproduction authorized by the Fototeca del INAH-CONACULTA
Pachuca, Hidalgo

It is reasonable to believe that this image was taken in Cerro Gordo on April 18, 1847. But what daguerreotypist was wandering around—with his heavy equipment and delicate creations—in the rearguard of the Mexican army?

The only daguerreotypists known to have been in the war zone were the professionals who followed the U.S. troops. After his face-off with the enemy rifles, Vander Linden provided medical aid to several North American soldiers, and perhaps they sought to repay him by commissioning this image as a trophy of war. It is reasonable to assume that the photographer was Charles S. Betts, who opened a studio in Veracruz in

early April 1847 and accompanied Winfield Scott's troops from Jalapa to Puebla and, later, to Mexico City.

Betts worked in Puebla in July of that year in partnership with the self-taught dentist and daguerreotypist J. C. Gardiner. The partnership did not work out and, days after the fall of Mexico City, Charles S. Betts (now working with a Mexican, Antonio L. Cosmes de Cosío) set up business on the second floor of a building on the corner of Plateros and Refugio. There he had a large canvas painted with a view of Chapultepec Castle that served as a backdrop used by officers who wanted to have their portraits made against the symbol of the fallen city.[5]

Another American daguerreotypist, George Noessel,

began working in Veracruz in September 1847 at a location referred to as the "Palace," possibly the Palacio de Gobierno. During the same period, a daguerreotype portraitist named L. H. Polock showed up in Puebla.

With the withdrawal of the army of occupation in July 1848, the North American daguerreotypists left the country, with the exception of Andrew J. Halsey, who retained his Mexican clientele long after the conflict was over.

In 1938, historian Robert Taft analyzed the daguerreotypes discovered by H. Armour Smith in 1927 and identified them as the oldest known photographs of war.[6] On the other hand, Beaumont Newhall, who also refers to these images in his history of photography, points out that these were not scenes of battle, but portraits.[7] In fact, the presence of daguerreotypists among the invading troops should not be understood as a conscious decision to document the events of the war. Rather, it reflects the nature of the business in that early stage of its existence: searching out a clientele, in this case a captive one—the soldiers, far from their families and desirous of sending their portraits home.

While the North American press was seeking ever-faster ways to inform the public and used images to complement its stories, these were almost always the work of painters and draftsmen who also accompanied the regiments. Daguerreotypes were not used, since their long exposure times precluded action scenes.

The daguerreotype collections at the Amon Carter Museum and the Beinecke Library lead us to qualify Beaumont Newhall's early statement. While many are indeed portraits—although not in the conventional sense—there are a surprising number of buildings, cityscapes, and scenes taken in the streets of Saltillo (twenty-five, out of a total of forty-five images). The groups of soldiers posed in the streets of Saltillo, on foot and on horseback, in parade formation or at rest, can be considered variants of the more typical portraits of officers in their dress uniforms and souvenirs of the occupation of the city. Another image documents the tomb of Henry Clay, Jr., who died on the battlefield at Buenavista on February 23, 1847. The views of Saltillo, Parras, and Durango—sometimes taken from high vantage points to obtain a panorama of the locale and its fortifications—are among the curiosities in these collections, as are the images of the church of Santiago (now the Cathedral of Saltillo), the Cathedral of Durango, and the Stahlknecht and Lehmann cotton mill in that city. More noteworthy are the images of types, such as the portrait of a "Mexican Lady," sold (possibly to U.S. soldiers) for $10, as an annotation of the image indicates. This same woman also appears in an interesting group portrait taken in the patio of a

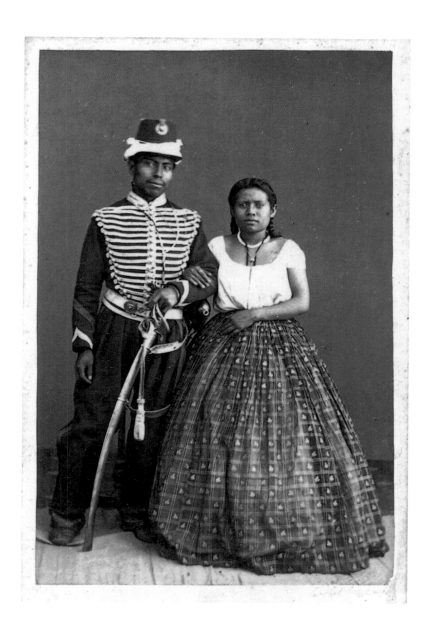

Aubert & Cía.
Mexican Soldier of Maximilian's Army and Woman, ca. 1864–1867

Albumen print, carte-de-visite
Center for Southwest Research, General Library
University of New Mexico No. 997-013-0021

house, entitled *A Mexican Family.* It includes only women, somberly dressed in dark clothing, and some children and adolescents in their Sunday best. A middle-aged woman in the second row seems absorbed in reading a book, perhaps her Bible, and pretends total disinterest; another holds her face in her hands and looks down; a young girl stares at the camera, hands on her hips. They all appear unhappily and reluctantly resigned to their role in the picture-making process. Is this a discreet act of resistance before the enemy and his mysterious machines? The absence of men—with the exception of a probable employee on the far left—seems to indicate that this "family" was obliged to pose. There are also indications of an interest in exotic customs, such as the funeral rite shown in a plate titled *Post-Mortem.* The variety of these images suggests that both the creators and their clients of these daguerreotypes recognized the versatility of the medium.

The daguerreotypes of the Mexican War are significant in that, as individual commemorations and rapid reenactments of heroic wartime deeds, they herald the advent of photojournalism.[8]

Though daguerreotypes gave way to negative-positive, reproducible paper prints by 1860, the use of photographs in newspapers or other publications was still hampered by existing technology. Until the invention of halftone reproduction in the 1880s (which translated photographs into "dots" of varying density that could be printed directly onto ordinary paper), photography mainly furnished printers with images that were copied as lithographs or engravings for reproduction. In a few cases, the photographic images themselves, printed by the hundreds, became a medium for disseminating the news. This is what happened, perhaps for the first time, during the French Intervention and the brief empire of Maximilian.

François Aubert and Company, Imperial Reporters

The best-known of the foreign photographers who established studios in Mexico during the Empire (1864–1867) was François Aubert, whose brief career has recently been reevaluated. His case, in fact, offers an interesting example of the kind of opportunism so typical of the profession in its early years.

Aubert was born in 1939, in Lyon, where he studied painting, possibly with the Flandrin brothers. He arrived in Mexico with the imperial court in 1864 and set up business at 7 Calle de San Francisco, in a studio previously occupied by someone named Amiel, a French photographer whose only known work consists of a few cartes-de-visite. At least two other photographers were associated with Aubert and Company: Julio de Maria y Campo (possibly of Spanish origin), who was appointed "photographer in chambers" to Maximilian in August 1866, and another named Torres. Cartes-de-visite made by the Maria y Campo and Torres firm were

Aubert & Cía.
Montage: Maximilian, Miramón, Méndez, Mejía, and Carlota, ca. 1864–1867

Albumen print, carte-de-visite
Center for Southwest Research, General Library
University of New Mexico
No. 997-013-0006

emblazoned on the back with the imperial eagle and bear the same studio address as Aubert and Company.

Because he is better known than his colleagues, many of the images produced during the Empire are attributed to Aubert. Among these are portraits of important political and social figures of the moment: official portraits of Maximilian and Carlota, General Bazaine and his Mexican wife Pepita, various ladies of the court, chamberlains, and aides-de-camp photographed in the studio on San Francisco. There are also group portraits made in the open air: Bazaine's general staff seated on a bench (probably in the famous home of the Escandón family in Tacubaya—now part of the Parque Lira—that the general occupied during his residence in Mexico) or the very curious panoramic view of the emperor and his court playing cricket in the fields surrounding Chapultepec Castle (possibly the area now known as Campo Marte, along the Paseo de la Reforma).

A photographer from the firm was "secretly" in Querétaro during the period in June 1867 when the emperor was arrested by the republican army. An anonymous reporter wrote this story at the end of September 1867:

He sent the photographs taken in Querétaro following the execution, the one of the vest of Maximilian's servant—worn by the emperor, whose clothing had been stolen—as well as group portraits of the squad of soldiers who shot him. These photographs were given to me by the doctor in charge who embalmed Maximilian or, better said, packed him—since he put big black eyes [into the sockets] for lack of blue ones. These photographs were made in secret.[9]

The photographer also made views of the specific sites related to the emperor's unfortunate end: the San Sebastián neighborhood; the Capuchin convent where Maximilian was first imprisoned; and the Iturbide Theater, where the military trial was held. He also captured, from a distance, the final moments of Maximilian and his generals Mejía and Miramón: a strange photograph shows a group of soldiers in the far background leading the condemned men to the execution site at the Cerro de las Campanas. In the foreground, broken cactuses, destroyed by the passage of troops, add a sin-

ister note. The photographer was unable—perhaps for technical or security reasons—to capture the supreme instant. Nevertheless, he completed his photographic report in a manner similar to that employed very shortly before by Matthew Brady on the battlefield at Gettysburg during the U.S. Civil War. The Mexican photographer climbed the hill and took two images of the site of the execution (in one, the place where the emperor stood is indicated by a paper crown and a wooden cross). Later he reunited the firing squad, posed in formation in front of the wall. He also managed to enter the premises where Dr. Debethoft embalmed the bodies. The corpse of Maximilian was photographed in its coffin, in full uniform, with the glass eyes taken from a nearby statue of the Virgen de los Remedios. Another photograph shows Mejía's body seated in a chair, bent forward, his jaw gaping open in a hideous expression. The photographer also made several bizarre still-lifes. In one, the emperor's shirt, pierced by bullets, is nailed to a door; in others, Mejía's vest and trousers appear against a blank ground.[10] The anonymous photographer at Querétaro supplemented his report with a view of the cart that carried Maximilian to the Cerro de las Campanas.

In July or August 1867, these images began to be distributed commercially, perhaps surreptitiously, since in the newly restored Republic they could only be appreciated as relics by the monarchical opposition, by families whose descendants still hold them in their private collections. They began to appear in Paris at approximately the same time.[11]

Nevertheless, Aubert soon began to advertise the sale, by prepaid subscription, of these "historical views," and primarily for this reason they have all been attributed to him. This "reportage" (a term applied to these images by the historian Gilbert Gimon) was enormously popular, not only in Mexico, where they were also distributed with the signatures of Auguste Péraire and Cruces and Campa, but also in Europe.[12] They appeared under the imprint of B. K., Liebert, Disderi, Neurdein, and Weurden in Paris and of P. Kaeser and G. von Jägermayer in Vienna. These served to promote the cult of "the blond emperor that they shot over there," to use the words of Guillaume Apollinaire, and were used by Édouard Manet in creating, with near-obsessive detail, the various versions of his painting *The Execution of Maximilian*. The final version, which relied most on

Adrian Cordiglia (attributed)
The Execution of Maximilian, Mejía, and Miramón, 1867

Photograph of a painting after a photomontage
Albumen print, carte-de-visite
Center for Southwest Research, General Library
University of New Mexico No. 997-013-0012

Aubert's photographs, was intended for display in the Exposition Universelle of 1867, but was withdrawn for political reasons.[13]

Adhering to an absolute realism in his composition, Manet portrayed the emperor with a *charro*'s sombrero, which—in fact—he wore on the day of his death. This detail had been left out of the official history.[14]

Aubert's images were also used to create unusual photomontages of the moment of the execution itself. They were made, perhaps, by Auguste Péraire, who was author of an allegorical montage of Carlota and "the four Ms" (Maximilian, Mejía, Miramón, and Méndez), and another of a projected funerary monument to the emperor. These were published in France by the Ducacq firm and were widely distributed in the carte-de-visite format.

Toward the end of 1867, Aubert announced in the press that he was seeking a new photographic studio. Shortly afterward, he left the country. One of his last known images shows the arrival of Benito Juárez in Mexico City. A multitude of Indians dressed in white and dignitaries in black tailcoats appear in the foreground. Behind, possibly over what was then called the "emperor's road" (now the Paseo de la Reforma), an imposing triumphal arch was erected bearing the slogan "Viva Juárez."

Before the Revolution

Looking at the photographs, we see that the Centenary Celebrations of 1910 were, above all, about movement. From all over the country people flocked to the capital: rich and poor, distinguished aristocrats with their servants, as well as peasants and Indians. The streets that Porfirio Díaz ordered cleared of beggars and the most wretched became filled instead with elegant citizens who arrived for the occasion from the cities of the interior and the border.

The Centenary Celebrations were a triumph for the railroads, for restaurateurs and hotel owners, but photographers also made a killing. Filed in the copyright

office of the Archivo General de la Nación is a series of odd patent applications dating from 1909–1910 for photographic buttons, envelopes illustrated with views of the most famous sites in the country or portraits of patriotic heroes, photomechanically illustrated albums, and other similar products.[15]

Like the modernized city that he wanted to show the world—adorned for the occasion with palaces in the style of Second Empire France—Don Porfirio too had changed appearance with the passage of time. Both the city, which he dominated from the balconies of Chapultepec, and the president had become "Europeanized." The angular face with its high cheekbones and strong jaw, the full lips of the Oaxacan Indian, and thick neck of the peasant, restricted by the buttons of his colonel's uniform, traits that appear in a carte-de-visite portrait taken by François Aubert in 1866 or 1867, have disappeared under the imperial mask forged to resemble Kaiser Wilhelm of Germany. Díaz's protrud-

François Aubert (attributed)
Maximilian's Clothing, during the Embalming Process, 1867

Albumen print, carte-de-visite
Courtesy Patricia Stevens Lowinsky

ing wide gray moustache now compensated for the jaw, hiding the characteristic form of his mouth; his eyes seem to have become smaller as his face filled out, a sign of opulence beneath the top hat. His skin tone, moreover, was lightened with rice powder. The black-and-white of the photographs took care of the rest.

The machinery of power is scenographic, a mere façade. That is how Porfirio Díaz appeared on May 5, 1902, when Manuel Ramos photographed him at the Llanos de la Vaquita receiving the army's oath of allegiance from his place on the wooden stage, theatrically decorated in the "French" style with *trompe l'oeil* paintings of stucco work and moldings. Somehow, the flatness of the decoration carries over to the members of his staff: in their hieratic arrangement, they look like painted backdrops to a president carved in relief.

The Centenary Celebrations were—and had to be—this way. Mexico City had been converted into a stage set. The principal buildings of the *porfiriato*—the National Theater still under construction, the Palace of Communications (now the Museo Nacional de Arte) with its unfinished interior—display elaborate façades, as if painted. The theaters were transformed, as were the Zócalo, Alameda Park, Avenida Juárez, the dazzling Paseo de la Reforma, the Condesa racetrack, and the Tívoli del Elíseo amusement park. Such extravagance had not been seen since the time of the Aztec emperors. In reality, however, the underlying structure of state was less solid than it appeared . . .

"Appearance" is the key word—it also "appeared" that all this was erected solely for the delight of photographers. They, it seemed, were the greatest beneficiaries of the festivities and took advantage of the situation to photograph, film, and disseminate images of those in power. This was the culmination of Díaz's thirty years of political stability.

Around the commander-in-chief, society played its own game of appearances, enraptured with its self-image. There were always a number of ladies in Mexico quite disposed to put aside the austere clothing of a *campesina* in order to dress like Parisians. Their enthusiasm, however, was for many years mitigated by the strict morals of Mexican society. But the extravagances introduced during the empires of Iturbide and Maximilian—titles of "Napoleonic" nobility, elaborate protocol dreamed up on sleepless nights by the Austrian archduke and his Belgian princess—had also irre-

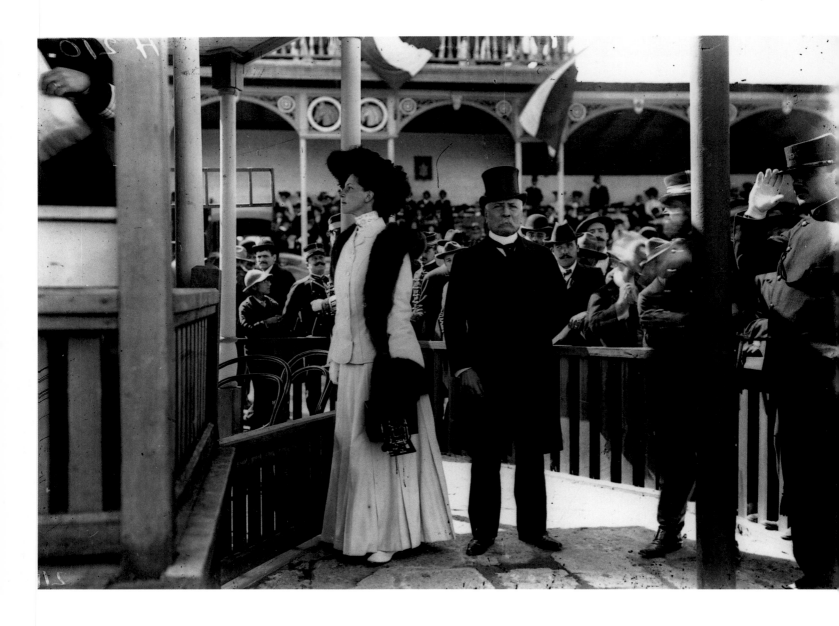

Agustín Víctor Casasola
*Fiesta in the Hipódromo de Peralvillo to Celebrate the
Birthday of Kaiser Wilhelm,* ca. 1904

Modern copy print
Reproduction authorized by the Fototeca del INAH-CONACULTA
Pachuca, Hidalgo

vocably transformed the symbols of status and introduced fashions that quickly became customs, manners that would be continually ratified by photography.

By the turn of the century, photography had existed for sixty years. It had changed and spread to the point that it was no longer considered a mysterious process whose bizarre workings escaped common understanding. By this time, it had become a routine practice. There were seventy-four photographic studios in Mexico City, and perhaps three hundred in the country, receiving the business of rich and poor, peasants and landowners, office and factory workers, professionals, soldiers, children . . . lots of children . . . entire families.

In September 1910, family groups could be seen parading through the capital, attracted by the festivities that had transformed the city into an evocation of some future Disneyland. Souvenirs of these trips can still be found in family albums. For example, the family of Welsh miner Lewis Card Burke (father of the painter Abraham Ángel) traveled from El Oro in the State of Mexico and posed on the threadbare carpet of a studio in Mexico City. Another such image can be seen among the family photographs of the painter Alfonso Michel, from Colima.

September 1910: The Kaiser's daughter, caught off guard by the indiscreet camera of Agustín Víctor Casasola during festivities at the Peralvillo racetrack, carries a view camera with bellows in one hand. She looks into the distance as if seeking a vantage point, selecting a shot.

With or without Tripod: The Technical (R)evolution

Several years before the celebrations of 1910, photography began to be used in the Mexican press, first by Rafael Reyes Spíndola, dedicated *porfirista* and founder of *El Universal, El Mundo Ilustrado, El Imparcial,* and *El Mundo.* In 1896, he introduced high-volume rotogravure presses, German Linotype machines, and the halftone technique used in the United States since 1890.

Initially, photography did not completely replace the old engraved or lithographed illustrations, but instead complemented them. Advertisers were the first to realize its importance; motivated by the pressures of competition, they resorted to the modern medium of photography to promote their products. Even then, photographs were inserted within a design layout inherited from more traditional and manual forms of graphic illustration. Often cropped and retouched, the photographic image appeared as a vignette framed within an art-nouveau border or printed in a space superimposed over a lithographic illustration, itself often made from an enlarged and retouched photograph or drawn after one. These advertisements also influenced the page layout, probably done by the same anonymous typographers who designed the ads themselves. Used simply as a piece of information in a collage of techniques, photography was different only in its verisimilitude, apparent objectivity, and impartiality.

Photography became an increasingly important element, occupying ever-greater space in Reyes Spíndola's

Anonymous
Galería de bellezas mexicanas

El Mundo Ilustrado (November 4, 1894)
Hemeroteca Nacional, UNAM

newspapers. Aware of the growing importance of the illustrated press in Western societies, businesspeople exploited the power of visual impact—particularly useful in a society still largely illiterate and unaccustomed to reading. In particular, *El Mundo* and its Sunday supplement *El Mundo Ilustrado*—the earliest examples in Mexico of progovernment journalism masked as objective reporting—relied heavily on the use of images. Embedded in the conglomeration of society columns and sensational reports of crimes and accidents, the photographs were the most credible element.

During the first two decades of the twentieth century, photography gradually began to invade graphic spaces until it became virtually the only representational medium in the newspapers. Only political cartoons and comic strip drawings would survive, and even these were removed from many newspapers in the 1970s and 1980s.

A noteworthy incident: when José Guadalupe Posada died in 1913, the broadsheet publisher Vanegas Arroyo replaced some of Posada's engravings with photographs. Now quite rare—few were preserved since they were deemed to have no artistic value—some of these are housed in the Beinecke Rare Book and Manuscript Library at Yale. They include portraits of Emiliano Zapata (from Hugo Brehme's negative), Francisco ("Pancho") Villa, and Francisco I. Madero.

The two world wars would accelerate the development of lightweight photographic equipment, which soon replaced the old heavy, large-format cameras and tripods and eliminated the immobility that had characterized studio photography. First came the hand-held Kodaks, particularly the Kodak 3A. Originally marketed to amateurs, it was adopted by many professionals or semiprofessionals during the Mexican Revolution of 1910–1920 for its small size and ease of operation (although the lenses left something to be desired). Despite its weight, the German single-lens reflex Graflex camera did not need a tripod if light conditions were good. It was still the instrument of choice for professional photographers at the end of the 1930s, although at times it required spectacular maneuvers on the part of the photographers. The Graflex appears in a picture taken of Agustín Víctor Casasola, hanging insecurely inside in a kind of basket suspended above the La Condesa bullring . . . Lola Álvarez Bravo recalled climbing the dangerous stairway of an oil storage tank in Poza Rica, carrying her Graflex and holding up her skirt.

In 1939, the Mayo brothers emigrated from Spain and introduced the use of Leica cameras among professional photographers in Mexico. Faustino Mayo remembered how skeptical his Mexican colleagues were about these small cameras, the first to take 35mm film similar to that used in movie cameras.[16] While it was necessary to change the negative of the Graflex after each exposure, a photographer could make up to thirty-six shots with the Leica before changing the roll. The Casasolas made fun of it, but not the newsroom editors, who were thrilled to receive so many images in such a short time.

The versatility of the Leica, combined with its sharp lenses, did the rest: in a few short months, the Graflex was relegated if not to the flea markets, then at least to studios and special projects. This was a genuine revolution: the photographer was transformed from spectator to participant and—sometimes—creator of history.

The Revolution

Few wars have excited the imagination like the Mexican Revolution. Few have been so extensively represented, so intensely observed. This is due not only to its having been the first popular uprising of the twentieth century, but to the incredible complexity of the forces within the Revolution and the confusion and tensions that it provoked. Perhaps, then, it is worthwhile to examine this event and attempt an interpretation of its visual impact. To do so, it might be helpful to turn to prior conflicts, especially to the great war of 1914–1918 and its corollary, the Bolshevik Revolution of 1917, for in many ways, and particularly as concerns photography, the Mexican civil war of the same decade was strangely different.

World War I was a foreseeable and expected event—predicted and awaited, a "technical" war like earlier territorial conflicts in Europe that became "mechanical" when, with the arrival of the first winter, the two opposing armies dug themselves into stationary trenches. When that happened, the real front was transferred from the battlefield to the offices of the Ministries of War and the conflict became internationalized.

Few memorable images of these events have been left us: empty landscapes taken at ground level, sites of in-

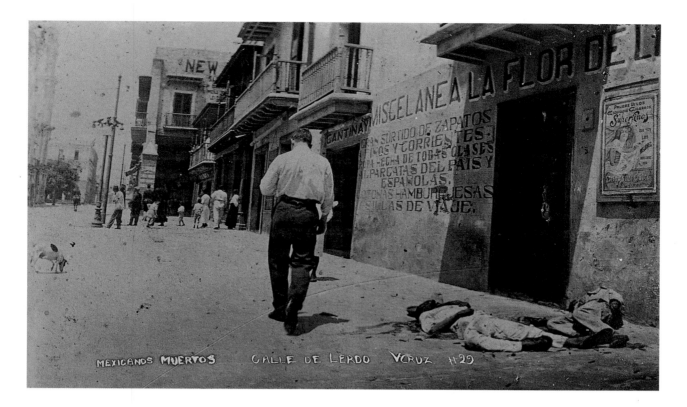

Guillermo Blumenkron
Dead Mexicans, Calle de Lerdo, Veracruz, 1914

Gelatin silver print, postcard
Private collection, Mexico City

conclusive battles signifying nothing under dark skies perforated by rockets. Images of the soldiers' daily life in the trenches reveal the waiting, boredom, and disillusionment that came to replace the patriotic fervor of the early days of the war. Out of this forced, literal halting of energies emerged the notion of the "meaninglessness" of war. On the other hand, the war produced an overwhelming number of portraits—all taken behind the front lines—that soldiers sent back to their families.

Evelyne Desbois, who made a thorough study of these photographs, has singled out "an exceptional photograph," published on May 9, 1915, in the French newspaper *Le Miroir*. It shows

a soldier photographed at the moment that a bullet rips through his arm. Beneath the photograph, the caption reads: "Is this an authentic document? We have investigated this. Place: Forest of C . . .; Date: April 11, 1 o'clock; Name of the wounded: Pierre Quer . . .; Region where event occurred: Southern." With such clarification, there can be no doubt.[17]

War—as we know from the experience of Roger Fenton, Jean-Charles Langlois, and Léon Méhédin in Crimea, and Brady and Alexander Gardner during the U.S. Civil War—is extremely difficult, not to say impossible, to photograph. More than ever, the photographer struggles against time. To anticipate and understand and then halt the destruction for a given moment, just before its irrevocable disappearance, is a special kind of photographic exercise—an exercise in limits.

André Rouillé described how Langlois and Méhédin "fought" against bad weather, military advances, the destruction of cities . . . "Every successful attempt [to make an image] is 'wrenched from winter,' 'saved' from the storm," achieved in spite of orders to erase all vestiges of human presence from the landscape and "reduce to a skeletal state" all military constructions, fortifications, and camps to prevent the enemy from making use of them.[18]

Depicting death is yet another difficult challenge: who wants to or can even bear to look on the (beloved) body lifeless and maimed? And yet the concrete repre-

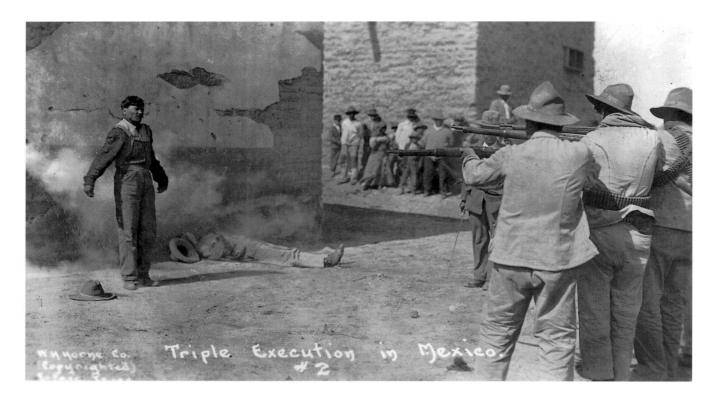

Walter H. Horne
Triple Execution in Mexico, 1915

Gelatin silver print, postcard
Center for Southwest Research, General Library
University of New Mexico
No. 986-015-0036

sentation of death, the irrefutable force of death, is now expected, even demanded as the ultimate evidence of war. And so the images of war are spattered with blood; the earth covered with corpses. In 1860, Félix Beato propped corpses against the buttresses of Baku during an opium trade war so that they would appear in every photograph in a way that was both visible and bearable to the viewer. His manipulation becomes obvious if the images are compared: a body twisted to the left is also twisted to the left in a photograph taken from the opposing vantage point.

The technical impediments, cumbersome nineteenth-century cameras, and need for laboratory facilities, if not at the front lines, at least near the scene of combat, all prevented the photographer from rushing into the heat of battle (and how many photographers, moreover, were mistaken for enemy spies and became targets?).

Thus, war photographers were—at least until the appearance of lightweight cameras in the 1930s—denizens of the rearguard, moving among the supply trains and field hospitals. They arrived on the battlefield after the combat was over to photograph the smoking ruins, devastated countryside, decomposing corpses, and, perhaps, the survivors who asked to be recorded as they appeared during their little celebrations, their small victories: to be here, now, standing in the main square of the captured town, fort, or enemies' trench.

Historically, World War I marked a transition less in the way that war was photographed than in the massive way it was disseminated, something that had been foreseen, but never before realized. Yet, in spite of being published widely in the patriotic press and as postcards, these images did not serve as icons or inspire a mythology of the war. The historian who comes across them now in publications or military archives is overcome by a feeling of emptiness. They are of little use because they reveal nothing. They are merely arid and sad. Take, for example, one of the most eloquent in an evocative sense: the hills of Verdun covered anew with grass, now dotted with white crosses—an image of mute testimony to what had happened in a place that no

camera was able to portray. It serves, moreover, as an intimation of the mass slaughters of the twentieth century, a silent memorial legible *a posteriori*. Yet it tells us little about the war itself, no more than a photograph of soldiers cutting each other's hair between exchanges of bullets.

Paradoxically, photographs of the revolutions of Saint Petersburg in February and October of 1917 rarely show "battles." In the photographs taken of urban fighters in this most Western-style of cities within the immense Russian empire—specifically along the only "modern" artery of the city, the Nevskii Prospekt—the revolution looks like an organized labor movement. There are no images of the (few, in fact) bloody confrontations: the capture of the Winter Palace and the Fortress of Peter and Paul. The leader—Lenin or Trotsky—is always at the center of the image, haranguing the crowds that appear as a sea of upturned heads. The leader is the only figure who counts here, the indispensable link. He is the visual emanation of the ideological, and nothing must prevent his being recognized in the picture.

With the exception of a few images made in Yekaterinburg at the scene of the assassination of Czar Nicolas II and his family—the only "recreated" images which thus served as the stimulus for the creation of popular mythologies in the way that those of the execution of Maximilian had done in Mexico—the photographs of the October Revolution never showed violent incidents per se. Instead, they depicted moments of triumph: Trotsky carried on his followers' shoulders after the fall of the Winter Palace, Lenin stepping off the armored car at the Finland Station, agit-prop trains decorated by Bolshevik artists, and later images of the assemblies in the kolkhozes, triumphal scenes of the reconstruction of the nation.

Were photographs of the rebellions outside the capital censored, or were none ever made? And what of the counterrevolution in the southern republics of the Soviet Union? Were such images perhaps taken, but made to "disappear" by the succeeding Soviet regimes? Perhaps because of this lack of documentation, it was easy to invent a mythology. For out of this visual void, Soviet filmmakers took the opportunity to create their own system of symbols, without concern for verisimilitude. They were free to establish more convincing and forceful symbolic relationships, as Sergei Eisenstein did in *October* when he put the statues of Saint Petersburg into motion and "reenacted" the battles that had taken place in the streets.

On the contrary, the Mexican Revolution—which began only a few years before the events described above—depended heavily, from its inception, on visual representations and, in particular, on photographs.

What symbolic need—the beginnings of which can be found in Porfirio Díaz's fascination with decorum—gave rise to this particular relation to the image? What led so many incipient (and inexpert) aspiring photojournalists and American amateurs to cross the border from the early days of the uprising led by Francisco I. Madero? Or is this an *a posteriori* view, one developed out of the state apparatus's need to contemplate a fixed view of—and thus comprehend—a chaotic situation?

Like the Mexican Revolution itself, an uncoordinated succession of contradictory, isolated movements, alternatively united and disunited, the history of the photography of the Revolution is also complex, incomprehensible, and contradictory.

From the very beginning, since Madero's "long march" from Ciudad Juárez to Mexico City, photography played a defining role. "The place was lousy with free lance photographers," recalled W. A. Willis, the *New York Herald*'s Mexican correspondent.[19] A postcard collector in Ohio told researchers Paul J. Vanderwood and Frank N. Samponaro that he had identified more than a hundred photographic firms and individuals who worked in Mexico between 1911 and 1917.[20]

In the few short weeks after the outbreak of the war in Mexico, most U.S. newspapers sent correspondents south, some accompanied by photographers, others who worked as both reporters and photographers. Jack Ironson, a sports photographer, was among the first to "quit dodging baseballs and start dodging bullets," in compliance with his assignment from the International wire service.[21] In 1911, Jimmy Hare, who had covered the Spanish-American War in Cuba for *Collier's Magazine* in 1898, was in Ciudad Juárez, along with photographers named Kiefer and Harris, Gerald Brandon (a photographer who worked in Panama), Robert Dorman (manager of Acme News Pictures of New York), El Paso photographers Otis A. Aultman and Homer Scott, Edward Larocque Tinker, William Heartfield (of the *New York Daily News*), William Durbrough, Carl Helm, Victor Kubes (also of International), William Fox,

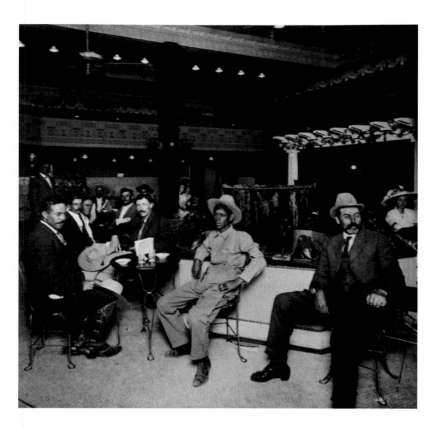

Otis A. Aultman

Generals Orozco and Villa in the Elite Confectionery,
El Paso, 1911

Gelatin silver print
Courtesy El Paso Public Library

Ashton Duff, and Walter Horne and his associates at the Mexican War Photo Postcard Company, among others.

Several of those who started working in the El Paso–Ciudad Juárez area in 1911 set out for Veracruz in 1914, following the U.S. invasion of that port. Such was the case of Jimmy Hare, who boarded the American cruiser *Louisiana* in Havana in hopes of getting the "scoop" on the story of the U.S. landing in Mexico.

On March 21, 1916, Walter Horne wrote his family that he had sold 2,600 copies—that day alone—of his photographs of Pancho Villa's raid on Columbus, New Mexico. Several days later, production reached five thousand photographic postcards a day.[22] Although these numbers fell rapidly after the United States entered World War I in May of 1917, they provide an eloquent testimony to the immediate and avid interest of the North American public and to the incredible and un-

precedented flood of photographic images generated by of the Mexican Revolution.

George R. Leighton attributed this sudden proliferation to the press's need to provide itself with photographic images different from those on the society pages, which had initially given impetus to the development of halftone reproduction in the 1890s.

If the span of years of the Mexican Revolution is accepted as it is given in this volume [*The Wind That Swept Mexico*], then it is fair to say that no revolution has ever been so thoroughly photographed. The bulk of the picture making was done either by news photographers in line of duty or by individuals who were either participants or spectators and had a particular interest in what was going on . . . The names of most of these people are lost, their pictures scattered. The newsmen were not "artists" but simply photographers earning a living; few of the others had any idea that their pictures would be reproduced. To some of the newsmen—this was before the day when correspondents had economic interpretation on tap at all hours—the revolution was a powerful jolt. One of them says: "Do you know why the Mexicans started that revolution? It was because most of them were slaves."[23]

More recent studies, however, prove that postcards—which enjoyed favorable postal rates for decades—were at least as important as the press in disseminating images of the Mexican Revolution. Like the photographs of the October Revolution in Russia, the focus was often on the figure of the leader, beginning with Madero. Aultman portrayed him in Ciudad Juárez in 1911, seated in a hotel lobby with his staff. Later, he appeared on horseback in the streets of Chihuahua, in a car in San Luis Potosí, and again on horseback at the moment of his arrival in Mexico City in the midst of an enthusiastic crowd. Unlike the border "rebels" Pascual Orozco and Francisco Villa, Madero dressed like a gentleman with his English-style campaign jacket and riding boots . . . a reassuring image, totally unlike those adolescent, ragged *bandidos* draped with cartridge belts, rifles raised, who were observed across the Rio Grande from atop the highest buildings in El Paso. These vantage points were made available for a fee to accommodate the ever-larger groups of curiosity seekers who

gathered along the border. Likewise, during the skirmishes in Tijuana with the *magonistas* (followers of the Flores Magón brothers) in 1911, some imaginative entrepreneurs rented platforms along the banks of the river to residents of San Diego who wished to observe the bloody battles. A few stray bullets quickly dispersed the tourists, a number of whom had brought along their cameras.

The Revolution did not end with the exile of Díaz and the ascendancy of Madero to the presidency. The rebel leaders Villa, Zapata, Venustiano Carranza, Orozco, and Álvaro Obregón, motivated no doubt by Madero's unprecedented success with photographers, hired others to follow their campaigns, publicize their feats, and add to their prestige. For example, Obregón contracted the musician/photographer Jesús H. Abitia from Jalisco, who traveled with him for several years. Meanwhile, Hugo Brehme went to Morelos to "work" with Emiliano Zapata, and Eduardo Melhado covered

the area between the northern states of Durango and San Luis Potosí. Not surprisingly, many photographers adopted political positions, and some even left the profession to take up arms in the struggle. Francisco Murguía, a studio photographer in Monclova, Coahuila, joined the conflict, becoming provisional governor of the State of Mexico in 1914. He was later promoted to the rank of general in Guadalajara in 1915 and died in 1922, during a rebellion against Obregón.[24]

In the beginning of his revolutionary career Villa followed the fashion established by Madero and dressed in a colonial pith helmet and tailored jacket, but soon exchanged it for his dusty campaign outfit and cultivated a certain unkempt charm in his appearance. As Populist leader and horseman, his fearsome legend began . . .

In candid images totally unlike the "official" portrayals of Porfirio Díaz, Villa always rides alone, surrounded by a kind of aura—an empty circle, a magic

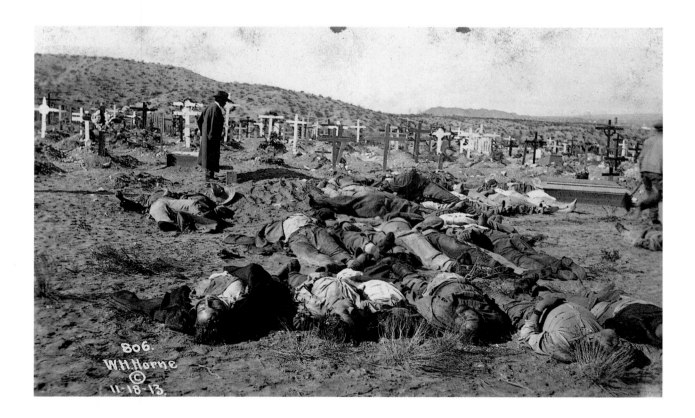

Walter H. Horne
Corpses in a Cemetery, 1913

Gelatin silver print
Courtesy Throckmorton Fine Art, New York

circle—that emphasizes his dignity as an all-powerful leader. Madero on horseback may have dominated the crowd, but always remained immersed in the people. Villa rides forever before the cinematic camera of Mutual film in a series of images that appeared from time to time in various publications, credited to different photographers (Aultman, Horne, and Casasola have all claimed authorship).[25] Indeed, the history of the photography of the Mexican Revolution is a history of pirated images (and the pirates were not always the ones behind the cameras).

These first photographs of the Revolution are anchored in a real and recognizable space—the Zócalo in Mexico City, the banks of the Rio Grande, the plaza in Chihuahua, the hacienda of Villa Ayala—that is, in a particular reality, a specific here and now that underscores the political rapport between the leader and the masses that acclaim him.

In the next phase—approximately following the so-called Decena Trágica which culminated in the assassination of Madero in February 1913—photography became an omnipresent accessory to the armed struggle. This occurred not only because a number of the leaders, notably Victoriano Huerta, Venustiano Carranza, and Francisco Villa, demonstrated a particular interest in what would become the major propaganda medium of the twentieth century, but because the presence of the international press (particularly American) forced photographers to organize. This is what motivated Agustín V. Casasola, until then an ordinary reporter specializing in social and sporting events (with a predilection for bullfights), to establish the Agencia Fotográfica Mexicana in 1911. By bringing together many photographers in a single organization, the agency ensured an unprecedented multiplication of images. Responding to the realities of the Revolution—with

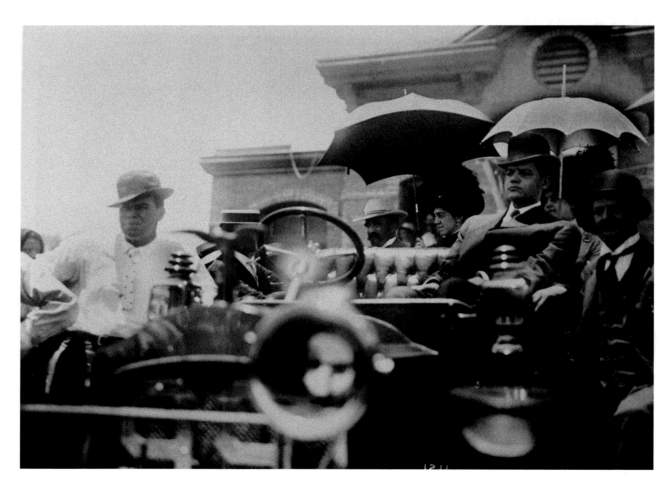

Otis A. Aultman
Madero and Wife, Ciudad Juárez, 1911
Gelatin silver print, El Paso Public Library

its multiple focuses and factions—photography became ubiquitous. This represents one of the key differences from the situations in Europe during World War I and in the recently created USSR: the Mexican Revolution was photographed from every point of view, both geographically and ideologically.

The sometimes ingenuously objective views adopted by foreign photographers emphasized certain readily mythicized aspects of the conflict. The case of Pancho Villa is eloquent in this respect, as are the images of extreme violence (rifles, hangings, piles of burning bodies in the streets, etc.) or extreme poverty. Soon, however, a multiplicity of focal points had emerged corresponding *grosso modo* to the reality of the Revolution. Each of the factions had its pictorial bard; everyone invented his own style. Victoriano Huerta and his staff, for example, were posed by Casasola in the National Palace. In contrast with the atmosphere of jubilation revealed in the photographs of Madero's triumph—the plaza filled with enthusiastic supporters waving brightly colored scarves, his spirited mount, the bright April morning—Huerta appears severe and inscrutable, lugubrious in his general's uniform covered with medals, emerging from the shadows within a carefully measured penumbra: the official portrait of a dictator. Augusto Pinochet would be portrayed the same way in 1973 at the Palacio de la Moneda in Santiago.

From Celaya, Álvaro Obregón initiated a cult: that of his own hand. The most famous photograph of the general, taken by Abitia, commemorates the costs of his bravery. The photographer accompanied the wounded officer into the operating room to observe the amputation of his arm. Obregón was photographed on the operating table, looking composed in spite of the pain, his arm hanging down—a heroic image, the hand now transformed into a trophy of war. In his later portraits, Obregón exhibits an empty sleeve: simultaneously absence and trophy. Later a monument was erected in the Parque La Bombilla, where this relic of the Revolution was exhibited until 1989, when it was finally cremated. (There was already a prephotographic antecedent for this type of commemoration in Mexico: a monument had been erected to contain the amputated leg of General Santa Anna, which was ceremonially enshrined there in 1845.)

Unlike the images of World War I, those of the Mexican Revolution were indeed violent, sometimes excessively so. In large part this was due to the needs of the government in Washington, which was quietly preparing a possible military intervention along the border. Although the full plan was never put into place, there were brief incursions into Mexico following Villa's raid on Columbus (Pershing's Punitive Expedition). Conditioned by images of atrocities committed by the Mexican "bandits," U.S. public opinion was not likely to—nor did it—raise any objections.

A segment of the opposing Mexican forces and their photographers also favored distributing this kind of image. Walter Horne photographed the executions of Francisco Rojas, Juan Aguilar, and José Moreno by Mexican forces in Chihuahua on January 15, 1915. To capture these images—which Casasola included as his own in his *Historia gráfica de la Revolución mexicana*—Horne had to give a substantial bribe to guarantee his place in the first row: at a signal from the head of the firing squad, Horne took his own shot . . .[26] Jimmy Hare also paid a firing squad to ensure that they would execute prisoners in Veracruz under ideal lighting conditions: death as theater. In his postcards, Horne accumulated bodies: people dead from starvation in the desert, carts filled with corpses in the streets of Columbus, among many others.

Francisco Villa, whose fascination with photographic and film images is well known, went so far as to "sell" his battles—complete with his repertory of spectacular forms of death—to American reporters to obtain funds and arms or simply to impress them and enhance his reputation. In his memoirs, Raoul Walsh recounted his adventures in making *The Life of Pancho Villa* (1914), produced by D. W. Griffith:

I thought I saw [Villa] smile. Ortega motioned me to sit down again. "General Villa wanted to know if you were a newspaperman. He does not like newspaper people. I have tell him you are the big director from Hollywood, come to make the picture of his life. He just wanted to make sure."

Now was the time to try out my script. I did not hand it to Ortega because I was not sure he could read English. Instead I told it to him.

"The picture will be seen by millions of people in the United States and other countries. It will show General Villa as a boy, living with his mother and sister outside Hidalgo del Parral." (This I had cop-

ied from the book.) "As he grew up, he got work as a *vaquero* on a nearby ranch. He was poorly paid, and when he heard of an opening on the big Terrazas hacienda in southern Chihuahua, he embraced his mother and sister and rode away after leaving them with what little money he had. Translate that and ask the general if he likes it."

Not a muscle of Villa's dark face moved as he listened. The memory of his return to Parral to find his mother and sister raped and butchered by federal soldiers must have been painful. But only his eyes changed. They had been dully critical when we arrived. Now they shone as he licked his lips briefly. I thought of a jaguar getting ready to spring.

"Go on," Ortega prompted.

I ran through the sequence where he swore to avenge the deaths of his mother and sister after the parish priest told him what had occurred. I had him saying, "I swear before God that I will raise an army and destroy these murderers. Then I will ride to Mexico City and pull down the government which hires them."

Villa had been staring moodily at the moneybag while his lieutenant translated. When Ortega came to the part about attacking the government, he looked up and his eyes bored in on mine.

"The people who sent me here call him the liberator of the Mexican people; another Juárez, come to write a new constitution." I thought I laid it on thick but, as it happened, I was not far wide of the truth. Three years later a new constitution was drawn up, though Villa did not write it.

The general's set face relaxed and he smiled and nodded. "He wishes to congratulate you," Ortega said.

We both stood up and shook hands across the half-rolled maps . . . "The general says he will be pleased for you to make the story. And he will take good care of you, because if you are killed there will be no picture for the world to see."[27]

All these images were brought together in Mexico City, displayed each morning in the shop window of Agustín Casasola, where the curious gathered in search of news, looking over the latest photographs and attempting to assess the current state of the Revolution.

The Profession of Photographer: Second Phase

In a series of articles published in 1947 in the magazine *Mañana,* art historian and critic Antonio Rodríguez described, perhaps for the first time, the way in which photography entered the Mexican press. Although limited in its scope, Rodríguez's research remains unsurpassed. This is perhaps due to the close contact that he maintained with press photographers, many of whom had lived through this preliminary stage. It is, therefore, worth transcribing much of this little-known direct account. Above all, Rodríguez is one of the few historians in Mexico who "reads" a photographic image for what it is, without aesthetic prejudices and without reference to the "fine arts."

Progressing step by step, the illustrated press in Mexico received a new and powerful impulse with the introduction of an improved form of photoengraving.

According to Armando Salcedo, one of Mexico's earliest photoengravers, the process was introduced in Mexico in 1888 or 1889 by Naval Commodore Don Ángel Ortiz Monasterio.

"Shortly thereafter"—says Salcedo—"an Italian arrived in the country, a Sr. José Tabarrache, an immigrant photoengraver who brought over artistic typography, the process of engraving using Lepage's gum and perfected halftone engraving."

That moment virtually inaugurated the era of photography in the Mexican press, and little time passed before the first newspaper photographs were published.

The first to our knowledge appeared in *El Mundo Ilustrado* in 1896.

There we see portraits of theatrical artists, factory workers, views of carnival in Mexico—all static, immobile, as if the figures depicted were not men, but mannequins. Yet already in the issue of February 23, 1896, there was a photograph of a horse race in full action.

Aside from this exceptional photo, we find, at every step, photographs that would surely provoke laughter among contemporary photographers. Among them are those of a banquet in honor of General Díaz given in April of that same year, in

which the photographers—in order to simplify things—took views of the banquet . . . before the arrival of the guests, in other words, of the empty tables. Using a bit of imagination, the photographers complemented their informative note with the explanation: "Views of the room in which the banquet was held . . ." "Places occupied by . . . ," and so on.

In September of 1896, *El Mundo* published a story presented as a photographic reportage about the Casa de la Moneda. The article was entitled "History of a *Peso*" and described various aspects of the minting of money, but done in a fragmentary manner without a sense of continuity, using photos in which everything was immobile: workers that look into the camera, idle machines, interrupted action.

Yet, one year later, we see a photo of extraordinary journalistic interest, worthy of the best professionals of the contemporary press. It concerns an "execution in China," taken by Dr. Carlos Glass, in the course of a trip around the world aboard the ship *Zaragoza*.

A month and a half later, *El Mundo* scored a big hit when it published the extraordinary photograph of an assassination attempt against the person of the president of the Republic, General Porfirio Díaz.

After relating how the interesting photograph was made—revealing "professional secrets" to the readership—the editorial staff declared, in a display of power:

"Ownership of this photograph is retained by the author in conformance with the Law. But *El Mundo*, which spares no expense when it is a matter of providing its readers with something important, has acquired the reproduction rights and gone to great efforts to make the enlargement which can be seen on the appropriate page of this issue."

At this time, *El Imparcial,* another newspaper published by Reyes Spíndola at the beginning of the twentieth century, still did not systematically publish halftone photographs, just the occasional portrait, archaeological monument, building, or machine. However, in January 1903, it included a sensational photograph that approximates the best of this genre today. The lucky photographer, Manuel Ramos, captured the spectacular goring of the bullfighter Segurita. The importance of the photo

commanded the author's signature, which appeared below the image. For the first time, we see a signed photograph in the Mexican press.

From then on, the era of press photography in Mexico had truly begun. One after another, the illustrated magazines appeared: *Artes y Letras, La Ilustración, La Semana Ilustrada, El Tiempo Ilustrado.* The modern newspapers conceded an ever-increasing importance to photography. Out of the heat of great events were forged a number of photographers who played extremely important roles in the history of Mexican photojournalism: the Casasolas . . . , Isaac Moreno, Gerónimo Hernández, Uribe, Eduardo Melhado, Samuel Tinoco, Ezequiel A. Tostado, H. Negrete, Victor León, Luis Santamaría, and Manuel Ramos.

Day after day, new periodicals appeared—*Excélsior,* Gonzalo de la Parra's *El Popular* (the first rotogravure daily in Mexico), *Revista de Revistas, Jueves de Excélsior, El Ilustrado* and *Todo*—the epoch of Palavicini and others who gave special importance to photography. But a picture journalism still did not exist, one that expressed itself fundamentally through images. Nor were there "photojournalists" as we know them today, with the skill and independence to present a story—beginning, middle, and end—through the medium of photography.

That epoch in Mexican journalism was born with the magazines *Hoy* and *Rotofoto* and, with them, a new kind of photographer.[28]

Periodicals are, obviously, the principal consumers of photographic images. Since the invention and development of halftone reproduction, however, photographers have not really felt comfortable in the press room, awaiting their assignments. They prefer to work freelance with people in their own profession, who are interested in the image itself as a medium for news, rather than as an anonymous illustration beside the text. In his 1937 history of journalism in Mexico, Teodoro Torres described how press photographers worked at that time:

Also under [the chief editor] were the photographers . . . auxiliaries of the newspaper, like the cashiers or linotypists . . . puffed up with the prerogatives of the journalist (which they enjoyed in good

measure), they never tired of complaining about their rank as "graphic editors," as they were called.[29]

To improve their situation, the photographers organized themselves. They not only created professional associations that defended their interests, but also gained greater freedom and flexibility in their work. A new concept, the picture agency, would alleviate the problems of journalism and provide the press with the best images, made by photographers working in relative independence. This story has repeated itself with each generation of photographers, from the agency founded by Casasola in Mexico in 1911 to the Magnum group created in New York in 1947.[30] Other photo agencies established in Mexico include the organization known as Hermanos Mayo;[31] and in recent years Graff Prensa, Imagen Latina, and Cuartoscuro.

The professional photographer is no longer the studio portraitist of the nineteenth century, but the "person on the street," who "grabs the story." The situation is one of continual struggle for quality, the scoop, the preeminence of the image over written information, and the recognition of authorship.

The stories of two photographers who became small businessmen, owners of picture agencies, demonstrate this evolution within the profession.

Agustín Víctor Casasola

Agustín Víctor Casasola was thirty-five years old when the Revolution began in 1910. He had already worked in journalism for sixteen years, first as a typographer and then as a sports reporter. In 1894, he joined the staff of the newspaper *El Liberal*. From there he went to *El Popular* and, finally, to *El Imparcial*. He acquired his first camera—the type is unknown—in 1900 and began sporadically illustrating his articles with photographs that he made himself.

As a journalist, Casasola had, as they say, an "eye" and knew how to get a scoop, the exclusive news story. In 1907, when he was working at *El Imparcial,* he covered the trial of Manuel Boullas, circumventing a ban prohibiting reporters from the proceedings by climbing a post from which he could take pictures. This bit of skillful audacity earned him a reputation among his fellow journalists, as well as those in power.

Handsome, slender, nearly six feet tall, and dressed in the style of Porfirian dandies (this is how he appears in a number of photographs), Casasola mingled with the powerful of the country. Press photographers are, in a way, like courtiers. This is the only way they can gain the confidence of their subjects, get close to them, and ask them to pose. (Of course, this was before that modern phenomenon, the *paparazzi,* changed the rules of the game.) To make photographs at the beginning of the twentieth century, it was still necessary to ask history to stop long enough to make the picture. For this reason, photography in the final years of the *porfiriato* still largely conformed to the formal, static models established by the studios, even though Casasola and some of his colleagues (such as Manuel Ramos) were already using magnesium flash inside the National Palace.

The social section was, at that time, one of the most important parts of the newspaper, often its principal *raison d'être*. Only *El Imparcial,* which, as its name indicates, sought to provide its readers with relatively objective information, gave prominence to social problems, covering the wars against the Yaqui Indians in Sonora and the Maya in Yucatán and the sporadic strikes that broke out here and there among the few modern industries in Mexico at the time: the textile factories in Puebla and Veracruz, the mines of Hidalgo and Chihuahua, the sugar mills, the cotton and sisal industries.

Although he did not actually bear the title as such, Casasola was, in fact, the official photographer of Porfirio Díaz until 1911 when the *Ypiranga* sailed for Europe, carrying the former dictator into exile. Casasola "cautiously reported the development of the *maderista* movement, but like all the other photojournalists, he preferred to focus his attention of the last act of *porfirismo*."[32]

Casasola was a loyal man. He accompanied Díaz to Veracruz and saw him off. A few weeks earlier, the photographer had set his own course in history when he founded the Agencia Fotográfica Mexicana, the first Mexican news photo agency. His firm would compete with the Sonora News Company, run by the American Frederick Davis,[33] and with International and Underwood, the two best-known picture agencies of the time. The Agencia Fotográfica Mexicana distinguished itself from the other commercial firms by its dynamism. Among the photographers who worked with

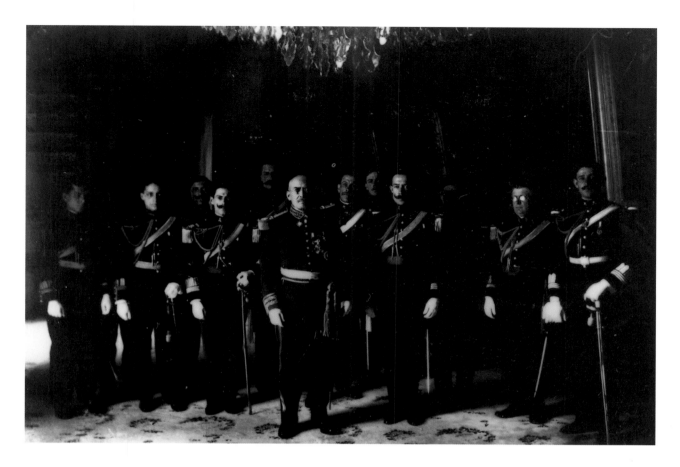

Agustín Víctor Casasola

Gen. Victoriano Huerta, Interim President of the Republic, and His Staff, 1914

Gelatin silver print
Reproduction authorized by the Fototeca del INAH-CONACULTA
Pachuca, Hidalgo

Casasola were Eduardo Melhado, José María Lupercio and his younger brother Abraham, Samuel Tinoco, Gerónimo Hernández, Víctor León, Luis Santamaría, Manuel Ramos, and Hugo Brehme.

From then on, Agustín Víctor Casasola became, more than a photographer, a compiler of images. From the headquarters of the agency, he directed his associates, sometimes purchasing photographs from foreign reporters, even amateurs, and redistributing these to the newspapers. His is not an isolated case: the U.S. firms Mutual Film and International did the same. However, at that time Casasola did not intend to build a collection per se, but to cover the revolutionary movement in full.

As a person close to power, Casasola enjoyed the support of interim president León de la Barra in 1911. Before an audience of his professional colleagues, the president thanked Casasola for having "inaugurated a new phase of freedom in press photography." Yet this "new freedom" did not prevent the Zapatistas from assassinating a photographer named Rivera near Ticumán in the state of Morelos in August 1912. In response, Casasola organized a protest—the first of its kind.

At the end of 1912, the Agencia Fotográfica Mexicana was enlarged and its name changed to the Agencia Mexicana de Información Fotográfica, with offices at 76 Calle de Nuevo México (now Calle Artículo 123). Several photographers were added to the staff at that time. Although Casasola became a business owner, he never completely stopped working as a photographer, principally in Mexico City, at the center of power.

In February 1913, while Victoriano Huerta, Félix Díaz, and Manuel Mondragón attacked the Ciudadela, Francisco I. Madero was compelled to take refuge in the first establishment he passed as he headed for the palace. That happened to be the Fotografía Daguerre

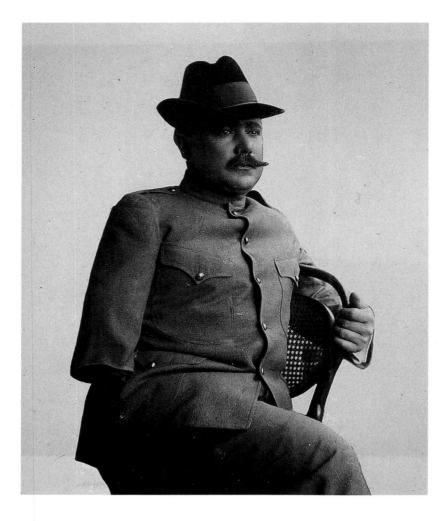

Agustín Víctor Casasola
Gen. Obregón, 1920

Gelatin silver print
Reproduction authorized by the Fototeca del INAH-CONACULTA
Pachuca, Hidalgo

studio, on the corner of Avenida Juárez and Calle Dolores. There, by chance, he encountered Casasola, who made a portrait of the president mounting his horse. It turned out to be the last photograph of Madero made during his lifetime. Just two days later, in the depths of the Lecumberri penitentiary, Casasola put on Madero's bullet-riddled bloody jacket, seen in a famous photograph, taken by his assistant. After 1913, Agustín Víctor Casasola was joined in the firm by his son Gustavo.

When *El Imparcial,* where he had worked for nearly ten years, went out of business in 1917, Agustín Casasola recovered that paper's photographic archive. With these materials, plus those that he had gathered between 1911 and 1920, he published his *Álbum histórico gráfico,* with texts by Luis González Obregón. The bilingual edition of *Álbum histórico gráfico* seems to indicate that it was

directed as much to an American as to a Mexican audience. The book did not enjoy the success that Casasola had hoped, and he only managed to publish the first of six projected volumes, covering the years 1910 (the Centenary Celebrations) to 1912 (the *maderista* phase of the Revolution). This is not surprising: in 1921, the pressing issues were totally different, and the government of Álvaro Obregón clearly intended to put forward a policy of national reconstruction. Mexico was sick of civil war and revolutions. People wanted to forget the "lost" decade, the deaths, and the violence.

Between 1920 and 1930, the press went through a period of expansion, transformation, and consolidation that Fátima Fernández Christlieb, a scholar of the history of communication in Mexico, has analyzed as follows:

> The first World War coincided with the harshest moments of the Mexican social Revolution, which would deliver its swan's song at the Convention of Aguascalientes in [1917] and continue solely as a political struggle. As its legacy in the field of communications, the world war left new wireless systems that would be exploited by the American global corporations that were displacing the European capitalists that had prevailed [in Mexico] during the *porfiriato.* These corporations controlled several news sources using [traditional] written media, as well as exploiting new media such as radio. This fact had considerable impact on Mexican newspapers. Two of these, *El Universal* and *Excélsior,* founded during the first World War, would later be brought into the world of radio broadcasting that emerged in the United States with a distinctively commercial imprint. The idea of newspapers as business enterprises was also developed in this period, although there were precedents in the final decade of the nineteenth century: those newspapers that attempted to gain readers not through ideological content, but with their modern format. Such was the case with *El Imparcial,* whose name (despite its *porfirista* tendencies) is revealing: [it was] supported neither by the government, nor by the opposition, only by the money that came from its readers.[34]

Intense competition favored the development of businesses specializing in images. The case of Ezequiel

Álvarez Tostado is significant in respect to the growing demand and market for images at this time.

Ezequiel Álvarez Tostado, Businessman

Ezequiel Álvarez Tostado was born in Guadalajara in 1886. At an early age he became interested in photography and cinema. Together with Jorge Stahl, he opened El Salón Verde, the first movie theater in Guadalajara. Shortly thereafter, he apprenticed in the photographic studio of Ignacio Gómez Gallardo, who became—after Octaviano de la Mora moved to Mexico City—the most prestigious portraitist in the capital city of Jalisco. Álvarez Tostado opened his own studio in front of the University of Guadalajara around 1900. He must not have received much business there because between 1900 and 1903 he worked as an itinerant photographer covering fairs, towns, and haciendas in the interior of the country. He finally settled in Mexico City in 1905 and soon landed a job as a camera "operator" in the Droguería La Profesa, a firm owned by the Messrs. Labadie, suppliers of imported chemical products used by photographers. He did not remain there long, joining the staff of the photoengraving shop at *El Imparcial* in 1907. Álvarez Tostado's work at that paper as a photojournalist just slightly preceded that of Agustín Víctor Casasola. According to his biographers Héctor Yliescas and Ezequiel Álvarez Nuño, it was Álvarez Tostado who photographed the entrance of Madero into Mexico City in 1911 and the scenes of the Decena Trágica in February 1913. On that occasion, he was able to enter the besieged military headquarters at the Ciudadela, where he took a number of photographs.[35]

In 1913, thanks to the support of Alfredo Chavero, who had replaced Reyes Spíndola as director of the *El Imparcial* publications, Ezequiel Álvarez Tostado established the Compañía Periodística Nacional, an agency devoted not only to photojournalism (like that of Agustín Víctor Casasola), but to the processing of both text and image. His collaborators there included José María Cuéllar, Miguel Langárica, Alberto Garduño, Ricardo Cabrera, and Abraham Lupercio.

A committed follower of Madero, Álvarez Tostado was forced to emigrate to Havana for a short period between November 1914 and July 1915, when he returned and joined *El Pueblo,* the newspaper edited by Arturo Pani in Veracruz and official organ of the forces backing General Venustiano Carranza.

In 1916, Rafael Alducín invited him to manage the photoengraving department at the recently founded *Revista de Revistas,* published by the *Excélsior* chain. However, the high demand for images prompted him to abandon journalism and to establish his own firm Tostado Grabador in a workshop at Calle Magnolia 141, in the Colonia Guerrero. Many newspapers and magazines that did not have their own photoengraving facilities brought their business to his studio, which quickly became a large commercial enterprise, offering a broad range of services and modern machinery installed in 1924 in new premises at the corner of Calles Mina and Guerrero, where it still operates today. During the years preceding Álvarez Tostado's death in 1948, the first trichromatic images in Mexico were printed there, as well as catalogs, magazines, and libretti.

The careers of Álvarez Tostado and, to a certain degree, of those who followed his example allow us to put into more realistic perspective the personality and contributions of his contemporary Casasola—who has been made into something of a sacred cow—a sort of Diego Rivera of photography. Casasola's pioneering work was key during the crucial transitional moment of the Revolution, but because he maintained connections with those who succeeded one another in the presidential chair, representing (however briefly) the government of the moment, his career continued the pattern established by nineteenth-century photographers who had to struggle for their professional existence, allied with power. During his career, Casasola made a visual record of nearly all the human types that were to be seen during the *porfiriato.* This can be clearly seen in his postrevolutionary work: photographs of prominent figures from politics, literature, film, and the arts, photo essays on everyday life in the capital, updated "popular types," and the large series of documents that Flora Lara Klahr and Marco Antonio Hernández selected—from among hundreds of negatives—about life in the Lecumberri penitentiary.[36] Yet his archive—an incredible amalgam of images gathered from every imaginable source—survives mainly as the supreme visual document of the Revolution.

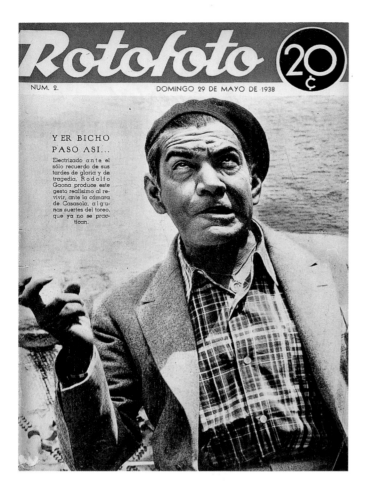

Anonymous
Cover, Rotofoto 2 (May 29, 1938)

Collection, Armando Bartra

Rotofoto: Visual Journalism and Nothing More

In 1937, José Pagés Llergo, co-director of the magazine *Hoy,* created *Rotofoto,* an American-style magazine with a format and design that openly imitated the successful formula of the recently founded *Life* (1936), but was substantially different from anything previously published in Mexico. Unlike its American model, however, *Rotofoto* set out to be a magazine with specifically political content, informed by national events.

Rotofoto, which advertised itself as a *revista supergráfica* (super-visual magazine), was a photographers' publication, and—for the first time in the history of the Mexican press—their names figured prominently in the editorial credits: Ismael Casasola, Antonio Carrillo, Jr., Enrique Díaz, Gustavo Casasola, Farías, Luis Olivares, Luis Zendejas, and Enrique Delgado.

From time to time, the magazine included images by other photographers: Alfonso Soto Soria, Elvira Vargas, and . . . Lázaro Cárdenas.

The magazine frequently used full-page photographic illustrations, and the quality of the printing was impressive. The photographers used high-contrast black-and-white images that lent an expressionistic look to their work and introduced a number of innovations in layout and design, as well as in sequencing.

> Without journalistic precedent, we believe, in any country, *Rotofoto* says everything through photography, which lends it an unexpected eloquence. *Rotofoto* makes photographic jokes, provides information, attacks, praises, caricatures, and demolishes. But while it destroys, cutting the strings of many a puppet, *Rotofoto* firmly establishes that the broadest range of expression is possible through the medium of photography.[37]

In fact, photography has seldom been used with such intelligence and with such corrosive effects. Gustavo Casasola introduced a novelty: the photographic interview laid out like a comic strip (or the later *fotonovelas*). With his camera, he "interviewed" a number of political prominent figures of the moment: Diego Rivera, Leon Trotsky (who appeared behind his desk, gesturing and smiling, presenting an image of himself in absolute contradiction to his legendary seriousness and austerity), Salazar Mallén explaining that "fascism is salvation," Frida Kahlo de Rivera painting her famous work *What the Water Gave Me* (1938), etc. The serial images offer an almost cinematic coverage of the personalities interviewed.

Even the advertisements were treated differently—purely photographically—in the pages of *Rotofoto.* "What a find! And they're 'Elegantes' by 'Buen Tono'!" exclaims a young scavenger upon finding a half-filled pack of cigarettes in the city dump. The photograph, at once joking and critical, was by Enrique Díaz.

Above all, *Rotofoto* introduced an uncommon sense of humor into the print media and, particularly, into press photography. "A violin? A watermelon?" asks the caption below a photo superimposed on a strange "abstract" image. On turning the page, the reader discovers that it is, in reality, the bald spot on Enrique Díaz's

Ismael Casasola
Interview with Diego Rivera
Rotofoto 2 (May 29, 1938)
Collection, Armando Bartra

head in a "bird's eye view" photograph taken at the editorial offices by Gustavo Casasola. But this biting playfulness went beyond the editorial staff; public figures were also targets.

In the third issue of *Rotofoto,* the editors published a photograph of Dr. Atl in the pose of Auguste Rodin's *Thinker,* half asleep in a corner of the former Convento de la Merced, an empty bottle at his side. The image— otherwise an excellent portrait of the painter—was apparently taken without his consent. A small scandal broke out, in part because of the subsequent confession that the photograph had been staged and taken by President Lázaro Cárdenas himself. Gustavo Casasola had lent him the camera and the controversial bottle. To redeem itself and Cárdenas's public image, in its next issue *Rotofoto* published a portrait of the president, taken by Antonio Carrillo during a political tour, that would go down in history. Cárdenas, surrounded

by a dim aura that accentuates his Indian features, addresses a group of old people dressed in white. No joke this time: the president appears here as the noble, yet egalitarian leader of Mexico.

Nevertheless, each in turn, Mexico's politicians fell victim, easy targets for the photographic lampoons. One or another congressman caught sleeping at his desk during the official and solemn sessions or the president's address, including the siesta of General Federico Montes Alanís, chief of police: "if you fix the camera on him awhile, you might catch him opening an eye to see what's going on," said the caption. Perhaps the best of these was Enrique Díaz's image of the "president's men" in bathing suits, fishing for sharks . . .

The sarcasm in *Rotofoto* was often more biting than that of the current generation of journalists, with their penchant for caricature and political exposé. A myth began circulating a few years back, especially among

the photojournalists at the newspaper *La Jornada,* which attributed the demise of *Rotofoto* to a photograph of Cárdenas in bathing trunks.[38] Although this image was indeed published, it was not the reason for the magazine's disappearance. On the occasion of José Pagés Llergo's death, Carlos Monsiváis gave this short history of the death of *Rotofoto:*

> *Rotofoto* is especially memorable, and its eleven issues demonstrate the agility and aggressive virtues of its director. Fundamentally visual, *Rotofoto* was provocative and amusing. The cover photo of the first issue, for example, showed President Lázaro Cárdenas squatting beside an imperturbable Indian

Enrique Díaz
Rotofoto en La Huasteca con Cedillo
Rotofoto 2 (May 29, 1938)
Collection, Armando Bartra

for a picnic on the ground. Further on, there was a picture essay on Madre Conchita,[39] various pictures of Agustín Lara, one of Secretary of the Interior Ignacio García Téllez posing like a mermaid on the beach, and several snapshots of poor people—included not as a social commentary, but for their picturesque quality. Other issues show General Manuel Ávila Camacho running in his bathing suit, Novo and José Mojica in situations considered scandalous at the time,[40] and—the cause of the closure of the magazine—the extensive photo essay on the rebellion in the Huasteca region led by Saturnino Cedillo ("I had to laugh when the government launched a campaign to engage my small forces in combat.")

The powerful leader of the Confederación de Trabajadores de México, Vicente Lombardo Toledano, was outraged. He denounced the magazine and called for its closure. The cover of the last issue of *Rotofoto* was a picture of Lombardo raising his right hand, accompanied by these lines: "The most conspicuous traffic cop in Mexico attempts to halt the circulation of *Rotofoto.* Sorry, but we're in a hurry and are resolved to commit the infraction anyway." *Rotofoto* defended itself—in vain. Led by Lombardo, several union leaders instigated a strike at the magazine, and an assault against its facilities that included arson.[41]

The author of the reportage on Cedillo was that "photographic ace" Enrique Díaz, whom *Rotofoto* had sent as "war correspondent." According to Antonio Rodríguez, "Díaz, overcoming enormous difficulties that included the danger of being killed in an ambush, was able to reach the General at his headquarters while the federal forces had searched in vain without finding him."[42]

In San Luis Potosí, Díaz rediscovered the motifs and spirit of the photographers of 1911, re-aestheticized now after the rise of modernist photographers like Weston and Strand and, above all, epic cinematography. The opening image of his report showed rebel troops on top of a train, armed young men holding their rifles high and smiling into the camera. Further on, as in Casasola's photographic interviews, Díaz presented a sequence of images: a *soldadera* and a soldier bid farewell between the tracks. The caption beneath the picture read:

The few remaining minutes before the train's departure cannot be better devoted than to offering comfort and strength to that self-sacrificing woman who is [all too] familiar with tenderness and privation: the *soldadera,* beautiful and dignified flower of our civil wars.

The soldier tells his son good-bye. The soldier climbs onto the train. These are not scenes of battle, but contain something that will soon disappear: Enrique Díaz depicted the image of the Revolution for what was, in fact, the last time.

Yet something had changed since the epic feats of Pancho Villa's legendary army: Díaz's photographs revive and glorify, but simultaneously subvert, the imagery of the Mexican Revolution disseminated by the Archivo Casasola and the films of Fernando de Fuentes. It is obvious that the administration of Lázaro Cárdenas intended to "reanimate the Revolution," to continue it. This program was not based on Trotskyist slogans about permanent revolution, but on a political nostalgia that included an awareness of the "gains of the Revolution of 1910." There was no question, of course, of returning to the chaos of the uprising: this Revolution on the verge of institutionalizing itself was strictly symbolic. (And to it we owe, among other things, the resurgence of mural painting and, if not support for, at least tolerance of organizations such as the Liga de Escritores y Artistas Revolucionarios and the Taller de Gráfica Popular.)

Enrique Díaz's images of the Cedillo rebellion, though much more sophisticated than those of the reporters of 1914, were offensive to the government because they dealt with an actual revolution, rather than nostalgia. They brought back a vision of the civil war and militarization of daily life that the regime wanted to eliminate at any cost.

What *Rotofoto* confirmed—and this resulted in its closure—was the power and persuasiveness of photographic images when effectively employed.

With *Rotofoto* gone, the magazine's photographers went to work for various other publications. Among these were the magazines *Todo, Mañana,* and *Siempre!* (also owned by the Llergo family) and Colonel José García Valseca's *Esto.* None of these, however, placed as much emphasis on images as *Rotofoto* had; nor would they ever attempt such visually imaginative journalism.

Palpitaciones de la vida nacional

The Second World War transformed the photojournalist into a hero. At that moment—immediately preceding the advent of television—the public was thirsty for information, hungry for images. Weekly magazines such as *Life* or *Paris-Match,* with their large format, well-printed illustrations, and incipient use of color, complemented the radio and newspaper as sources on current events. The images that appeared in their pages would both affect and become emblematic of the history of that period.

This revaluation of photojournalism occurred in Mexico during the postwar years. Writing in *Mañana,* Antonio Rodríguez proposed the first exhibition of press photography in Mexico, to be selected through a competition. Luis Alcayde, editor of the magazine, took up his idea, and Fernando Gamboa, then director of the Museo Nacional de Bellas Artes, installed the show at the Palacio de Bellas Artes.

The exhibition, pompously entitled *Palpitaciones de la vida nacional (México visto por los fotógrafos de prensa),* was inaugurated in July 1947 by none other than President Miguel Alemán. The show included a number of photographs made during the Revolution, but the majority had been taken in the late 1930s and early 1940s. Thirty-three Mexican photojournalists participated in the competition.[43] Some submitted isolated images, others reportages (at times extensive), consistent with the mandate issued ten years before by Beaumont Newhall regarding the need for "purity" and the importance of presentation in documentary photography.[44]

Antonio Rodríguez's intention was clear: to rescue from anonymity images of "undeniable informational value . . . often accompanied by a highly refined aesthetic."[45]

Few professionals within the Mexican press exercise an activity as anonymous and obscure as that of the photographers.

Yet their contributions are so vital and creative in the production of our newspapers and magazines that, without them, contemporary journalism would be unimaginable.

From their knack for visual news that captures the public's interest, spirit of vigilance that mani-

fests itself in the continued search for the unusual, quick decision to seize the passing moment that opportunity provides, and, finally, their talent for surprising life in all its facets and under the best possible technical conditions (the ideal angle, best lighting, correct aperture and shutter speed—all simultaneously balanced by the photographer with exceptional ability)—come the great documents of our age: the candid images that give life, movement, poignant realism, and extraordinary eloquence to the pages of our newspapers and magazines.[46]

This enthusiastic declaration of principles did not, however, accurately reflect reality. A few paragraphs further on, Rodríguez added this qualification: "As the first exhibition of this kind, no rigorous selection criterion was employed. In fact, many of the photographs exhibited do not completely respect the proposed theme."

In fact, there was a little of everything in the show: photographs of political events, particularly the confrontation between a horse and an automobile during a demonstration between Communists and protofascist "camisas doradas" in the Zócalo in 1935 taken by Manuel Montes de Oca, photographer for *El Universal*; Cedillo in arms by Enrique Díaz; the death of a soldier during military maneuvers in Puebla by Francisco Mayo; a shipwreck in the Pacific by Faustino Mayo; a photographic essay on witchcraft by Hugo Moctezuma and another on secret rituals in Guatemala by Gustavo Casasola; the incineration of Umansky by Armando Zaragoza; the literacy campaign, also by Faustino Mayo; an image of a man embracing his dead son by Víctor León of *Excélsior*; images of the collection of public donations at the time of the oil expropriation in 1938; a portrait of Cárdenas signing over deeds to land in Michoacán by Antonio Carrillo, Jr.; President Miguel Alemán embracing his mother; the eruption of Paricutín (an unavoidable image at that time) and familiar and typical Mexican scenes of the Day of the Dead; *tehuanas* dancing the *zandunga;* and many, many photographs of sports ranging from bullfighting to tennis. In the final analysis, this eclectic exhibition had little impact, yet was certainly representative of the type of images routinely made by photojournalists in Mexico at that time.

In his review of the exhibition, Rodríguez established the antecedents for the differentiations in genre and style that would dominant photographic discourse in the late 1970s and 1980s.

We do not believe that journalism and art are contradictory . . .

It would be impossible to judge this exhibition and evaluate its qualities, without including the aesthetic factors inherent in any work made by Mexicans, even documentary work.

Perhaps this is what distinguishes Mexican photojournalists from those of other countries and surely constitutes a personal characteristic of their work.

The important thing is that a press photograph, when beautiful, still fulfills its informational function, and this our photographers have done, if I may say so, quite well.

There are in this exhibition, certainly, some photographs in which there is manifest a deliberate intention to make art, to the detriment of journalism . . . those of clouds, trees, houses, and Indians in which the photographer, guided by a preoccupation with "prettiness," forgot his principal task. In those cases . . . the photographer has produced neither journalism, nor art, since the merely "pretty," the sugar-coated, borders on preciousness and is as far from beauty as it is from journalism.

We have heard of the curious case of a photographer, greatly concerned with aesthetics, who, when faced with both an event of great importance and a dramatic cloud, preferred the cloud and, in the end, failed to capture either the news report or the cloud.[47]

The awarding of prizes to photojournalists was a classic example of the small faults and great limitations of the Mexican press: it was hardly different from a big family fiesta in which gifts are handed out. "The certificate . . . received by Enrique Delgado, of the photographic corps of *Mañana* magazine, was awarded him by his colleague and good friend Enrique Díaz . . . From Don José García Valseca, publisher of the great newspaper chain that bears his name, photographer Paco Mayo received the first prize . . ."

In 1951, Antonio Rodríguez tried to put together a second, improved, exhibition of press photography, but ran up against "the stinginess and lack of vision of Daniel Morales (owner of *Mañana*)."[48] In a final attempt to promote the work of the press photographers,

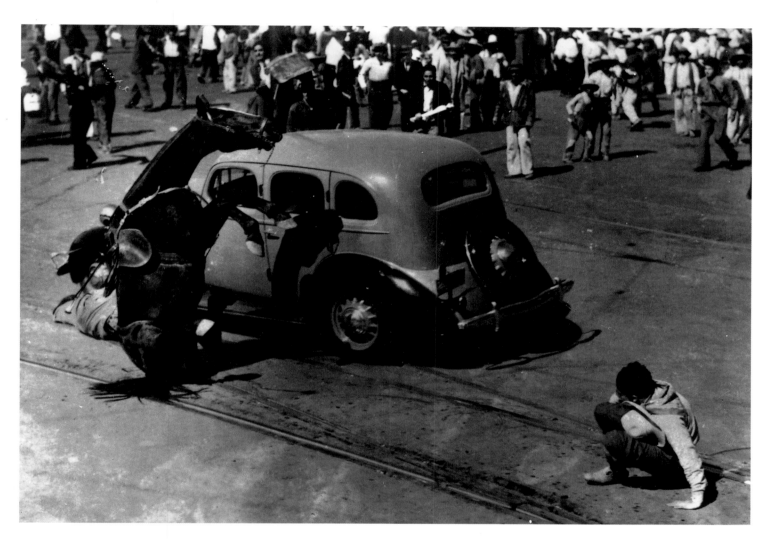

Manuel Montes de Oca
Clash between the Taxi Drivers' Union and the Fascist Gold Shirts Cavalry, Mexico City, 1935

Gelatin silver print
Archivo General de la Nación, Centro de Documentación Gráfica
Mexico City

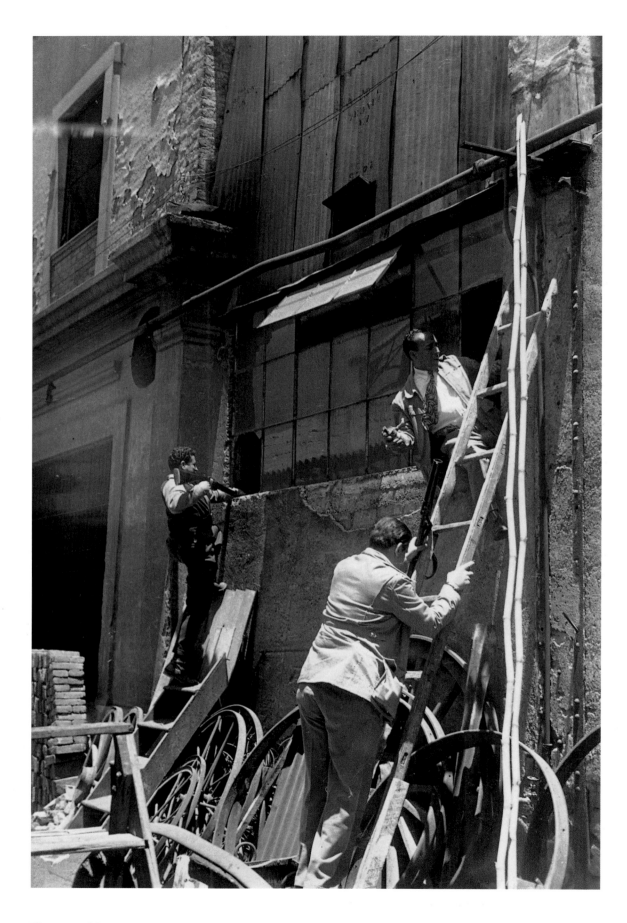

Hermanos Mayo

Antiterrorist Police Raid, ca. 1958

Gelatin silver print
Archivo General de la Nación, Centro de Documentación Gráfica
Mexico City

he did a series of interviews that were published in *Mañana* in late 1951 and early 1952.

In spite of their fights, their strikes, their continued (and largely unsuccessful) demands, and regardless of their proximity to power, Mexican press photographers did not make significant gains between 1947 and 1975. Only after that—in large part thanks to the tenacity of two "outsiders," Héctor García and Nacho López—did photojournalism reenter the sacrosanct halls of the museum.

Days to Remember

Héctor García was born in the Mexico City working-class neighborhood of Candelaria de los Patos in 1923. He was orphaned at an early age and, as a street child, was placed in the Correctional Institute at Tlalpan. He left in 1942 to go to the United States as a *bracero,* working at railroad construction until he was deported in 1945 in the first wave of migratory workers to be returned to Mexico at the end of the Second World War. Returning to Mexico City, he became an office boy for several publications, which allowed him to meet photojournalists and to begin working in photography.

By 1958, Héctor García was working for *Excélsior,* for which he completed an extensive photo essay on the student and railway workers' demonstrations in Alameda Park and the Colonia Tabacalera, as well as the subsequent detention of Demetrio Vallejo, who was sentenced to twelve years in prison for his role in these events. Faces of enraged railway workers, the impressive line of torches along Avenida Juárez in front of the Monument to the Revolution, then the repression: one sequence shows soldiers beating nurses. Not surprisingly, *Excélsior* refused to publish his photographic reportage. In response, Héctor García disseminated the images himself (thanks to the support of Horacio Quiñones) in *Ojo, Una Revista Que Ve,* a magazine that appeared only once. The historic issue appeared in September 1958 and was a remarkable and successful effort to overcome censorship, allowing García to publish his full photographic sequence.

Another photographer who witnessed the government repression during the summer of 1958, Enrique Bordes Mangel, never managed to get his photographs printed in the newspaper of the day. They remained

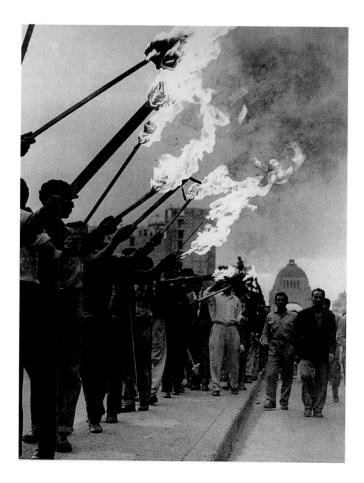

Héctor García
Movimiento vallejista, Mexico City, 1958

Gelatin silver print
Courtesy Héctor García

unpublished until the mid-eighties, when they were included in *El poder de la imagen y la imagen del poder,* an anthology edited by Flora Lara Klahr and Marco Antonio Hernández.

History repeats itself, especially the history of political repression. During a brief period in 1968, Héctor García simultaneously covered the student marches, the government's use of a bazooka to blast open the door of the National Preparatory School, and preparations for the Summer Olympics (for which he was, in fact, the official photographer). On October 2, he followed the massive student march down Insurgentes toward the Plaza of Tlatelolco. He made numerous photographs there, including one of the students radiating outward like an exploding star from the center of the plaza, illuminated by the harsh light of the streetlamps.

None of his images of the event leading up to the infamous massacre of students by government forces

appeared in the daily newspapers, although they were used in countless publications in the following years: in 1969, for example, Carlos Monsiváis included García's photographs in his important first book, *Días de guardar*.

Elena Poniatowska traced Héctor García's sympathy and commitment to his subjects to his childhood on the streets:

> A fatherless child, Héctor García's photographs reflect his own life, his situation as an abandoned child, a waif, a street kid from Candelaria, tied to the foot of the bed while his mother went out to work, an ugly duckling, orphan from Candelaria [de los Patos . . .] Having lived through a childhood of injustices and outrages, he has never forgotten to focus his camera on the downtrodden, the poor, what the sociologists refer to as the "lumpen."[49]

What is it that characterizes the images of Héctor García, that differentiates them from those of Manuel Montes de Oca, Gustavo Casasola, Enrique Díaz, or the Hermanos Mayo—the photojournalists of the preceding generation? Was it a change in political consciousness, or was it his determination to make a more personal body of photographic work? Or both of these, interconnected? Both García and Nacho López deliberately positioned themselves on the razor's edge between pure documentary and personal expression.

In the fifties, Héctor García was a singularly "daring" photographer who discovered a way to break through official barriers to get a scoop better than any-

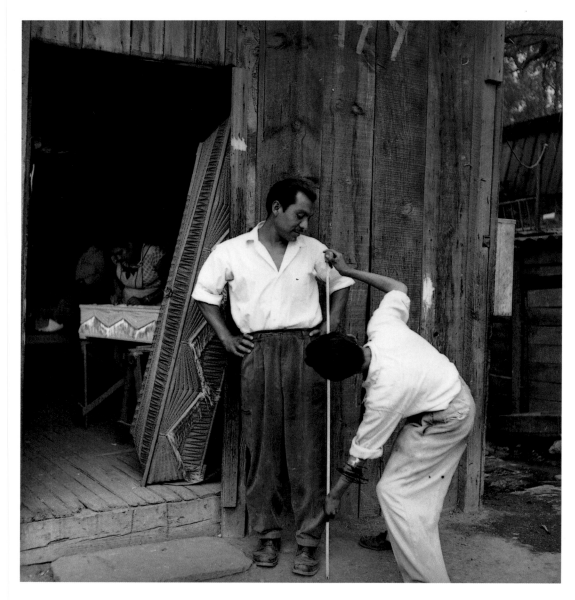

Nacho López
Colonia Nonoalco, 1955

Gelatin silver print
Reproduction authorized by the
Fototeca del INAH-CONACULTA
Pachuca, Hidalgo

one else. For example, he got into Lecumberri, when President Adolfo López Mateos had decreed that no photographer could work in the prison. Moreover, he had the determination to get his images published and to create new venues for their distribution (he helped found a number of magazines, including the once-famous *Cine Mundial*). Most importantly, his irreverence (in contrast to the officialism of his colleagues) set him and his work apart. His best-known photograph, *Nuestra señora sociedad,* is a satirical image of a society lady at the Palacio Nacional, attempting to straighten her evening gown after one of the official guests stepped on it.

Héctor García seems to have a gift for ubiquity: he must have nearly bumped into himself coming and going in the street photographing major events, strikes, marches, and ceremonies, the funerals of Frida Kahlo and Diego Rivera, parties at the home of María Félix, the incarceration of David Alfaro Siqueiros, and dance contests in the nightclubs in the area of the city known as Niño Perdido. Meanwhile, his wife, María Sánchez de García, works in the laboratory, developing, printing, finishing his images: a close and uncommon collaboration that deserves recognition and gives Héctor García a freedom of movement comparable to that of the equally ubiquitous—but much more numerous—Hermanos Mayo.

Nacho López: Photojournalist

Great transformations and wars will come, and photography will continue to record the eternal conflict: man in search of his dignity.[50]

Although a contemporary of Héctor García, Nacho López is a very different case: he chose a different path, a more complex and nuanced approach than is generally common among photographers, based on a respect for the image and what it signified. A photojournalist above all, Nacho López once stated:

Photography finds its best application in journalism. There the photographer comes into contact with human destiny, with the drama of the defenseless, the arrogant behavior of plutocrats, the hypocrisy of officials who kiss babies and pet dogs while mur-

dering men and women. In a fraction of a second, the photographer captures an apparently chaotic reality and organizes his vision into a portrait of his times.

Many photographers, following a fashionable trend, portray the poor in a superficial and degrading manner, ignoring the social context. In doing so, they join the game of the powerful, who insist in presenting us as sleepy but paradisical countries, acculturating us through their promotional media. These photographer-tourists depict the human zoo without considering themselves part of that same zoo. And when they exhibit their photos full of "local color" and folkloric picturesqueness, the response is immediate: How pretty! How interesting![51]

His own way of working, however, occupied a place at the border between photojournalism and what would come to be known as "personal expression."

In Nacho López's photographs, as in those of Héctor García, there are marches, demonstrations, and acts of repression, but never so violent or taken from so close a vantage point. And there are faces, but above all there is something that does not appear in the work of any other photographer of the period (with the possible exception of Lola Álvarez Bravo): gestures, gesticulations, and movement—lots of movement. This was duly noted by Antonio Rodríguez, who recalled that Nacho López started out as a photographer of dance (with his sister, the dancer Rocío Sagaón):

The sense of rhythm is so constant in the work of this refined and passionate artist that it seems less an image that he captured from life, with his camera, than an imposition of willful life itself, as seen in the cadenced step of those Indians walking the trail to their village with the gestures and poses of a ceremonial ritual.

Human beings, objects, fruits: everything responds . . . to an orchestration of rhythm as if in tune with some universal beat.[52]

The majority of López's photographs were published as extensive photo essays in the magazines *Mañana* and *Siempre!* These were affected at times by the pathetic tone typical of the Mexican press in the 1940s—something between sensationalism and sentimentality. *Pris-*

ons of Dreams, Once We Were Human Beings, and *I, Too, Was a Good Boy* are the titles imposed on just three of his many photo essays.[53]

Nacho López's photographs reveal his interest in gesture: open hands emerge pathetically from a hole in the door of a prison cell (*Penitenciaría de Lecumberri,* 1954); a street child rubs his eyes to hide his tears (*Escuela Revolución, Calle Niños Héroes,* 1959); the hands of the leader on the platform echo the hands of those who have come to listen and cheer him (*Plaza de la Constitución,* 1958); the hand of the delinquent in the police station who denies his crime (*Delegación de Policia,* 1957); the widow who covers her face with her hand (*Delegación de Policia,* 1957); or the young men on the street who turn to catch the swift passage of the wasp-waisted woman (*Calle Balderas con Ayuntamiento,* 1957).[54]

There is an intentionality in the images of Nacho López that is not generally found in the press photo-graphs, which typically seek only to deliver information in the most direct and effective manner. López's work—situated on the fringes of documentation—emphasizes certain aspects of daily life that do not necessarily demand a dramatic or aesthetic treatment. It is not an easy task: to create an image simultaneously didactic, eloquent, descriptive, sufficiently expressive, and symbolically meaningful, all of which allows the image to transcend the brief life of a news story and become, to some extent, atemporal. This is the path opened by Nacho López and, with it, the doors of postmodern photojournalism, no longer strictly linked to an ephemeral news story. This approach was taken up after 1977 by Pedro Valtierra, Christa Cowrie, Marco Antonio Cruz, Andrés Garay, Fabrizio León, Rubén Cárdenas Pax, Luis Humberto González, Frida Hartz, Rogelio Cuéllar, and Francisco Mata Rosas.

First *Unomásuno,* then *La Jornada:* a new form of intelligent journalism that emerged in Mexico as a re-

Nacho López
Penitenciaría de Lecumberri, 1954

Gelatin silver print
Reproduction authorized by the
Fototeca del INAH-CONACULTA
Pachuca, Hidalgo

Pedro Valtierra
Protesta minera, Pachuca, Hidalgo, 1985

Gelatin silver print
Courtesy Pedro Valtierra

sult of the crisis of consciousness following the student massacres of 1968 and the easing of restrictions on the press in the 1970s. Enjoying a measure of tolerance gained at the price of confrontation and death, these publications offered their pages to the new generation of photojournalists. With the passage of years, many people have forgotten the battle of *Rotofoto.* With the ingenuousness of a medium that has returned to its infancy and learned to speak all over again, photojournalists once again depict representatives napping at their desks and politicians scratching themselves, Fidel Velázquez at an eternally unfinished banquet, hunger in Oaxaca, the victory of Miguel de la Madrid (of Carlos Salinas, of . . .), the smog behind the Torre Latinoamericana, and those often ignored by the news media: anonymous pilgrims at Chalma, drunks in La Lagunilla, striking miners who took off their clothes in public because baring their buttocks for the front page seemed the only way to gain attention to their plight,

dancers at the Basilica of Guadalupe, strikers at the Cathedral, jailed *campesinos, braceros* from Cañón Zapata, masked Tzotzil Indians crawling in the mud, Zapatista leaders dignified by their anonymity, emerging from the rain forest, mourning mothers leaning over simple mounds of dirt . . .

The history of photojournalism in Mexico can also be written using the countless letters to the editors, practically the only testimony that remains of constant abuses and continually reinvented repressions. It is a tragic story—at times boring in its repetitiveness—a litany of imprisonments, arbitrary detentions, kidnappings, beatings, hospitalizations, seized cameras, stolen cameras, smashed cameras, exposed film, destroyed film, laboratories smashed with axes or burned, images lost, losses . . . It is a chapter in the story of the Mexican press, but that is another story.

Gustavo F. Silva
Portrait of Lola Álvarez Bravo, 1922

Gelatin silver print
Private collection, Mexico City

10
Danzón

Manuel Álvarez Bravo
El ensueño, 1931

Gelatin silver print
Courtesy Manuel Álvarez Bravo

The pensive girl leans against an iron railing, looking toward the back of the patio . . . Manuel was sick, recuperating from the tuberculosis that almost cost him his life that year, 1931. Still, he sat up in his armchair and took the photograph that he later entitled *El ensueño* (The Daydream).

In its time, the building had been one of the city's old colonial mansions, an opulent house with three stories and a massive wooden doorway that had been completely opened only to allow carriages to pull up next to the principal stairway. There were two patios—one for the masters, the other for the servants who made up the enormous domestic staff. Located near shops that sell religious paintings and statues and ornaments for churches, number 20 Calle de Guatemala was and remains "straight up from the door of the Cathedral."[1]

The big mansion on Guatemala, converted into apartments, has not remained intact over the passage of years. Like the rest of the district, it suffered the changes that transformed the city: the flight of the students when the university moved to south to the dark lava fields of the Pedregal, the flight of the businesses when the Zona Rosa, Cuauhtémoc, and Polanco neighborhoods became centers of attraction—in short, the generalized movement out of the city's congested historic center.

But in the 1920s, as Lola Álvarez Bravo remembered, Dr. Atl lived in the convent of La Merced; other artists—Robert Montenegro and Jorge Enciso—shared a studio at the back of the church of San Pedro y San Pablo, beside the university's periodicals library. The School of Medicine was nearby, as were sidewalk stalls that sold hot *garnachas* and neighborhood restaurants where in the evenings one drank beer in back rooms. Across the way, the Robredo bookstore opened onto the street and just beyond it Las Delicias, a traditional Mexican restaurant, was an unavoidable stop. From 20 Calle de Guatemala to the Academy of San Carlos was only a short way. From there to the old El Volador market with its wooden stalls, or *cajones,* was a five-minute walk.

To live in the city's colonial heart at this time was to be truly at the center of everything. The extent of the city in 1920 was such that one could walk almost anywhere; for longer excursions to the colonial towns that surrounded the city center—Tacuba and Tacubaya, San Ángel and Coyoacán—streetcars led off in all directions from the Zócalo.

As a very young girl, Lola had lived a few blocks away, in the tailors' district. Her father—an importer of furniture and art from Europe—owned a big house, almost a small palace. Today it too is a tenement, its façade of white stone painted with glossy, bright red lacquer. She took me there several years ago. We entered the first patio: it was filled with sacks of fabric remnants from the countless apparel-makers' workshops that now occupy the old apartments. Strips of every color hung from the wrought iron railings, the stairways, the windows, even from the roof.

But in 1910, Lola's father, Gonzalo Martínez de Anda, died from a heart attack suffered during a train trip to Veracruz with his daughter. She was probably around eight years old and was sent to live with her older brother and his wife in their apartment at 20 Calle de Guatemala.[2]

Lola was a boarding student at Sagrado Corazón de Jesús—a school run by French nuns in Tacubaya. Manuel boarded at the French Marist fathers' school in Tlalpan, at the other end of the city. On weekends, however, they were reunited on the rooftop terraces of Calle Guatemala.

The Álvarez Bravos occupied the floor just above the second patio; the apartment of Lola's brother was located on the first floor. The rooftop terrace was their common space and refuge. There Federico, Manuel, and Isabel Álvarez Bravo, Lola Martínez de Anda, and a boy named Santiago leapt the walls, tormenting the birds with a borrowed air rifle.

The Álvarez Bravo children lived with their mother, Soledad, widow of Álvarez García, a painter and writer whose father, Don Manuel Álvarez Rivas, had been a painter and photographer back in the heyday of the carte-de-visite.

Manuel did not attend the school in Tlalpan very long. In 1914, the French priests returned to their country to fight on the German front. Life was not easy in the second patio of the house on Calle de Guatemala—it was the year of unforgettable hunger—and the thirteen-year-old began to work in order to help out. He knew some French, so it was not difficult to get a job as an office boy in a French firm.

Somehow, he still found time to learn, taking night classes at the Academy of San Carlos to study art, at the nearby Conservatory (music was always a passion), and at the School of Business Administration (numbers—a cerebral cacophony—were something for which Manuel had demonstrated an uncommon gift early on).

In 1916, Manuel began working as an accountant at the Comptroller's Office of the Mexican Government. He rose quickly through the ranks: no one else could match his ability to add, subtract, and multiply in his head, without mistakes. For years his head was filled with formulas—adding, subtracting, and multiplying with the speed of a computer. Since he solved mathematical problems before anyone else, he was often left with little to do and spent his free time wandering about for the rest of the day.

Robredo's bookstore, the shop windows on Avenida Madero and 5 de Mayo, the advertisements posted on the walls, strange apparatuses on display in the medical equipment stores, accumulations of hammers, saws, and hinges of various sizes in the hardware shops, and—above all—the machines fascinated him.

The photographic studio of Martín Ortiz was located at 24 Avenida Madero, near the corner of Palma. Gustavo F. Silva was in business at 5 de Mayo and Motolinía. But the most luxurious studio, the one that really impressed the young Álvarez Bravo, was that of Emilio Lange, near the Avenida San Juan de Letrán.[3]

Manuel Álvarez Bravo had a companion at the school in Tlalpan named Luis Ferrari. He was the son of Fernando Ferrari Pérez, a quintessential scientist of the *porfiriato,* whose work in the field of botany might have found a place in the history of Mexican science if the boat carrying the collection he had patiently compiled over more than thirty years had not sunk beneath the waters of the Gulf of Mexico, destroying his entire herbarium, his classifications, and irreplaceable findings. Ferrari Pérez was also an engineer. He built the Museum of Natural History in the cast-iron style made famous in Paris by Gustave Eiffel. Shortly after the Centennial Celebrations of 1910, he installed the eternally popular mastodon exhibit there which was later moved to Chapultepec. He also made photographs: *El Mundo* published some of his views of the caves of Cacahuamilpa illuminated with magnesium flash and several aerial views of the central part of Mexico City, taken from an airplane with the assistance of the portrait photographer Gustavo Silva. Don Fernando collected cameras, both old and new. Somehow he managed to acquire the camera manufactured by Daguerre and Giroux which is now on display at the Museo de Arte Moderno, a gift from Manuel Álvarez Bravo. He was once seen standing in front of the Aztec calendar stone manipulating a strange apparatus: the first light meter in Mexico.[4]

Gustavo F. Silva
Portrait of Manuel Álvarez Bravo, 1922

Gelatin silver print
Courtesy Manuel Álvarez Bravo

Ferrari Pérez showed Manuel how to make photographs. This early apprenticeship did not last long, nor was it complicated: mainly one had to learn to calculate the exposure settings—but Manuel, the accountant, was accustomed to playing with numbers. Something about it captivated him—exciting within him a passion for images. He borrowed a camera (according to other versions of the story, his first camera was a hand-held Kodak that belonged to Lola's brother), and thus began his career as a photographer.

Ferrari Pérez seemed to know everyone in Mexico. He was a friend of the German photographer Hugo Brehme, who had a successful studio in Mexico City and whom he often accompanied on photographic ex-

cursions in the states of Puebla and Morelos. Once—it would have been in 1921 or 1922—they invited Manuel, with his little camera, to come along.

Brehme taught him how to develop film and make platinum prints—no simple technique, this was a sophisticated process that required extreme care and equipment that was expensive and difficult to acquire in Mexico. Brehme even gave him little jobs doing things like printing postcards, preparing solutions, and drying photographs.

Was it before or after this that Manuel Álvarez Bravo decided he wanted to be a doctor of homeopathic medicine? He studied briefly and practiced on his willing friends, his family, and his fiancée Lola.

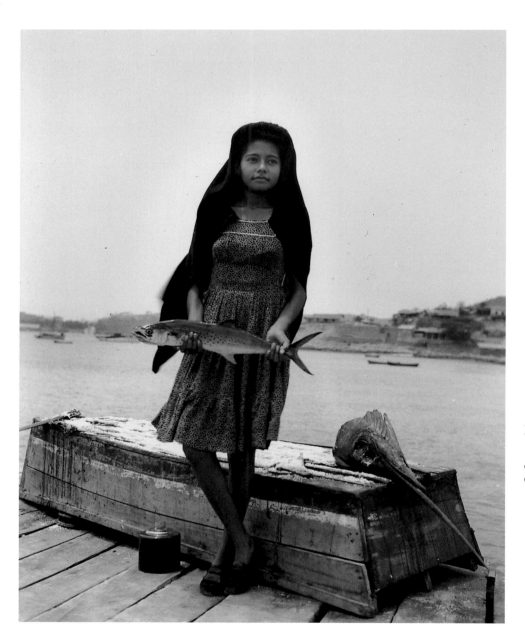

Manuel Álvarez Bravo
Un pez que llaman sierra, 1944

Gelatin silver print
Courtesy Manuel Álvarez Bravo

Manuel Álvarez Bravo

Arena y pinitos, ca. 1924

Gelatin silver print
The University Art Museum, gift of Frederick and Elizabeth Myers
University of New Mexico, Albuquerque
Courtesy Manuel Álvarez Bravo

His next step was to subscribe to a number of photography magazines published in France, England, and the United States: *Camera, Camera Craft, American Photography*. He still has some of these in his studio on the Calle de Espíritu Santo in Coyoacán, which he modeled after Martín Ortiz's storefront that had so impressed him back in 1922.

On Sundays, Manuel went with Ferrari Pérez to the Volador flea market. The engineer was also the first in Mexico to collect old photographs: daguerreotypes, ambrotypes, cartes-de-visite. There were mountains of them at El Volador, and they were practically given away. Manuel and Lola began to form a collection.[5] Manuel and Lola Álvarez Bravo are not only principal actors in the history of Mexican photography; they were also among its first historians, an avocation that they shared with their friends Felipe Teixidor and Enrique Fernández Ledesma. In this respect, too, their contributions have been invaluable. As early as the 1930s, Lola reproduced several of these old images with her comments in the architectural magazine *Avance,* published by Rosell de la Lama.

Manuel Álvarez Bravo's career might have been very different had he not gone on those excursions with Ferrari Pérez and Hugo Brehme. It was then that Manuel made his first serious photographs. Those few that he dares show reflect the profound influence of the German photographer. He kept *Arena y pinitos* (Sand and Pines), perhaps because it is one of the oddest. It appears to be a shot of Popocatépetl covered with snow, seen between trees. In reality it is a photographic trick: a pile of sand with a few small twigs placed in the foreground. Was it a joke on the sublime volcanic landscapes that Brehme sold so successfully? The image entitled *Peluquero* (Barber) of 1924 and *El evangelista de Santo Domingo* (The Letter Writer)[6] are more revealing of the type of photographs that Manuel Álvarez Bravo made during that period. In any event, Hugo Brehme used one of Manuel's negatives to make a postcard and published it as his own. Manuel Álvarez Bravo considered it a great honor. Perhaps it was, in 1924.

But 1924 would bring changes as well. In an interview with Mildred Constantine in the 1970s, Manuel Álvarez Bravo recalled how "one day a friend pointed out two people, Tina and Weston; each was carrying a camera. That was the first time I saw her, near the

church of La Santíssima. They looked at the church but didn't take any photographs."[7] Then, in the middle of 1924, Manuel was transferred to the Oaxaca branch of the Comptroller's Office. Before he left, he married Lola and bought a new camera, a Century Master 25.

In November of that year, the Ministry of Public Education presented a collective exhibition at the Palacio de Minería in which Edward Weston and, for the first time, Tina Modotti participated. Manuel and Lola saw the show during one of their trips to Mexico City. Lola remembered that the Mr. Weston about whom everyone was talking was there. They only saw him from a distance, however, since they did not dare speak with him.

Edward Weston had been in Mexico just over a year, living in a house in Tacubaya that had once been part of a hacienda. Weston was already well known in the United States, in California above all, where he was considered a first-rate portraitist, although he had lately abandoned that type of photography. Edward had married in 1909 and had four sons, but married life in the suburb of Glendale weighed heavily, and he frequently escaped with his models to the nearby beaches. Both professionally and personally, he was seeking something else and felt stifled and unsatisfied in the conservative art world of Los Angeles.

It happened that in April 1921 Weston was taken by the photographer Johan Hagemayer to a party attended by Los Angeles's small Bohemian circle. There he met the Canadian poet Roubaix de L'Abrie Richey—known as Robo—and his wife, an Italian actress named Tina de L'Abrie, who let it be known that she had worked in a film by Roy Clements, *The Tiger's Coat* (1920).[8] At the same party, Weston also met the modernist poet Ricardo Gómez Robelo—considered the dean of young Mexican poets in 1909—whom Antonio Saborit has described as an archetypal figure of the Mexican *fin-de-siècle* literary milieu.[9] Gómez Robelo was in Los Angeles as a political refugee, having openly supported the 1913 coup of General Victoriano Huerta. While there, he published a collection of poems entitled *Sátiros y amores* (Satyrs and Cupids), illustrated with drawings by Roubaix de L'Abrie that showed Tina as a *femme fatale,* the same role that she had portrayed in the movies.

The group spoke of Mexico. In those early months of 1921, Gómez Robelo was thinking of returning to

his country, reassured by the friendship of a fellow member of the Ateneo de la Juventud—now minister of public education—José Vasconcelos. Gómez Robelo invited Robo to accompany him and organize a show of Los Angeles artists in Mexico. Several months passed before this plan took effect. Then, at the end of that year, Roubaix decided to go alone. Tina chose not to accompany him, apparently because her father was ill.

Edward and Tina had already begun a discreet, but intense, relationship.[10] This time, it was serious for Edward and difficult to live with. The best he could do, for the moment, was to leave the house in Glendale and move temporarily into his studio in downtown Los Angeles. Then, in February 1922, Robo died of a heart attack in Mexico City, and Tina—who had been about to take the train to join him—went there instead with her mother-in-law to take care of the funeral. She did not remain long in the Mexican capital. In March, her father died in San Francisco, and she returned to the United States to deal with another death.

The few weeks that Tina spent in Mexico nevertheless proved useful. She not only made arrangements for her husband's burial, but completed the exhibition, initiated by Robo, of the work of their Los Angeles friends, which was installed in the galleries of the Academy of San Carlos.[11] Thanks to her friendship with Gómez Robelo, Tina met many artists in Mexico who gave her a warm welcome, perhaps because some had seen her on the silver screen. She liked the country; she liked the people and thought that this might be the place where she and Weston could conceal their relationship. When she returned to Los Angeles, she began to persuade Edward.

It was not very difficult. But before going south, Weston went to New York to meet with Alfred Stieglitz, the leading patron of modern photography in the United States. Stieglitz did not much like the images of smoking factories that the Californian showed him. "Ah!" he said, but nothing more.

Flora Chandler Weston remained in Glendale with Brett, Neil, and Cole, the youngest sons. Margarethe Mather, Weston's photographic disciple, took charge of the photographic studio in Los Angeles while Edward, his oldest son, Chandler, and Tina sailed aboard the SS *Colima* to Mazatlán in August 1923.

Needless to say, they arrived at a good moment. Although they were unaware of it when they left California, there had never been such a feeling of exhilaration in Mexico City, especially in the arts. Diego Rivera had started painting his murals at the Ministry of Public Education, working sixteen hours a day on the scaffold; and his domestic quarrels with Lupe Marín were the talk of the town. In several places around the city, young painters founded open-air art schools that accepted children from all classes. David Alfaro Siqueiros founded an artists' union, and the Estridentista poets walked the streets shouting "Verde! verde! verde!" while shaking green sheets of paper, inscribed with a single word: "Verde!"[12] Everyone got together at the house in the Colonia Juárez that belonged to Oscar Braniff, their millionaire patron, to eat and drink, since none of the artists could afford more than tortillas and *pulque*. A turbaned Hindu could often be seen there, sitting silently in a corner . . .

The former interim president, Adolfo de la Huerta, had led an uprising, and the country was once again in turmoil. When Tina remarked to Otokar Rubicek, owner of the Aztec Land curio shop, that "a friend told us that soon there would be another revolution," his reply was: "He lies . . . there will be not one, but forty!"[13]

One of Edward's students, Llewellyn Bixby-Smith, joined his teacher in Mexico. Rafael Salas, his wife, Mona Alfau, and friend Felipe Teixidor, Jean Charlot (infatuated at the time with Anita Brenner), Germán Cueto and his sister Lola (neighbors of the Riveras at 12 Calle de Mixcalco), the future congressman Manuel Hernández Galván, Ricardo Gómez Robelo, Xavier Guerrero and his sister Elisa, and cameraman and landscape photographer Roberto Turnbull formed a close-knit group of friends. They met punctually at the habitual hour to drink hot chocolate in the evenings. Weekends, they might organize excursions to places outside the city: Amecameca, Desierto de los Leones, Tepotzotlán, Fred Davis's house in Cuernavaca. Around this nucleus gravitated many well-known people: German, French, Jewish, Mexican, Italian, gringo.

Going to the Teatro Lírico, watching Diego paint at the ministry, attending the lectures of Gabriela Mistral in the amphitheater at the Preparatory School, breakfasting at Sanborn's, lunching at Los Monotes, discussing and debating the validity of the artists' union or the future of the Communist Party: there was no lack of things to do. But Edward could not avoid working. Mexico was cheap, compared to Los Angeles, but he

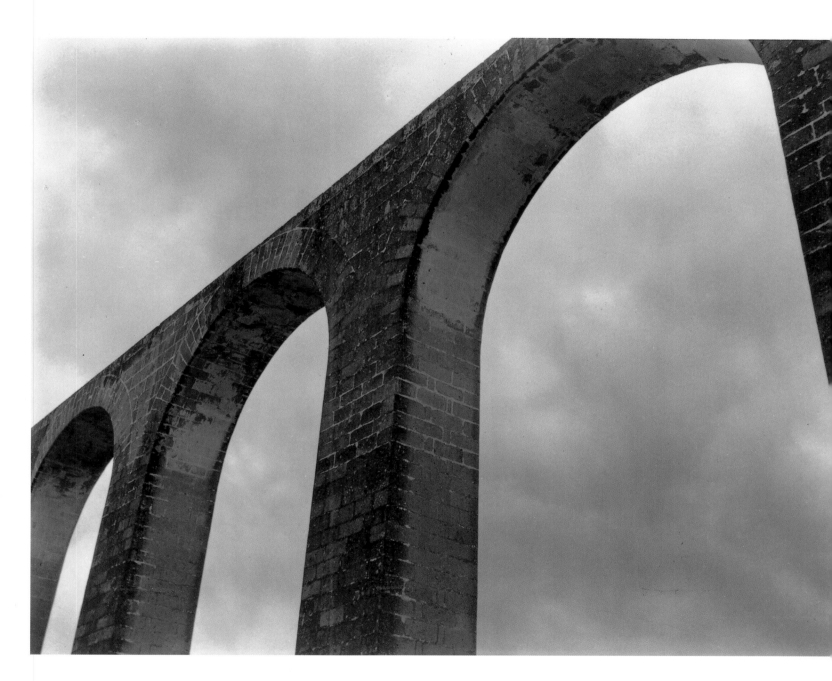

Edward Weston

Aqueduct, Los Remedios, 1924

Gelatin silver print
Collection, Center for Creative Photography, The University of
Arizona
© 1981 Center for Creative Photography, Arizona Board of Regents

still had to pay the rent and eat. He moved from the big house in Tacubaya to a studio at 12 Calle Lucerna, which was cheaper and had a telephone. Tina occupied a room on the rooftop terrace; Edward used the first floor rooms where the North American residents of the city, his first clients, came to have their portraits done.

On October 30, 1923, Edward Weston exhibited some of his American photographs at Aztec Land as a way to promote his work and attract business. Hardly a traditional art gallery, it was basically a store for tourists at 24 Avenida Madero. There the Hungarian-born Rubicek sold, indiscriminately, serapes from Saltillo, *Terry's Guide to Mexico,* copies of Precolumbian figures from the National Museum, authentic figurines brought to him by Indians from Tlaxcala and Oaxaca, photographs by Charles Waite, wicker baskets, copies of James Joyce's *Ulysses* (censored in the United States), sombreros and silver buttons used by *charros,* and Mexican jumping beans.

The exhibition was an overwhelming success. The public's reception of Weston's new work was much more enthusiastic in Mexico than in Los Angeles. As Weston recorded in his *Daybooks*:

> I have never before had such an intense and understanding appreciation. Among the visitors have been many of the most important men in Mexico, and it is the men who come, men, men, men, ten of them to each woman; the reverse was always the case in the U.S. The men form the cultural background here, and it is a relief after the average "clubwoman" of America who keeps our culture alive. The intensity of this appreciation and the emotional way in which the Latins express it has keyed me to a high pitch, yet, viewing my work day after day on the walls has depressed me greatly, for I know how few of them are in any degree satisfying to me, how little of what is within me has been released.[14]

"Do you know . . . that you are the talk of Mexico City? No matter where I go—to afternoon teas, to card parties—your exhibit seems to be the principal topic for discussion. You have started out with a bang!—already famous in Mexico," declared one American.[15]

One year later, on October 19, 1924, Weston exhibited a second time at Aztec Land, with even greater success, showing photographs that he had made in Mexico as well as some made earlier in California: portraits of Lupe Marín and Nahui Olín, nudes of Tina. In his daybooks, Edward Weston recorded the comments of Diego Rivera, Dr. Atl, Jean Charlot, and the reporter María Appendini, as well as the response of that dashing portrait photographer Gustavo F. Silva, who sported long hair, a black cape, and bohemian-style cap.

> That mad Mexican photographer came yesterday, tells Tina, and after raving and waving and tearing his hair went up to a certain "Torso," exclaiming, "Ah, this is mine—it was made for me—I could—" and with that he clawed the print from top to bottom with his nails, utterly ruining it. Tina was horrified and furious, but it was too late. "I will talk to Sr. Weston," said Silva. "The print is mine, I must have it!" Tina was called away and later found that the mount had been signed—"Property of Silva." I don't know whether Silva is really mad or only staging pretended temperament; if the latter, I could quite graciously murder him. Either way the print is ruined.[16]

José Vasconcelos also visited the exhibition and asked for permission to reproduce images for his magazine *La Antorcha*.[17] Weston sold several prints—in particular (and not surprisingly) nudes of Margarethe Mather at the beach.

Several weeks later, Edward Weston and Tina Modotti exhibited together in the group show at the Palacio de Minería that Lola and Manuel Álvarez Bravo attended. The exhibit was inaugurated by Álvaro Obregón, just days before he ceded the presidency to his successor, Plutarco Elías Calles.[18]

Modotti became a devoted disciple of Weston after they arrived in Mexico. She may have already had this position in mind before she left Los Angeles, because she had bought a hand-held Corona camera, which she started using in Mexico under Weston's supervision.[19] She learned quickly. Weston himself expressed surprise at the rapid progress of his student: "Tina has one picture I wish I could sign with my name—that does not happen often in my life!" he wrote in a letter to Hagemayer at the end of February 1924.[20] And, referring to the exhibition at the Palacio de Minería in his

Tina Modotti
Cloth Folds, Mexico, ca. 1924

Platinum/Palladium print
The Museum of Modern Art, New York, given anonymously
Copy Print © 1998 The Museum of Modern Art, New York

Manuel Álvarez Bravo
Juegos de papel 1, 1926

Gelatin silver print
Courtesy Manuel Álvarez Bravo

diary, he noted that "Tina's [photographs] lose nothing by comparison with mine—they are her own expression."[21]

It is difficult to determine exactly which of her photographs Modotti displayed in that first exhibition. According to Manuel Álvarez Bravo, they were from "her romantic period."[22] Many of her images from 1924, not surprisingly, are quite similar to Weston's. They were shot in the same places—shoulder to shoulder, so to speak—and developed in the same darkroom. Those they took of the Circo Ruso, in March 1924, may be considered among the earliest, and a comparison reveals differences, not in subject, but in conception. Weston completely isolated the abstract form of the canvas tent and at least in one case mounted the image in the upper left-hand corner of a large matboard, an asymmetrical placement that emphasized the diagonal lines of the composition in a somewhat Constructivist manner.[23] Tina, in contrast, included portions of the bleachers that situate the image in a real space.

One month later, during Holy Week, Tina and Edward worked together in the convent at Tepotzotlán, outside Mexico City. The forms of the maguey plants drew Weston's attention as much as the architecture of the Jesuit monastery for which the town was famous. Tina, on the other hand, allowed herself to be seduced by the whitewashed walls, the angles, the somber atmosphere of the edifice, which, by that time, had fallen into a state of neglect. *Interior of Church,* a view of the church tower in Tepotzotlán, is perhaps one of Modotti's boldest images of this period and the one that most clearly approximates the concept of photographic abstraction that Weston was moving toward in his Mexican work. Another of Modotti's images from that Holy Week excursion, *Convent of Tepotzotlán* (Stairs through Arches), is curiously similar in composition, atmosphere, and lighting to Weston's *Arch from the Patio of the Former Convento de la Merced, Mexico City* (dated 1926) showing a single arch.[24] It is enough to compare these images with the painstakingly descriptive views of the same convent made earlier by Guillermo Kahlo, the soft-focused evocations of Henry Ravell, or the suggestive emptiness of Hugo Brehme's stairwells to realize that the very concept of photography had changed definitively and that the imitation of romantic painting was a thing of the past.

I should be photographing more steel mills or paper factories, but here I am in romantic Mexico, and, willy-nilly, one is influenced by surroundings. I can, at least, be genuine. Life here is intense and dramatic, I do not need to photograph premeditated postures, and there are sunlit walls of fascinating surface textures, and there are clouds! They alone are sufficient to work with for many months and never tire.[25]

Perhaps because Mexico is so "picturesque"—above all, because of the omnipresent remnants of the prehispanic and colonial past that abound everywhere—Weston adopted a radical approach that led him to expel context and external references and to concentrate on a single object, seeking the best, simplest, and most direct angle. "I shall let no chance pass to record interesting abstractions, but I feel definite in my belief that the approach to photography is through realism—and its most difficult approach," he wrote in the spring of 1924.[26] This intuition gradually developed into a position, an aesthetic manifesto. In 1925, Weston returned to California for eight months to see his younger sons. When he returned to Mexico in August—now separated from Tina, though they shared the same house and darkroom at 42 Calle Veracruz—Weston distanced himself even further from the picturesque. Ensconced in the bathroom, he spent days photographing the toilet bowl, searching for the right angle and light, modeling a form without reference to any medium other than photography itself:

I might call my work in Mexico a fight to avoid its natural picturesqueness. I had this premonition about working in Mexico before leaving Los Angeles and used to be almost angry with those who would remark, "O, you will have such a wonderful opportunity to make pictures in Mexico."[27]

Then, in 1926, on the same rooftop terrace of the Calle Veracruz building where he had taken nude portraits of Tina, Weston made *Tres Ollas de Oaxaca.* "These black clay toys and pottery from Oaxaca, I like extremely well. Some toys are in the tradition of the ancient idols,—direct descendants indeed."[28] Exhibited in Mexico, and published in *Mexican Folkways,* Frances

Edward Weston

Two Swan Gourds, 1924

Gelatin silver print
Collection, Center for Creative Photography, The University of
Arizona
© 1981 Center for Creative Photography, Arizona Board of Regents

Toor's magazine, this image can be considered one of the most successful works of modern art in Mexico, in the sense that it intrinsically synthesizes—and ultimately signifies—the quest of the 1920s. Extremely simple and purified, the subject links the legacy of popular culture with references to the ancient past (unchanged for centuries, the ollas' rounded bottoms allow them to be placed in the earth, merging with it, as Weston explained, fascinated), while at the same time the emphasis on form and the photographic technique itself are wholly contemporary. "The modern painters are all off. They have chosen the wrong medium to express their ideas—but they would not dare admit so if they saw these photographs," exclaimed René d'Harnoncourt. "This print *(Tres Ollas de Oaxaca)* is the beginning of a new art."[29]

This "new art" was quickly recognized and publicized. By 1924, the Estridentistas had already used Weston's photograph of the Armco factory in Ohio for the cover of their magazine *Irradiador.* Another Estridentista publication, *Horizonte,* published images by Weston and Modotti in 1926 and 1927. And Gabriel Fernández Ledesma's *Forma,* financed by the Ministry of Public Education, reproduced several photographs by Modotti (including *Tank No. 1* and *Telephone Wires, Mexico*) in the late 1920s, before being censored for including Weston's *Excusado* in what would be its seventh, and final, issue.

Meantime, in Oaxaca, Manuel Álvarez Bravo was bored: doing accounts and more accounts in the Regional Office of the Comptroller. This life of a bureaucrat was monotonous . . . *Juegos de papel* (1926–1927), contemporary with Weston's *Tres Ollas de Oaxaca,* might even be considered the photography of a bored bureaucrat, stuck in his office and wasting time making Moebius strips from adding machine tape. Entertaining himself with the paper that threatens to overwhelm him, he contemplates then photographs it.[30] The image is clearly influenced by Weston's abstractions. Comparing Álvarez Bravo's *Andante*[31] *(Walker, Oaxaca,* ca. 1925) with his *Peluquero* from 1924, it is easy to appreciate the difference between his earlier work influenced by the picturesque vision of Brehme and the style that he began to develop in Oaxaca. The human figure ceases to be central; it seems to have escaped the image entirely. His focus was now on the whitewashed wall, the window, the shadows.

In interviews, Manuel Álvarez Bravo always said that there were two important influences on his early work. The first was what he referred to as the "strangeness" of Pablo Picasso, whose work he discovered in 1922 in a book by Maurice Raynal that he thumbed through in Robredo's bookstore; the second, reproductions of the prints of Hokusai. It is possible to perceive a certain Japanese influence in his 1927 image *La roca cubierta de liquen* (Rock Covered with Lichen).

Lola Álvarez Bravo herself began making photographs in Oaxaca, working beside Manuel:

One day I said to him, "Let me take a picture," and made a photo. But for a long time I did not take myself seriously. I would make photo, develop it, and think no more about it; then I'd make another and the pattern would repeat itself. I was more concerned with developing his film, washing the negatives, and doing things together, like peas in a pod, shall we say. What I did, I did with pleasure, but unconsciously, without any real interest in preserving it or filing it away because I believed more in his work than in my own.[32]

Toward the end of 1927, Manuel and Lola returned to Mexico City. They moved back into the apartment on Calle Guatemala, with Manuel's mother, Soledad. Lola was pregnant and, soon after their arrival, gave birth to their son, Manuel Álvarez Martínez.

When Edward left Mexico in November 1926, Tina left the apartment on Calle Veracruz. She rented a modest studio on Calle Abraham González, near where Frances Toor, Carleton Beals, and other "refugees" from the United States lived, and continued making photographs. The work that she did with Weston between March and November 1926 to illustrate Anita Brenner's future *Idols behind Altars* (published in 1929) had opened doors to her in Mexico. Weston's disciple and successor became the official photographer of *Mexican Folkways.* She made a specialty of photographically documenting murals. Among those that sought her services were Rivera, José Clemente Orozco, Máximo Pacheco, and Jean Charlot.[33] Using a Graflex camera that she had bought secondhand in Los Angeles during a brief return trip,[34] Modotti began to make portraits, as had Weston. She also printed several of the negatives that he had left in Mexico, especially com-

Lola Álvarez Bravo

Portrait of Salvador Novo, ca. 1940

Gelatin silver print
Collection, Center for Creative Photography, The University of Arizona
© 1995 Center for Creative Photography, Arizona Board of Regents

missioned works and copies of portraits requested by the sitters (although she admitted that there was not much demand).

The Salas had gone to Spain; Charlot was in Yucatán, working with Sylvanus Morley on the excavation of Chichén Itzá; Brenner was living in New York . . . In 1927, Modotti could already look back with distance and, perhaps, nostalgia to the turbulent days of 1924. She had a new group of friends and new interests. Her relationship with Xavier Guerrero—begun when Edward had gone back to Los Angeles—did not last long, but led her in a new direction.[35] Guerrero, a former assistant to Roberto Montenegro and Diego Rivera, had radicalized his political position and probably influenced Tina's decision to move closer to the Communist Party.

When Weston returned from Los Angeles in August 1925, he noticed the change. He did not write a

single line in his diary during the time that he spent in Guadalajara, where he met Tina. They spent several days in the house of the Marín family and opened their second group show, sponsored by Governor José Guadalupe Zuno (himself an artist). Finally, Tina and Edward took the train to Mexico, traveling in different cars: Edward and his son Brett in first class, Tina in second . . .

Tina first worked with the Comité Manos Fuera de Nicaragua (Hands Off Nicaragua Committee), then contributed photographs to *El Machete,* which became—after the dissolution of the Sindicato de Obreros Técnicos, Pintores y Escultores—the organ of the Mexican Communist Party. She joined the Party in 1927.

Without departing greatly from Weston's formalist aesthetic and the manner they had developed together—photographing Mexican handcrafted objects to emphasize their form, texture, and volume to illus-

Enrique Díaz
Interrogation of Tina Modotti, 1929

Gelatin silver print
Archivo Fotográfico Díaz, Delgado y García, Archivo General de la Nación, Mexico City

trate Brenner's book and Toor's magazine—Modotti composed several "allegories": *Sickle, Bandolier, and Guitar; Bandolier, Corn, and Guitar;* and *Mexican Sombrero with Hammer and Sickle* in early 1927.[36] By juxtaposing objects heavily charged with symbolism, decontextualized by the neutral background, Modotti created emblematic images reminiscent of Diego Rivera's motifs in his murals at Chapingo—perhaps with the idea of reproducing them as posters.[37] Manuel Álvarez Bravo recalled:

> In 1927 she had that same elegance and grace she had brought with her to Mexico. The walls of her studio were white and clean; later she started to write some of Lenin's and Marx's phrases on them . . . I visited her on many occasions and she was generally very busy—meetings with people like Carleton Beals and Frances Toor, but they were speaking English and I don't know how to speak English. But very often on a visit she would show me what she had done and what Weston was sending her and we would talk for a long while . . .[38]

Tina showed him the photographs of plants and shells that Weston sent her in June 1927. The Californian photographer had begun his famous series of still-lifes, continuing the formal explorations initiated in Mexico with *Excusado* and *Tres Ollas.*

> Edward—nothing before in art has affected me like these photographs—I just cannot look at them a long while without feeling exceedingly perturbed—they disturb me not only mentally but physically—There is something so pure and at the same time so perverse about them—They contain both the innocence of natural things and the morbidity of a sophisticated distorted mind—They make me think of lilies and of embryos at the same time—They are mystical and erotic . . .[39]

Tina showed these photographs to everyone she knew in Mexico: to René d'Harnoncourt, to Frances Toor, to Manuel Álvarez Bravo, to Diego Rivera. Rivera, in particular, expressed his enthusiasm for the images. As he contemplated them, he asked Tina, "Is Weston sick at present?"[40]

Manuel Álvarez Bravo also showed his photographs (timidly?) to Tina, who liked them. She suggested that he send copies to Weston, but Manuel did not do so—or if he did, it was later. It was Tina, in fact, who put a group of his photographs in an envelope and sent them to Glendale. She did not know that Edward had moved to Carmel. The pack was delayed in the mail and only arrived at the beginning of 1929.[41] Weston's response is recorded in a letter:

> It is not often I am stimulated to enthusiasm over a group of photographs.
>
> Perhaps the finest, for me, is the child urinating: finely seen and executed. Others I especially like are: the pineapple, the cactus, the lichen covered rock, the construction, the skull.
>
> I will not write more, until I hear from you—some explanation, and word about yourself.[42]

An entry in Weston's diary shows that he believed the photographs to be Tina's:

> May 1. I have been the recipient of a package of photographs from M. Álvarez Bravo of Mexico, D.F. When I was assessed $2.50 duty, I felt rebellious, but upon opening the package that feeling vanished—I was enthusiastic! Photographs of better than usual technique, and of excellent viewpoint. One of a child urinating, just the little round belly, his "trimmings" in action, and an enameled dish to catch the stream: very fine! So many were of subject matter I might have chosen,—rocks, *juguetes*, a skull, construction. I wonder if this person, Sr., Sra., Srita, *quien sabe*?—does not know my work, or Tina's? In fact I had a suspicion—and still wonder—if these prints are not from Tina—under assumed name,—perhaps to get my unbiased opinion. The inclusion of a delightful *petate recuerdo* also excites suspicion. And the prints are mounted on the same cover board we used in Mexico. It is all a very nice mystery![43]

In fact, *Niño orinando* (Urinating Boy, a portrait of Manuel and Lola's son) is closely related—compositionally, formally, and thematically—to Weston's portrait of *Neil (Torso)* and *Excusado.* One might say that it somehow synthesizes and unites Weston's two images,

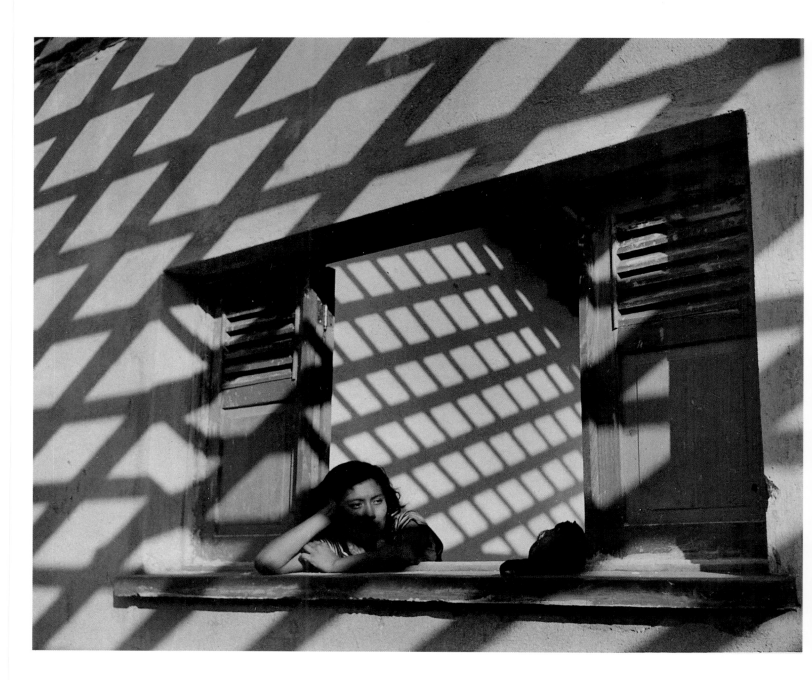

Lola Álvarez Bravo

En su propia cárcel, ca. 1940

Gelatin silver print
Collection, Center for Creative Photography, The University of
Arizona
© 1995 Center for Creative Photography, The University of Arizona
Foundation

although Álvarez Bravo's work is more complex and subtly provocative.

In 1927 and 1928, Manuel Álvarez Bravo photographed *Calabaza y caracol* (Squash and Snail), *El espíritu de las personas* (The Spirit of the People)—a simple grave, just a mound of earth with some leaves and four candles—*Dos pares de piernas* (Two Pairs of Legs)—one of his classic compositions, with painted signs that recall Eugène Atget's images of Paris observed at the beginning of the twentieth century, and three compositions with toy horses: *Caballito del carro de helados* (Little Horse on the Ice Cream Cart), *Caballo de madera* (Wooden Horse), and *Los obstáculos* (The Obstacles). *Caballo de madera* is typical of one of the distinctive ways in which Álvarez Bravo composed his images, an example of what could be called his "homeopathic" style.

Manuel Álvarez Bravo offers only the tiniest doses of "reality," only what is essential to the comprehension of the image. This approach to objects has something in common with the "abstractions" of Edward Weston, the tendency to isolate a form, to take it out of context and transform it into a pure object for aesthetic contemplation. However, Álvarez Bravo's work differs significantly in one way: he plays with the limits, "abstracting" only a portion of the image while allowing something of the environment to come through, placing the object in a new context. In this sense, Manuel Álvarez Bravo does not isolate, like Weston or Modotti, the form of a calla lily, a shell, or a suggestive pepper. Rather, he allows us to glimpse a fragment of the floor, wall, or background. *Dos pares de piernas* may be a *trompe l'oeil,* yet the cropping is not the photographer's creation but his "discovery." It is a difficult image to read: there is a aura of mystery about it; it becomes a game, and is—like others—not without a certain "homeopathic" humor. In *Caballo de madera,* the accent, the light, is placed on the horse's eye, which is framed by a drape on one side and by the fragment of a screen on the other. But these are incidental, accessory.

This image marks the first appearance of one of the characteristic traits of Manuel Álvarez Bravo's photographs, a tendency to reveal one part of an image fully while obscuring the rest under drapery. This is particularly evident in his nudes.[44]

At the age of twenty-six, Manuel Álvarez Bravo had mastered not only the composition, but the unexpected interaction of elements or "motifs" that typically surprise us in his work. He would create his most important images between 1929 and 1932.

In the summer of 1928, Tina Modotti and Manuel Álvarez Bravo participated in a photography contest organized by Antonio Garduño in preparation for the upcoming World's Fair in Seville. Tina sent a variant of *Bandolier, Corn, and Guitar, Mella's Typewriter* (also known as *La Técnica*), and *Tank No. 1.* "Modotti has won with a purely Mexican art," wrote the reviewer for *El Universal Ilustrado,* while the "amateur," Manuel Álvarez Bravo

> likes what's real. He portrays with facility a pen holder, some small paper birds, a branch . . . And he does it very well. Undoubtedly, his best photograph is that of a little cage. He puts all his efforts into making a good picture, without being affectedly "artistic."[45]

In a letter to Edward Weston dated September 18, 1928, Tina commented:

> Edward, had I told you that an exhibit of photography took place here? Gee, I wish you had seen it; it surely was a mess! I also exhibited; I first had refused, but nice people like Garduño insisted so and I could see that they interpreted my refusal to snobbery, so I accepted and got a prize thereby. But don't get excited, it was just the fifth part of a first prize, since they had five first prizes; a delicious way of pleasing several at one time, and of not showing partialities, don't you think so? We did not get the prizes yet, but I understand they consist of a medal (being executed in Paris) and of a diploma—Are you not proud of your disciple? I wish you could have read some of the newspaper comments on the various prints. Of one, a head of an old man with a long beard, a terrible thing, the sort of thing [pictorialist photographer] Jane Reece might have done and called "Son of Man" for instance, a would-be art critic said, "The technique with which the beard is rendered makes one feel the brush strokes of Cezanne." Enough said, don't you think, Edward?[46]

It was probably in this period that Modotti made *Worker Reading "El Machete," Workers' Parade, Child in Sombrero* (also known as *Son of Agrarista*), and her photograph of the hands of a worker holding a shovel (*Hands Resting on a Tool*). In the magazine *Creative Art* (published in New York) Carleton Beals wrote in 1929:

The influence of the painter Rivera, her anti-Fascist attitude, her contacts with the simpler things of Mexico, have made her socially minded. Her attitude, in some ways regrettably, towards photography has changed. Modotti is superb in still compositions, portraits and architectural details, in the arrangement of something as artificial as a cartridge belt, a guitar and a dried ear of corn, laid together to symbolize the Mexican people. Today, however, she declares that her ideal is a perfect snapshot. The

moving quality of life rather than still studies absorbs her. Looked at from this angle, camera-work, she feels, expresses the life of today better than painting or any other medium. With this newer attitude has come the desire for divulgation. She no longer contents herself with perfect platinum prints for wealthy collectors but has become desirous of a wider audience.

. . . The same desire to catch the inner spirit of modern life reveals itself in her newly developed love of signs, or script, the flow of printed word, which imparts to some of her pictures an animated sort of stillness, a taut tenseness. Thus a workman reading a newspaper, the details of the script clearly visible, arranged in composition so effectively as to achieve a symbolism, the meaning of which is suggestive rather than obvious; or it may be a photo-

Tina Modotti
Campesinos Reading "El Machete," 1929

Modern copy print
Reproduction authorized by the Fototeca del INAH-CONACULTA
Pachuca, Hidalgo

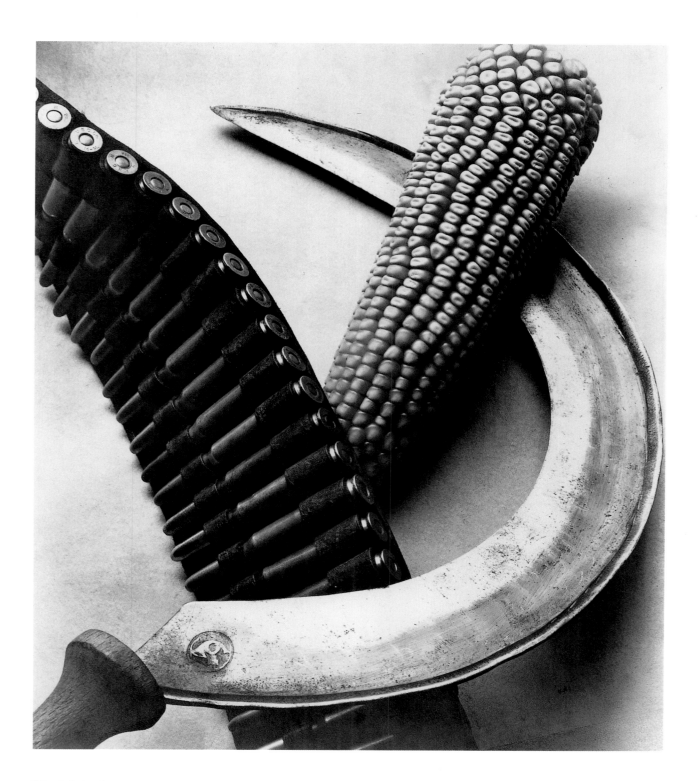

Tina Modotti
Bandolier, Corn, Sickle, 1927

Gelatin silver print
Courtesy Throckmorton Fine Art,
New York

graph of a typewriter taken at an angle which imparts to this compact instrument a mystery, almost an uncanniness, probably never observed by the steno who hammers it for a living. Too, she has gone into the slums of Mexico and discovered there types so terrible in their misery as to attain an [sic] Michelangelesque exaggeration. The terror of some of these scenes becomes elevated to something Dantesque.[47]

Modotti increasingly photographed in the streets and poor neighborhoods of the city those who lived in poverty, their faces prematurely aged. She abandoned her studio still-life compositions for a new and more socially concerned direction. If Worker Reading "El Machete" appears to be a posed photograph, composed as a political manifesto (the subject folds the page over, allowing us to read the newspaper's title), and carefully lit, then a somewhat later image, Campesinos Reading "El Machete," is truly a photojournalistic image, a candid shot captured at just the right moment. There the focus is less sharp, and the light falls at a much flatter angle.

Álvaro Obregón decided to run in the presidential elections of 1928. At the end of 1927, Francisco Serrano and Arnulfo Gómez led armed uprisings in response. Serrano and his followers were assassinated at a crossroads between Cuernavaca and Mexico City in October 1927. Gómez was shot in Veracruz in November. Victorious in 1928, Obregón was preparing to move into the Palacio Nacional for the second time when he was murdered by León Toral during a banquet at La Bombilla restaurant on July 17. The summary judgment and execution of Toral provoked public and private lynchings. In a somewhat desperate move—though it proved to be productive in the long run—Calles convened the legislators in Querétaro, amended the Constitution, and regrouped the "vital forces" into a single organization: the PRN (Partido Revolucionario Nacional), which over the years evolved into the long-ruling PRI (Partido Revolucionario Institucional). A few factions remained outside the new political organization. The Communists, tactical allies for a period, became the chief target of the government, which nurtured public paranoia on this issue as much as possible. Diego Rivera resigned from the Central Committee of the Mexican Communist Party. During a time of government repression, his gesture was seen as a betrayal.

Tina met the Cuban refugee revolutionary Julio Antonio Mella at a meeting of the Hands Off Nicaragua Committee (Comité Manos Fuera de Nicaragua) in July 1928. Xavier Guerrero (with whom she had been having an affair for several months) was about to leave for Moscow. Shortly afterward, Mella moved into Tina's studio on Calle Abraham González. On the night of January 10, 1929, as they were walking back from a meeting of International Red Aid, Mella was shot twice. As he lay dying in the hospital, Beals heard him accuse Cuban dictator Gerardo Machado of the crime. Mella died at the Red Aid headquarters at two o'clock that morning.

The story got around fast. Edward Weston learned of it in the morning paper—a strange way to get the latest news about the woman with whom he had shared his life over the past few years. The Mexican press, particularly Excélsior, turned Tina Modotti's life into a horror story. With a perversity that was then uncommon, the papers published transcripts of her interrogation by the police, real and altered photographs, false and actual interviews, dredged up anecdotes from the past, and delved into her personal life. In times of paranoia, persecution knows no bounds.

Tina stoically bore the humiliation, but, morally and physically exhausted, she further radicalized her political posture. Fully aware of the consequences, she devoted increasingly greater amounts of time to militant political activities.[48] Christiane Barckhausen-Canale has traced the photographs that Tina Modotti published in various left-wing magazines in Germany, the United States, and the Soviet Union during the last three years that she lived in Mexico.[49] These images suggest that Modotti participated fully in a number of organizations persecuted by the authorities and illustrated both their public and private political activities with her photographs. Later she fled and took refuge in Tehuantepec. The images from this trip, carelessly made and printed, reveal to some degree her mental and emotional state at the time.

Her friends in the Communist Party and at Red Aid took up her defense. In late November, the painters Carlos Orozco Romero and Carlos Mérida organized an exhibition of her photographs at the Biblioteca

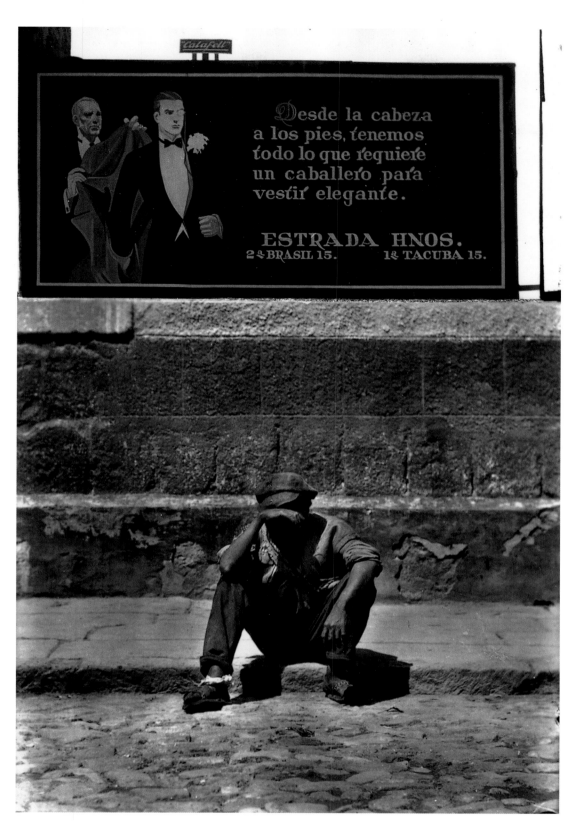

Tina Modotti

Elegance and Poverty, ca. 1928

Photomontage, Modern copy print
Reproduction authorized by the Fototeca del INAH-CONACULTA
Pachuca, Hidalgo

Nacional. David Alfaro Siqueiros gave a lecture at the opening. For the catalog, Modotti wrote a brief statement in the style of a manifesto. Her essay included an epigraph by Leon Trotsky that was deleted when it was published several weeks later in *Mexican Folkways:*

Always, when the words "art" and "artistic" are applied to my photographic work, I am disagreeably affected. This is due, surely, to the bad use and abuse made of these terms.

I consider myself a photographer, nothing more. If my photographs differ from that which is usually done in this field it is precisely because I try to produce not art but honest photographs, without distortions or manipulations. The majority of photographers still seek "artistic" effects, imitating other mediums of graphic expression. The result is a hybrid product that does not succeed in giving their work the most valuable characteristic it should have—photographic quality.

. . . Photography, precisely because it can only be produced in the present and because it is based on what exists objectively before the camera, takes its place as the most satisfactory medium for registering objective life in all its aspects, and from this comes its documental value.[50]

This declaration must be attributed, like the stylistic changes in her work of 1929, to the effects of the defamation campaign waged against her that spring. Until then, Modotti had not taken a very strict position on purism in photography. Manuel Álvarez Bravo often made fun of her 1925 photograph *Wine Glasses,* a somewhat lyrical composition printed from two negatives. In the same vein, Weston wrote in his diary, on May 2, 1924:

Tina printed her most interesting abstraction done in the tower of Tepotzotlán.[51] She is very happy over it and well she may be. I, myself, would be pleased to have done it. She printed from the enlarged positive, so she has a negative print and shows it upside down. All of which sounds "fakey," and, in truth, may not be the best usage of photography, but it really is very genuine and one feels no striving, no sweat as in the Man Ray experiments.[52]

One of Tina Modotti's most frequently reproduced images, *Elegance and Poverty* (ca. 1927), presents an enigma and a problem.[53] It depicts an apparently dejected and impoverished worker sitting on the curb beneath a billboard advertising the services of a fashionable haberdasher on Calle Brasil and showing a man wearing a tuxedo. As a dialectical discourse on the class struggle, it is an eloquent image. Careful observation, however, reveals a "seam" joining the images (between the wall and the advertisement, more easily visible on the right), as well as the dual focus on the hands of the figure in the foreground and the billboard behind. Other photomontages by Tina Modotti were published between 1926 and 1928 in *El Machete.* In October 1930, the German magazine *Arbeiter Illustrierte Zeitung* (*AIZ*) published her "mosaic" of photographs of children.[54]

Tina became further embroiled in the tumults of twentieth-century Mexican politics. In February 1930, she was accused of participating in a plot against the recently elected president, Pascual Ortiz Rubio. Briefly imprisoned, she was expelled from the country under Article 33 of the Mexican Constitution, which prohibits foreign nationals from involvement in Mexican politics. She was given just one day to pack her things and did so with the sole help of Lola and Manuel Álvarez Bravo, who accompanied her, along with guards, to the Buenavista railroad station. She left Mexico aboard the Dutch ship *Edam.* At the port of Tampico, an Italian militant from Trieste named Carlos Vidali, alias Eneas Sormenti, alias Comandante Carlos, boarded the ship. He would be Tina's companion until she returned to Mexico in 1942.[55]

Modotti took a few photographs, of little interest, in Berlin. They were her last.[56]

In July 1925, Tina wrote a moving letter to Edward Weston (then back in Glendale) in which she expressed her doubts and dissatisfactions:

I have not been very "creative," Edward, as you can see—less than a print a month. That is terrible! And yet it is not lack of interest as much as lack of discipline and power of execution. I am convinced *now* that as far as creation is concerned (outside the creation of species) women are negative—They are too petty and lack power of concentration and the faculty to be wholly absorbed by *one thing.*

Is this too rash a statement? Perhaps it is, if so I humbly beg women's pardon—I have the unpardonable habit of always generalizing an opinion obtained mainly from an analyzation of *just* my personal self— And speaking of my "personal self": I cannot—as you once proposed to me "solve the problem of life by losing myself in the problem of art"—Not only I cannot do that, but I even feel that the problem of life hinders my problem of art.

Now what is "my problem of life"? It is chiefly: an effort to detach myself from life so as to be able to devote myself completely to art—

And here I know exactly that you will answer: "Art *cannot exist without* life"—Yes—I admit but there should be an even balance of both elements, while in my case life is always struggling to predominate and art naturally suffers—By art I mean creation of any sort—You might say to me then that since the element of life is stronger in me than the element of art I should just resign to it and make the best of it—But I cannot accept life as it is—it is too chaotic—too unconscious—therefore my resistance to it—my combat with it—I am forever struggling to mold life according to my temperament and needs—in other words, *I put too much art in my life*— and too much energy—and consequently I have not much left to give to art—

This problem of "life" and "art" is my tragi-comedy—the effort I do to dominate life is wasted energy which might be better used if I devoted it to art—I might have more to show for— As it is, my efforts are wasted so often—they are futile—

That is why I say: Women are negative—(again I am generalizing), well, at least, *I* am negative as far as creation is concerned.

Enough for to-night, dear.
Hasta mañana[57]

In recent years, Tina Modotti's reputation has enjoyed a new, elevated status. She has been the subject of books, articles, theater plays, films, and countless television programs. Some of her photographs have attained record prices at photographic auctions (*Roses,* for example, was sold for $163,000 in 1991 to clothing impresario Susie Tompkins of Esprit, who reproduced it as a logo). Nevertheless, the rediscovery of Tina Modotti is based not on her photographic work, but on the anecdotes that link her biography to the political and cultural history of Mexico. The mythification of Tina is part of a broader reevaluation of the period between the wars, years that in Mexico coincided with the postrevolutionary phase of national reconstruction. Once simply thought of as the "Roaring Twenties," or "les années folles," the decade of the 1920s is now also seen as a heroic moment in the struggle for social justice and modernization that, supposedly, swept away obsolete social and mental structures existing prior to the First World War.

Frida Kahlo, Tina Modotti, and Antonieta Rivas Mercado have become—along with Anaïs Nin and Camille Claudel—long-suffering heroines of postmodernism. One might ask if these feminists *avant la lettre* did not merely recycle the clichés of a *machismo* that no longer dared show its face, rather than seeking new, more subtle and paradoxical ways to affirm themselves. In this literature, their companions (Diego Rivera, Edward Weston, José Vasconcelos, Henry Miller, and Auguste Rodin, respectively) are condemned as "oppressors," and the women are transformed into martyrs to a cause that had not yet come into being; artists deprived—because no other options were available to them—of sentimental bonds. This is the perspective from which they have been appreciated and discussed in their (sometimes morbid and melodramatic) biographies. These analyses shed more light on our conception of the world, our struggles and disappointments at the end of the twentieth century, and our own troubled consciences than on the historical figures that have inspired them.

In the case of Tina Modotti, particularly, the abundant literature seldom discusses her work. Her photographs serve merely to illustrate her biography, like the pictures used by historians to illustrate any other text.[58]

The photographs of Tina Modotti have been used, thus far, as evidence to verify that this tragic, romantic figure, buffeted by history, did indeed exist. But what has been shown is less "works" than aspects of her life. Several writers have sought in the photographs of Tina Modotti the same qualities celebrated in the paintings of Frida Kahlo. There is, however, an enormous difference between them: the work of Kahlo is a continual self-exhibition, a painted and exceedingly emotional

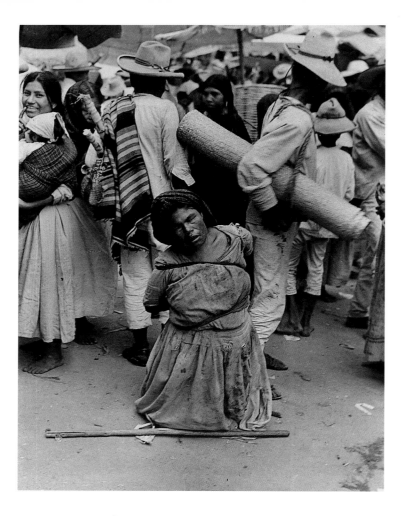

Lola Álvarez Bravo
Indiferencia, ca. 1940

Gelatin silver print
Collection, Center for Creative Photography,
The University of Arizona
© 1995 Center for Creative Photography, The University of Arizona
Foundation

dramatization of her physical pain, feelings, and personal history. The photographs of Tina Modotti do not function in the same way. Partly because they *are* photographs and not paintings, they establish a distance (an objectivity) that effaces *a priori* the presence of the photographer.

Manuel and Lola Álvarez Bravo inherited Tina's Graflex, some unused photographic paper, a few documents, and negatives by Lupercio, Weston, and Modotti. Manuel also inherited her "jobs": the position of photographer at *Mexican Folkways* and commissions to document paintings, including making photographs for art historian Emily Edwards's book on Rivera's murals. "*La Edwards* measured everything with a ruler, then made the calculations to find the Golden Mean," recalled Lola Álvarez Bravo.[59] The anecdote may be more important than it seems: both Manuel and

Lola Álvarez Bravo admitted to having learned much from reproducing details of the murals of Diego Rivera and José Clemente Orozco. Working for the painters forced them to be more rigorous.

In 1931, Manuel Álvarez Bravo became ill and gave up—to his great relief—his job with the Comptroller's Office. When he returned to work, it was as a professional photographer. And yet, when asked to assess himself as a photographer, Manuel Álvarez Bravo has always said that he never considered himself a "professional," but, rather, an amateur in the broadest and noblest sense—that is, someone who makes photographs purely for pleasure.[60] Indeed, his approach to photography is drastically opposed to that of most other professionals during the first half of the twentieth century. Nonchalance, an attitude that is distanced—without being cold or indifferent—of someone who takes his time, whose time is solely dedicated to contemplation, is strongly present in the photographic work of Manuel Álvarez Bravo. Only in that way could he have "discovered" in the streets of Mexico City, in the landscapes of the Valley of Mexico, on the walls, in the trash, and at demolition sites those strange objects, those unexpected *objets-trouvés* that would later capture the interest of André Breton.

In 1929, Manuel Álvarez Bravo made *Sistema nervioso del gran simpático* (The Sympathetic Nervous System), one of his most complex and difficult photographs—and because of this, perhaps, also one of his richest and most revealing images. It appears to be "composed," but is—in fact—a "straight" image. He supposedly found and shot a flat panel with anatomical illustrations that was displayed in the show window of a shop in downtown Mexico City. The image—a reproduction *a priori*—doesn't look like a photograph. Rather, it takes on photographic value only when seen in the context of other photographs—whether in a portfolio, a book, or an exhibition.

In doing this, Manuel Álvarez Bravo was playing on a certain aspect of photography, stressing its nature as a flat, two-dimensional, physical support. He forces us to look upon the sheet of sensitized paper for what it is: a sheet of sensitized paper. An intellectual exercise, perhaps, but the neurological subject matter (the sympathetic one, the nervous system) brings us indirectly back to photography: a visual support neutralized by appearances, the representation of the real, a reality that

begs to be deciphered. The photographs of Manuel Álvarez Bravo are clarified by this image. After seeing this, it becomes impossible to elude their neurological meanings and their emotional affect.

Parábola óptica (Optical Parable), made in 1931, functions in the same way: the painted eye on the sign attracts our attention and obliges us to become conscious of the act of looking, here and now. Manuel Álvarez Bravo thus includes a temporal element, a present time, our time, in the photograph. This temporal element, an "action," appears in many of his other images, though often not as clearly as in *Parábola óptica*.

Obrero en huelga, asesinado (Striking Worker, Assassinated) is a particularly good example of this. In this instance, the temporal element resides behind, rather than in, the image. The title reads: *Obrero en huelga* (comma) *asesinado*. Manuel Álvarez Bravo has always insisted on the importance of his titles—titles that, while they never fully explain the image, often serve as guides. The comma, in this case, is indispensable. Given that the "striking worker" and "assassinated" are not written contiguously, the comma marks a break in action, in time.

Taken in 1934 in Tehuantepec, where Manuel Álvarez Bravo engaged on his only film project (*Tehuantepec*—similar in many ways to *The Wave,* the film that Paul Strand was working on in Alvarado), *Obrero en huelga, asesinado* is one of Álvarez Bravo's few "documentary" images. Certainly, it possesses the traits of social documentary that characterized Mexican art during the

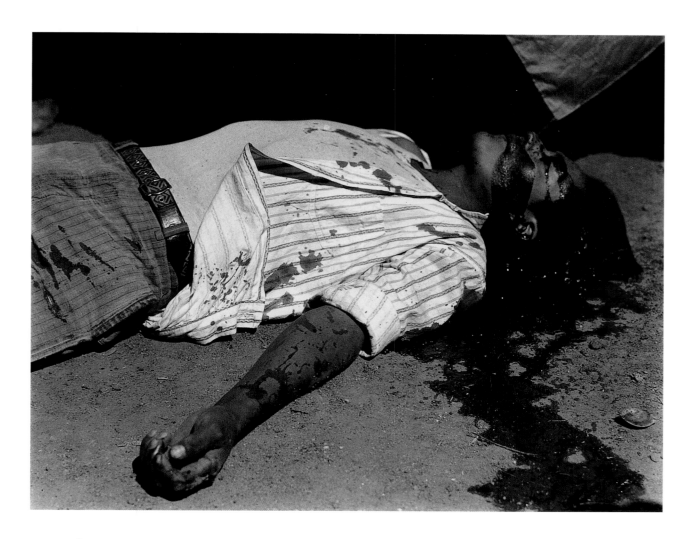

Manuel Álvarez Bravo
Obrero en huelga, asesinado, 1934

Gelatin silver print
Courtesy Manuel Álvarez Bravo

Cárdenas regime and can be considered the photographic equivalent of the mural paintings and printed posters made by the Liga de Escritores y Artistas Revolucionarios and the Taller de Gráfica Popular. In fact, the image was incorporated into a photomontage for the cover of the third issue of the former's magazine *Frente a Frente* in 1936. In the 1970s, Chicano artist Rupert García created a poster in which he transformed the image into an emblem, sacrificing in the process its most distinctive qualities: its photographic "realism" (the appearance of the blood that flows from the victim's mouth, covering the ground) and its dual temporality.

"The very nature of the Mexican imagery in the work of Manuel Álvarez Bravo can be an impediment to understanding," wrote Alex Castro in one of the few essays that analyze Manuel Álvarez Bravo's work in depth.[61] It is not so much the "nature of the Mexican imagery" that complicates the reading of these images—there is nothing specifically Mexican about *Dos pares de piernas* (Two Pairs of Legs, 1929) or *Sobre el invierno* (About Winter, 1939)—but a particular way of seeing that merits careful consideration. It is not "the poetic sense" (a word that merely denotes an inability to understand something directly), but a complex perception of the world that is translated in the photographs through an emphasis on the invisible, on what is left out of the picture and yet is indispensable to its existence. The obvious example of this is *Muchacha viendo pájaros* (Girl Looking at Birds, 1931). The girl in the picture covers her face with her hands as if to ward off an apparition. *Retrato de lo eterno* is less a portrait of Isabel Villaseñor emerging from the shadows of a dark-

Manuel Álvarez Bravo
Sobre el invierno, ca. 1939–1940

Gelatin silver print reproduced on cover of catalog *Exposición international del surrealismo,* 1940
Courtesy Manuel Álvarez Bravo

ened room than the image reflected in the mirror—invisible from our point of view. Likewise, *Ensayo para una cámara bien afocada* (Exercise for a Well-Focused Camera, 1943) is apparently a pure exercise in texture and tonal range with no other subject. Yet the extended arm and the title suggest a relationship and an external action beyond the frame.

Manuel Álvarez Bravo, despite his reticence to assume the title, was indeed a photographic "professional." From the moment that he gave up his career as an accountant, he was forced to live (poorly) from his photography and worked successively as a portraitist (as had Weston and Modotti), owner of a studio and shop that sold photographic materials (which he shared briefly with Lola Álvarez Bravo), and—with his second wife, Doris Heyden—still photographer on countless movie productions for Clasa Film Mundiales in the 1940s. He taught photography at the Academy of San Carlos beginning in 1929, when Diego Rivera briefly served as director, and again in 1935, when Manuel Rodríguez Lozano occupied the post for an equally brief time. He was also a founder and co-director of the publishing house Fondo Editorial de la Plástica Mexicana and throughout these years a promoter, analyst, and researcher of photography. In the 1980s, he created a museum-workshop where he accumulated vintage prints by many photographers with the intention of increasing public interest in the medium.[62]

The work of Manuel Álvarez Bravo has changed over the years, although less obviously than that of many painters of his generation. After 1960, he became increasingly interested in female nudes, which became his principal subject. He also experimented with sophisticated processes: color and palladium prints. As Jane Livingston has pointed out in her catalog to Manuel Álvarez Bravo's exhibition at the Corcoran Gallery of Art in Washington, his style of printing also changed. The wide range of grays that never reached absolute black, diffusing the forms and volumes in his works of the 1920s and 1930s, has changed in recent years. This can be seen, for example, in comparisons of early and late prints of *Retrato de lo eterno,* an extremely dark image. In the vintage print, greater emphasis is placed on the light that falls upon the face and part of the dress; in the later printings, the shadows are dominant.

The earliest works of Lola Álvarez Bravo can be mistaken for those of her husband, Manuel, just as the first works of Modotti are sometimes confused with those of Weston. In both cases, the couple used the same camera and darkroom. In some cases, it is difficult to be certain who took the shot or who printed it.

Lola Álvarez Bravo decided to separate from Manuel. She moved temporarily into the apartment of the painter María Izquierdo. To support herself and her son, she gave drawing classes in elementary schools. She might never have considered a photographic career on her own if it hadn't happened that, one day, Héctor Pérez Martínez asked her to take photographs of a political ceremony in the patio of the Ministry of Public Education. With shaking knees and trembling hands, Lola accepted the challenge. The photos were good, and Pérez Martínez appointed her staff photographer for the newly created magazine *El Maestro Rural.* Necessity took care of the rest: for the next thirty years Lola Álvarez Bravo illustrated books and magazines, worked as a photojournalist for the magazines *Vea* and *Voz,* served as official photographer for the Instituto Nacional de Bellas Artes, and photographed paintings and organized exhibitions outside the capital. Eventually, she opened her own exhibit space, the Galería de Arte Contemporáneo, located at 12 Calle Amberes in the fashionable Zona Rosa.

Lola Álvarez Bravo's decision to become a photojournalist follows Tina Modotti's move in the same direction. "I was the only woman that ran around the streets with a camera, at sports events and the Independence Day parades, and all the reporters made fun of me. That's how I got to be tough."[63] "All the reporters" refers particularly to "El Gordito" Enrique Díaz, photographer for *Mañana* magazine, who harassed her on a number of occasions. Others—the Mayo brothers among them—had great respect for her. But Lola's situation was unusual: in a hostile environment, doing a job considered "dangerous," her career developed in opposition to the norms. She was not, nor can she be considered, a typical photojournalist. The range of her work does not cover "the news," but rather consists of "special assignments," such as reproducing details of a colonial choir stall in the National Preparatory School for an album (now quite rare) commissioned by the National University; illustrating a volume commemorating the presidency of Manuel Ávila Camacho; docu-

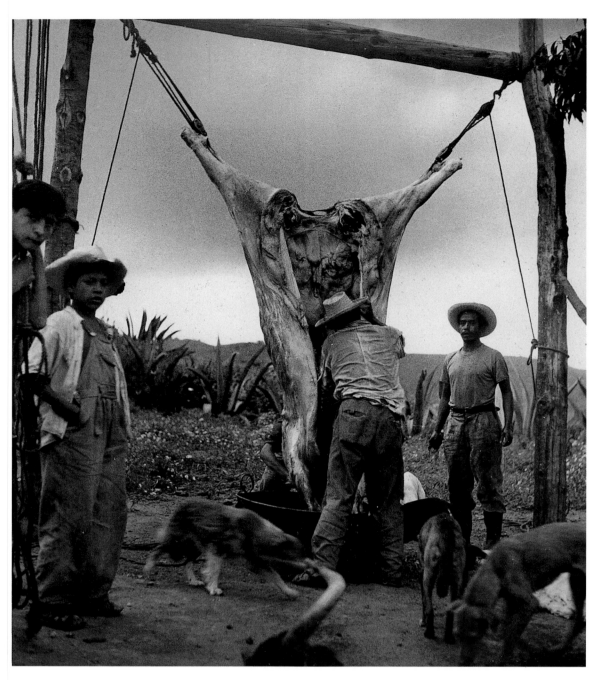

Lola Álvarez Bravo
En las montañas, ca. 1940

Gelatin silver print
Private collection, Mexico City

menting the drought in the region of La Laguna for the Ministry of Health; preparing with the Spanish poet Francisco Tario (brother of the painter Antonio Peláez) a coffee-table book for tourists about Acapulco; making a documentary film on Diego Rivera's murals at Chapingo; and traveling throughout the indigenous zones of Veracruz, Tabasco, and Oaxaca to record traditional dances on a commission from musician Carlos Jiménez Mabarak and dancer Ana Sokolov.

Because she had initiated and built her career for many years as Lola Álvarez Bravo, she kept her married name. This was also a way of acknowledging her ori-

gins, of not breaking with a growing reputation, and with it a personal standard, a style, and—above all— an aesthetic.

Yet Lola Álvarez Bravo's photographs are absolutely distinct. She observed the world with a certain respectful distance that contrasts with the subtle irony and biting wit of Manuel. She trained her lens on human types, examining them with an empathetic nostalgia, stripped of illusions.

The work of Lola Álvarez Bravo is as extensive as it is multifaceted, yet it fits within a current thematically and stylistically related to both photographic modern-

ism and the so-called Mexican school of painting. She shared with Diego Rivera, María Izquierdo, Rufino Tamayo, Julio Castellanos, and Antonio Ruiz a certain way of seeing Mexico. She utilized pictorial material that has been called Mexican because, as she herself said, "that is what life placed in front of me." She observed the country as so many others painted or described it, from an ethical point of view, inflected by a nationalist humanism that emerged from the Revolution of 1910, defined and regulated by José Vasconcelos and those who participated in the Mexican cultural ferment of the 1920s. The Indian world—previously hidden in Mexican culture and considered a national humiliation to the point that the government discouraged tourists from photographing native peoples—now appeared in the foreground of mural painting and in the photographs of Edward Weston, Tina Modotti, José María Lupercio, Antonio Reynoso, Manuel Álvarez Bravo, and Lola Álvarez Bravo.

In her work, a grave-faced widow crosses an impressionistic, tree-lined avenue (*8 a.m., Morelia,* ca. 1940); women and children—smiling, sleepy—pass through provincial markets. A pair of old lovers contemplate an ocean of empty sand (*Mar de Ternura,* ca. 1945). Two feminine silhouettes in the hallway in Juchitán converse . . . (*La visitación,* ca. 1934); fishermen drag a monstrous shark from the sea . . . (*Tiburoneros,* 1949). In the mountains, hungry dogs gather in expectation around the butcher as he cleans the carcass of a slaughtered cow that hangs suspended, as though crucified (*En las montañas,* ca. 1940). On the beach in Acapulco, three women sacrifice themselves to desire (*Tríptico de las martirios,* 1949). Before a mirror, a young toreador (*Torero,* ca. 1935) . . .

Time suspended.

Lola Álvarez Bravo balanced her photographs by distributing the volumes along diagonal axes, perhaps unconsciously, applying the classic laws of composi-

tion. In *El Rapto* (Rapture) and *11 a.m.,* shadows cast by objects outside the camera's field of vision fall on objects visible in the pictures. There is a disquieting illogic in the lack of registration between these objects and the shadows. Instead, the dark zones penetrate the masses, creating an atmosphere that extends beyond the frame. The shadows of palm trees on the faces of prostitutes in Acapulco transform them into anonymous, soulless bodies. The features of Luis Cardoza y Aragón are sculpted by diagonal lighting that converts a simple portrait into a carefully composed photograph. In other images, which function like "interior landscapes," differing textures—sharply rendered and controlled—lend a very personal air that reflects, in the most intimate manner, certain of Lola's obsessions. Her contrasts do not violently jar the eye; rather, our gaze moves smoothly over them, like fine grains of sand partially covering the dead bird in *Homenaje* (Homage).[64] The whitewash spattered across the overalls of the painter on a scaffold blends with the wall itself. The intertwined roots of a ceiba tree become fantastic, zoomorphic forms.

Lola Álvarez Bravo allowed reality to impose itself on her lens. Her own presence is barely felt—similar to the way that Paul Strand's personality seems to lie behind, rather than in, his images. She typically photographed people from the back or side. Without their realizing it, she captured them unaware in their domestic tasks, caught in their mundane gestures and daydreams. This voluntary distancing does not reduce the subjectivity of her vision or result in cold or impersonal images. Rather, it deepens the feeling of intimacy. The reflective gaze of Lola Álvarez Bravo was always respectful and profoundly human. The tenderness that she bestowed upon her subjects marks her photographs with an uncommon sincerity. Hers is the gaze of an honest observer who attempted to convey, without artifice, what she saw and felt.

11
Fantasía

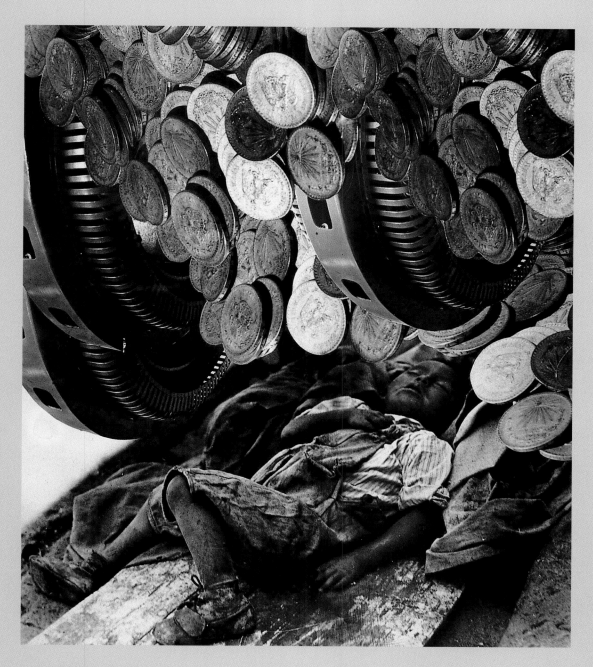

Lola Álvarez Bravo
El sueño de los pobres II, 1935

Photomontage
Collection, Center for Creative Photography, The University of
Arizona
© 1995 Center for Creative Photography, The University of Arizona
Foundation

Essays

A history of photography, to be complete, should include information that would allow the reader to see and interpret the images in context. Where and how were they published, and why? What was, and is, their impact? How were they perceived? Unfortunately, the broad scope of this book does not permit the type of in-depth study required for a complete rereading of all the images in the various contexts in which they have appeared.

In some cases, moreover, photographs have been used in a manner considered by advocates of both "artistic" photography and "conscientious" photojournalism to be "impure," taken out of context, their meanings altered. The images discussed in this chapter are just a few examples of these alternative uses of photography. They have been taken from the press and the visual arts, as well as several peripheral studies related to the medium.

Photomontages are composed from preexisting images glued to a piece of cardboard or paper, rephotographed, and printed to give them the appearance of a normal photograph. This *trompe l'oeil* deception has been somewhat marginalized in the history of photography in the twentieth century because the "compositions" are a conceptual creation, like paintings or nonphotographic printmaking. Both the selection of images that make up the montage and their arrangement within the defined space of the printed page are determined by narrative intentions.[1] Photographic purism, codified by Alfred Stieglitz's group in the first decade of the twentieth century and reaffirmed by the reformist and combative photojournalism of the 1930s and 1940s, maintained—on the contrary—that the photograph should be absolutely faithful to reality, not only in its form (its aesthetic), but in its content (its ethic). The photographer becomes responsible for the impact that his or her image has on the viewer. The successful photograph must also convey, convincingly, the photographer's surprise at encountering the "found" image, the unique, unrepeatable moment. Any "trick-

ery" or manipulation was, therefore, prohibited and considered unfaithful, a betrayal of the natural function of photography. This somewhat authoritarian ideal still has many defenders. However, it has been relativized—not only by the work of photographers who push the apparent limits of the medium and by common commercial practices (advertising) and propaganda, but through critical discourse of every type that has, in recent years, demonstrated the deception inherent even in this supposedly objective position. Once the photograph was adopted as a medium for personal expression (and not only for visual communication) by creators who considered themselves on an equal basis with artists in other visual media, photography's compromises with realism have been continually and increasingly challenged.

The overtly manipulative practice of photomontage goes back to the earliest days of photography. The photographic allegories of the Second Empire in Mexico have already been discussed: the genealogical tree of the Hapsburgs composed by rephotographing European cartes-de-visite, Maximilian and Carlota kneeling before an apparition of the Virgin of Guadalupe, cartouches of the "4 Ms" (Maximilian and his generals Miramón, Méndez, and Mejía) surrounding that of the empress, and in particular the atypical "documentary" photographs of the execution at Cerro de las Campanas. The latter, made from original photographs taken during the siege of Querétaro, were attempts to recreate visually the "decisive moment" that had been impossible to capture in a single direct photograph. These photomontages were widely distributed in both Mexico and France. The large number of images produced—many of which are still extant—is an indication of their popularity.

Even so, this kind of photomontage was soon rejected, considered to be a form of dishonesty that contradicted the veristic nature of the photographic medium. It would not be much used again until well into the twentieth century. These ethical and aesthetic con-

siderations aside, photomontage became both obsolete as a documentary technique—due to technological improvements in film and lenses—and unfashionable as an artistic genre until picked up by the Constructivists and Dadaists in the early decades of the twentieth century.

At the turn of the century, the press—and advertising in particular—mixed graphic processes freely. The use of graphic reproductions was increasing rapidly, and editors employed photographs as *materia prima*—one more available element—to create compositions that would catch the viewer's eye. This occurred shortly after it became possible to include photomechanical half-tone images in mass-media letterpress publications, such as newspapers and illustrated magazines. However, they took care to denote their sources by framing photomechanical images with a double line to differentiate them from the drawings. Later—following the work of Edward Weston, Paul Strand, and the documentary photographers of the Farm Security Administration—photography was considered an "open window" on the world. This photographic ethic literally prohibited alterations of either negative or print and continually denounced "set-up" photographs—the best-known case being Robert Capa's famous photograph of a Republican soldier taking a bullet during the Spanish Civil War. It was, in fact, a staged event that has been compared, in the name of purism, to the forging of historical documents. A variant of this practice (in this case, altered images) appeared during the Stalinist era: Trotsky's image mysteriously disappeared without a trace from the 1917 photographs of the Saint Petersburg uprising.

Still, many photographers have elected to transgress the strict ethic of photographic purism, covertly or openly, privately and publicly, for amusement or deception.

The ambiguous case of Tina Modotti's photograph *Elegance and Poverty* has already been discussed, but, as a general rule, those who have made photomontages or experimental photographs in Mexico have taken the trouble to note—on the image itself—their sources. Thus, in 1940, when Manuel Álvarez Bravo made two strange X-ray images, *Lucía* and *Flor y anillo* (Flower and Ring), he made clear what he had done, although these were not photomontages, but rather compositions made using "found objects" and an alternative photo-

graphic technology—the X-ray machine.[2] At any rate, Álvarez Bravo emphasized his sources: *Lucía* includes a pearl necklace, earrings, and a medallion in the form of a heart, pierced by a sword, that appear in harsh whiteness, like bones superimposed on a headless image. It should be noted that Manuel Álvarez Bravo did not publish these early experiments until the end of the 1980s, at a time when "alternative" uses of photography were being reconsidered and young photographers (Pablo Ortiz Monasterio, Rubén Ortiz, Gerardo Suter, Juan Castañeda, Eugenia Vargas) were eagerly and openly employing manipulations in order to create powerful images.

Emilio Amero

An odd personality who deserves greater recognition, Emilio Amero was the first Mexican artist to investigate the possibility of photography as an alternative technique. Born in Ixtlahuaca, in the State of Mexico, Amero entered the Academy of San Carlos in 1911—the year of a student strike against director Antonio Rivas Mercado. Soon after, Amero transferred to the open-air school of painting headed by dissident professor Alfredo Ramos Martínez. In addition to having assisted on mural projects (Carlos Mérida's at the Ministry of Public Education and José Clemente Orozco's at the Preparatory School), Amero also managed a bookstore called El Hipocampo in the Colonia Juárez. There he exhibited the works of his friends and colleagues: Jean Charlot, Ramón Alva de la Canal, and other members of the Estridentista group. In 1924, when the first phase of muralism came to an end with the resignation of José Vasconcelos as minister of education, Amero went to Havana and then to New York. There, like Miguel Covarrubias, he found work as an illustrator for periodicals, including the *New York Herald Tribune* and *New Yorker*. He also designed furnishings and did interior decoration and painted a mural for Bellevue Hospital (now destroyed).

In this period, Amero became interested in the graphic arts and techniques of multiple reproduction. He set up an experimental lithography workshop in a New York school, made an abstract film "using pieces of machinery as actors, and experimented in making

Emilio Amero
Fotograma, 1934

Futuro 6 (February 1, 1934)
Courtesy Barbara Amero

direct chemical photographs without negatives."[3] Some of these experimental works, published in the magazines *Contemporáneos* and *Futuro,* reveal the influence of Marcel Duchamp and Man Ray. "When Amero stopped painting murals," recalled Jean Charlot, "he began his eventful career as an explorer of many mediums. Just as others show a versatility in style, he had worked and inquired through the whole gamut of technique, weighing each, careful of its limitations, yet always ingenious in adapting it to original uses. He has worked his way through etchings, lithographs, water colors, oils, photographs, and cinematography. He is an exponent of international expression, delightfully so, and his work is as Mexican as he is, *sotto voce* more convincing than many who shout."[4]

Carlos Jurado and the Revelation of the Unicorn

The experiments of Emilio Amero might be compared with the alternative processes that Carlos Jurado developed in the early 1970s at his experimental workshop at the School of Fine Arts at the Universidad Veracruzana in Jalapa.

Returning to the obscure origins of photography, to a time before the "inventors" of 1820–1840, Jurado and his followers "reinvented" the processes of reproducing images, with and without a camera, with and without manufactured chemical products, with and without recourse to sorcery (or so it would seem). Trained as a painter—he was a student of María Izquierdo and a friend of Antonio Ruiz—Jurado became particularly interested in the mythological bases of photography and published his own version of the facts in *El arte de la aprehensión de las imágenes o el unicornio* (The Art of Capturing Images or the Unicorn, 1974), a book that itself deserves to be qualified as "mythic." In an essay entitled "Contra la Kodak," Jurado developed a process he called "estenopeia" or "juradotipia" that consisted of making images with a pinhole camera like that primitive optical device used in the Renaissance—the camera obscura. The resulting images did not have (nor were they intended to have) the quality of conventionally made photographs. Still, they are interesting as a discourse on the medium that has so thoroughly penetrated and invaded our culture. These simple images

are a reaction against the hypersophisticated—and often extremely expensive—technologies of the mid- to late twentieth century.[5]

Criticism of the medium is also present in the *fotonovela*-inspired format developed by the Spanish refugee photographer Kati Horna. Her narrative sequences of photographic images have a surrealistic quality that goes beyond the conventional popular genre of romance pulp literature.

Horna denies—like Manuel Álvarez Bravo and, before him, Frida Kahlo—a relationship with surrealism. Of Hungarian origin, Horna married the Spanish artist José Horna, with whom she went to Mexico at the end of the Spanish Civil War. Her photographs have something of a "Viennese touch," like Franz Kafka or Robert Musil: a cool distance touched by a subtle macabre humor uncommon in Mexico. In a similar vein, Rosa Covarrubias did, in the 1930s, a few "surrealist" montages without the use of a camera. Less aggressive and modernistic than Amero's work, her work combined her own drawings with insects and fragments of photographs.

Several younger Mexican photographers have done work in this same narrative-poetic line, using various techniques. Jan Hendrix, Lourdes Almeida, and Adolfo Patiño have employed Polaroid prints as elements in multimedia assemblages; Lourdes Grobet, Enrique Bostelmann, and Juan Castañeda have constructed photographic installations; Jesús Sánchez Uribe, Francisco Barriga, Agustín Estrada de Pavia, Pablo Ortiz Monasterio, and Gabriel Figueroa have created artificial and unrealistic compositions; Juan José Gurrola, Eugenia Vargas, Silvia Gruner, and Laura González have used photography in—and to document—their performance pieces. The sophisticated nudes of Aníbal Angulo, Pilar Macía, Oweena Camille Fogarty, and Pedro Olvera might also be included here. These artists all somehow use photography for its "magic" properties, for the way in which it reveals and projects unconfessed fantasies and serves as a means to discover and unveil the most intimate preoccupations.

Montages

The practice of photomontage became widespread during the 1920s in Germany and the Soviet Union, where

it was used principally for propaganda purposes in leftist magazines. Until fairly recently, however, photomontage was very rarely used in Mexico. Still, there are a few early and revealing cases. In the mid-thirties, *Futuro* (the magazine founded in 1933 by Vicente Lombardo Toledano as the official publication of the Universidad Obrera de México) used photomontage to illustrate marches, political demonstrations, and strikes. In this case, the montages were composed of images taken from various periodicals. Photographs by Manuel Montes de Oca and Enrique Díaz, among others, are recognizable in them. The author of these compositions, German refugee Enrique Gutman, would include an incredible number of images on a double-page spread, as if to economize printing costs while achieving the maximum visual impact. In effect, Gutman simply carried to an extreme a type of graphic design typical of the period, which consisted of recomposing fragments of photographic images, cutting out some parts and emphasizing others with outlining.

One of these photomontages makes obvious visual reference to Diego Rivera's murals in Detroit (1932) and at the New Workers' School in New York City (1933). *Primera huelga de brazos caídos que registra la historia de México y que realizó la CTM en apoyo de los trabajadores ferrocarrileros*[6] plays with the idea of juxtaposed "compartments" that Rivera used to introduce different scenes in a single panel and that recall certain techniques of photographic editing inspired by or derived from cinematography and the narrative sequencing thus created. In another photomontaged image, Gutman created a kind of structural scaffolding to repeat over and over the same image of telegraphic cables.[7]

Gutman's photomontages can be compared to those of Lola Álvarez Bravo from the same period. In 1935, María Izquierdo directed a project to promote painting by women and organized an exhibition of political posters by some of her students. The show, *Carteles Revolucionarios de las Pintoras del Sector Femenino de la Sección de Artes Plásticas, Departamento de Bellas Artes* (Revolutionary Posters by the Painters of the Women's Section of the Plastic Arts Division, Department of Fine Arts), opened in Guadalajara in May 1935.[8] Lola Álvarez Bravo participated in the show, exhibiting two photomontages. One depicted a *fifí* (as the dandies of the period were called), his head replaced by a skull and his hands filled with money, which recalls Sergei Eisenstein's sequence of clothed, animated skeletons in the final scene of his unfinished film *¡Que Viva México!* The other was entitled *El sueño de los pobres* (Dream of the Poor). "Sometimes I wanted to say something, and photography wouldn't let me," explained Lola Álvarez Bravo. "So, I would take a piece of cardboard, make a sketch, choose some negatives, print them to the necessary size, cut and glue them [to the paper]."[9]

El sueño de los pobres is eloquent in its simplicity: a strange-looking machine mounted on rails seems to mint coins, overwhelming a poor child, dressed in rags and sleeping on rough boards. This strange image seems to have influenced David Alfaro Siqueiros—an enthusiast of photomontage—who reproduced a similar "minting machine" in the center section of his masterpiece *Portrait of the Bourgeoisie* (1939–1940), a mural at the Electrical Workers' Union in Mexico City. Lola Álvarez Bravo later exhibited an unmanipulated photograph with the same title as her montage. Taken in a market, it shows a child at rest amid piles of *huaraches*, the leather sandals worn by the working class in Mexico. The composition of the two pictures is similar: the agglomeration of *huaraches* corresponds spatially to the coins of the aggressive money-making machine.

A somewhat later montage, *El sueño del ahogado* (The Dream of the Drowned Man), was probably never published at the time. It was a piece made for personal amusement, using one of her portraits of the painter Juan Soriano, one of Lola's best friends. The composition and technique recall the surrealist collages that Agustín Lazo was making at that time, using nineteenth-century prints and illustrations. Here, as in *El sueño de los pobres*, Lola Álvarez Bravo tried to retain the illusion of photographic depth, despite the differences of scale.

It was a number of years before she returned to the practice of photomontage. Her next known works in this genre were probably made at the end of the 1940s or beginning of the 1950s. Unlike the earlier examples, her later montages are not surrealistic exercises; nor do they express her political views. Commissioned by various commercial enterprises or governmental institutions, they fall into the category of advertising posters, to be reproduced and displayed in large format.[10]

Lola Álvarez Bravo regularly recorded and collected

Enrique Gutman

Primer huelga de brazos caídos que registra la historia de
México y que realizó la CTM en apoyo de los trabajadores
ferrocarrileros

Photomontage
Futuro 3, no. 5 (July 1936)
Private Collection, Mexico City

pictures of machinery, architectural elements, fragments of statuary: torsos, arms, etc. In her montages—even more than in her photographs—she reveals her knowledge of pictorial composition and, above all, an intelligent and understanding reading of mural painting. She makes bold use of foreshortening, as seen in the elongated perspectives that also appear in some of her photographs. Roadways, train tracks, rows of posts, all brutally foreshortened, recall the formal contributions of the Russian Constructivist photographers Aleksandr Rodchenko and El Lissitzky. These elements serve as axes, opening up contradictory, interrelated spaces in a Cubist fashion. Designed as large-format works, the photomontages are filled with juxtaposed elements—men working, perspective views of machinery—aligned and repeated to achieve a choreographic effect.

The proportions of *Hilados del norte,* done for a textile factory in Monterrey, in particular, are spatially organized like a mural. The reference to *Man at the Crossroads,* Diego Rivera's destroyed fresco in Rockefeller Center in New York—later reproduced as *El hombre en la encrucijada* in the Palacio de Bellas Artes in Mexico City—is evident. In both cases, the composition is organized around a central point from which diagonal force lines radiate, intersected by different elements at one or another side of the photomontage. There is even a thematic similarity to Rivera's mural in another of her photomontages, *Computadora,* which shares certain iconographical elements: doctors performing surgery, a radio tower, a mixture of prehispanic motifs with modern machinery.

Like Rivera, Lola Álvarez Bravo celebrated modernity in her work and believed—like so many in the mid-twentieth century—in the social benefits of science. In spite of this, the chaos apparent in several of these compositions reveals a certain skepticism about the advances of technology. *Anarquía urbana de la ciudad de México* (Urban Anarchy in Mexico City) is an obvious example. In this premonitory photomontage, made in the mid-1950s, Lola Álvarez Bravo introduces a rocky outcropping in the foreground that threatens to dominate the elegant skyline of the modern city. The control of nature by science and industry ultimately reveals itself as chaos within an extremely fragile system.

In *Vegetaciones,* a triptych made for the stairway of the Teatro Reforma of the Instituto Mexicano de Seguro Social, Lola Álvarez Bravo gave free reign to her imagination and sense of composition. Here her exuberant and whimsical vegetal chaos, replete with stalking felines, recalls the tropical deliria of the Douanier Rousseau.

Lola Álvarez Bravo always worked with her own negatives and only incidentally employed previously published images by other photographers. She did not attempt to modify reality, but to complement it by presenting an ideal dimension that the camera alone could not provide.

Her brief incursion into the area of photomontage should be attributed to the moral and ideological climate of the Cárdenas years. In that period, many people—including artists and government officials—felt that it was necessary to extend the discourse on Mexican culture to include all parts of the country and sectors of the population, in particular the less-fortunate classes. Among other things, this initiated a second phase of muralism. Art education for children and adults was part of the polemic of the establishment of socialist schools in the country. Since the days of ¡30-30!—a movement of young, leftist would-be muralists who had no walls to paint on after Vasconcelos resigned as minister of education in 1924—propaganda posters made by artists had become a potent arm in the political struggle, more efficient than periodicals or mural painting. Tina Modotti had composed the image *Bandolier, Corn, and Sickle* with obvious polemic and semantic intent. The artists that worked together with Leopoldo Méndez to create the Taller de Gráfica Popular also used photography to create propaganda posters. Among many examples: Alberto Beltrán copied a photograph of Villa on horseback to create *El gran guerrillero Francisco Villa;* Isidoro Ocampo used the photograph of Madero's arrival at the Zócalo; Alfredo Zalce based a work on Aurelio Montes de Oca's photographic image to create an eloquent graphic work entitled *Choferes contra camisas doradas en el Zócalo de la ciudad de México, 20 de noviembre, 1935* (Taxi Drivers against the "Gold Shirts" in the Zócalo, Mexico City, November 20, 1935).[11] In those cases, the photographs were copied almost verbatim. A different method was used by David Alfaro Siqueiros when he collaborated with the graphic designer and photomontage artist Josep Renau, a Spanish refugee living in Mexico, in the creation of *Retrato de la burguesía* (Portrait of the Bourgeoisie), a mural in the Mexican Electricians' Union.

Siqueiros, Renau, Kahlo

Working under the direction of David Alfaro Siqueiros, Josep Renau prepared cartoons for the mural that were later transferred to the narrow staircase wall and painted using Duco, a commercial enamel.[12] According to art historian Laurence Hurlburt, who found that Renau had saved several source photographs in his archive:

> The specific origin of the mural's imagery may in many cases be identified. For example, a turbine-mould, a photo from *Life,* served as the model for the "Infernal Machine" and one from *Look* inspired the hanged black. For the right wall the effects of Nazi aerial bombardment of Madrid were adapted (*Life*) along with Italian soldiers killed in the battle of Guadalajara [Spain].[13]

David Alfaro Siqueiros had previously sought ways to integrate painting with modern technology (or, better said, to convert painting into a modern technology). To this end, he had undertaken a series of experiments using industrial materials, including the reproductive techniques of the "commercial poster, photography, documentary photography, cinematography, photomontage, etc."[14]

Portrait of the Bourgeoisie was not the only example of the use of photography by David Alfaro Siqueiros. At his Experimental Workshop in New York in 1936, he made a number of attempts to paint from images that he projected directly on panels without first drawing the composition. These techniques influenced some of the American students who were members of the workshop. And in 1945, as Raquel Tibol has discussed,

> [Siqueiros] stripped down to his underwear and, in that partially nude state, enacted some of the poses that he needed for his paintings. Since it was a good faith agreement, it never occurred to him to ask for the negatives or sign a contract prohibiting the photographer from using this darkroom material. Based on these photographs, he created paintings, such as *Víctima del fascismo* [Victim of Fascism], *Prostrado pero no vencido* [Down But Not Defeated], *Nuestra imagen actual* [Our Present Image]. When the latter painting, from 1947, provoked heated discussions, the . . . photographer told the press that Siqueiros

had expropriated his work, stolen his intellectual property.[15]

Siqueiros's use of photography was unquestionably interesting, above all because he did not alter the perspective effects specific to the photographic medium. The foreshortenings and acute perspective views that are comprehensible in a "realistic" medium ("straight" photography) appear as deformations when translated to another, less veristic, two-dimensional medium such as painting. From this point, it is possible to compare the differences in the ways in which Diego Rivera, José Clemente Orozco, and David Alfaro Siqueiros composed their works. Rivera and Orozco drew from life, following the rules of academic perspective (even when they were reinterpreted). Siqueiros, on the other hand, incorporated these photographic deformations into his mural compositions, achieving violent and expressive foreshortening effects.

Josep Renau had a long career as a graphic designer in Mexico, before returning to Europe (he died in Berlin in 1982). During his years in Mexico, he produced a great number of movie posters and book and magazine covers. Renau had introduced political photomontage in Spain before the Civil War and continued practicing it during his exile in Mexico. His covers for the magazine *Futuro,* which appeared from 1940 to 1942, are particularly eloquent commentaries about events in Europe and Mexico. In a later series of images entitled *The American Way of Life,* published only after his death, Renau again used photographic images taken from U.S. magazines, particularly *Life,* to create corrosive pamphlets, violent and humorous satires that revealed disguised sexual motifs. "The fragmentation, breakdown and reassembling of different images, through the condensation and displacement of meanings, makes up a symbolic universe which in *The American Way of Life* revolves around the paradoxes of the capitalist system: hunger and opulence, poverty and the arms race, sex and morality."[16]

In 1933, Frida Kahlo created a hybrid composition that was without parallel at the time (except, perhaps, for the early collages of Argentine artist Antonio Berni, a disciple of Siqueiros in the 1930s, and the rare experimental montages of Rosa Covarrubias). *Mi vestido cuelga ahí* (My Dress Hangs There) was done during the period when Diego Rivera was painting his contro-

Josep Renau

Cover, Futuro 72 (August 1942)

Photomontage
Courtesy © Fundació Josep Renau, Valencia

versial mural at Rockefeller Center (1933). Lola Álvarez Bravo kept a negative of the work in progress that suggests that the picture may have been painted or at least completed in Mexico.

The work shows the dress of a *tehuana* hanging in front of a cityscape of New York skyscrapers. Various objects (a garbage can, a toilet, a telephone, a trophy) complete the composition. In a way that she had not done in her previous work, Kahlo altered the scale and proportions, based on the complex juxtapositions that Rivera had articulated in his Detroit and New York murals, although she used them here with a certain, perhaps ironic, flatness. In the upper and lower parts of the picture, Kahlo included photographic elements from magazines: above, a distant view of Manhattan and a boat cruising in front of the Statue of Liberty; below, multitudes of the unemployed forming long lines, soldiers marching, political demonstrations, and fragments of metallic structures. Hayden Herrera counted more than twenty different photographic fragments in the lower portion of the picture.[17] Although this work is an oil painting, it may be considered a kind of antecedent to the mixed-media works now common in the oeuvre of contemporary artists. Using photomontage, Kahlo established a perceptible distance between the painted, colored portions and the black-and-white photographic, collaged areas. It should be noted that Kahlo was far from the first to mix photography with painting: the Cubists had already done this in the first decades of the twentieth century. Unlike their work, however, Kahlo exploited photography's representative functions in order to complement the painted work and introduce radical variations of scale and alterations of perspective in her work. I know of no precedent in the history of painting for this particular way of using photography.

Artifice

The mass-media industry—television networks, advertising and news agencies, film companies—is increasingly habituating audiences to accept digital imagery, the product of an alliance between photography, television, and computers. These electronically generated images have the appearance of photographs, the texture of photographs, and are sometimes even printed on a photographic supports (sensitized paper). In fact, they are "composed" of visual data produced on computers to simulate "straight" photographic images. They are so well done that it is sometimes difficult to detect their intrinsic deception. Yet they differ fundamentally from photography in that they "represent" nothing. They lack the "strict adherence to reality" that is (or was) the distinctive trait and essential value of photography. Nevertheless, these perfect examples of *trompe l'oeil* imagery simulate reality and intend (even if they don't always succeed) to deceive.

Like photomontages, they are constructed, fabricated, using existing images, electronically cut out of context and processed to create a new and different one. In the final analysis, the way they are produced does not differ greatly from that of certain paintings—I'm thinking here of the work of Siqueiros and a number of contemporary artists who also work from "photographic data," such as Carla Rippey, Javier de la Garza, and Julio Galán. Their works, however, differ from digital photographs in their support and the use that they make of it: painting always presents itself as an artificial space and the painted image, therefore, is always a construction, an interpretation. On the contrary, the photograph—whether produced by conventional photographic technology or electronically generated—lays claim to a special, direct relationship with "reality."

The polemics surrounding photography, its truths and lies, convictions, contradictions, artistic value, and documentary function, are in the process of being resolved, paradoxically, by the simple existence of these new mechanisms—not, as Walter Benjamin said, of mechanical reproduction, but of electronic simulation. Curiously, this allows the historian of images to take a nostalgic look back in time and restore the medium to what it has been in the past: a machine to freeze the "decisive moment," an instrument of knowledge—of the world and also of itself—a mechanism of appreciation, classification, and evaluation of the physical world.

With this in mind, we return, with nostalgia, to the words of José Emilio Pacheco, who—before any of this happened—lodged his own protest "Against Kodak":

A terrible thing is photography	Cosa terrible es la fotografía
To think that in these	Pensar que en estos objetos
quadrangular objects	cuadrangulares
resides an instant from 1959	yace un instante de 1959
Faces that no longer are	Rostros que ya no son
Air that no longer exists	Aire que ya no existe
Because time avenges itself	Porque el tiempo se venga
on those who break the natural order	de quienes rompen el orden natural
detaining it	deteniéndolo
the photos crack and yellow	las fotos se resquebrajan amarillean
They are not the music of the past	No son la música del pasado
They are the din	Son el estruendo
of internal ruins collapsing	de las ruinas internas que se desploman
Not poetry	No son el verso
but the rustling	sino el crujido
of our irremediable cacophony[18]	de nuestra irremediable cacofonia[19]

José Emilio Pacheco, *Irás y no volverás: Poemas*

Henri Cartier-Bresson
Chapultepec, Mexico, 1964

Gelatin silver print
Magnum Photos, New York

Notes

1. Overture

1. Douglas Crimp, "The Museum's Old/The Library's New Subjects," in *The Contest of Meaning: Critical Histories of Photography,* ed. Richard Bolton, p. 7.

2. Ibid.

3. Christopher Phillips, "The Judgment Seat of Photography," in *The Contest of Meaning: Critical Histories of Photography,* p. 23.

4. The directors of the Department of Photography at MOMA were, successively, Beaumont Newhall, Edward Steichen, and John Szarkowski.

5. Phillips, "The Judgment Seat of Photography," p. 19.

6. Ibid., p. 36.

7. This interpretation has been proposed on other occasions by Mexican photographer Pedro Meyer.

8. Mexican critic Raquel Tibol has cited René Burri's eloquent account on this subject: "It was in Cyprus, in 1959. I returned to my hotel after a hard day. I put the cameras on the bed and, while I was putting things in order, turned on the television set. The same events that I had photographed were being shown on the screen. 'Wait,' I cried. I still had to develop and send my photos. It was a terrible blow" (Raquel Tibol, *Episodios fotográficos,* p. 27).

9. See Luis Humberto González, *Que el mundo lo sepa* (Mexico City: José Martí, 1990).

10. The late Cuban photohistorian Marucha Haya and the Brazilian Boris Kossoy, in particular, have been extremely severe in their criticism of the singular, Eurocentric view of these institutions.

11. Carlos Monsiváis, "Notas sobre la historia de la fotografía en México," *Revista de la Universidad de México* (Mexico City) 25, nos. 5–6 (December 1980–January 1981), 48–49.

12. The Instituto de Investigaciones Estéticas is the center for the study of visual arts at UNAM (Universidad Nacional Autónoma de México).—*Trans.*

13. In contrast to the bohemian glamour of a European arts café, VIPS is a popular U.S.-style chain of restaurants in Mexico—*Trans.*

14. Tibol, *Episodios fotográficos,* pp. 68–69.

15. The Third Colloquium, held in Havana, Cuba, in November 1984, had a more intellectual character than the previous colloquia. Unfortunately, the presentations and discussions were never published. The Fourth Colloquium was held in Mexico City, more than a decade later, in 1996.

16. "Palabras de presentación," in *Hecho en Latinoamérica 2,* p. 10.

17. "La calidad vs. el contenido en la imagen fotográfica," in ibid., p. 32.

18. "Respuesta a Lázaro Blanco," in ibid., p. 38.

19. A reference to the photojournalistic images documenting the massacre of Vietnamese villagers in My Lai by American soldiers in 1967 which outraged public opinion in the United States and abroad and strengthened opposition to the war.—*Trans.*

20. "Imágenes de miseria: folclor o denuncia," in ibid., p. 81.

21. "Comentario a la ponencia de Lourdes Grobet," in ibid., p. 87. In subsequent articles, Carlos Monsiváis further developed his opposition to what he called the "poeticization" of photography.

22. Collaborators on this project included Claudia Canales, Rita Eder, Néstor García Canclini, and American researcher René Verdugo. On this occasion, the Museo de Arte Moderno published a special issue of the magazine *Artes Visuales* dedicated to the history of photography, with contributions by Judith Hancock de Sandoval, Ema Cecilia García, and Carlos Monsiváis, in addition to those by several of Eugenia Meyer's collaborators.

23. Tibol, *Episodios fotográficos,* p. 80.

24. Eugenia Meyer et al., *Imagen histórica de la fotografía en México,* p. 7.

25. Ibid.

26. Ibid., p. 10.

27. For example: Manuel de Jesús Hernández, *Los inicios de la fotografía en México: 1839–1850*; Flora Lara Klahr, *Jefes, héroes y caudillos*; Rosa Casanova and Olivier Debroise, *Sobre la superficie bruñida de un espejo: Fotógrafos del siglo XIX.*

28. Francisco Reyes Palma, personal communication.

29. Francisco Reyes Palma, *Memoria del tiempo: 150 años de fotografía en México,* pp. 19–20.

30. Crimp, "The Museum's Old/The Library's New Subjects," p. 9.

31. A painter's oeuvre only rarely reaches three or four hundred works, while a photographer's archive may consist of thousands or even hundreds of thousands of negatives.

32. Charles Baudelaire, "The Modern Public and Photography," in *Art in Paris 1845–1862,* trans. Jonathan Mayne (Ithaca: Cornell/Phaidon Books, 1965), pp. 149–155.

2. Ritornello

1. Luis Becerra Tanco, *Felicidad de México en el principio, y milagroso origen que tubo el santuario de la Virgen María N. Señora de Guadalupe* (Mexico City: Viuda de Bernardo Calderón, 1675). Cited by Ignacio Manuel Altamirano, *Obras completas V, Textos costumbristas* (Mexico City: SEP, 1986), pp. 133–134. The following passages and much of the discussion of daguerreotypes in this book were previously published in Casanova and Debroise, *Sobre la superficie bruñida de un espejo.*

2. Cited in Jean François Chevrier, "La photographie dans la culture du paysage," in *Paysages,* p. 358.

3. Ibid.

4. According to an undocumented assertion by Carlos Jurado, *El arte de la aprehensión de las imágenes o el unicornio.*

5. The astronomer François Arago was a representative from the Eastern Pyrenees region.

6. J. . . , "La Daguerréotypomanie," cited in *Paris et le daguerréotype* (Paris: Musée Carnavalet, 1989), p. 11.

7. Prélier ran a printing business after 1837. Later he became an associate of the engraving firm Duboille, Prélier, and Sons. Duboille was probably his brother-in-law. See Auguste Genin, *Les français au Mexique du XVI siècle à nos jours* (Paris: Nouvelle Èditions Argo, 1993), p. 438; and *El Siglo XIX,* February 15, 1855. Historian Manuel de Jesús Hernández gives his name as Jean François Prélier Duboille, probably confusing him with one of his descendants (Manuel de Jesús Hernández, *Los inicios de la fotografía en México (1839–1850),* p. 45).

8. *El Cosmopolita,* January 15, 1840. None of these images is known to have survived.

9. *El Cosmopolita,* January 29, 1840.

10. Cited in Armando B. Casaballe and Miguel Ángel Cuarterolo, *Imágenes del Río de la Plata: Crónica de la fotografía rioplatense, 1840–1940.*

11. This was the case of Joaquín Díaz González, the first Mexican daguerreotypist, who operated a portrait studio in 1844 without having completed his studies at the Academy of San Carlos.

12. "Hmnos. Sciandra," in *Le Trait d'Union,* May 16, 1872.

13. Alain Corbin, "Le secret de l'individu," in Phillipe Ariès et al., *Histoire de la vie privée,* 5 vols. (Paris: Le Seuil, 1987), vol. 4, pp. 423–424.

14. This became the basis of her book *Photographie et société* (Paris: Èditions de Seuil, 1974), later published in Spanish as *Fotografía como documento social* (1976) and in English as *Photography and Society* (1980).

15. "Interesante," in *El Siglo XIX,* November 13, 1842. Cited by Keith McElroy, *Early Peruvian Photography: A Critical Study,* p. 14.

16. Madame Calderón de la Barca (Frances Erskine Inglis), *Life in Mexico,* p. 188.

17. Peter Galassi demonstrated this in an exhibition at the Museum of Modern Art in New York in 1981. Galassi also explains how the search for realism led a number of amateur artists to employ the camera lucida in order to achieve greater accuracy in their draftsmanship. See Galassi, *Before Photography.* Jean François Chevrier took this argument and developed it further in "La photographie dans la culture du paysage."

18. The images of Saltillo, Durango, and Parral taken by an anonymous daguerreotypist during the U.S. intervention in 1847 are an exception, the result of extraordinary circumstances and the need to preserve a visual record and memories of the scenes associated with the war. See Casanova and Debroise, *Sobre la superficie bruñida de un espejo*; and Martha A. Sandweiss et al., *Eyewitness to War: Prints and Daguerreotypes of the Mexican War, 1846–1848.*

19. Théodore Tiffereau, *Les métaux sont des corps composés,* pp. 9–10. Thanks to Philippe Roussin for the references related to Théodore Tiffereau.

20. A. T. L., "Sciences," *La Lumière* 4, no. 22 (June 3, 1854), 85–86.

21. Probably Teocaltique, Jalisco, north of San Juan de Los Lagos.

22. Ernest Lacan, "Revue photographique, Le Secq, Soulié, Tiffereau," *La Lumière* 4, no. 30 (July 29, 1854).

23. Ernest Conduché, "Nouvelles applications de

la photographie," *La Lumière* 5, no. 6 (February 10, 1855).

24. Sandweiss et al., *Eyewitness to War.*

3. Canon

1. Monsiváis, "Notas sobre la historia de la fotografía en México," p. 48.

2. Gutierre Aceves Piña, *Tránsito de angelitos: Iconografía funeraria infantil.*

3. Hernández, *Los inicios de la fotografía en México: 1839–1850.*

4. *El Monitor Republicano,* May 3, 1871; and *La Voz de México,* May 6, 1871.

5. For more information on Joaquín María Díaz González, see Rosa Casanova and Olivier Debroise, "Fotógrafo de cárceles: usos de la fotografía en las cárceles de la ciudad de México en el siglo XIX," *Nexos* 119 (November 1987).

6. As mechanically reproducible means of representation became more common, the value of painting increased. In a certain sense, lithography and photography gave impetus to the rise of an art market based less on the intrinsic value of the representation than on the "unique" and irreplaceable talent of the artist and his or her global vision, the much-discussed "aura" defined by Walter Benjamin.

7. Walter Benjamin, "A Short History of Photography" (1931), in *Classic Essays on Photography,* ed. Allan Trachtenberg, pp. 204, 205, 207.

8. The carte-de-visite, patented in 1862 by the Frenchman André Adolphe Eugène Disdéri, is a photograph mounted on card stock the size of a calling card. A special lens made it possible to take four, six, or eight photographs simultaneously. These were then contact printed, making positive paper prints the same size as the negatives. There were other standardized formats: those known as *tarjetas Imperiales* in Mexico were known in France as *boudoir-cartes* or *portrait-cartes* and in the United States as cabinet cards and were approximately the size of today's postcards.

9. The strange spellings of some of these foreign names may be due to orthographic errors in the period press.

10. *El Boletín Republicano,* July 5, 1867. Cervantes sold portraits of Zaragoza, Juárez, Ocampo, Comonfort, Lerdo, and Degollado.

11. In 1865, Antíoco Cruces went to Paris, where he worked in the Bacard studio (*El Fotógrafo Mexicano* 2, no. 12 [June 1901]).

12. "Cruces and Campa hung a sign out announcing their Artistic Photography, thus differentiating it from 'agricultural or hydraulic' photography" (*El Monitor Republicano,* April 21, 1874).

13. *Diario de Avisos,* October 20, 1868.

14. *El Monitor Republicano,* November 7, 1873. Perhaps the portrait was of the well-known Mexican writer Guillermo Prieto.

15. *El Correo de Comercio,* November 21, 1874. Vicenta Salazar also exhibited views and landscapes at the Centennial Exhibition in Philadelphia in 1876 (*El Siglo XIX,* January 16, 1877).

16. The North American artist Pamela Scheinman has made a thorough study of the history of photo-sculpture. In the same way that Gabriel Fernández Ledesma, Roberto Montenegro, and Dr. Atl reclaimed the popular arts in Mexico in the period 1921–1924, bestowing a new status upon them and, in some cases, reviving practices (such as the making of laquerware in Uruapán and Olinalá) that were on the brink of disappearing, Scheinman breathed new life into the manufacture of photo-sculpture.

17. Esther Acevedo de Iturriaga, *Catálogo del retrato del siglo diecinueve en México en el Museo Nacional de História* (Mexico City: Instituto Nacional de Antropología e Historia, 1982). See, in particular, catalog entries 69, 174, and 204.

18. *El Siglo XIX,* February 20, 1862. Cited in Ida Rodríguez Prampolini, *La crítica de arte en México en el siglo XIX,* vol. 2, pp. 46–47.

19. José María Escudero y Espronceda painted in oil over photographs that he had taken (*La Iberia,* June 22, 1869, and December 21, 1871). Antonio Esnaurizar, a miniaturist who studied at the Academy of San Carlos, also colored portraits. His portrait of Sra. Ducoing was exhibited at the shop of Julio Michaud, a printer, framer, and distributor of art supplies.

20. Luis García Islas, *Velasco, pintor cristiano* (Mexico City: Ediciones Proa, 1932), pp. 32–34. Some photographic portraits by Velasco are reproduced in *José María Velasco, 1840–1912: National Homage* (Mexico City: Museo Nacional de Arte, 1993).

21. Carlos Martínez Marín, "José María Velasco y el dibujo arqueológico," in *José María Velasco: Homenaje,* comp. Xavier Moyssen, p. 213.

22. The collodion negatives that Velasco used for these illustrations are preserved in the Maler Collection at the Fototeca del INAH. Before this, they had

been kept with other archaeological materials at the Fototeca of the Museo Nacional, located in the former convent of Culhuacan. For more on Velasco and photography, see Olivier Debroise, "José María Velasco y el paisaje fotográfico decimonónico (apuntes para un paralelismo)," in *José María Velasco: Homenaje,* comp. Xavier Moyssen.

23. There were exceptions: as late as the beginning of the twentieth century, a number of itinerant photographers traveled the country, setting up their fragile equipment in markets and town fairs, serving a particular segment of the population. Ángel Maldonado, associate of Miguel S. Valenzuela (photographer in Apan) and of Ramón Bancizo, worked throughout the Huasteca until the end of the nineteenth century. *El Fotógrafo Mexicano* 1, no. 9 (March 1900). And, of course, there are still itinerant photographers who bring their Polaroids and painted backdrops to fairs and fiestas.

24. Gutta-percha is a hard, rubberlike material, invented shortly before 1840.

25. Ch. Theo. Mason, "Photography in Mexico City," *Professional and Amateur Photographer: A Journal of Practical Photography* (Buffalo) 11, no. 8, 826–833.

26. The exception is the above-mentioned School of Arts and Trades for Women. The Academy of San Carlos used photographs, but did not began teaching classes in photography until the late 1920s.

27. *El Heraldo,* March 1, 1856.

28. Ybáñez usually signed his photographs "Ybáñez y Sora," and the firm appears thus in many catalogs. "Sora" is, in fact, an abbreviation for "Señora."

29. Claudia Canales, *Romualdo García: Un fotógrafo, una ciudad, una época.*

30. *El Mundo,* June 2, 1899, cited by Juan Coronel Rivera, "150 años de fotografía," *Unomásuno,* August 14, 1989.

31. Tibol, *Episodios fotográficos,* p. 235. On Natalia Baquedano, see also Patricia Priego Ramírez and José Antonio Rodríguez, *La manera en que fuimos: fotografía y sociedad en Querétaro, 1840–1930.*

32. Jean François Chevrier and Jean Sagne, "L'Autoportrait comme mise en scène . . . essai sur l'identité, l'exotisme et les excès photographiques," *Photographies,* April 4, 1984, 46–47.

33. Enrique Fernández Ledesma, *La gracia de los retratos antiguos,* pp. 20–21, 55.

34. Some photographers placed portraits of individuals missing from the group in medallions

above the photograph. One photographer from Tepeji del Río, in the State of Mexico, made photomontages with pictures taken at wakes in which the deceased appears in "heaven," above or beside the coffin.

35. José Carlos Becerra, "Fotografía junto a un tulipán," in *El otoño recorre las islas,* prologue by Octavio Paz, published by José Emilio Pacheco and Gabriel Zaid (Mexico City: Era, 1973). This text was originally written as a prologue to an edition of the poems of Andrés Calcáneo Díaz.

36. Ibid.

37. While it remains the best known, this was not the first such album. In 1862, Juan D. Abadiano y Pérez published "an album of monarchs, artists, and church officials" (*El Constitucional,* April 26, 1862).

38. This rare album is mentioned in an article in *El Siglo XIX,* November 28, 1872.

39. Rosa Casanova, "Usos y abusos de la fotografía liberal: ciudadanos, reos y sirvientes, 1851–1880," *La Cultura en México,* supplement, *Siempre!* 1639 (November 21, 1984), 36–37.

40. This section takes up and synthesizes earlier research by Rosa Casanova. See Casanova and Debroise, "Fotógrafo de cárceles: usos de la fotografía en las cárceles de la ciudad de México en el siglo XIX."

41. Archivo Histórico de la Ciudad de México/ Archivo del Ayuntamiento (AHCM/AA), File 897, Folder 1, July 22, 1856.

42. Manuel Dublán and José María Lozano, *Legislación mexicana: colección completa de las disposiciones legislativas expedidas desde la Independencia de la República* (Mexico City: Imprenta del Comercio, 1876), vol. 7, pp. 407–408.

43. AHCM/AA, File 897, Folder 22, September 22, 1876.

44. AHCM/AA, File 897, Folder 8, April 15, 1871.

45. AHCM/AA, File 897, unnumbered folder, May 24, 1887.

46. AHCM/AA, File 897, Folder 22, August 18, 1876.

47. Ignacio Fernández Ortigoza, *Identificación científica de los reos* (Mexico City: Imprenta del Sagrado Corazón de Jesús, 1892), p. 11.

48. AHCM/AA, File 897, Folder 8, April 15, 1871.

49. One of the images from the *Prostitución 1905–1909* book bears the signature "Antonio Salazar, photographer."

50. Volume entitled *Prostitución, 1909–1916,* Archivo del Ayuntamiento, Oaxaca.

51. Volume entitled *Prostitución, 1905–1909,* Archivo del Ayuntamiento, Oaxaca.

52. Volume entitled *Mujeres públicas, 1892,* Archivo del Ayuntamiento, Oaxaca.

53. Ibid.

54. Dublán and Lozano; *Legislación mexicana,* vol. 7, pp. 407–408.

55. Mason, "La fotografía en la ciudad de México," p. 831.

56. See Gina Zabludowsky, "¿Ha existido la fotografía artística mexicana?" *Artes Visuales* 1 (December 13–15, 1973).

57. Rosa Castro, "Hablan a *Hoy* los ases de la fotografía," *Hoy,* January 6, 1951, 26–35. Salvador Novo also remembered "the photographic portraits that we used to have made by a photographer named Silva who was very fashionable at the time, a long-haired nervous bohemian who dressed all his clients in a ruffled collar and cape that he kept in his studio, transforming them into Colonials. Enameled portraits, as Xavier [Villaurrutia] used to say" (Salvador Novo, *La vida en México en el período presidencial de Miguel Alemán* [Mexico City: Empresas Editoriales, 1964], p. 557).

58. See the exhibition catalog *El que mueve, no sale* (Mexico City: Museo de Culturas Populares, SEP, 1989).

59. Agustín Aragón Leiva, "La fotografía y la fotografía en México," *El Nacional,* December 5, 1933.

60. A very early photographic self-portrait in a mirror, taken by the future painter Alfonso Michel, ca. 1900, and showing one of these small cameras, also lends support to this hypothesis.

61. *Helios* was not the first periodical dedicated to photography published in Mexico. In July 1889, the first issue of *El Fotógrafo Mexicano* appeared on the newsstands, published by the American Photo Supply Company, the principal supplier of photographic materials in Mexico City. The magazine was aimed at both professionals and the country's many amateurs. (The "Letters" section lists the names of amateur photographers from as far away as Maravatío, Michoacán, Matehuala, and San Luis Potosí, demonstrating how widespread the practice of amateur photography was at the turn of the century.) Edited in the United States, the magazine included the works of the best-known studio photographers in Mexico as well as a selection of photographs sent in by amateurs. It continued to be published until 1901. In 1902, another short-lived magazine, *Foto,* ap-peared. This one was more specifically oriented toward amateur photographers.

62. Apparently, the association had actually been founded in 1926. At least this is what is indicated on its logo. It was not the first such organization. José Luis Requena created the Sociedad Fotográfico de Profesionales y Aficionados in 1904 (Rafael Heliodoro Valle, "Datos para una historia de la fotografía en México," *El Nacional,* supplement 10, November 23, 1958). The Mexican Association of Press Photographers was established in 1920 by Agustín Casasola, together with Ezequiel Álvarez Tostado, Ezequiel Carrasco, Alberto Garduño, Gerónimo Hernández, León León, Abraham Lupercio, Eduardo Melhado, José Isaac, Tarditi, Samuel Tinoco, and Rodolfo Toquero. Enrique Díaz founded a similar organization of the same name in 1947. A full account of the numerous professional and amateur groups that appeared in the first half of the twentieth century, both in Mexico City and elsewhere in the country, is beyond the scope of this study. I will note, however, that while looking through the miscellaneous files of the Hemeroteca Nacional (National Periodical Library), I happened upon the statutes of the Photographic Society of Monterrey, which clearly attest to the rise and institutionalization of the profession. Likewise, the regional research undertaken by José Antonio Rodríguez reveals the existence of similar organizations in Puebla and Guadalajara. Before the creation immediately following World War II of the Club Fotográfico de México, some artistic organizations also created their "photography sections." For example, the LEAR (League of Revolutionary Writers and Artists) assigned responsibility for that area to Manuel Álvárez Bravo and Enrique Gutman. The history of the various photographic associations and their political and aesthetic leanings merits a separate study.

63. The inclusion of famous painters on the juries of photographic competitions was a common practice based on the academy's annual salons. In June 1900, Leandro Izaguirre, Luis Monroy, and Carlos Bello judged the competition sponsored by the Catholic Circle of Puebla (*El Fotógrafo Mexicano* 1, no. 2 [June 1900]). Later the same year, however, in Oaxaca, winners were selected by photographers: Julio Valleto, Octaviano de la Mora, and Emilio Lange (*El Fotógrafo Mexicano* 2, no. 3 [September 1900]).

64. B. Hakenberger had served as director of the Rochester Photo Stock House since the late 1880s ("El valor de la unión," *Helios* 3 [October 1930], 1).

65. *Helios* 8 (March 15, 1931), 2.

66. *Helios* 4 (November 15, 1930), 8.

67. *Helios* 9 (April 15, 1931), 1.

68. The Cristero Rebellion, initiated by anticlerical President Plutarco Elías Calles.—*Trans.*

69. *Helios* 11 (June 15, 1931), 9.

70. *Helios* 15 (October 15, 1931), 3.

4. Pastorale

1. Roger Brunet, "Réévaluation des paysages," in *Paysages,* p. 51.

2. Chevrier, "La photographie dans la culture du paysage," pp. 371–372.

3. Tibol, *Episodios fotográficos.* See also Luis Gutiérrez Muñoz, *Documentos gráficos para la historia de México, Veracruz, 1858–1914.*

4. Zabludowsky, "¿Ha existido la fotografía artística mexicana?" p. 38.

5. Hugo Brehme, *México pintoresco,* vol. 2, pp. xv–xvi. [The quotations from Brehme's book are translated from the Spanish edition. These texts were not published in the English edition.—*Trans.*]

6. Ibid., p. viii.

7. Ibid., p. iii.

8. Ibid., p. xi.

9. The Fototeca del INAH has an original platinum print of oranges in a fruit market that is toned a delicate shade of blue-gray.

10. Eugene Witmore, "Fotografía en Mexico," *Helios* 6, no. 42 (March 31, 1935). [Translated from Spanish—*Trans.*]

11. Ibid.

12. Castro, "Hablan a *Hoy* los ases de la fotografía," pp. 26–35.

13. Valle, "Datos para una historia de la fotografía en México."

14. For example, *Bohemios* in *Foto* 1, no. 13.

15. *Foto* 2, no. 17.

16. Coronel Rivera, "150 años de la fotografía."

17. José Fuentes Salinas, "Cuarenta años del Club Fotográfico de México," *El Universal y la Cultura,* supplement, *El Universal* (Mexico City), March 21, 1989. Among the most important members of the club were Manuel Ampudia (first president), José Arturo Carol, Andrés Gonzáles Ortega, María Gómez, Ángel Ituarte, Manuel Pla Miracle, Virginia Rodríguez, Enrique Segarra, José Sue, Netzahualcóyotl Torres, and Lorenzo Zakani. Many contemporary photographers have been members of the association at some time, including José Luis Neyra, Pedro Meyer, and Salvador Lutteroth.

18. George Hoyningen-Huene, *Mexican Heritage,* text by Alfonso Reyes.

19. Eliot Porter, *Baja California and the Geography of Hope,* p. 3.

20. Eliot Porter and Ellen Auerbach, *Mexican Churches,* p. 9.

21. Eliot Porter and Ellen Auerbach, *Mexican Celebrations,* essays by Donna Pierce and Marsha C. Bol.

22. Porter and Auerbach, *Mexican Churches,* p. 7.

23. Published in translation as *The Burning Plain and Other Stories* (Austin: University of Texas Press, 1967). Media Luna is the name of the ranch in Juan Rulfo's *Pedro Paramo* (Mexico City: Fondo de Cultura Económica, 1955).—*Trans.*

5. Oratorio

1. A hill near Querétaro; site of the execution of Emperor Maximilian in 1867.—*Trans.*

2. Ignacio Manuel Altamirano, "Revistas literarias de México," *La Iberia* (June–August 1868), reprinted in José Luis Martínez, *La literatura nacional,* vol. 1, pp. 85–89.

3. Gábor Szilági, *La fotografía histórica.*

4. Discovered in 1981 together with a series of daguerreotypes made in Saltillo during the U.S. invasion of 1847, the image is now housed at the Amon Carter Museum in Fort Worth, Texas.

5. Gábor Szilági and Sándor Kardos, *Leletek, A Magyar Fotográfia Történetéböl.*

6. *Diario de Avisos,* April 22, 1858, p. 3.

7. *La Unión Federal,* June 9, 1861.

8. In a similar undertaking, two German photographers residing temporarily in Mexico, Terry Buelher and a Mr. Berlpseh, proposed "to visit private residences, villas, country houses and haciendas, to take views of interesting objects" (*Two Republics,* January 18, 1874). Some of these images, now in Tovar's collection, are reproduced in his book *La ciudad de los palacios: crónica de un patrimonio perdido* (Mexico City: Vuelta, 1990).

9. Secretaría de Fomento, Colonización, Industria y Comercio, *Memoria presentada al Congreso de la Unión por el Secretario del Despacho de Fomento, Colonización, Industria y Comercio de la República,* pp. 416–417.

10. Ibid.

11. William Henry Jackson, *Time Exposure: The Autobiography of William Henry Jackson*.

12. Another copy is in the collection of the Fototeca of the Centro Cultural/Arte Contemporáneo in Mexico City.

13. The author has located the following photographic series by Briquet: *Rumbos de México* (1890); *Vistas mexicanas; Álbum mexicano; Álbum de la Compañía Constructora Nacional; México* (two with this title, from 1901 and 1909); *Ferrocarril Central Mexicano* (1908 and 1910); *Tipos mexicanos; México moderno* (1909); and *Alrededores de México* (1897 and 1910). The images in these series are often similar, with the exception of those in *Álbum de la Compañía Constructora Nacional* and *México moderno,* both located in the Fototeca of the Centro Cultural/Arte Contemporáneo. Recently, J. A. Rodriguez acquired another album, assembled in the period by an unknown individual, that includes photographs by Briquet and Waite and was probably used as a sales catalog for the images.

14. It appears that Waite may have worked in collaboration with other photographers, managing a kind of small business enterprise. His images have appeared in various collections bearing different signatures. For more information, see Francisco Montellano, *C. B. Waite, fotógrafo: una mirada diversa sobre el México de principios del siglo XX.*

15. Mario de la Garza, "Entre Maximiliano y la Bola/2: Un oceano azul añil cuelga de un foco," *La Cultura en México,* supplement, *Siempre!* 1100 (July 6, 1983).

16. Ibid.

17. Approximately one hundred of Kilburn's Mexican stereographs are located in the Photo Archives at the Museum of New Mexico in Santa Fe.

18. Notable among these are the collections of the Archivo General de la Nación, the Fototeca del INAH, Princeton University, and the archives of the Keystone View company (now the Keystone-Mast Collection) at the University of California at Riverside.

6. Requiem

1. Casanova and Debroise, *Sobre la superficie bruñida de un espejo.*

2. John Lloyd Stephens, *Incidents of Travel in Yucatan,* vol. 2, p. 27.

3. Claude Désiré Charnay, *Le Mexique, 1858–1861: souvenirs et impressions de voyage,* ed. Pascal Mongne, p. 142.

4. The Civil War of Reform, or Three Years' War, 1858–1861.—*Trans.*

5. Pascal Mongne, "Introducción," in Charnay, *Le Mexique, 1858–1861.*

6. Ibid., p. 252.

7. Ibid., p. 169.

8. Philippe Roussin, "Découvertes d'une mythologie: images européennes du Mexique," *Photographies* 6 (December 1984).

9. Frédérick de Waldeck, "Les antiquités mexicaines et la photographie," *Le Trait d'Union,* April 19, 1862. It should be noted that Waldeck's own drawings of Precolumbian monuments are inaccurate and highly idealized.—*Trans.*

10. There are indications that Charnay returned to Mexico as a secret agent during the French Intervention. In 1865, he traveled to Madagascar with a French scientific expedition.

11. Melissa Banta and Curtis M. Hinley, *From Site to Sight: Anthropology, Photography, and the Power of Imagery,* p. 75.

12. Augustus Le Plongeon, *Vestiges of the Mayas, or Facts Tending to Prove That Communications and Intimate Relations Must Have Existed, in Very Remote Times, between the Inhabitants of the Mayab and Those of Asia and Africa* (New York: John Polhemus, 1881); *Sacred Mysteries among the Mayas and the Quiches, 11,500 Years Ago: Their Relations to the Sacred Ruins of Egypt, Greece, Chaldea and India; Free Masonry in Times Anterior to the Temple of Solomon* (New York: Robert McCoy, 1886).

13. Lawrence Gustave Desmond and Phyllis Mauch Messenger, *A Dream of Maya: Augustus and Alice Le Plongeon in Nineteenth–Century Yucatan.*

14. *Archives de la Commission Scientifique du Mexique* (Paris: Imprimerie Impériale, 1865), vol. 2, p. 247.

15. Claire Bustarret, "Autobiographie photographique de Léon Méhédin," *La Recherche Photographique* 1 (October 1986).

16. Luis A. Ramírez Aznar, *Puuc: Testimonios del pueblo maya.*

17. These early images are housed today in the Museo Nacional de Historia in Mexico and the Photo Archives of the Peabody Museum at Harvard University (two photographs of Palenque made in 1877). Other copies reside in the collections of the Ibero-American Institute in Berlin and the Musée de l'Homme in Paris.

18. Gerdt Kutscher in Teobert Maler, *Edificios mayas trazados en los años de 1886–1905 y descritos por Teobert Maler,* p. 70.

19. Ramírez Aznar, *Puuc,* reprints Maler's extended diatribe against Thompson's abuse of the site, a text first published in Mérida in 1910.

20. Maler, in ibid., p. 42.

21. Teobert Maler, *Impresiones de viaje a las ruinas de Cobá y Chichén-Itzá,* pp. 35–36.

22. Ibid., p. 45. Indeed, Charnay's name can still be seen inscribed on one of the piers of the Palace at Palenque.

23. Banta and Hinley, *From Site to Sight,* pp. 95–96.

24. Ibid., p. 93.

25. Weston, *The Daybooks of Edward Weston, I: Mexico,* p. 33.

26. Martha A. Sandweiss, *Laura Gilpin: An Enduring Grace,* p. 61.

27. Ibid., pp. 78–79.

28. Maler's tinted prints are now in the collections of the Bibliothèque Nationale and the Peabody Museum of Archaeology and Ethnology at Harvard.

29. Armando Salas Portugal, *Los antiguos reinos de México.*

30. Ibid., p. 5.

31. Alfonso Morales, in Gerardo Suter and Alfonso Morales, "Silbando entre los huecos," *En el Archivo del Profesor Retus.*

7. Capricho

1. Valle, "Datos para una historia de la fotografía en México."

2. Hayden Herrera, *Frida, una biografía de Frida Kahlo,* pp. 5–13. See also Coronel Rivera, "150 años de la fotografía/4," *Unomásuno,* August 28, 1989.

3. One predecessor of this work, Sylvester Baxter's *Spanish Colonial Architecture in Mexico* (Boston, 1901), was amply illustrated with photographs by Henry Greenwood Peabody.

4. Hayden Herrera, *Frida: A Biography of Frida Kahlo,* p. 7.

5. See *Guillermo Kahlo: Vida y obra* (Mexico City: Museo Estudio Diego Rivera, Museo Nacional de Arquitectura, 1993); and *Guillermo Kahlo: Fotógrafo oficial de monumentos,* ed. Jorge Alberto Manrique et al. (Mexico City: Casa de Imágenes, 1992).

6. H. Ravell, "Vanishing Mexico," *Harper's* 134, no. 799 (December 1916), 97–104.

8. Toccata

1. In the history of Mexican photography, photographs of nudity are extremely rare; the recent discovery of a set of "pornographic" cartes-de-visite (some of them very crude) in the Sotero Jiménez archives in Juchitán is particularly interesting from this point of view. When recently shown in a Oaxaca museum (since then the photographers' descendants have retired them from display), they soon became objects of speculation: who were these women showing their genitals to the photographer? Prostitutes? Common girls giving away their "pride" or trying to excite their boyfriends? The photographer's own "girlfriends"?

2. Emmanuel Èmile Dieudoné Domenech (1825–1874) arrived in Mexico in 1846 and was ordained a priest there in 1848. In 1862, he returned as Maximilian's press attaché and published an account of that experience, *De México a Durango,* and a book of Mexican customs entitled *Le Mexique tel qu'il est* (1867).

3. André Rouillé, "Les images photographiques du monde du travail sous le Second Empire," *Actes de las Recherche en Sciences Sociales* 54 (September 1984), 31.

4. Ibid.

5. Calderón de la Barca, *Life in Mexico,* p. 220.

6. Manuel Payno, *Los bandidos de Río Frío* (Barcelona: M. Bordoy & Cía, 1888).

7. Françoise Reynaud, "Des cris aux petits métiers," introduction to catalog *Petits métiers et types parisiens vers 1900.*

8. Ibid.

9. There are a few publications, such as *Los mexicanos pintados por sí mismos* (1854), mainly illustrated by Hesiquio Iriarte, that describe the full range of Mexican society. In this series of lithographs, people are defined first by their occupation, "popular types" being the most numerous.

10. Weston, *The Daybooks of Edward Weston, I: Mexico,* pp. 73–74.

11. *Estridentismo* was an avant-garde modernist movement, led by Mexican poet Manuel Maples Arce, in which Weston and Modotti briefly participated. It was loosely related to the Italian Futurist movement of the early 1920s.—*Trans.*

12. Weston, *The Daybooks of Edward Weston, I: Mexico,* p. 32.

13. Eisenstein relates in his memoirs how he had to have a white serape made, since there were none in

Mexico. He intended to relate it to traditional Japanese mourning dress.

14. From Sergei Eisenstein, *Beyond the Stars: The Memoirs of Sergei Eisenstein,* ed. Richard Taylor, trans. William Powell (London–Calcutta: British Film Institute Publishing-Seagull Books, 1995), pp. 743–744.

15. "Mexican intellectuals, including painters, writers and educators, are vigorously protesting in Mexico City, too, that the film has been 'Hollywoodized' and is nothing but an 'emasculation and distortion' of the original" ("Eisenstein's Thunder Reverberates," *Art Digest* 8, no. 1 [October 1, 1933], 15).

16. Mariana Yampolsky and Elena Poniatowska, *Estancias del olvido,* p. 91.

17. The dates of Diguet's travels are Baja California (1893–1896); Jalisco and Tepic (1896–1898); San Luis Potosí, Colima, and northern Jalisco (1899–1900); Puebla, Oaxaca, and Tehuantepec (1902–1904); Michoacán and the State of Mexico (1904–1910); and Baja California and Jalisco (1911–1914).

18. D. Bois, "Notice nécrologique sur Léon Diguet," in Léon Diguet, *Les cactacées utiles du Mexique.*

19. "Local industries, shop signs and names, street cries, popular amusements, games of skill for adults, children's toys and games, popular celebrations, charms and amulets, witchcraft, popular divinations, popular medicine, examples of conservatism, votive offerings, religious miscellany, and pamphlets and papers" (Frederick Starr, *Catalogue of a Collection of Objects Illustrating the Folklore of Mexico* [London: Folk-Lore Society, 1899]).

20. James D. Oles, "From 'Modern Mexico' to Mexico's Modernism: Mexican Folk Art on Public Display, 1823–1940," p. 12.

21. Carl Lumholtz, *Los indios del noroeste,* ed. Pablo Ortiz Monasterio.

22. Louis B. Casagrande and Phillips Bourns, *Side Trips: The Photography of Sumner W. Matteson, 1889–1908,* p. 27.

23. Ibid.

24. Cartier-Bresson arrived in Mexico in early 1934, accompanying an expedition assigned to chart the route of the future Pan-American Highway. He had also accepted ethnological assignments from the Musée de l'Homme in Paris.

25. Néstor García Canclini, "Estética e imagen fotográfica."

26. Carlos Monsiváis, "Los testimonios delatores, las recuperaciones estéticas," *La Cultura en México,* supplement, *Siempre!* 1074 (January 5, 1983).

27. James D. Oles, "Paul Strand in Mexico: Capturing an Image for the Folks Back Home," p. 5.

28. Manuel Álvarez Bravo's *Tehuantepec* and Luis Márquez's *Janitzio* were also funded by the Ministry of Public Education as part of the same film project.

29. Robert Stebbins, "Redes," *New Theater* 3, no. 11 (November 1936), 21.

30. Ibid. This quotation by Strand was transcribed from a proposal presented to the Ministry of Public Education.

31. C. A. [Carolina Amor], "Paul Strand, el artista y su obra," *Revista de Revistas* (Mexico City), March 12, 1933, pp. 36–37. Quoted in Calvin Tomkins, *Paul Strand: Sixty Years of Photography,* p. 155. Strand later stated that "I started working in Mexico the minute I crossed the border. It was a continuation of New Mexico although quite different."

32. It was not coincidence that Strand's *Photographs of Mexico* was published on the eve of the opening of the blockbuster exhibition *Twenty Centuries of Mexican Art* at the Museum of Modern Art in New York. A second edition of the portfolio was printed under Strand's supervision and published as *The Mexican Portfolio* in 1967.

33. Letter to Irving Browning, cited in Sarah Greenough, *Paul Strand: An American Vision,* p. 96.

34. Strand abandoned this subterfuge shortly after his trip to Mexico. He found it inconvenient and somewhat unethical. As a result, his approach to portraiture changed substantially. See his interview with Milton Brown in Kaspar Fleishmann, *Paul Strand,* p. 94.

35. Christopher Phillips, "Anton Bruehl," in *Contemporary Photographers,* p. 126.

36. Anton Bruehl, *Mexico.*

37. Cited in "Bruehl's Mexico," *Art Digest,* 8. no. 1 (October 1933), 19.

38. Raquel Tibol, *Episodios fotográficos,* 118.

39. Ibid., p. 119.

40. Agustín Aragón Leiva, "La fotografía y la fotografía en México," *El Nacional* (Mexico City), December 5, 1933.

41. Agustín Aragón Leiva to Seymour Stern, November 19, 1931, Sinclair MSS, I, Box 17, Lilly Library, Indiana University, Bloomington.

42. For more information on Jiménez, see Salvador Albiñana, "Agustín Jiménez," in *Mexicana: Fotografía moderna en México, 1923–1940,* pp. 103–137.

43. Blanco, in *Contemporary Photographers,* ed. Colin Naylor, p. 547.

44. Nacho López, *Los pueblos de la bruma y el sol,* text by Salomón Nahmad, p. 8.

45. More than Manuel Álvarez Bravo, precursors of this kind of hyperaestheticization of poverty are the Ecuadorian Camilo Luzuriaga and, even more so, the Brazilian Sebastião Salgado. This phenomenon can also be seen in cinema and video documentaries, particularly those of Nicolás Echevarría (*Poetas campesinos,* 1980; *El niño Fidencio,* 1983) and Sarah Minter (*Nadie es inocente,* 1986; *Alma punk,* 1991).

46. Not to be confused with Homer Scott, an El Paso photographer who made images along the border during the Mexican Revolution and Pershing incursion, or with Gen. Winfield Scott, who served in the Mexican-American War of 1846–1848. This information was published by Georgina Rodríguez in "Niños desnudos en el Porfiriato," *Luna Córnea* 9 (1996).—*Trans.*

47. Manuel and Lola had their portraits made by the photographer on that occasion. Lola Álvarez Bravo, personal communication.

48. The full Spanish title is Coalición Obrero-Campesina-Estudiantil del Istmo.

49. See Luis González, "Los artífices del cardenismo," in *Historia de la Revolución mexicana,* vol. 14 (Mexico City: El Colegio de México, 1979), p. 45.

50. For more information, see James Oles, *Helen Levitt: Mexico City* (New York: Center for Documentary Studies, Duke University, in association with W. W. Norton and Co., 1997).

51. This is a reference to the title of another book by Salvador Novo, *En defensa de lo usado y otros ensayos* (In Defense of Things Past and Other Essays; Mexico City: Ed. Polis, 1938).—*Trans.*

52. Dorothea Lange's few Mexican images can be found in the Library of Congress in Washington, D.C., in the files of the Farm Security Administration.

53. This project is much different from the news photos of *braceros* taken by the Hermanos Mayo in Mexico City in the 1940s and recently compiled in John Mraz and Jaime Vélez Storey, *Uprooted: Braceros in the Hermanos Mayo Lens.*

54. See also *Mixtecos,* text by Eduardo Vásquez Martín (Mexico City: Editorial Grupo Desea, 1994).

9. Counterpoint

1. *American Flag* (October 1846).

2. The Armour Smith Collection contains twelve daguerreotypes, now housed in the Beinecke Rare Book and Manuscript Library at Yale University. In 1981, the Amon Carter Museum in Fort Worth, Texas, acquired the thirty daguerreotypes found in Connecticut. A portrait of Major John M. Washington, probably taken in Saltillo at the same time as a related portrait in the Amon Carter Museum, is preserved in the Photo Archives of the Palace of the Governors, Museum of New Mexico, Santa Fe. For more information, see Sandweiss et al., *Eyewitness to War.*

3. Sandweiss found letters written by the soldiers of the occupation in which they mention having been photographed by a Yankee daguerreotypist (ibid., p. 57).

4. Pedro Vander Linden, "Cuerpo médico militar," *Diario de Gobierno,* April 30, 1847.

5. "Adelanto el daguerrotipo," *El Monitor Republicano,* October 24, 1849.

6. Robert Taft, *Photography and the American Scene: A Social History, 1839–1889,* p. 224. According to Taft, these daguerreotypes were so few in number that they had no impact on later war photography.

7. Beaumont Newhall, *The History of Photography,* p. 67.

8. The preceding section on daguerreotypists in the Mexican-American War of 1847 is translated from Casanova and Debroise, *Sobre la superficie bruñida de un espejo.*

9. "Captura y ejecución del emperador Maximiliano," *La Revista Universal,* September 23, 1867, p. 2. Cited in Claudia Canales, "A propósito de una investigación sobre la historia de la fotografía en México," *Antropología e Historia, Boletín del Instituto Nacional de Antropología e Historia* III, no. 23 (July–September 1978), 67.

10. Patricia Stevens Lowinsky located a photograph in a private collection in the United States in which the bloody clothing appears, piled on a table in a medical examining room, accompanied by a jar containing some organ, possibly Maximilian's brain.

11. Aaron Scharf, *Art and Photography.* Juliet Wilson Bareau has qualified Scharf's statements in her meticulous reconstruction of the diffusion of these images throughout Europe. See Juliet Wilson Bareau, *Manet: The Execution of Maximilian* (Lon-

don: National Gallery Publications, in association with Princeton University Press, 1992).

12. Gilbert Gimon, "Le 19 juin 1867 . . . François Aubert couvre l'événement," *Prestige de la Photographie* 3 (December 1977).

13. Scharf, *Art and Photography.*

14. Ibid.

15. The J. Ballesca Company, Ezequiel Carrasco, and César A. Estrada presented commemorative albums; Ángel Echavarriete proposed to make envelopes with photographic portraits of famous patriotic figures; Manuel Ramos compiled an album about the inauguration of the National Mental Hospital of La Castañeda (Archivo General de la Nación, Propiedad Pública division, 1909–1910).

16. Faustino Mayo, personal interview. The use of compact 35mm cameras by amateur photographers prior to this date has been documented. The first German 35mm Leicas were introduced in 1930: Edouard Tissé, Eisenstein's cinematographer, traded one of his two Leicas while in Mérida, on April 31 of that year. But the diffusion of these "jewels" among Mexican photojournalists took place quite a bit later.

17. Evelyne Desbois, "La vie sur le front de la mort," *La Recherche Photographique* 6 (June 1989), 41.

18. André Rouillé, "Un combat photographique en Crimée," *La Recherche Photographique* 6 (June 1989), 13–18.

19. Quoted in Anita Brenner and George R. Leighton, *The Wind That Swept Mexico,* p. 295.

20. Paul J. Vanderwood and Frank N. Samponaro, *Border Fury: A Picture Postcard Record of Mexico's Revolution and U.S. War Preparedness, 1910–1917,* p. 269, note 40.

21. Brenner and Leighton, *The Wind That Swept Mexico,* pp. 294–295.

22. Vanderwood and Samponaro, *Border Fury,* p. 13.

23. Brenner and Leighton, *The Wind That Swept Mexico,* p. 295.

24. Humberto Musacchio, "Fotografía," in *Diccionario enciclopédico de México.*

25. Aurelio de los Reyes has carefully analyzed the images of Villa distributed by the press. A number of these are actually film "stills" made by the same photographers. See Enrique Krauze and Aurelio de los Reyes, *Francisco Villa, entre el ángel y el fierro* (Mexico City: Fondo de Cultura Económica, 1987); and *Con Villa en México: testimonios de camerógrafos norteamericanos en la revolución, 1911–1916* (Mexico City: UNAM, 1992).

26. Vanderwood and Samponaro, *Border Fury,* pp. 94–95.

27. Raoul Walsh, *Each Man in His Time: The Life Story of a Director.*

28. Antonio Rodríguez, "Del códice al rotograbado: La ilustración de la noticia en la prensa de Mexico/3," *Mañana* 203 (Mexico City), July 19, 1947.

29. Teodoro Torres, *Periodismo* (Mexico City: Botas, 1937), p. 59.

30. One of the Magnum photographers who worked in Mexico immediately after the war was Robert Capa, then using the name Andrei Friedman, who reported on Manuel Ávila Camacho's presidential campaign.

31. Hermanos Mayo was an association formed by the Spanish photographers Cándido Souza, Francisco Souza, Julio Souza, Pablo Souza, and Faustino Souza, who came together under this name to commemorate the political repression of May 1, 1936, in Madrid. They arrived in Mexico in 1939 and for many years worked for the newspaper *El Día.* Francisco, the leader of the group, died in an airplane accident in 1949. For more information, see *Foto Hnos. Mayos* (Valencia: IVAM, 1992).

32. *Casasola, un fotógrafo desconocido.*

33. Davis had obtained the concession from Díaz's government for the distribution of newspapers and magazines in the train stations. His agency, Sonora News, also marketed photographs by Waite, Briquet, and others in the form of postcards and stereographs. When the Revolution broke out, this network of correspondents allowed him to serve as a link between journalists and photographers. This business did not particularly interest him, however, and he soon turned to selling crafts and antiques.

34. Fátima Fernández Christlieb, *Los medios de difusión masiva en México,* p. 20.

35. Héctor Ignacio Yliescas y de los Santos and Ezequiel Álvarez Tostado Nuño, "Biografía del señor Ezequiel Álvarez Tostado Alonso Ortiz, 'Tostado grabador.' "

36. Flora Lara Klahr and Marco Antonio Hernández presented a selection of this material at the Archivo General de la Nación in 1989.

37. Rodríguez, "Del códice al rotograbado."

38. "It is said that it was pressure from the Cárdenas government that limited its existence to a few issues. The story is based on a verifiable fact, the appearance in its pages of the President . . . in his

underwear, enjoying a dip in the river. Yet Cárdenas never assumed an untouchable position for himself, nor were any of his other attitudes toward the press . . . compatible with the image of a governor and government that opposed the free expression of ideas. Nevertheless, the fact remains that *Rotofoto* is a museum piece" (Miguel Ángel Granados Chapa, "La imagen en la industria periodística mexicana," in *El poder de la imagen y la imagen del poder,* p. 21).

39. Madre Conchita was a leader of the conservative Cristero movement—*Trans.*

40. They were photographed swimming naked together in a pool, in pictures with unambiguous homosexual overtones.

41. Carlos Monsiváis, "Pagés Llergo defendió la tolerancia y auspició la libertad de expresión," *Proceso* (Mexico City), January 5, 1990.

42. Rodríguez, "Del códice al rotograbado."

43. Antonio Almanza, Alfonso Carrillo, Antonio Carrillo, Antonio Carrillo, Jr., Agustín Casasola, Gustavo Casasola, Ismael Casasola, Ismael Casasola, Jr., Mario Casasola, Benigno Corona, Anselmo Delgado, Enrique Delgado, Enrique Díaz, Juan Guzmán, Julio León, Manuel Madrigal, Cándido Mayo, Faustino Mayo, Francisco Mayo, José Mendoza, Hugo Moctezuma, Tomás Montero Torres, Aurelio Montes de Oca, Manuel Montes de Oca, Jenaro Olivares, Agustín Pérez, Juan Manuel Ramírez, José Ríos, Fernando Sosa, Antonio Velázquez, Armando Zaragoza, Ignacio Zavala, and Luis Zendejas.

44. "A better way to give this orientation is by a series of photographs, which when properly presented approach the cinema. This is the richest manner of giving photographs significance, for each picture reinforces the other. It is, I believe, the logical method of presentation. It is more—it is the logical approach to the medium" (Beaumont Newhall, "Documentary Approach to Photography," *Parnassus* [March 1938], 6).

45. Antonio Rodríguez, "Homenaje a los fotógrafos de prensa," in *Mañana.* The copy of this catalog consulted was given to Francisco Reyes Palma by Rodríguez and includes his handwritten notes.

46. Ibid.

47. Ibid.

48. Ibid.

49. Elena Poniatowska, prologue to Héctor García, *México sin retoque,* p. 8.

50. Nacho López, "Arte fotográfico de Nacho López: mi punto de partida," *Revista de Bellas Artes* 30 (1976), 23.

51. Ibid.

52. Antonio Rodríguez, "Nacho López, fotógrafo de la vida," *Excélsior,* September 5, 1989.

53. Photohistorian scholar John Mraz has researched the press of that period in order to study the original context for the reception of these images. His work has shed a great deal of light on the production of the Hermanos Mayo, Héctor García, and Nacho López and has made it possible to correct much misinformation. See John Mraz, *La mirada inquieta: nuevo fotoperiodismo mexicano: 1976–1996.*

54. The titles are taken from Nacho López, *Yo, el ciudadano.* There are variants in other publications.

10. Danzón

1. Manuel Álvarez Bravo, personal conversation.

2. Lola herself long asserted she was born in 1907, the year of birth cited in all publications (including my previous work). Documents in her archive, now in the possession of her son, however, seem to indicate she was somewhat older and may have been born in 1898 or 1900 (which would have made her older than her husband, Manuel). Further research will be necessary to confirm the actual date.

3. Manuel Álvarez Bravo, personal conversation.

4. Zabludowsky, "¿Ha existido la fotografía artistica mexicana?"

5. Manuel Álvarez Bravo eventually deposited this collection at the Museo de Arte Moderno in Mexico City.

6. *El evangelista de Santo Domingo* is dated 1930 in the catalog of the exhibition of Manuel Álvarez Bravo's work at the Musée d'Art Moderne de la Ville de Paris (MAMVP, 1986), 1920s in the show at the Corocoran Gallery in Washington (CGAW, 1978), and early 1930s in the Museum of Modern Art exhibition catalog (MOMA, 1997). These three catalogs are the most complete and accurate publications on the work of Manuel Álvarez Bravo, and those to which I gave priority in preparing this study. They contain some variations in titles and, to a lesser degree, dates.

7. Mildred Constantine, *Tina Modotti: A Fragile Life,* p. 113.

8. She made two other films under the name Tina de L'Abrie: *Riding with Death* (Jacquard, 1921) and *I Can Explain* (Baker, 1922).

9. Antonio Saborit, "Imágenes de Tina Modotti."

10. Tina began another relationship, almost simultaneously, with Johan Hagemeyer. See Christiane Barckhausen-Canale, *Verdad y leyenda de Tina Modotti*, pp. 65–68.

11. Tina traveled to Mexico with works by Robo, Weston, Arnold Schroder, Margarethe Mather, and Jane Reece. See Rafael Vera de Córdoba, "Las fotografías como verdadero arte," *El Universal Ilustrado*, March 13, 1922; and Barckhausen-Canale, *Verdad y leyenda de Tina Modotti*, pp. 74–76.

12. Lola Álvarez Bravo, personal communication.

13. Edward Weston, *The Daybooks of Edward Weston, I: Mexico*, ed. Nancy Newhall, p. 68.

14. Ibid., p. 25.

15. Ibid., p. 26.

16. Ibid., p. 99.

17. Published in *La Antorcha* 7 (November 15, 1924).

18. Weston exhibited two more times that year. On April 12, he showed his work at the Estridentista group's El Café de Nadie, in an event organized by Manuel Maples Arce, Germán Cueto, and Jean Charlot. In Guadalajara in late April, he exhibited forty photographs—thanks to Federico Marín—five of which were acquired by Governor José Guadalupe Zuno, a key figure in the Centro Bohemio of that city.

19. Despite the assertions of Mildred Constantine and Amy Stark, there is no direct evidence that Tina Modotti made photographs before her arrival in Mexico.

20. Amy Stark, "Letters from Tina Modotti to Edward Weston," *Archive* 22 (January 1986), 18.

21. Weston, *The Daybooks of Edward Weston, I: Mexico*, p. 101.

22. Constantine, *Tina Modotti: A Fragile Life*, p. 112; and Manuel Álvarez Bravo, personal conversation.

23. The photograph is described as item 205 in *Photographs* (auction catalog: New York: Sotheby's, April 7, 1988). It is said to have been removed from this mount by the purchaser.—*Trans.*

24. Titles for Weston's and Modotti's works here are taken from Amy Conger, *Edward Weston: Photographs from the Collection of the Center for Creative Photography* (Tucson: University of Arizona, Center for Creative Photography, 1992); and Sarah Lowe, *Tina Modotti: Photographs* (New York: Abrams/Philadelphia Museum of Art, 1995).

25. Weston, *The Daybooks of Edward Weston, I: Mexico*, p. 21.

26. Ibid., p. 55.

27. Ibid., p. 66.

28. Ibid., p. 157.

29. Ibid., p. 188.

30. This image was entitled *Juego de papel* in the catalog of the Musée de l'Art Moderne exhibit (MAMVP, 1986) and *Papel para máquina* in the Corcoran catalog (CGAW, 1978), which also included works captioned *Juego de papel (1)*, *Juego de papel (2)*, and *Cáscara de mandarina*, also taken in Oaxaca. Manuel Álvarez Bravo claims to have destroyed, in the 1940s, almost all his negatives from that period.

31. The title appeared as *Caminante, Oaxaca* in MAMVP (1986).

32. Lola Álvarez Bravo, *Recuento fotográfico*.

33. Up to that time, José María Lupercio, official photographer for the National Museum, had been charged with that task (between approximately 1925 and 1926). He photographed Diego Rivera's murals on the ground floor of the Ministry of Public Education; Tina did the upper story.

34. Tina went to visit her ailing mother in San Francisco in December 1925 and remained there until March 1926.

35. According to an unpublished article by Carleton Beals, Modotti and Guerrero's affair lasted until the mid-1930s, when the painter went to live in Moscow. Carleton Beals, "Tina Modotti, Communist Agent" (1942), Carleton Beals Collection (Box 78), Special Collections, Mugar Memorial Library, Boston University.

36. This third and little-known variation was published on the cover of the magazine *New Masses* in 1928. See Barckhausen-Canale, *Verdad y leyenda de Tina Modotti*, p. 151. Modotti had previously tried this type of still-life when she photographed objects of popular art for Anita Brenner's book: a composition with sarape and polychromed gourd from Olinalá was published as *Pez-calabaza* (Fish-Gourd) in *El Universal Ilustrado* in 1926.

37. One of Modotti's friends gave her personal stationery with *Bandolier, Corn, and Guitar* lightly reproduced on each page; Tina only used it, however, when nothing else was available on the boat that carried her into exile.

38. Cited in Constantine, *Tina Modotti: A Fragile Life*, p. 113.

39. Letter 27.4 (June 25, 1927), reprinted in Stark, "Letters from Tina Modotti to Edward Weston."

40. Letter 27.5 (July 4, 1927), in ibid. These images may have influenced the series of paintings—expressive forms of cactuses, roots, and radishes—that Diego Rivera began making around 1930–1931.

41. This could be the mysterious package that Amy Stark attempts to identify. See Letter 28.3 (September 18, 1928), in ibid.

42. Edward Weston, letter to Manuel Álvarez Bravo, April 30, 1929, published in *Manuel Álvarez Bravo*, prepared by Fred R. Parker, p. 40; reprinted in Susan Kismaric, *Manuel Álvarez Bravo* (New York: Museum of Modern Art, 1997), p. 18.

43. Weston, *The Daybooks of Edward Weston, II: California,* ed. Nancy Newhall, p. 119.

44. See *Las sábanas* (The Sheets, 1933), *La buena fama durmiendo* (Good Reputation Sleeping, 1939), *Tentaciones en la casa de Antonio* (Temptations at Antonio's House, 1970), etc.

45. "Interesante exposición fotográfica," *El Universal Ilustrado,* August 25, 1928.

46. Letter 28.3, reprinted in Stark, "Letters from Tina Modotti to Edward Weston."

47. Carleton Beals, "Tina Modotti," *Creative Art* 4, no. 2 (February 1929), xlix, 1.

48. These activities were supported by the Soviet Embassy in Mexico; she also took photographs of visitors and events there.

49. See Barckhausen-Canale, *Verdad y leyenda de Tina Modotti.*

50. Tina Modotti, "La fotografía debe ser fotografía y nada más," *Mexican Folkways* 5, no. 4 (October–December, 1929), 196–198.

51. The photograph referred to is *Interior of Church,* reproduced in Constantine, *Tina Modotti: A Fragile Life,* between pages 114 and 115.

52. Weston, *The Daybooks of Edward Weston, I: Mexico,* p. 69.

53. The only known vintage copy of this image is in the Comitato Tina Modotti in Trieste, in the Vittorio Vidali collection. The original negative apparently has not been found (although a copy negative exists at the Fototeca del INAH). It is reproduced in Barckhausen-Canale, *Verdad y leyenda de Tina Modotti,* with the title *Contrastes.*

54. Barchausen-Canale, *Verdad y leyenda de Tina Modotti,* p. 220. The "mosaic" format may have been the idea of the magazine's editor.

55. According to Carleton Beals, Modotti and Vidali established their relationship before this ("Tina Modotti, Communist Agent").

56. Modotti worked in Berlin with the photographer Lotte Jacobi and exhibited at Jacobi's studio. She also published a few of her Mexican photographs in *Arbeiter Fotografie.* According to Barckhausen-Canale, she gave up photography shortly after she went on to Moscow, partly due to the competition she found in Berlin. Above all, however, her activities within the upper echelons of International Red Aid occupied all her time and energy. See Barckhausen-Canale, *Verdad y leyenda de Tina Modotti,* p. 211. Modotti published a pamphlet entitled "Photography as a Weapon of Political Agitation of the IRA" in *Mopr* (March 1932), the organ of International Red Aid. The American historian Betsy Cramer recently found, in Moscow, photographs of Modotti taken in Madrid during the Spanish Civil War.

57. Reprinted as Letter 25.4 in Stark, "Letters from Tina Modotti to Edward Weston," pp. 39–40.

58. With few exceptions—such as the work of Amy Stark Rule and Raquel Tibol, Modotti's work has been studied less by historians or critics of photography than by literary historians (Antonio Saborit) or amateurs who have taken a somewhat sentimental and subjective approach to her life (Constantine and even Barckhausen-Canale). However, a new generation of historians of photography (notably Sarah Lowe) has begun to adopt a more critical approach to Modotti's work.

59. Lola Álvarez Bravo, personal conversation. Manuel Álvarez Bravo also remembers this anecdote.

60. Manuel Álvarez Bravo, personal conversation.

61. Alex Castro, in *Manuel Álvarez Bravo,* documentation by Frances Fralin, essays by Alex Castro and Jane Livingston, p. 19.

62. Sponsored by the Fundación Cultural Televisa (the cultural foundation of the Televisa broadcasting network), this project was abandoned after several years. The photography collection compiled by Manuel Álvarez Bravo was eventually housed in the Department of Photography of the Centro Cultural/ Arte Contemporáneo. See the three-volume catalog: *Luz y tiempo* (Mexico City: Fundación Cultural Televisa, 1995).

63. Lola Álvarez Bravo, personal communication.

64. This photograph was taken in Acapulco in 1949, on the same afternoon that Lola Álvarez Bravo learned of the death of her friend Salvador Toscano in an airplane accident. Thus, the photograph is sometimes known as *Homage to Salvador Toscano.*

11. Fantasía

1. Joan Fontcuberta, in his study of the photomontages of the Catalan artist Josep Renau, clearly defined the difference between photomontage and photocollage: "Photocollage . . . is a poetically pure technique of association of elements, in which the act of association is more important than the elements themselves . . . Photomontage, on the other hand, includes a rationality that directs interest toward the semantic content of the elements employed . . . Photomontage . . . creates a rigorous photographic space out of photographic elements taken from different spaces" (*Josep Renau, fotomontador,* p. 12).

2. *Flor y anillo* appears in the Musée d'Art Moderne de la Ville de Paris exhibition catalog (1986); *Lucía* is reproduced only (at this writing) in the catalog published by the Museum for Photographic Arts of San Diego, California (1990). Another X-ray image, *Mano que dá* (Giving Hand, 1940), is included in the catalog to the 1997 exhibition at MOMA.

3. Virginia Stewart, *Forty-five Contemporary Mexican Artists,* p. 78.

4. Ibid., p. 80. For more information on Amero, see Horacio Fernández, "Emilio Amero," in *Mexicana: Fotografía moderna en México, 1923–1940* (Valencia: IVAM Institut Valencià d'Art Modern, 1998), pp. 162–193.

5. Tibol, *Episodios fotográficos,* pp. 247–266.

6. The montage uses images of a strike by the CTM (Comité de Trabajadores Mexicanos) in support of railroad workers illustrated in *Futuro, Revista Popular* 3, no. 5, (July 1936).

7. *La huelga eléctrica, July 16–25, 1936,* published in *Futuro, Revista Popular* 3, no. 6 (August 1936).

8. "Se inauguró la Primera Exposición Femenina en ésta," *El Jalisciense* (May 11, 1935). Besides Lola Álvarez Bravo, the participants included Regina Pardo, Gloria Urrueta, Esperanza Muñoz, Aurora Ramos, Francisca Sánchez, Elena Huerta, Celia Arredondo, and Isabel de Carrio. Apparently, the organizers planned to circulate the show, but there is no information to document that it was shown in any other city.

9. Lola Álvarez Bravo, personal communication.

10. She was not the only Mexican artist commissioned by local industrial patrons: Diego Rivera made a poster for Aceros Monterrey; Jorge Gonzáles Camarena, Carlos Mérida, and Agustín Jiménez worked for Cementos Tolteca, etc.

11. For further comparisons between photographs and prints in the work of the Taller de Gráfica Popular, see Helga Prignitz, *TGP: Ein Grafiker-Kollektiv in Mexico von 1937–1977.*

12. Laurence Hurlburt, "David Alfaro Siqueiros's 'Portrait of the Bourgeoisie,'" *Art Forum* 15, no. 6 (February 1977), p. 42.

13. Ibid. p. 41.

14. David Alfaro Siqueiros, cited in ibid.

15. Tibol, *Episodios fotográficos,* p. 39. *Prostrado pero no vencido* actually dates from 1939, but Siqueiros may have used a photograph here as well.

16. Marta Gili, in *Contemporary Photographers,* ed. Colin Naylor, p. 847.

17. Herrera, *Frida: A Biography of Frida Kahlo,* pp. 173–175.

18. English translation by Stella de Sá Rego.

19. José Emilio Pacheco, *Irás y no volverás: Poemas 1969–1972,* 2nd ed. (Mexico City: Ediciones Era, 1980), p. 29.

Bibliography

Aaland, Mikkel. "Mexico's Gentle Giant." *Darkroom Photography* (Marlon, Ohio) 4, no. 7 (November 1982).

Abbas. *Retorno a Oapán.* Río de Luz. Mexico City: Fondo de Cultura Económica, 1986.

Aceves Piña, Gutierre. *Tránsito de angelitos, iconografía funeraria infantil.* Mexico City: Museo de San Carlos, 1988.

Ades, Dawn. *Photomontage.* New York–London: Thames and Hudson, 1976.

Aguilera, Eduardo. "Manuel Carrillo, un fotógrafo olvidado." *El Día* (Mexico City), August 27, 1989.

Albiñana, Salvador. "Agustín Jiménez." In *Mexicana: Fotografía moderna en México, 1923–1940,* pp. 103–137. Valencia: IVAM Institut Valencià d'Art Modern, 1998.

Alfaro Siqueiros, David. "Una trascendente labor fotográfica." *El Informador* (Guadalajara), April 9, 1925.

Altamirano, Ignacio Manuel. "Revistas literarias de México." *La Iberia* (June–August 1868). Compiled by José Luis Martínez in *La literatura nacional,* vol. 1. Mexico City: Porrúa, 1949.

Altúzar, Mario Luis. *Agustín Víctor Casasola, el hombre que retrató una época, 1900–1938.* Mexico City: Editorial Gustavo Casasola, 1988.

Álvarez Bravo, Lola. *Escritores y artistas de México.* Mexico City: Fondo de Cultura Económica, 1982.

———. *Recuento fotográfico, entrevistas de Luis Zapata, José Joaquín Blanco y Manuel Fernández.* Mexico City: Penélope, 1982.

Álvarez Bravo, Manuel. *303 photographies.* Paris: Musée d'Art Moderne de la Ville de Paris, Mois de la Photo, Direction des Affaires Culturelles, 1986.

———. *Dreams, Visions and Metaphors: The Photographs of Manuel Álvarez Bravo.* Text by Nissan N. Perez. Jerusalem: Israel Museum, 1983.

———. *M. Álvarez Bravo.* Documentation by Frances Fralin, essays by Alex Castro and Jane Livingston. Boston: David R. Godine, 1978.

[Based upon an exhibition prepared by the Corcoran Gallery of Art, Washington, D.C.]

———. *Manuel Álvarez Bravo.* Coord. José-Miguel Ullán. Madrid: Ministerio de Cultura, Dirección General de Bellas Artes y Archivos, 1985.

———. *Manuel Álvarez Bravo.* Text by Denis Roche. Paris: Photogalerie, 1976.

———. *Manuel Álvarez Bravo.* Essay by A. D. Coleman. New York: Aperture, 1987.

———. *Manuel Álvarez Bravo.* Catalog prepared by Fred R. Parker. Pasadena: Pasadena Art Museum, 1971.

———. *Revelaciones: The Art of Manuel Álvarez Bravo.* Essay by Arthur Ollman. San Diego: Museum of Photographic Arts, 1990.

———. *Selección retrospectiva.* Mexico City: Centro Cultural/Arte Contemporáneo, 1989.

"Al verte así: arte fotográfico de Jesús Martínez." *Revista de Bellas Artes* (Mexico City) 22 (1975).

Andrade, Yolanda. *Los velos transparentes, las transparencias veladas.* Prologue by Carlos Monsiváis. Villahermosa: Gobierno del Estado de Tabasco, 1988.

Apollonio, Umbro. "Fotografía/Pintura." *Artes Visuales* (Mexico City) 12 (October–December 1976).

Aragón Leiva, Agustín. "La fotografía y la fotografía en México." *El Nacional* (Mexico City), December 5, 1933.

Archives de la Commission Scientifique du Mexique. 4 vols. Paris: Imprimerie Impériale, 1865.

Arriola, Enrique. *La rebelión delahuertista.* Colección Memoria y Olvido: Imágenes de México. Mexico City: Martín Casillas, 1982.

"Arte fotográfico de Colette Urbajtel, El." *Revista de Bellas Artes* (Mexico City) 28 (1976).

"Arte fotográfico de Jesús Sánchez Uribe, El." *Revista de Bellas Artes* (Mexico City) 21 (1975).

"Arte fotográfico de Jorge Noriega, El." *Revista de Bellas Artes* (Mexico City) 24 (1975).

"Arte fotográfico de Lázaro Blanco, El." *Revista de Bellas Artes* (Mexico City) 23 (1975).

"Arte fotográfico de Manuel Álvarez Bravo, El." *Revista de Bellas Artes* (Mexico City) 19 (1975).

"Arte fotográfico de Rafael Doniz." *Revista de Bellas Artes* (Mexico City) 20 (1975).

"Arte fotográfico de Rafael López Castro: el mercado de Puente de Fierro." *Revista de Bellas Artes* (Mexico City) 25 (1976).

"Arte fotográfico de Renata von Hanffstengel: Los Conventos, El." *Revista de Bellas Artes* (Mexico City) 26 (1976).

Ayres, Atlee B. *Mexican Architecture: Domestic, Civil and Ecclesiastical.* New York: William Helbrun, Inc., 1926.

Baird, Joseph Armstrong. *The Churches of Mexico, 1530–1810.* Photos by Hugo Rudinger. Berkeley: University of California Press, 1962.

Banta, Melissa, and Curtis M. Hinley. *From Site to Sight: Anthropology, Photography, and the Power of Imagery.* Cambridge, Mass.: Peabody Museum Press, 1986.

Barckhausen-Canale, Christiane. *Verdad y leyenda de Tina Modotti.* Havana: Casa de las Américas, 1988.

Barthes, Roland. *La chambre claire: Note sur la photographie.* Paris: Cahiers du Cinéma/ Gallimard/Seuil, 1980.

Baxter, Sylvester. *Spanish Colonial Architecture in Mexico.* Photographic plates by Henry Greenwood Peabody; plans by Bertram Grosvernor Goodhue. Boston: J. B. Millet, 1901.

Bayona, Pedro. *México, imagen de una ciudad.* Text by Salvador Novo. Mexico City: Fondo de Cultura Económica, 1967.

Beacham, Hans. "Mexican People, Mexican Places." *Texas Quarterly.* 11, no. 1 (Spring 1958).

Beals, Carleton. "Tina Modotti." *Creative Art* 4, no. 2 (February 1929).

Beceyro, Raúl. *Ensayos sobre fotografía.* Mexico City: Arte y Libros, 1978.

Beezley, William H. "Shooting the Mexican Revolution." *Americas* 28, nos. 11–12 (November 1976).

Benjamin, Walter. "A Short History of Photography." In *Classic Essays on Photography,* ed. Allan Trachtenberg. New Haven: Leete's Island Books, 1980.

———. "The Work of Art in the Age of Mechanical Reproduction." In *Illuminations,* ed. Hannah Arendt. New York: Schocken, 1969.

Berger, John. *L'Air des choses.* Paris: François Maspero, 1979.

———. *Modos de ver.* Barcelona: Gustavo Gili, 1974.

———. *The Sense of Sight.* New York: Pantheon Books, 1985.

Billeter, Erika. *Fotografie Lateinamerika von 1860 bis heute.* Bern: Museo Español de Arte Contemporáneo: Dirección General de Bellas Artes, Archivos y Bibliotecas, 1982.

Bishop, William. "Bravo Reserve." *Creative Camera* 231 (March 1984).

Blanco, José Joaquín. *Empezaba el siglo en la ciudad de México.* Colección Memoria y Olvido: Imágenes de México. Mexico City: Martin Casillas, 1983.

———. *Los mexicanos se pintan solos.* Mexico City: Pórtico de la Ciudad de México, 1991.

Blanco, Lázaro. "Berenice Kolko." In *Contemporary Photographers,* ed. Colin Naylor. Chicago: Saint James Press, 1988.

———. *Luces y tiempos.* Prologue by Guillermo Samperio. Río de Luz. Mexico City: Fondo de Cultura Económica, 1987.

Bolton, Richard (ed.). *The Context of Meaning: Critical Histories of Photography.* Cambridge, Mass.: MIT Press, 1989.

Bourdieu, Pierre. *La fotografía, un arte intermedio.* Mexico City: Nueva Imagen, 1979.

Brehme, Hugo. *Así era . . . México: Colección Juan Manuel Casasola.* Mexico City: Larousse, 1978.

——— (photographs). *Banco Nacional de México.* Mexico City: Banco Nacional de Mexico City, 1960.

———. *México pintoresco.* Mexico City: published by Hugo Brehme, 1923.

Brenner, Anita. "Arte y mecánica: Edward Weston nos muestra nuevas modalidades de su talento." *Revista de Revistas* (Mexico City) 16, no. 804 (October 4, 1925).

Brenner, Anita, and George R. Leighton. *The Wind That Swept Mexico.* Austin: University of Texas Press, 1971. [1st ed. 1943.]

Brigandi, Phillip, Jr. "Phillip Brigandi: Keystone Photographer." *California Museum of Photography Bulletin* 11, no. 3 (1983).

Brooks, Reva. *Fotografías.* Mexico City: Instituto Nacional de Bellas Artes, 1970.

Bruehl, Anton. *Mexico.* New York: Delphic Studios, 1933.

———. *Photographs of Mexico.* Text by Sally Lee Woodall. New York: Camera Publishing Corp., 1945.

"Bruehl's Mexico." *Art Digest* 8, no. 1 (October 1933).

Brunet, Roger. "Réévaluation des paysages." In *Paysages.* Photographie–La Mission, Photographique de la DATAR. Paris: Hazan, 1985.

Bustarret, Claire. "Autobiographie photographique de Léon Méhédin." *La Recherche Photographique* (Paris) 1 (October 1986).

C. A. [Carolina Amor]. "Paul Strand, el artista y su obra." *Revista de Revistas* (Mexico City), March 12, 1933.

Cabada, Juan de la. Prologue to *Héctor García, árbol de imágenes.* Mexico City: Museo de Arte Moderno, 1979.

Calderón de la Barca, Madame (Frances Erskine Inglis). *Life in Mexico.* New York: E. P. Dutton and Co., 1931.

Canales, Claudia. "A propósito de una investigación sobre la historia de la fotografía en México." *Antropología e Historia, Boletín del Instituto Nacional de Antropología e Historia* (Mexico City) III, no. 23 (July–September 1978).

———. *Romualdo García: un fotógrafo, una ciudad, una época.* Guanajuato–Mexico City: Museo Regional de la Alhóndiga de Granaditas/Instituto Nacional de Antropología e Historia, 1980.

Cancian, Frank. *Another Place: Photographs of a Maya Community.* San Francisco: Scrimshaw Press, 1974.

Cardoza y Aragón, Luis. "Light and Shadow, Manuel Álvarez Bravo Photographer." *Mexican Art and Life* 6 (April 1939).

Casaballe, Armando B., and Miguel Ángel Cuarterolo. *Imágenes del Río de la Plata: Crónica de la fotografía rioplatense, 1840–1940.* Buenos Aires: Editorial del Fotógrafo, 1983.

Casagrande, Louis B., and Phillips Bourns. *Side Trips: The Photography of Sumner W. Matteson, 1889–1908.* Milwaukee: Milwaukee Public Museum and Science Museum of Minnesota, 1983.

Casanova, Rosa. "Usos y abusos de la fotografía liberal: ciudadanos, reos y sirvientes, 1851–1880." *La Cultura en México* (Mexico City) supplement, *Siempre!* 1639, November 21, 1984.

Casanova, Rosa, and Olivier Debroise. "Fotógrafo de cárceles: usos de la fotografía en las cárceles de la ciudad de México en el siglo XIX." *Nexos* (Mexico City) 119 (November 1987).

———. *Sobre la superficie bruñida de un espejo: Fotógrafos del siglo XIX.* Río de Luz. Mexico City: Fondo de Cultura Económica, 1989.

Casanovas, Martí. "Las fotos de Tina Modotti: El anecdotismo revolucionario." *¡30-30! Órgano de los Pintores Mexicanos* (Mexico City) 45 (July 1928).

Casasola, Agustín Víctor. *Álbum histórico gráfico: contiene los principales sucesos acaecidos durante las épocas de Díaz, De la Barra, Madero, Huerta, Carvajal, Constitucionalista, la Convención, Carranza, De la Huerta y Obregón.* Selection and photographs by Agustín V. Casasola and sons; text by Luis González Obregón and Nicolás Rangel. 15 vols. Mexico City: n.p., 1921.

———. *Historia gráfica de la Revolución mexicana.* 2nd ed. Mexico City: Trillas, 1973.

Casasola, Gustavo. *Biografía ilustrada de don Venustiano Carranza.* Mexico City: Editorial Gustavo Casasola, 1974.

———. *Biografía ilustrada del general Álvaro Obregón.* Mexico City: Editorial Gustavo Casasola, 1975.

———. *Biografía ilustrada del general Emiliano Zapata.* Mexico City: Editorial Gustavo Casasola, 1975.

———. *Biografía ilustrada del general Lázaro Cárdenas.* Mexico City: Editorial Gustavo Casasola, 1975.

———. *Biografía ilustrada del general Plutarco Elías Calles.* Mexico City: Editorial Gustavo Casasola, 1975.

———. *Hechos y hombres de México: anales gráficos de la historia militar de México, 1810–1980.* Mexico City: Editorial Gustavo Casasola, 1980.

Casasola, Gustavo, and Piedad Casasola. *Monografía de la Basílica de Santa María de Guadalupe.* Mexico City: Editorial Gustavo Casasola, 1953.

Casasola, Ismael. *La caravana del hombre: reportaje*

fotográfico. Text by José Revueltas and Victoria Novelo. Puebla: Universidad Autónoma de Puebla/Fototeca del Instituto Nacional de Antropología e Historia, 1986.

Casasola, Juan Manuel. *México . . . los de ayer: Colección Juan Manuel Casasola.* Photographs by Hugo Brehme, C. B. Waite, La Rochester, et al. Mexico City: Larousse, 1978.

Casasola, un fotógrafo desconocido. Galería Latino-americana. Havana: Casa de las Américas, 1984.

Castellanos, Alejandro. "La fotografía mexicana en el extranjero." *México en el mundo de las colecciones de arte.* Mexico Contemporáneo 2. Mexico City: El Gobierno de la República, 1994.

Castro, Rosa. "Hablan a *Hoy* los ases de la fotografía." *Hoy* (Mexico City), January 6, 1951.

Charnay, Claude Désiré. *Le Mexique, 1858–1861: souvenirs et impressions de voyage.* Ed. Pascal Mongne. Paris: Éditions du Griot, 1989.

———. *Viaje a Yucatán a fines de 1886.* Trans. Francisco Cantón Rosado. Cuadernos Fondo Editorial de Yucatán. Mérida: Fondo Editorial de Yucatán, 1978.

Chellet Díaz, Eugenio. *Instante recobrado.* Illustrations by Gilberto Aceves Navarro, Víctor Chellet, Guillermo Ceniceros; photographs by Lourdes Grobet. Mexico City: Costa-Amic, 1978.

Chevrier, Jean François. "La photographie dans la culture du paysage." In *Paysages.* Photographie–La Mission Photographique de la DATAR. Paris: Hazan, 1985.

Chevrier, Jean François, and Jean Sagne. "L'Autoportrait comme mise en scène . . . Essai sur l'identité, l'exotisme et les excès photographiques." *Photographies* (April 4, 1984).

Coleman, A. D. "The Indigenous Vision of Manuel Álvarez Bravo." *Artforum* 14, no. 8 (April 1976).

Concha, Waldemaro, and Jimmy Montañez. *Archivo de Pedro Guerra.* Mexico City: Museo de la Ciudad de Mexico, 1989.

Conger, Amy. *Edward Weston in Mexico, 1923–1926.* Foreword by Van Deren Coke. Albuquerque: University of New Mexico Press/San Francisco Museum of Modern Art, 1983.

Conger, Amy, and Elena Poniatowska. *Compañeras de México: Women Photograph Women.* Riverside: University Art Gallery, 1990.

Constantine, Mildred. *Tina Modotti: A Fragile Life.* New York: Paddington Press, 1975. [Spanish translation: *Tina Modotti, una vida frágil.* Trans. Flora Bottom Burlá. Mexico City: Fondo de Cultura Económica, 1979.]

Coronel Rivera, Juan. "150 años de la fotografía." *Unomásuno* (Mexico City), August 2, 7, 14, 21, and 28, 1989.

Cortés, Antonio. *La arquitectura en México: iglesias.* Project directed by Genaro Estrada. Mexico City: Talleres de Imprenta y Fotograbado del Museo Nacional de Arqueología, Historia y Etnología, 1914.

Covarrubias, Miguel. *Mexico South: The Isthmus of Tehuantepec.* Photographs by Rosa Rolando de Covarrubias et al. New York: Alfred A. Knopf, 1946.

Crespo de la Serna, Jorge Juan. "Estampas fotográficas de Lola Álvarez Bravo." *México en la Cultura,* supplement, *Novedades* 207 (Mexico City), October 4, 1953.

Crimp, Douglas. "The Museum's Old/The Library's New Subjects." In *The Contest of Meaning: Critical Histories of Photography,* ed. Richard Bolton. Cambridge, Mass.: MIT Press, 1989.

———. *Reflexiones.* Mexico City: Galería José Clemente Orozco, 1980.

Daniel, Pete, et al. *Official Images: New Deal Photography.* Washington, D.C.: Smithsonian Institution Press, 1987.

Davis, Keith F. *Désiré Charnay: Expeditionary Photographer.* Albuquerque: University of New Mexico Press, 1981.

Debroise, Olivier. *Claude Désiré Charnay.* Mexico City: Centro Cultural Santo Domingo, 1989.

———. "Impresiones en papel sensible." In *Salón nacional de artes plásticas: sección bienal de fotografía 1980.* Mexico City: Instituto Nacional de Bellas Artes, 1980.

———. "José María Velasco y el paisaje fotográfico decimonónico (apuntes para un paralelismo)." In *José María Velasco: homenaje,* comp. Xavier Moyssen. Mexico City: Instituto de Investigaciones Estéticas, Universidad Nacional Autónoma de México, 1989.

———. "Tina Modotti, fotógrafa: una evaluación." *La Cultura en México,* supplement, *Siempre!* 1107 (Mexico City), August 31, 1983.

Denton, Sharon. *Paul Strand Archives.* Tucson: Center for Creative Photography, University of Arizona, 1980.

Desbois, Evelyne. "La vie sur le front de la mort." *La Recherche Photographique* 6 (June 1989).

Desmond, Lawrence Gustave, and Phyllis Mauch Messenger. *A Dream of Maya: Augustus and Alice Le Plongeon in Nineteenth–Century Yucatan.* Albuquerque: University of New Mexico Press, 1988.

Diguet, Léon. *Les cactacées utiles du Mexique.* D. Bois, "Notice nécrologique sur Léon Diguet." Paris: Archives d'Histoire Naturelle/Société National d'Acclimatation de France, 1926.

———. "Idiome Huichol: contribution à l'étude des langues mexicaines." *Journal de la Société des Américanistes de Paris* (Paris) 8 (1911).

Doniz, Rafael. *Casa Santa.* Prologue by Antonio Alatorre. Río de Luz. Mexico City: Fondo de Cultura Económica, 1986.

"Early Photography in Yucatán." *Image* 11, no. 5 (May 1953).

Eisenstein, Sergei. *Mémoires.* Vol. 3. Paris: Union Générale d'Édition, 1985.

"Eisenstein's Thunder Reverberates." *Art Digest* 8, no. 1 (October 1, 1933).

Elizondo, Salvador. "Manuel Álvarez Bravo." *Plural* (Mexico City) 47 (August 1975).

———. "Obra de Manuel Álvarez Bravo: La fotografía único arte realista." *Excélsior* (Mexico City), July 21, 1972.

Erwin, Freger. *México.* Foreword by María Elena Luján; text by Marianne Greenwood. Düsseldorf: Accidenta Druck und Verlag Gematt.

Ewing, William A. *The Photographic Art of Hoyningen-Huene.* New York: Rizzoli, 1986.

Fernández Christlieb, Fátima. *Los medios de difusión masiva en México.* Mexico City: Juan Pablos, 1987.

Fernández Ledesma, Enrique. "The Grace of Old Portraits." *Mexican Art and Life* 4 (October 1938).

———. *La gracia de los retratos antiguos.* Prologue by Marte R. Gómez. Mexico City: Ediciones Mexicanas, 1950.

Fleishmann, Kaspar. *Paul Strand.* Zurich: Zür Stockeregg Galerie für Kunstphotographie, 1987.

Flores Guerrero, Raúl. "Las fotografías que 'denigran' a México." *México en la Cultura,* supplement, *Novedades* 5 (Mexico City), October 25, 1956.

Flores Olea, Víctor. *Los encuentros.* Prologue by Carlos Fuentes. Río de Luz. Mexico City: Fondo de Cultura Económica, 1984.

Fontcuberta, Joan. *Josep Renau, fotomontador.* Río de Luz. Mexico City: Fondo de Cultura Económica, 1985.

Francés, José. "La fotografía artística." *Foto* (Guadalajara) (October 1935).

Freund, Gisèle. *La fotografía como documento social.* Barcelona: Gustavo Gili, 1980.

Fuentes Salinas, José. "Cuarenta años del Club Fotográfico de México." *El Universal y la Cultura,* supplement, *El Universal* (Mexico City), March 21, 1989.

———. "Pedro Meyer: de lo individual a lo institucional." *El Universal* (Mexico City), August 28, 29, and 31 and September 1, 2, 3, 4, 5, and 6, 1989.

———. "El Salón de la Plástica y la Fotografía." *El Universal* (Mexico City), September 14, 1989.

Fulchignoni, Enrico. *La civilisation de l'image.* Paris: Petite Bibliothèque Payot, 1972.

Galassi, Peter, *Before Photography.* New York: Museum of Modern Art, 1981.

———. *Henri Cartier-Bresson: The Early Work.* New York: Museum of Modern Art, 1987.

Galindo, Enrique. "La fotografía de asuntos típicos." *Foto* (Mexico City) (May 1935).

———. "La fotografía pictórica." *Foto* (Mexico City) (April 1935).

García, Emma Cecilia. "Una posible silueta para una futura historiografía de la fotografía en Mexico." *Artes Visuales* (Mexico City) 12 (October–December 1976).

García, Gustavo. "Espejos viejos." *Unomásuno* (Mexico City), August 26, 1989.

García, Héctor. *Escribir con luz.* Río de Luz. Mexico City: Fondo de Cultura Económica, 1985.

———. *México sin retoque.* Prologue by Elena Poniatowska. Los Creadores y las Artes. Mexico City: Difusión Cultural, Universidad Nacional Autónoma de Mexico, 1987.

García Canclini, Néstor. "Estética e imagen fotográfica." Paper presented at the III Coloquio Latinoamericano de Fotografía, Havana (unpublished manuscript). 1984.

Garza, Mario de la. "Entre Maximiliano y la Bola 1: notas sobre el retrato fotográfico mexicano de fines del siglo XIX a principios del XX." *La Cultura en Mexico,* supplement, *Siempre!* 1088 (Mexico City), April 13, 1983.

———. "Entre Maximiliano y la Bola 2: un oceano azul añil cuelga de un foco." *La Cultura en México,* supplement, *Siempre!* 1100 (Mexico City), July 6, 1983.

Gibson, Margaret. *Memories of the Future: The Day Books of Tina Modotti, Poems.* Baton Rouge: Louisiana State University Press, 1986.

Gili, Marta. "Josep Renau." In *Contemporary Photographers,* ed. Colin Naylor. Chicago: Saint James Press, 1988.

Gilpin, Laura. *The Rio Grande: River of Destiny.* New York: Duell, Sloan and Pearce, 1949.

———. *Temples in Yucatan: A Camera Chronicle of Chichén-Itzá.* New York: Hastings House, 1948.

Gimon, Gilbert. "Le 19 juin 1867 . . . François Aubert couvre l'événement." *Prestige de la Photographie* 3 (December 1977).

Gleed, Arthur. "La fotografía como record del espíritu de los tiempos." *Foto* (Mexico City) (June 1935).

Gómez Vergara, Joaquín. *Fotografías a la sombra: retratos en silueta de las muchas caricaturas sociales que nos salen al encuentro por todas partes, escritas en prosa desaliñada por Demócrites [seudónimo].* Mexico City: El Siglo XIX, Imprenta de Ignacio Cumplido, 1871.

González Rodríguez, Sergio. "Congelar la imagen, ensayar la lucidez." *La Cultura en México,* supplement, *Siempre!* 1074 (Mexico City), January 12, 1984.

Gould, Lewis L., and Richard Greffe. *Photojournalism: The Career of Jimmy Hare.* Austin: University of Texas Press, 1977.

Granados Chapa, Miguel Ángel. "La imagen en la industria periodística mexicana." In *El poder de la imagen y la imagen del poder: fotografías de prensa del porfiriato a la época actual,* by Flora Lara Klahr and Marco Antonio Hernández. Chapingo, Estado de Mexico: Universidad Autónoma de Chapingo, 1985.

Green, Eleanor. *Fotografías de Edward Weston/Brett Weston.* Mexico City: Instituto Nacional de Bellas Artes/Museo de Arte Moderno, 1966.

Greenough, Sarah. *Paul Strand: An American Vision,* Washington, D.C.: National Gallery of Art/Aperture Foundation, 1990.

Guerra Peña, Felipe. *Fotogeología.* Mexico City: Universidad Nacional Autónoma de Mexico, 1980.

Gutiérrez Muñoz, Luis (ed.). *Documentos gráficos para la historia de México.* Vol. 1, *1848–1911.* Mexico City: Editorial del Sureste/El Colegio de México, 1985.

———. *Documentos gráficos para la historia de México.* Vol. 2, *1854–1867.* Mexico City: Editorial del Sureste/El Colegio de México, 1987.

———. *Documentos gráficos para la historia de México.* Vol. 3, *Veracruz, 1858–1914.* Mexico City: Editorial del Sureste/El Colegio de México, 1988.

"Hace un siglo nació el padre de la fotografía de prensa." *Siempre!* (Mexico City), July 1, 1974.

Hancock de Sandoval, Judith. "Cien años de fotografía en México." *Artes Visuales* (Mexico City) 12 (October–December 1976).

Harris, Alex, and Margaret Sartor. *Gertrude Blom: Bearing Witness.* Chapel Hill: University of North Carolina Press/Center for Documentary Photography, Duke University, 1984.

Hecho en Latinoamérica. Mexico City: Consejo Mexicano de Fotografía/Instituto Nacional de Bellas Artes, 1978.

Hecho en Latinoamérica 2. Mexico City: Consejo Mexicano de Fotografía/Instituto Nacional de Bellas Artes, 1981.

Helfritz, Hans. *Mexiko Früher und Heute.* Berlin: Deutsche Verlagsgesellschaft, 1939.

Henle, Fritz. *Mexico.* Chicago: Ziff-Davis Publishing Company, 1945.

Hernández, Manuel de Jesús. *Los inicios de la fotografía en México: 1839–1850.* Preface by Rafael C. Reséndiz-Rodríguez. Mexico City: Hersa, 1989.

Hernández Campos, Jorge. *Teoría de la fotografía en Manuel Álvarez Bravo, 400 fotografías.* Mexico City: Palacio de Bellas Artes, Instituto Nacional de Bellas Artes, 1972.

Herrera, Hayden. *Frida: A Biography of Frida Kahlo.* New York: Harper and Row, 1983. [Spanish translation: *Frida, una biografía de Frida Kahlo.* Mexico City: Diana, 1985.]

Hill, Paul, and Tom Cooper. "Camera-Interview, Manuel Álvarez Bravo." *Camera* 56, no. 5 (May 1977) (part 1); 56, no. 8 (August 1977) (part 2).

Homer, William Innes. *Alfred Stieglitz and the American Avant-Garde.* Boston–New York, Graphic Society, 1979.

Hoyningen-Huene, George. *Mexican Heritage.* Text by Alfonso Reyes. New York: J. J. Augustin Publishers, 1946.

Hughes, Langston. *Pictures More Than Pictures: The Work of Manuel Álvarez Bravo and Cartier-Bresson.* Mexico City: Instituto Nacional de Bellas Artes, 1935.

Hurlburt, Laurence. "David Alfaro Siqueiros's 'Portrait of the Bourgeoisie.'" *Art Forum* 15, no. 6 (February 1977).

Iturbide, Graciela. *Juchitán de las mujeres.* Text by Elena Poniatowska. Mexico City: Ediciones Toledo, 1989.

———. *Sueños de papel.* Prologue by Verónica Volkow. Río de Luz. Mexico City: Fondo de Cultura Económica, 1985.

Iturbide, Mercedes. *3 générations féminines dans la photographie mexicaine: Tina Modotti, Lola Álvarez Bravo et Graciela Iturbide.* Paris: Centre Cultural du Mexique, 1983.

Jackson, William Henry. *Time Exposure: The Autobiography of William Henry Jackson.* Albuquerque: University of New Mexico Press, 1986.

Jones, William C. "William Henry Jackson in Mexico." *American West Magazine* (July–August 1977).

Jouffroy, Alain. "Una objetividad natural: Víctor Flores Olea." *La Cultura en México,* supplement, *Siempre!* 1056 (Mexico City), September 8, 1982.

Jurado, Carlos. *El arte de la aprehensión de las imágenes o el unicornio.* Mexico City: Universidad Nacional Autónoma de México, 1974.

Kolko, Berenice [Bernice]. *Rostros de México.* Text by Rosario Castellanos. Mexico City: Dirección General de Publicaciones/Universidad Nacional Autónoma de México, 1966.

———. *Semblantes mexicanos.* Text by Fernando Cámara Barbachano. Mexico City: Instituto Nacional de Antropología e Historia, 1968.

Kozloff, Max. *The Privileged Eye: Essays on Photography.* Albuquerque: University of New Mexico Press, 1987.

Kramer, Hilton. "Edward Weston's Privy and the Mexican Revolution." *New York Times* (June 7, 1972).

Kusch, Eugen. *Mexiko im Bild: Aufgenommen und erläütert von Eugen Kusch.* Nuremberg: Verlag Hans Carl, 1957.

Lara Klahr, Flora. *Jefes, héroes y caudillos, Archivo Casasola.* Río de Luz. Mexico City: Fondo de Cultura Económica, 1986.

Lara Klahr, Flora, and Marco Antonio Hernández. *El poder de la imagen y la imagen del poder: Fotografías de prensa del porfiriato a la época actual.* Chapingo, Estado de México: Universidad Autónoma de Chapingo, 1985.

Lara Klahr, Marco. "Soy un fotógrafo terco e indisciplinado, sin grupo: Rogelio Cuéllar." *El Financiero* (Mexico City), September 7, 1989.

Leighton, George R. "The Photographic History of the Mexican Revolution." In *The Wind That Swept Mexico.* Austin: University of Texas Press, 1971.

Leñero, Vicente. Prologue to *Pedro Meyer, los otros y nosotros.* Mexico City: Museo de Arte Moderno, Instituto Nacional de Bellas Artes, 1986.

Livingston, Jane. *The Indelible Image: Photographs of War.* New York: Abrams, 1985.

López, Nacho. "Arte fotográfico de Nacho López." *Revista de la Universidad de México* (Mexico City) 30 (1976).

———. "Arte fotográfico de Nacho López: mi punto de partida." *Revista de Bellas Artes* (Mexico City) 30 (1976).

———. *Fotorreportero de los años cincuenta.* Mexico City: Museo de Arte and C. Carrillo Gil, 1989.

———. *Los pueblos de la bruma y el sol.* Text by Salomón Nahmad. Mexico City: Instituto Nacional Indigenista/Fonapas, 1981.

———. *Yo, el ciudadano.* Prologue by Fernando Benítez. Río de Luz. Mexico City: Fondo de Cultura Económica, 1984.

López de Mendoza, Rafael. *Los empeños de México, cuadros de costumbres escritos en versos, fotografías instantáneas.* Mexico City: La Ilustración, n.d.

Lumholtz, Carl. *Los indios del noroeste.* Ed. Pablo Ortiz Monasterio. Mexico City: Instituto Nacional Indigenista, 1979.

Luna, Luis, and Jean Meyer. *Zamora . . . ayer.* Morelia: El Colegio de Michoacán, 1985.

Maler, Teobert. *Edificios mayas trazados en los años de 1886–1905 y descritos por Teobert Maler.* Posthumous publication by Gerdt Kutscher. Monumenta Americana. Berlin: Ediciones del Ibero-Amerikanisches Institut, Preussischer Kulturbesitz IV, Editorial Gebr. Mann, 1971.

———. "Explorations in the Department of Peten, Guatemala." *Memoirs of the Peabody Museum of Archaeology and Ethnology* 5, no. 1. Cambridge, Mass.: Harvard University, 1911.

———. *Impresiones de viaje a las ruinas de Cobá y Chichén-Itzá.* Prologue by D. Santiago Burgos Brito. Mérida: José E. Rosado, 1932.

———. "Researches in the Central Portion of the Usumacinta Valley." *Memoirs of the Peabody Museum of Archaeology and Ethnology* 2, nos. 1 and 2. Cambridge, Mass.: Harvard University, 1901 and 1903.

"Manuel Álvarez Bravo." *New Yorker* (June 1975).

Márquez, Luis. *Mexican Folklore.* Text by Justino Fernández. Mexico City: Eugenio Fishgrund, ca. 1950.

Martel, P. "Para la historia de la fotografía artística." *Foto* (Mexico City) (September 1935).

Martínez Marín, Carlos. "José María Velasco y el dibujo arqueológico." In *José María Velasco: homenaje.* Mexico City: Instituto de Investigaciones Estéticas, Universidad Nacional Autónoma de México, 1989.

Mason, Ch. Theo. "Photography in Mexico City." *Professional and Amateur Photographer: A Journal of Practical Photography* (Buffalo) 11, no. 8 (August 1906).

Massé, Patricia. "Reflejos paralelos: Cruces y Campa/ Juan Cordero." *La Jornada Semanal* (Mexico City), December 23, 1990.

Matus, Macario. "Confesiones de Lola Álvarez Bravo." *Excélsior* (Mexico City), September 3, 1989.

Maudslay, Alfred Percival. *Biologia Centrali-Americana, Archaeology.* 5 vols. London: R. H. Porter and Dulau and Co., 1889–1902.

McBride, Henry. "Paul Strand: Series of Photographs of Mexico." *Springfield Sunday Union and Republican,* July 7, 1940.

McElroy, Keith. *Early Peruvian Photography: A Critical Study.* Studies in Photography, no. 7. Ann Arbor, Mich.: UMI Research Press, 1985.

———. "Fotógrafos extranjeros antes de la Revolución." *Artes Visuales* (Mexico City) 12 (October–December, 1976).

Memoria del Primer Coloquio Nacional de Fotografía. Ed. Agustín Martínez Castro. Mexico City: Consejo Mexicano de Fotografía/Instituto Nacional de Bellas Artes/Gobierno del Estado de Hidalgo, 1984.

Mercado, Enrique. "Los grupos pelliceres secundan el poema." *La Cultura en México,* supplement, *Siempre!* 1074 (Mexico City), January 12, 1984.

Meyer, Eugenia et al. *Imagen histórica de la fotografía en México.* Mexico City: Instituto Nacional de Antropología e Historia, 1977.

Meyer, Pedro. *Espejo de espinas.* Prologue by Carlos Monsiváis. Río de Luz. Mexico City: Fondo de Cultura Económica, 1986.

Meyer, Pedro, and Graciela Iturbide. *Mexico.* Alexandria, Va.: Time-Life Books, 1986.

Miguel, Francisco. "Un fotógrafo mexicano." *El Universal* (Mexico City), January 5, 1930.

"Mimo: arte fotográfico de Pablo Ortiz Monasterio, El." *Revista de Bellas Artes* (Mexico City) 27 (1976).

Modotti, Tina. "La fotografía debe ser exclusivamente fotografía." *Foto* (Mexico City), December 16, 1937.

———. "La fotografía debe ser fotografía y nada más." *Mexican Folkways* 5, no. 4 (October–December, 1929).

———. *Una mujer sin país.* Mexico City: Cal y Arena, 1991.

———. *Photographien und Dokumente.* Berlin: Sozialarchiv, Neue Gesellschaft für Bildende Kunst, 1989.

Monsiváis, Carlos. "Continuidad de imágenes: notas a partir del Archivo Casasola." *Artes Visuales* (Mexico City) 12 (October–December 1976).

———. *Días de guardar.* Mexico City: Galería Juan Martín, 1989.

———. *Foto estudio Jiménez: Sotero Constantino, fotógrafo de Juchitán.* Mexico City: ERA/Ayuntamiento Popular de Juchitán, 1983.

———. "Notas sobre la historia de la fotografía en

México." *Revista de la Universidad de México* (Mexico City) 25, nos. 5–6 (December 1980–January 1981).

———. "Pagés Llergo defendió la tolerancia y auspició la libertad de expresión." *Proceso* (Mexico City), January 5, 1990.

———. "Los testimonios delatores, las recuperaciones estéticas." *La Cultura en México,* supplement, *Siempre!* 1074 (Mexico City), January 5, 1983.

———. "Tina Modotti y Edward Weston en México." *Revista de la Universidad de México* (Mexico City) 21, no. 6 (February 6, 1977).

Montellano, Francisco. *C. B. Waite, fotógrafo: una mirada diversa sobre el México de principios del siglo XX.* Preface by Aurelio de los Reyes. Mexico City: Consejo Nacional para la Cultura y las Artes/ Grijalbo, 1994.

Morales, Alfonso. *Los recursos de la nostalgia.* Colección Memoria y Olvido: Imágenes de Mexico. Mexico City: Martín Casillas, 1982.

Morley, Sylvanus Griswold. "Yucatan; Home of the Gifted Maya." Photographs by Luis Marden; aerial photographs by Charles Lindbergh. *National Geographic Magazine* 70, no. 5 (November 1936).

Moyano, Beatriz. "¿Qué pasa con la fotografía mexicana de hoy?" *Artes Visuales* (Mexico City) 12 (October–December 1976).

Mraz, John. "From Positivism to Populism: Toward a History of Photojournalism in Mexico." *Afterimage* (January 1991).

———. *La mirada inquieta: nuevo fotoperiodismo mexicano, 1976–1996* (with Ariel Arnal). Mexico City: Centro de la Imagen/Consejo Nacional para la Cultura y las Artes, 1996.

———. "Video-historia y la clase obrera mexicana." *La Jornada Semanal* (Mexico City), April 15, 1990.

Mraz, John, and Jaime Vélez Storey. *Uprooted: Braceros in the Hermanos Mayo Lens.* Houston: Arte Público Press, 1996.

Murillo, Gerardo (Dr. Atl). *Iglesias de México.* Text by Manuel Toussaint; photographs by Guillermo Kahlo. Mexico City: Publicaciones de la Secretaría de Hacienda, 1924–1927.

Musacchio, Humberto. "Fotografía." In *Diccionario enciclopédico de México.* Mexico City: Andrés León, 1989.

Mutis, Álvaro. *Historia natural de las cosas.* Ed. Pablo Ortiz Monasterio. Río de Luz. Mexico City: Fondo de Cultura Ecónomica, 1985.

Naef, Weston J. *The Collection of Alfred Stieglitz: Fifty Pioneers of Modern Photography.* New York: Metropolitan Museum of Art/Viking Press, 1978.

Navarrete, Sylvia. "Lola Álvarez Bravo." *La Jornada Semanal* (Mexico City), September 3, 1989.

Naylor, Colin (ed.). *Contemporary Photographers.* 2nd ed. Chicago: St. James Press, 1988.

Nelken, Margarita. "Manuel Álvarez Bravo." *Excélsior* (Mexico City), June 3, 1966.

Newhall, Beaumont. "Documentary Approach to Photography." *Parnassus* (March 1938).

———. *The History of Photography.* New York: Museum of Modern Art, 1964.

———. "Weston in Mexico." *Art in America* (July 1962).

Newhall, Nancy. *Edward Weston/Brett Weston.* Mexico City: Museo de Arte Moderno/Instituto Nacional de Bellas Artes, 1966.

Neyra, José Luis. *Al paso del tiempo.* Prologue by Jaime Moreno Villareal. Río de Luz. Mexico City: Fondo de Cultura Económica, 1987.

Oles, James D. "From 'Modern Mexico' to Mexico's Modernism: Mexican Folk Art on Public Display, 1823–1940." Department of the History of Art, Yale University (unpublished manuscript), 1990.

———. "Paul Strand in Mexico: Capturing an Image for the Folks Back Home." Department of the History of Art, Yale University (unpublished manuscript), 1989.

Orive, María-Cristina. "Fotografía en América Latina: lucha, realidad o evasión?" *Artes Visuales* (Mexico City) 12 (October–December 1976).

Ortiz Monasterio, Pablo. *Los pueblos del viento: crónica de mareños.* Text by José Manuel Pintado. Mexico City: Instituto Nacional Indigenista, 1981.

———. *Testigo y cómplice.* Mexico City: Martín Casillas, 1982.

Oudin, Bernard. *Villa, Zapata et le Mexique en feu.* Paris: Découvertes/Gallimard, 1989.

Oxman, Nelson. "Días de guardar." *Unomásuno* (Mexico City), August 27, 1989.

"Paisaje del hombre: arte fotográfico de Rodrigo Moya, El." *Revista de Bellas Artes* (Mexico City) 29 (1976).

Palencia, Ceferino. "El arte en la fotografía de Lola Álvarez Bravo." *México en la Cultura,* supplement, *Novedades* (Mexico City), June 17, 1951.

Pane, Richard. "Manuel Álvarez Bravo: Hieratic Images of Life and Death." *New Art Examiner* (April 1974).

Parker, Fred. "Manuel Álvarez Bravo." *Camera* 51, no. 1 (January 1972).

Payne, Robert. *Mexico City.* Photographs by Dick Davis. New York: Harcourt, Brace and World, 1968.

Paz, Octavio. "Homenaje a Manuel Álvarez Bravo, cara al tiempo." *Plural* (Mexico City) 58 (July 1976).

———. *Instante y revelación.* Ed. A. Muñoz. Mexico City: Fondo Nacional para las Actividades Sociales, 1982.

Pérez Escamilla, Agustín. *Los ojos de la historia: obra fotográfica 1934–1984.* Mexico City: Dirección General de Comunicación Social de la Presidencia de la República, 1984.

Peters, Hank. Prologue to *Panorama del Paseo de la Reforma y otras obras,* by Jan Henderikse. Mexico City: Museo Universitario del Chopo, 1986.

Philadelphia Museum of Art. *Mexican Art Today* (catalog). Philadelphia: Philadelphia Museum of Art, 1943.

Phillips, Christopher. "Anton Bruehl." In *Contemporary Photographers,* ed. Colin Naylor. Chicago: Saint James Press, 1988.

———. "The Judgment Seat of Photography." In *The Contest of Meaning: Critical Histories of Photography,* ed. Richard Bolton. Cambridge, Mass.: MIT Press, 1989.

Pina, Francisco. "Raíces." *México en la Cultura,* supplement, *Novedades* 6 (Mexico City) September 26, 1954.

Poniatowska, Elena. "Manuel Álvarez Bravo." *La Jornada* (Mexico City), July 22, 23, 24, and 25, 1990.

Porter, Eliot. *Baja California and the Geography of Hope.* Introduction by Joseph Wood Krutch. San Francisco: Sierra Club, 1968.

Porter, Eliot, and Ellen Auerbach. *Mexican Celebrations.* Essays by Donna Pierce and Marsha C. Bol. Albuquerque: University of New Mexico Press, 1990.

———. *Mexican Churches.* Albuquerque: University of New Mexico Press, 1987.

Poyo, Ruth. *Mexico in Pictures.* Mexico City: Eugenio Fishgrund, ca. 1950.

Pozas Horcasitas, Ricardo. *El triunvirato sonorense.* Colección Memoria y Olvido: Imágenes de México. Mexico City: Martín Casillas, 1982.

Priego Ramírez, Patricia, and José Antonio Rodríguez. *La manera en que fuimos: fotografía y sociedad en Querétaro, 1840–1930.* Colección Fotografía Queretana. Querétaro: Gobierno del Estado de Querétaro, 1989.

Prignitz, Helga. *TGP: Ein Grafiker-Kollektiv in Mexico von 1937–1977.* Berlin: R. Seitz, 1981.

Ramírez Aznar, Luis A. *Puuc: Testimonios del pueblo maya.* Mérida: Maldonado Editores, 1983.

Ravell, H. "Vanishing Mexico." *Harper's* 134, no. 799 (December 1916).

Razetti, Ricardo. *Itinerario fotográfico de Ricardo Razetti.* Caracas, Venezuela: Galería de Arte Nacional, August 1990.

Reeves, Frank. *Hacienda de Atotonilco.* Yerbanis, Durango: Atotonilco Livestock Co., 1936.

Reyes Palma, Francisco. *Memoria del tiempo: 150 años de fotografía en México.* Mexico City: Museo de Arte Moderno, 1989.

Reynaud, Françoise. "Des cris aux petits métiers." Introduction to catalog *Petits métiers et types parisiens vers 1900.* Paris: Musée Carnavalet, 1985.

Rice, Leeland. "Mexico's Master Photographers." *Artweek,* May 22, 1971.

Ritchin, Fred. *In Our Own Image: The Coming Revolution in Photography.* New York: Aperture, 1990.

Rivera, Diego. "Edward Weston y Tina Modotti." *Mexican Folkways* (April 1926).

Roberts, David. "Artist's Dialogue: Manuel Álvarez Bravo, Mexico's Poet of the Commonplace." *Architectural Digest* 44, no. 38 (May 1987).

Roche, Denis. *La disparition des lucioles (réflexions sur l'acte photographique).* Paris: Éditions de l'Étoile, 1982.

Rodríguez, Antonio. "Del códice al rotograbado: La ilustración de la noticia en la prensa de Mexico/3." *Mañana* 203 (Mexico City), July 19, 1947.

———. "Después de doce años expone Manuel

Álvarez Bravo." *México en la Cultura,* supplement, *Novedades* (Mexico City) March 10, 1957.

———. "Homenaje a los fotógrafos de prensa." In *Mañana,* catalog for the exhibition *Palpitaciones de la vida nacional (México visto por los fotógrafos de prensa).* Mexico City: Asociación Mexicana de Fotógrafos de Prensa/Instituto Nacional de Bellas Artes, 1947.

———. "Nacho López, fotógrafo de la vida." *Excélsior* (Mexico City), September 5, 1989.

Rodríguez, José Antonio. "La fotografía en México: la múltiple historia de sus inicios." *Artes* (Mexico City) (1990).

Rodríguez Prampolini, Ida. *La crítica de arte en México en el siglo XIX.* 3 vols. Mexico City: Instituto de Investigaciones Estéticas, Universidad Nacional Autónoma de México, 1964.

Rodríguez Ramírez, Alfredo. "Magia y sorpresa en las fotografías de Lola y Manuel Álvarez Bravo." *El Sol de México* (Mexico City), September 8, 1989.

Román, Alberto. "Los rompecabezas del instante." *La Cultura en Mexico,* supplement, *Siempre!* 1074 (Mexico City), January 12, 1984.

Rouillé, André. "Un combat photographique en Crimée." *La Recherche Photographique* 6 (June 1989).

———. *L'Empire de la photographie, 1839–1870.* Preface by Jean-Claude Lemagny. Paris: Le Sycomore, 1982.

———. "Les images photographiques du monde du travail sous le Second Empire." *Actes de la Recherche en Sciences Sociales* (Paris) 54 (September 1984).

Roussin, Philippe. "Découvertes d'une mythologie: images européennes du Mexique." *Photographies* (Paris, Bibliothèque Nationale de Paris) 6 (December 1984).

Rubalcaba, Adam. *Puebla de Los Ángeles, estampas y glosas.* Mexico City: Editorial Arquitectura, 1962.

Rudisill, Richard. *Mirror Image: The Influence of the Daguerreotype on American Society.* Albuquerque: University of New Mexico Press, 1971.

Rulfo, Juan. *Inframundo: The Mexico of Juan Rulfo.* Text by José Emilio Pacheco et al. Hanover, N.H.: Ediciones del Norte, 1983.

———. *Juan Rulfo: homenaje nacional.* Introduction by Fernando Benítez. Mexico City: Instituto Nacional de Bellas Artes, 1980.

Ruy Sánchez, Alberto, et al. "El arte de Gabriel Figueroa." *Artes de México* (Mexico City), n.s. 2 (Winter 1988).

Saborit, Antonio. "De izquierda a derecha y en el orden acostumbrado, Lola Álvarez Bravo." *La Cultura en México,* supplement, *Siempre!* 1074 (Mexico City), January 12, 1984.

———. "Imágenes de Tina Modotti." Unpublished manuscript, 1991.

Sagne, Jean, *L'Atelier du photographe, 1840–1940.* Paris: Presses de la Renaissance, 1984.

Salas Portugal, Armando. *Los antiguos reinos de México.* Mexico City: Centro Cultural/Arte Contemporáneo, 1986.

———. *Fotografía del pensamiento.* Coord. Abel Cárdenas Chavero. Mexico City: Orión, 1968.

Sandweiss, Martha A. *Laura Gilpin: An Enduring Grace.* Fort Worth, Tex.: Amon Carter Museum, 1986.

Sandweiss, Martha A., et al. *Eyewitness to War: Prints and Daguerreotypes of the Mexican War, 1846–1848.* Fort Worth, Tex.–Washington, D.C.: Amon Carter Museum/Smithsonian Institution Press, 1989.

Sarber, Mary A. *Photographs from the Border: The Otis A. Aultman Collection.* El Paso, Tex.: El Paso Public Library Association, 1977.

Scharf, Aaron. *Art and Photography.* London: A. Lane, 1969.

Secretaría de Fomento, Colonización, Industria y Comercio. *Memoria presentada al Congreso de la Unión por el Secretario del Despacho de Fomento, Colonización, Industria y Comercio de la República.* Mexico City, 1876.

Selingson, Esther. Prologue to *Rogelio Cuéllar: huellas de una presencia.* Mexico City: Artífice Ediciones, 1983.

Silva Herzog, Jesús. *La expropiación del petróleo, 1936–1938: Álbum fotográfico.* Tezontle. Mexico City: Fondo de Cultura Económica, 1981.

Sociedad de Fotografía de Monterrey. *Estatutos y reglamentos, Monterrey.* Mexico City: Tipografía de Agustín Martínez, 1908.

Sontag, Susan. *On Photography.* New York: Farrar, Straus and Giroux, 1973.

Stark, Amy. "The Letters from Tina Modotti to Edward Weston." *Archive* (Tucson, Center for

Creative Photography, University of Arizona) 22 (January 1986).

Starr, Frederick. *Indians of Southern Mexico: An Ethnographic Album.* Chicago: [the author], 1899.

Stebbins, Robert. "Redes." *New Theater* 3, no. 11 (November 1936).

Stelzer, Otto. *Arte y fotografía, contactos, influencias y efectos.* Barcelona: Gustavo Gili, 1978.

Stephens, John Lloyd. *Incidents of Travel in Yucatan.* New York: Dover, 1963. [1st ed. 1842. There are a number of Spanish translations; the first, by Justo Sierra O'Reilly, was published in Mérida in 1848.]

Stewart, Virginia. *Forty-five Contemporary Mexican Artists.* Stanford, Calif.: Stanford University Press, 1951.

Stirling, Matthew Williams. *Stone Monuments of Southern Mexico.* Washington, D.C.: Government Printing Office, 1943.

Strand, Paul. *The Mexican Portfolio.* Preface by David Alfaro Siqueiros; foreword by Leo Hurwith. New York: Aperture/Da Capo Press, 1967. [1st. ed. 1940.]

Suter, Gerardo, and Alfonso Morales. "Silbando entre los huecos." *En el Archivo del Profesor Retus.* Tijuana: Secretaría de Educación Pública/ Programa Cultural de las Fronteras, 1986.

Szilági, Gábor. *La fotografía histórica* (flyer-catalog). Mexico City: Consejo Mexicano de Fotografía, 1986.

Szilági, Gábor, and Sándor Kardos. *Leletek, A Magyar Fotográfia Történetéböl.* Budapest: Képzömüvészeti Kiadó, 1983.

Taft, Robert. *Photography and the American Scene: A Social History, 1839–1889.* New York: Dover Publications, 1964. [1st ed. 1938.]

Taracena, Berta. "Nuevo sentido de la visión." *México en la Cultura,* supplement, *Novedades* (Mexico City), July 2, 1974.

Tibol, Raquel. *Episodios fotográficos.* Mexico City: Libros de Proceso, 1989.

Tiffereau, Théodore. *Les métaux sont des corps composés: Production artificielle de l'or; Lettres à MM. les membres de la Commission du Budget, à MM. les Sénateurs et à MM. les Députés, et cétera, et ce qu'a été mon existence jusqu'à ce jour.* Paris: the author, 1888.

Tomkins, Calvin. *Paul Strand: Sixty Years of Photography.* Millerton, N.Y.: Aperture, 1976.

Trutat, Eugène. *La photographie appliquée à l'histoire naturelle.* Paris: Gauthier/Villars, 1884.

Turok, Antonio. *Imágenes de Nicaragua.* Mexico City: Casa de las Imágenes, 1988.

Valle, Rafael Heliodoro. "Datos para una historia de la fotografía en México." *El Nacional* (Mexico City), supplement, no. 10, November 23, 1958.

Vanderwood, Paul J., and Frank N. Samponaro. *Border Fury: A Picture Postcard Record of Mexico's Revolution and U.S. War Preparedness, 1910–1917.* Albuquerque: University of New Mexico Press, 1988.

Vargas, Hugo. "Política, historia y creación: entrevista con Víctor Flores Olea." *La Jornada Semanal* (Mexico City), December 10, 1989.

Veintiséis fotógrafos independientes. Mexico City: Ediciones El Rollo, 1979.

Verger, Pierre. *Mexico: One Hundred and Eighty-five Photographies.* Introduction by Jacques Soustelle. Mexico City: Central de Publicaciones, 1938.

Vestal, David. "Tina's Trajectory." *Infinity* 15, no. 2 (February 1966).

Villagómez, Adrián L. "Lola Álvarez Bravo: semblanza de una artista mexicana." *México en la Cultura,* supplement, *Novedades* (Mexico City), May 4, 1952.

Villarreal Macías, Rogelio, et al. *Aspectos de la fotografía en México.* Vol. 1. Mexico City: Federación Editorial Mexicana, 1981.

Villarreal Macías, Rogelio, and Juan Mario Pérez Orozco. *Fotografía, arte y publicidad.* Mexico City: Federación Editorial Mexicana, 1979.

Volkow, Verónica. Prologue to *Refugios callados, fotografía de Vida Yovanovich.* Mexico City: Museo Universitario del Chopo, 1988.

Von Karnitschmigg, Maximiliano. "La fotografía como medio de expresión artística." *Foto* (Mexico City) (November 1935).

Waldeck, Frédérick de. "Les antiquités mexicaines et la photographie." *Le Trait d'Union* (Mexico City), April 19, 1862.

Walsh, Raoul. *Each Man in His Time: The Life Story of a Director.* New York: Farrar, Straus and Giroux, 1974.

Weston, Edward. *The Daybooks of Edward Weston, I: Mexico.* Ed. Nancy Newhall. New York: Horizon Press, 1961.

———. *The Daybooks of Edward Weston, II: California.* Ed. Nancy Newhall. New York: Horizon Press, 1961.

———. "Light vs. Lighting." *Camera Craft* 46 (January 1939).

———. "Thirty-five Years of Portraiture." *Camera Craft* 46 (January 1939).

———. "What Is Photographic Beauty?" *Camera Craft* 46 (January 1939).

White, Minor. "Manuel Álvarez Bravo." *Aperture Quarterly* 1, no. 4 (1953).

Windenberger, Jacques. *La photographie, moyen d'expression et instrument de démocratie.* Paris: Les Éditions Ouvrières, 1965.

Witmore, Eugene. "Fotografía en México." *Helios* 6, no. 42 (March 31, 1935). [Originally published in *Camera.*]

Yampolsky, Mariana. *La raíz y el camino.* Prologue by Elena Poniatowska. Río de Luz. Mexico City: Fondo de Cultura Económica, 1985.

Yampolsky, Mariana, and Elena Poniatowska. *Estancias del olvido.* 2nd ed. Mexico City: Educación Gráfica, 1987.

Yliescas y de los Santos, Héctor Ignacio, and Ezequiel Álvarez Tostado Nuño. "Biografía del señor Ezequiel Álvarez Tostado Alonso Ortíz, 'Tostado grabador.'" Unpublished manuscript, 1962.

Yovanovich, Vida (ed.). *Mujer × mujer, 22 fotógrafas.* Mexico City: Museo de San Carlos, 1989.

Zabludowsky, Gina. "¿Ha existido la fotografía artística mexicana?" *Artes Visuales* (Mexico City) 1 (December 13–15, 1973).

Index

Orellana, Antonio, 33

Orozco, José Clemente, 139, 214, 226, 235, 241

Orozco, Nieves, 139

Orozco, Pascual, 178, 179

Orozco Romero, Carlos, 222

Orozco y Berra, Manuel, 89, 108, 119

Ortiz, Martín, 48, 53, 203, 206

Ortiz, Rubén, 133, 235

Ortiz Monasterio, Ángel, 182

Ortiz Monasterio, Pablo: and borders, 158; and cities, 153; and ethnological photography, 133, 143, 146, 147; and landscape photography, 68; and Lumholtz, 129; and narrative-poetic line, 237; and photographic manipulation, 235; and Porter, 70
—Works: *Popocatépetl — Gregorio, 145; Los pueblos del viento,* 146

Ortiz Rubio, Pascual, 52, 224

Osorio, Juana, 46–47

O'Sullivan, Timothy, 4, 57, 101

Othón de Mendizábal, Miguel, 139

Outerbridge, Paul, 138

Pabst, G. W., 68

Pacheco, Jesús, 47

Pacheco, José Emilio, 243–244

Pacheco, Máximo, 141, 214

Pagés Llergo, José, 188, 190

Painting: and landscape photography, 18, 33, 56, 58, 59, 62, 79; and portrait photography, 31, 33, 34, 249n.6; and retouching/coloring portraits, 31, 32–33; and war photography, 169–170

Palpitaciones de la vida nacional, 191–192

Pani, Arturo, 187

Parés, J. B., 30

Parra, Gonzalo de la, 183

Paso y Troncoso, Francisco del, 33

Patiño, Adolfo, 37, 237; *La muerte del maguey,* 123

Payno, Manuel, *Los bandidos de Río Frío,* 116

Paz, Octavio, 34, 70

Pedebiella, José, 30

Pedro II (emperor of Brazil), 20

Peláez, Antonio, 230

Pellicer, Carlos, 104

Péraire, Auguste, 28, 30, 169, 170

Peres, Adelaida, 46

Pérez de Bonilla, Antonio, 41

Pérez Martínez, Héctor, 229

Peru, 6, 22

Petzval, Josef, 20

Phalipan, Armand, 89

Philips, Alex, 136

Phillips, Christopher, 5

Photographers: and Centenary Celebrations, 170–171; competition among, 29–30, 48; and history, 10–11, 13, 164; influences of, 12; intentions of, 4; itinerant photographers, 20, 28, 30, 34, 49, 63, 164, 250n.23; and photojournalism, 5; as professionals, 28–34, 63, 65, 76, 182–184; and social class, 31, 34; and technical revolution, 174, 257n.16; traveler-photographers, 74, 76, 105, 108. *See also* Amateur photographers; Portrait photographers

Photography: aerial photography, 99; alternative uses of, 234; ambiguity of, 13, 37–38; and art criticism, 33; and criminals' identification, 41–44; democratization of, 29–30; documentary nature of, 9, 70, 76, 99, 227–228; history of, 4–6, 10–15; Latin American colloquia on, 7, 9–10; and museum's role, 12; and photographic criticism, 4, 10, 90–91, 234–235; reevaluation of, 4, 5, 11, 12; and representation, 36–41; and reproduction concept, 29; and social class, 67, 164; social function of, 9, 12; and subjects, 12–13, 36–37, 38; and technical revolution, 173–174. *See also* Ethnological photography; Landscape photography; Photojournalism; Public works photography

Photojournalism: alternative uses of, 234; and Álvarez Bravo (Lola), 229; and Álvarez Tostado, 183, 186–187; and Casasola, 184–187; and daguerreotypy, 164–168; and ethnological photography, 133; and García, 195–197; and Iturbide, 150, 152; and Levitt, 153; and López, 197–199; and Mexican Revolution, 174, 177–182; and photographic purism, 234, 235; and profession of photographer, 182–184; and *Rotofoto,* 188–191; and technical revolution, 173–174; and television, 5–6; and World War I, 174–177; and World War II, 191–195

Photomontages, 234–235, 237–240, 241, 242

Photo-sculpture, 32, 65

Picasso, Pablo, 214

Piedras Negras, 94

Pingret, Èdouard, 118

Pinochet, Augusto, 181

Poitevin, Alphonse, 31

Polo, Joaquín, 31

Polo, Maximino, 31

Polock, L. H., 167

Poniatowska, Elena, 153, 196; *Estancias del olvido,* 125

Porta, Adolfa de, 53

Porter, Eliot, 4, 59, 136
—Works: *Mexican Celebrations,* 68–70; *Mexican Churches,* 69

Portrait photographers: and aesthetics, 5; and daguerreotypes, 19, 20, 21–22, 164; and identification portraits, 41–47, 49; new styles of, 48–49; socially prominent position of, 27; studios of, 30–31, 34–36, 49, 53, 114, 115, 173; and subject's influence, 12; and urban middle class, 20

Portrait photography: and Álvarez Bravo, 229; and Bruehl, 138; and commercial photography, 76; crisis in, 49, 50–53; and ethnological photography, 114–115; and hand coloration of, 31–33; and identity, 36–38; and Kahlo, 111; and Mexican-American War, 164, 167; and Modotti, 214, 216, 229; and painting, 31, 33, 34, 249n.6; prevalence of,